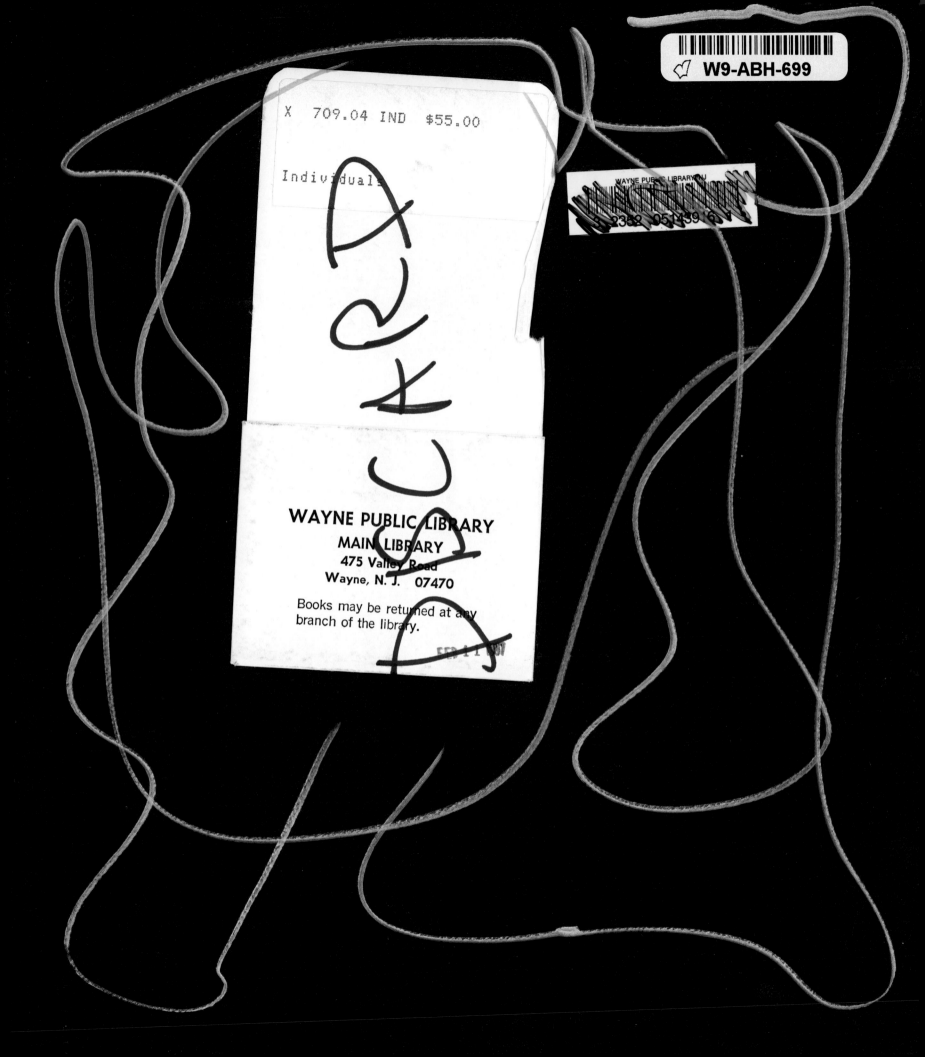

W9-ABH-699

X   709.04 IND   $55.00

Individual

WAYNE PUBLIC LIBRARY
MAIN LIBRARY
475 Valley Road
Wayne, N. J.   07470

Books may be returned at any
branch of the library.

WAYNE PUBLIC LIBRARY NJ

A Selected History of Contemporary Art

1945–1986

FEB 1 1 1987

# INDIVIDUALS

# A SELECTED HISTORY OF CONTEMPORARY ART

## 1945-1986

*Essays by*

*Kate Linker*
*Donald Kuspit*
*Hal Foster*
*Ronald J. Onorato*
*Germano Celant*
*Achille Bonito Oliva*
*John C. Welchman*
*Thomas Lawson*

*Organized by*
*Julia Brown Turrell*

*Edited by*
*Howard Singerman*

*The Museum of Contemporary Art*
*Los Angeles*

*Abbeville Press   Publishers*
*New York*

This book is published in conjunction with the exhibition
"Individuals: A Selected History of Contemporary Art, 1945–1986"
at The Museum of Contemporary Art, Los Angeles,
December 10, 1986–January 10, 1988.
The exhibition and this book are made possible by a grant from the
IBM Corporation.
Additional funding is provided by the National Endowment for the
Arts, a federal agency.
Curator and Project Director: Julia Brown Turrell
Assistant Curator: Kerry Brougher
Editors: Howard Singerman, David Frankel, and Nancy Grubb
Production Supervisor: Hope Koturo
Designer: Massimo Vignelli

Library of Congress Cataloging-in-Publication Data
Individuals: a selected history of contemporary art, 1945–1986.
    "Conjunction with the exhibition 'Individuals: a selected history of
contemporary art, 1945–1986' at the Museum of Contemporary Art,
Los Angeles. December 10, 1986–January 10, 1988"—
    Includes index.
    1. Art, Modern—20th century—Themes, motives.
I. Linker, Kate.   II. Singerman, Howard.   III. Museum of
Contemporary Art (Los Angeles, Calif.)
N6490.I45 1986   709'.04   86–20605
ISBN 0-89659-676-1
ISBN 0-89659-681-8 (pbk.)

First edition

Copyright © 1986 by Cross River Press, Ltd. All rights reserved
under International and Pan-American Copyright Conventions.
No part of this book may be reproduced or utilized in any form or
by any means, electronic or mechanical, including photocopying,
recording, or by any information storage and retrieval system,
without permission in writing from the Publisher. Inquiries should be
addressed to Abbeville Press, Inc., 505 Park Avenue, New York
10022. Printed and bound by Toppan Printing Co., Ltd., Japan.

Original English translation of Germano Celant's *Isolation Cells*
copyright © 1986 by Joachim Neugroschel.
Original English translation of Achille Bonito Oliva's *Figure, Myth,
and Allegory* copyright © 1986 by Alma Ruiz.
Certain photographs reproduced in this book are subject to
copyrights noted in the photography credits.

# Contents

In Anticipation of the Future
*Richard Koshalek*    6

One Very Lucky Museum
*Sherri Geldin*    10

Introduction
*Julia Brown Turrell*    28

Abstraction: Form as Meaning
*Kate Linker*    30

Material as Sculptural Metaphor
*Donald Kuspit*    106

The Crux of Minimalism
*Hal Foster*    162

Being There:
Context, Perception, and Art in the Conditional Tense
*Ronald J. Onorato*    194

Isolation Cells
*Germano Celant*    222

Figure, Myth, and Allegory
*Achille Bonito Oliva*    242

Image and Language:
Syllables and Charisma
*John C. Welchman*    262

The Future Is Certain
*Thomas Lawson*    292

Checklist of the Exhibition    338

Index    364

## In Anticipation of the Future
*Richard Koshalek*

With the dedication of our new building at California Plaza and the fifty-year extension of our lease for the Temporary Contemporary, The Museum of Contemporary Art is poised on the edge of a very promising future. Through the creativity and dedication of our trustees and staff, the museum has, since 1979, commissioned and completed two architecturally significant structures, established the essential core of its permanent collection, and organized a diverse and adventurous program of special exhibitions and of media and performing-arts events. From the outset, the museum has attempted to explore the expanded field of contemporary art, and to actively involve the general public in these explorations. In the process, we have generated considerable international interest, support, and affection.

To assemble a museum collection in the 1980s is a formidable task, and MOCA has made very gratifying progress toward this goal. In the last three years our permanent collection has been strengthened by the acquisition of eighty works of the 1940s, 1950s, and 1960s from Dr. and Mrs. Giuseppe Panza di Biumo, the magnificent gift of sixty-eight works of the last two decades from Barry Lowen, and the generosity of distinguished artists and collectors throughout the world. We have been particularly honored by the extraordinary support of artist Louise Nevelson, who, with Mr. and Mrs. Arnold Glimcher, has donated a series of major works to the museum's permanent collection. With the good will of individuals, foundations, and corporations such as the El Paso Natural Gas Company, which has provided a unique fund for the acquisition of work by emerging California artists, we believe that the collection will continue to grow with a keen sensitivity to quality.

The collection will also grow with a commitment to all of the disciplines that characterize the art of our time—including work that is not readily collectible. With the landmark gift from Virginia Dwan of Michael Heizer's *Double Negative*, a monumental earthwork in the Nevada Desert, MOCA became the first museum to acquire a work of art that is inextricably located outside its walls. The museum has also embraced the art particular to its region, acquiring a number of works by artists associated with the West Coast light and space movement, including Robert Irwin, James Turrell, and Douglas Wheeler.

Our inaugural exhibition, "Individuals: A Selected History of Contemporary Art, 1945–1986," addresses the time period that is the focus of the museum's collection and exhibition program. A selected survey, it emphasizes the contributions of the individual artists represented to the evolving dialogue of contemporary art. "Individuals" also serves as the context for a series of one-person exhibitions presented during the year. An integral part of the inaugural exhibition, these retrospectives of the work of Francesco Clemente, David Salle, Elizabeth Murray, and Donald Sultan continue the museum's commitment to present one-person exhibitions of the work of established and emerging artists. This tradition began with our initial programming of the Temporary Contemporary in November 1983, and has included exhibitions of artists such as Maria Nordman, Michael Heizer, Robert Therrien, Dan Flavin, Allen Ruppersberg, Mark Lere, Mary Corse, Jill Giegerich, Jo Ann Callis, James Turrell, Jonathan Borofsky, John Chamberlain, and William Brice, among others.

In addition to the exhibitions, the museum's inaugural year encompasses a wide range of interdisciplinary performing arts and media projects under the title "Future Forward." This aspect of MOCA's program reflects a development unique to twentieth-century art, a crossing and combining of disciplines that at its beginning involved such legendary collaborators as Eric Satie, Serge Diaghilev, Jean Cocteau, and Pablo Picasso, and has more recently attracted Merce Cunningham, John Cage, David Tudor, and Jasper Johns. From *Available Light*, a work by Lucinda Childs, John Adams, and Frank O. Gehry, which inaugurated the Temporary Contemporary, to *Zangezi*, which premieres as part of the dedication of the new California Plaza building, the museum has recognized its responsibility to encourage those artists engaged in pursuing this historic phenomenon.

The museum's production of *Zangezi* marks the first performance of Velimir Khlebnikov's constructivist play since its premiere in Moscow in 1922. In 1922, *Zangezi* featured sets by Vladimir Tatlin, the renowned Russian constructivist; its presentation at MOCA is also a collaborative effort, a work by theater director Peter Sellars, composer Jon Hassell, and actor David Warrilow. Other "Future Forward" media and performing-arts programs for the inaugural year explore the disciplines of film, dance, music, video, poetry, and performance art.

Augmenting these inaugural exhibitions and programs is a yearlong series of lectures and symposia by noted artists, art historians, theorists, and critics, cosponsored by the museum and the College of Fine Arts of the University of California, Los Angeles. In addition, the museum has created and produced a second series of its radio show, "The Territory of Art," which broadcasts original arts-related programming—from lectures and interviews to works of art conceived for the airwaves—to an international listening audience. Together, the exhibitions, programs, and events of the museum's inaugural year reaffirm our desire to involve the general public meaningfully, to develop a greater understanding and appreciation for contemporary art, and, in so doing, to encourage greater personal inquiry and discovery.

**With thanks to . . .**
The development of a museum and of an inaugural program on the scale of that being organized by The Museum of Contemporary Art takes the concentrated efforts of many people over a considerable period of time. December 1986 marks the realization of a dream shared by the entire community and faithfully pursued over several years by an enormously dedicated Board of Trustees and staff.

On such a historic occasion, numerous people deserve special recognition. Appointed by Mayor Tom Bradley in 1979, the Mayor's Advisory Committee provided the early inspiration and leadership for the founding of The Museum of Contemporary Art. Chaired by

William A. Norris, the committee members included Marcia Weisman (Vice Chairman), Eli Broad, Betye Monell Burton, Gary Familian, Sherri Geldin, Gary Gilbar, Maureen Kindel, Robert F. MacLeod, Jr., Fran Savitch, and Ira Yellin. Downtown Los Angeles' Ninth District City Councilman, Gilbert A. Lindsay, lent his strong and continuing endorsement to the museum from its inception.

The Artists Advisory Committee, led by DeWain Valentine, offered invaluable guidance to the museum in its early stages, playing a unique and seminal role in establishing the institution's personality and direction. Members included Lita Albuquerque, Peter Alexander, Karen Carson, Vija Celmins, Guy Dill, Fred Eversley, Sam Francis, Robert Heinecken, Robert Irwin, Gary Lloyd, Peter Lodato (Treasurer), Joe Ray, Roland Reiss, Alexis Smith, and Tom Wudl. Chuck Boxenbaum, Stanley Grinstein, Coy Howard, Jack Quinn, and Pat Boltz served as advisors, and Joyce Dever as the Administrative Coordinator.

The Community Redevelopment Agency under James N. Wood (Board Chairman), Ed Helfeld, and Donald Cosgrove developed the unprecedented urban-planning model that specified the inclusion of the museum as part of the Bunker Hill redevelopment project. Bunker Hill Associates, represented by Stanley V. Michota and William J. Hatch, generously contributed $22 million to underwrite the construction of Arata Isozaki's dramatic design as part of their fine arts commitment to the California Plaza project.

We are grateful to Arata Isozaki and, of his design team, Shin Watanabe, who have worked with us over a period of nearly five years to create the museum's extraordinary new building. Frank Gehry and his associate, Robert Hale, deserve special appreciation for their remarkable renovation of the Temporary Contemporary, which began its life as an interim home for the museum's programs and has since become part of MOCA's permanent exhibition space. We have been privileged to work with these individuals and believe that their work has made a lasting contribution to the cultural life of Los Angeles as

well as to a larger architectural community. Museum Vice Chairman Frederick M. Nicholas, with the assistance of Marcy Goodwin, orchestrated with patience, care, and expertise the successful completion of both buildings, balancing the complex requirements of staff, trustees, developers, architects, and contractors.

We are especially grateful to the Board of Trustees, initially led by Founding Chairman Eli Broad and Founding President William A. Norris, and now under the guidance of Chairman William F. Kieschnick, Vice Chairman Frederick M. Nicholas, and President Lenore S. Greenberg, for the cultural foresight and civic spirit that have characterized their efforts over the past several years. Their remarkable leadership deserves the gratitude of the entire city, along with that of the international art community.

I would like to thank Associate Director Sherri Geldin for her guiding counsel through the myriad of organizational, financial, and promotional issues related to the development of the museum. Reflecting her participation in, and contribution to, the renovation of the Temporary Contemporary and the realization of the new building, she has contributed an original essay to this catalogue on the museum's architecture.

The Director and Curator of "Individuals: A Selected History of Contemporary Art, 1945–1986" is Julia Brown Turrell, who, from 1981 to 1983, served as the museum's first curator, and guided its program as Senior Curator from 1983 through 1985. She organized this exhibition, selected the artists and individual works, and brought the exhibition to fruition. She deserves our utmost appreciation and thanks for the exhibition and for her contribution to the development of the museum. Assistant Curator Kerry Brougher worked closely with Julia Brown Turrell in all parts of the organization of the exhibition and was an integral partner in every phase of its development and completion. The successful realization of this complex undertaking reflects the curatorial and administrative skills he brought to it. Howard Singerman, Publications Coordinator,

organized the lecture series with members of the UCLA College of Fine Arts, and was the editor of the catalogue and the manager of its publication. The ongoing value of this publication as a resource text on the period is in large part due to his scholarly and critical judgment. From the museum's inception Curator Julie Lazar has worked to make the interdisciplinary and nonstatic arts an integral part of its program. In close cooperation with Production Manager Stephen Bennett, Curatorial Secretary Deborah Voigt, and the numerous artists and institutions involved, she organized and produced "Future Forward," the performing-arts and media component of the inaugural year.

Many other members of the staff were closely involved in the inaugural exhibitions. John Bowsher, Chief Preparator, designed the installation of the exhibition in collaboration with architects Isozaki and Gehry. Under his masterful supervision, the exhibition crew— Kevin Jon Boyle, Randall Brockett, Robert Espinoza, Jeff Falsgraf, Robert Gibson, Ken Hurbert, Eric Magnuson, Rudy Mercado, and Marc O'Carroll—realized an installation that fills both buildings and a number of adjacent sites. Registrar Mo Shannon, and Jill Quinn, her assistant, were responsible for the shipping and unpacking of over 400 works from all over the world for this exhibition; they did so with utmost care and concern for the specific requests and logistic demands attendant on each. Assistant Curator Jacqueline Crist and Curatorial Secretary Diana Schwab lent their special talents to the realization of large-scale projects commissioned by the museum for the exhibition. Leslie Fellows and Catherine Gudis, Curatorial Secretaries, were the backbone of the project's organization, coordinating correspondence, compiling the exhibition checklist, and preparing manuscript copy for this catalogue. Ann Goldstein, Research Associate, was of great assistance in the planning and research phases of the exhibition, and interns Joanne Heyler and Linda Mun also provided necessary research for the exhibition and catalogue.

Numerous other staff members have made major contributions to the

museum and to the inaugural-year program: Kerry J. Buckley, Director of Development, has managed with great skill the overall fundraising activities of the museum, from membership to major gifts; Brick Chapman, Operations and Facilities Manager, has diligently overseen all aspects of securing, operating, and maintaining two complex museum buildings; Nancy Fleeter, Controller, has managed the myriad financial arrangements required in such an endeavor; Barbara Kraft, Director of Communications, has coordinated press, outreach, and educational activities in connection with the exhibition; Nancy Rogers, Administrative Assistant, has brought unique organizational talents and a sensitivity to design to various aspects of the project. Special appreciation is due Alma Ruiz, who, as Executive Assistant, remained calmly and closely involved with all aspects of the museum administration. Her communicative skills and unique coordinating abilities contributed immensely to the successful development of this project.

The lenders to the exhibition are too numerous to mention here, but we are greatly appreciative of their generosity and their remarkable support of this institution. We also greatly appreciate the efforts of gallery directors and their staffs, in Europe and the United States, who have assisted us through the organizational phase of the exhibition. The artists whose work constitutes the subject of the exhibition are our most crucial partners of all, as both the exhibition and its catalogue are based on their achievements. The museum values tremendously their participation in this endeavor and expresses its most profound gratitude to each of them.

This catalogue represents a partnership between the museum and Abbeville Press, and we thank Robert E. Abrams, President; Nancy Grubb, Senior Editor; Sharon Gallagher, Managing Editor; and Hope Koturo, Production Supervisor, for all their work with us to bring this book to publication. The catalogue essayists—Kate Linker, Donald Kuspit, Hal Foster, Ronald Onorato, Germano Celant, Achille Bonito Oliva, John Welchman, and Thomas Lawson—make this book what it is, and we are very grateful for their insight into the art of

our times. Massimo Vignelli brings his thoughtful and elegant design to bear on a huge amount of material and, with his assistant Felicity Lodge, has created a beautiful publication.

The overwhelming generosity of the museum's Founders and their early commitment to what was initially no more than an idea has enabled the launching of this important civic project. Their pioneering efforts have allowed the museum to pursue an ambitious course, and their contributions are permanently recorded with gratitude on the museum's donor wall.

This exhibition is made possible by a grant from the IBM Corporation. The museum is profoundly grateful to the distinguished leadership of that organization for their vision and generosity.

Additional funding for the exhibition has been provided by the National Endowment for the Arts, a federal agency. Flying Tigers has also provided generous support.

At this writing, funding for the "Future Forward," the media and performing arts program of the inaugural year, and "The Territory of Art" has been provided by Polaroid Corporation; Rockefeller Foundation; American Public Radio; Gordon P. Getty; HCB Contractors; Millicent and Robert Wise; Michael Forman; and the National Endowment for the Arts, a federal agency.

Funding for "On the Artist in Society," the inaugural lecture series, has been provided by the Joseph Drown Foundation and the University of California, Los Angeles, College of Fine Arts.

It has taken the energy, effort, and support of a great number of individuals, foundations, and corporations to make the first seven years of The Museum of Contemporary Art a success. As we enjoy this historic occasion, I am honored to extend my overwhelming appreciation for their innumerable past efforts and contributions, and invite you to join us as we embark together in anticipation of the future.

**One Very Lucky Museum**
*Sherri Geldin*

*Architecture . . . to understand architecture, not through the eye, not through the brain, but more through the body. I think body feeling is much more important to understanding architecture.*
Arata Isozaki

*The primitive beginnings of architecture come from zoomorphic yearnings and skeletal images. . . .*
Frank O. Gehry

Since first contemplating the amazing good fortune bestowed upon The Museum of Contemporary Art in the form of two quite spectacular museum buildings, I have been unable to shake an especially persistent metaphor. It links Arata Isozaki's building in California Plaza to a favorite film star of his, and goes something like this: if Isozaki's design embodies the exquisite shape and proportion of a Marilyn Monroe—classic, voluptuous, and sensuously draped to enhance and tantalize—then surely Frank Gehry's Temporary Contemporary proclaims the inimitable bone structure of a Katharine Hepburn, magnificently lean and rugged yet indisputably regal, even in work clothes. The metaphor is seductive and tempting to pursue: Isozaki fashions a stunning, sometimes elusive creature of the moment, a creature whose allure and mystique are nonetheless certain to long endure, while Gehry brilliantly reanimates an already timeless legend who wears each passing decade with ever more bravura and style. Two goddesses of a very different sort—yet both cast an aura that transcends mere physical presence and hovers somewhere closer to the realm of pure energy.

Isozaki recalls that his first truly profound realization of architecture, his "being moved to feel something," occurred on his first visit to a European cathedral.[1] He believes that in today's society only the art museum approaches the sacred stature realized in the past by religious architecture. But while the notion of the museum as a dwelling for the gods may well have inspired Isozaki's design of serene, harmonious spaces, it has also provoked the witty and playful irreverence for which he has come to be known. If this museum is a

temple, then it is one in which the gods cavort, amuse, and delight, even as they inspire.

This spirit is perhaps best conveyed in the museum's entrance gallery, Gallery A, a dramatic forty-five-foot-square room surmounted by a single pyramidal skylight soaring to an apex of sixty feet. It is a space whose every facet is defined by sharp angles, yet one so bathed in light that edges and corners dissolve into near-seamless fluidity and grace. Its ambience invokes the power and wonder of the Roman Pantheon, though Isozaki has replaced cylinder and dome with cube and pyramid. The result is an equally uplifting space whose awesome splendor invites contemplation and joy.

At the opposite end of the spectrum, but no less powerful a presence, stands Gehry's Temporary Contemporary, in which the seemingly humble physical attributes of a rundown police garage stand subtly and skillfully transformed. Unlike Isozaki, Gehry denies any conscious allusion to spirituality. Instead, he pursues such essential museum ingredients as accessibility, informality, and a total absence of pretension. While he endeavors to extract and reinforce the building's symbolic meaning for the surrounding community, he refuses as inappropriate, if not impossible, the attempt to impose a sense of spiritual awe. Yet with the mastery of a medieval alchemist, he has coaxed from near rubble an extraordinary museum space, one that ironically has been most often compared to a vaulting cathedral. For Gehry, "the sacred cow is the feeling, and how it's there is mysterious."[2]

Typically self-effacing, Gehry refuses any credit for what is clearly a remarkable yet restrained renovation. He will allow, however, that because the museum was ultimately to have a second building, and because of the rather sensitive circumstances surrounding the selection of that building's architect (Gehry had been a finalist in the competition for it), he was sure that no one would "stand in his way one little bit" with respect to design decisions on the Temporary Contemporary. The gift of virtually unlimited freedom elicited an

*The Museum of Contemporary Art*
*at California Plaza*
*Gallery A*

*"The First Show" at the*
*Temporary Contemporary*
*Installation view*
*Fall 1983*

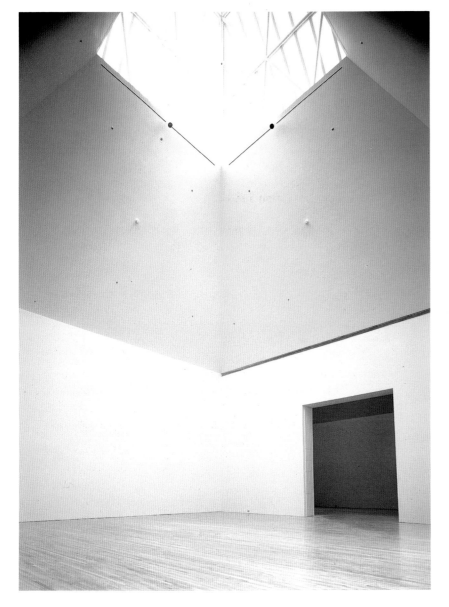

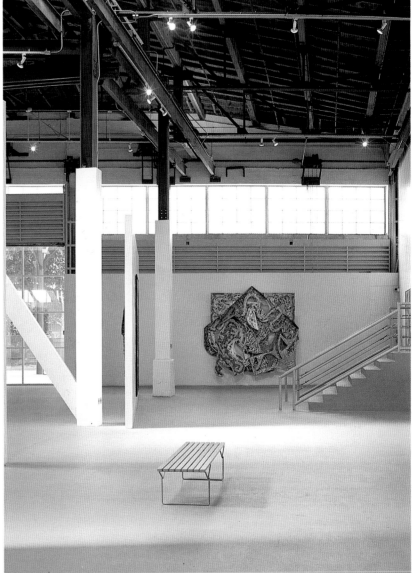

*The Museum of Contemporary Art*
*at California Plaza*
*Library barrel vault and*
*south wing pyramidal skylights*

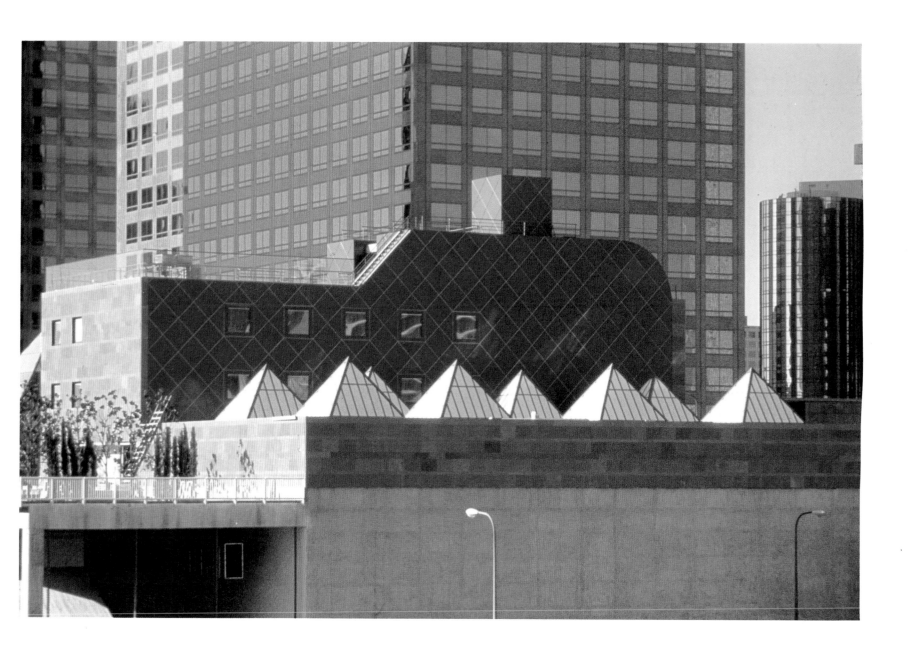

even greater sense of responsibility on Gehry's part to make the space "perfect."

How does it happen that two such ostensibly countervailing sensibilities have each managed to create a most extraordinary solution to the design of a contemporary art museum? Perhaps a clue can be found in their respective approaches to the fundamental issue of space. Isozaki cites the uniquely Japanese concept of *Ma*, the idea of a continuum that does not differentiate between space and time. Although *Ma* has no precise counterpart in Western thought, cubism poses an intriguing parallel in its exploration of the constantly shifting perspectives and composite observations of an individual's perception in time. It has been observed that Gehry's architectural aesthetic illustrates an almost perfect corollary to cubist theory[3]: a conscious use of fragmentation, blurred edges, and colliding forms, all of which demand the viewer's active participation to resolve. For Gehry, architecture would seem a passionate pursuit of the fugitive ideal he calls frozen motion. One need not fully grasp the complexities of *Ma* or of cubism to intuit their respective underlying influence in the museum buildings created by these two architects.

The Isozaki building derives its essential form from a yin/yang, or positive/negative, balance of space and mass: two gallery wings surround a sunken courtyard, a "void center" whose spiritual significance in Japanese tradition emanates from its very emptiness. Isozaki overlays this traditionally Oriental approach to space and volume with Western logic and motifs, freely adopting the Platonic forms that have become his trademark: the cube, the cylinder, and the pyramid. In contrast to traditional Japanese architecture, in which these shapes remain stubbornly two-dimensional and somewhat recessed, Isozaki's buildings have aggressively exploited the three-dimensionality and purity of these forms to imbue architecture with what he calls "symbolic power." For Isozaki, the geometric volumes "act as a fundamental tool when non-natural artificial things are created by human hands."[4]

The fairly rigid constraints posed by the building's physical site within California Plaza (an eleven-acre complex of shops, restaurants, commercial and residential towers, and a hotel) combined with the museum's essential programmatic requirements challenged Isozaki to devise a bold solution: more than half the building's volume lies below street level. The striking forms that rise above the street, most notably the barrel-vaulted "gateway" and the pyramidal skylights, etch an exotic profile which Isozaki likens to that of a "small village within a city." Punctuating a landscape dominated by towering skyscrapers, the museum firmly hugs the ground, yet establishes an unarguably commanding presence.

The shapes and forms exuberantly piled one upon the other make the museum's exterior seem vaguely disorienting; inside the building, however, ambiguity gives way to a comforting logic and clarity. Framing the entrance court, the gallery wings are proportioned according to the golden section, a classical Western formula which postulates the repeated subdivision of a rectangular space into a perfect square and another rectangle which can be similarly subdivided, and so on. Fortunately, ability to perform the computations is not a prerequisite to the appreciation of the harmonious spatial result. The volumes, though majestic, never overwhelm. They enfold, accommodate, and shelter, ever sensitive to human scale and the individual's physical presence in space. The building is a collection of these exquisitely self-sufficient parts; while the universal space may appear subordinate to the integrity of the individual components, an overall sense of wholeness ultimately prevails.

The nature and flow of the galleries, all contained on a single floor, reflect Isozaki's intention to "enrich the visitor's spatial experience by providing a sequence of diverse gallery spaces—each with its own proportion, height, lighting system, size, and type." The luminous cubic amplitude of Gallery A, with its single soaring pyramid, leads directly to a smaller rectangular space capped by steep twin pyramids which, clad in drywall almost to their skylight-topped

crowns, create a somewhat dimmer ambience. The double pyramids converge in a sharp wedge which descends toward the top of the gallery walls, giving the impression of bisecting the space without actually dividing it at all.

From this relatively intimate room one is drawn into the South Gallery, a magnificent expanse of approximately 7,000 square feet, generously illuminated by sawtooth skylights. Here and throughout the museum, the skylights employ the German Oka-Lux system: sheets of clear glass outside and translucent but not transparent wired glass inside are separated by a layer of Oka-Pane fibers that forms a polarizing filter, providing the optimum diffusion of light. Each of the eleven ceiling bays in the South Gallery also contains fluorescent lighting hidden in recessed coves; in addition, a track-lighting grid is suspended across the entire room.

Echoing the proportion and scale of the South Gallery, the voluminous North Gallery introduces a unique and equally elaborate skylighting system. Here, eight glass pyramids, invisible from the interior, capture and fracture the light, which is then filtered into the gallery through eight corresponding 56-pane grids of translucent glass. This system modulates and softens the light to a greater degree than is possible when the light source is directly exposed, creating a more traditional museum ambience. The eight ceiling grids are deliberately asymmetrical in their distribution; their placement will guide any subdivision of the gallery into a maximum of six large individual spaces, rather than the eight uniform rooms one might initially assume.

Isozaki has carefully invested each gallery with its own distinctive character, yet one's experience in winding through them along the logically charted circulation path is not the least bit jarring or abrupt. This may be attributable in part to the warmth of the maple flooring that flows throughout, and in part to the graceful spiral of one's path through the spaces. But beyond the building's identifiable attributes, there remains a rhythmic and mellifluous poetry that

eludes architectural classification entirely.

The Temporary Contemporary presented Gehry with a very different sort of challenge: to convert an existing warehouse, anonymously sandwiched between similar industrial structures on a sparsely trodden dead-end street in Little Tokyo. Furthermore, while the museum had successfully persuaded the city to preserve the Temporary Contemporary, its neighbors on either side were ultimately to be demolished, leaving the museum disengaged, isolated—as Gehry puts it, "like a supermarket sitting in an asphalt parking lot." This was the genesis of the building's chain-link canopy, the only "bit of architecture" Gehry claims to have allowed himself in the project (the remainder of the work having been in his estimation strictly "janitorial"). The canopy became imperative, to "stake out the street, because that was the only thing I found in my ruminating around that was soft and . . . that we could get away with." It succeeds not only in creating an outdoor foyer for the museum, but also in preserving a street of historic significance to the local Japanese community. The unpainted steel posts supporting the canopy provide an effective demarcation for the museum, as well as an imposing, though appropriately industrial, gateway.

In its proximity to the street and its utterly straightforward exterior, the warehouse suited Gehry's penchant for the accessible and the unintimidating. Here one finds none of the playful "hide and reveal" encountered upon approaching the Isozaki building, where curving parapets along the courtyard perimeter alternately obscure and reveal views of the building entrance as one descends to the entry level. From outside, the Temporary Contemporary is simply an unadorned storefront, left in its original, now faded, coat of pinkish paint. The massive overhead doors remain operable, allowing the museum to fling open its entire facade, whether for functional purposes or as a symbolic gesture of welcome.

Nothing on the exterior prepares one for the breathtaking vista that unfolds immediately upon entering the building. One is instantly

*The Museum of Contemporary Art*
*at California Plaza*
*Grand Avenue entryway to lobby court*

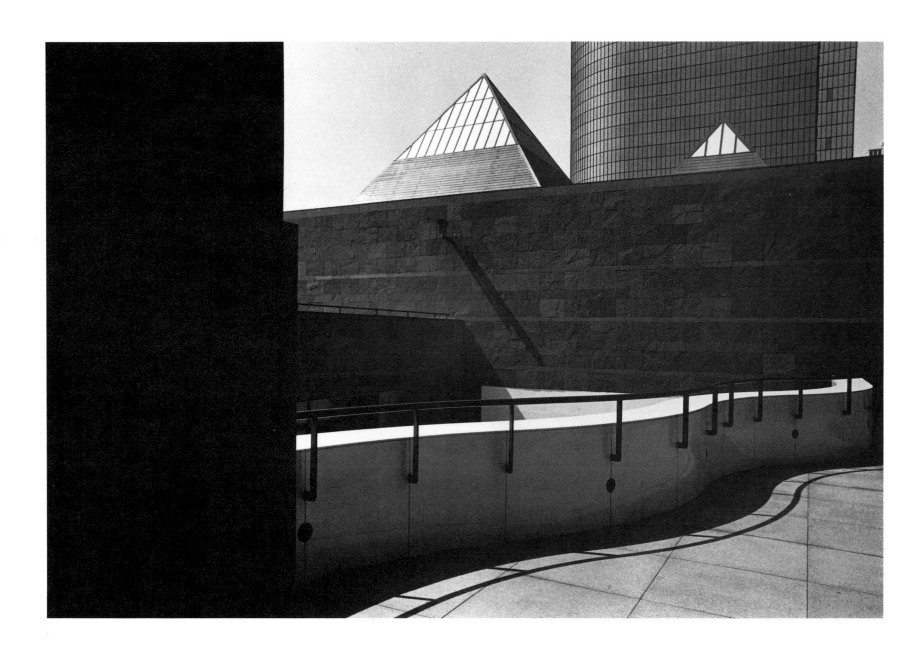

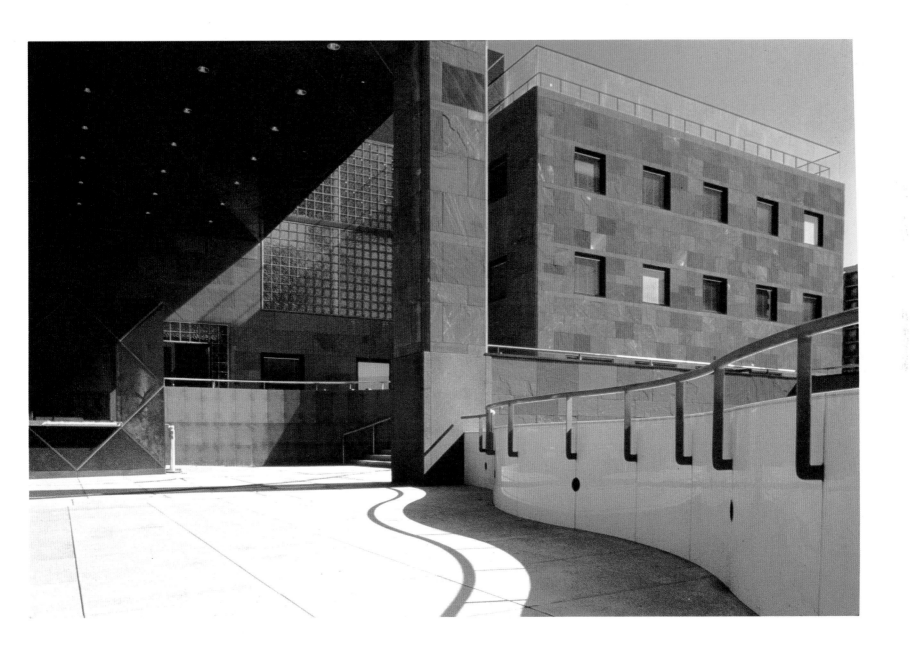

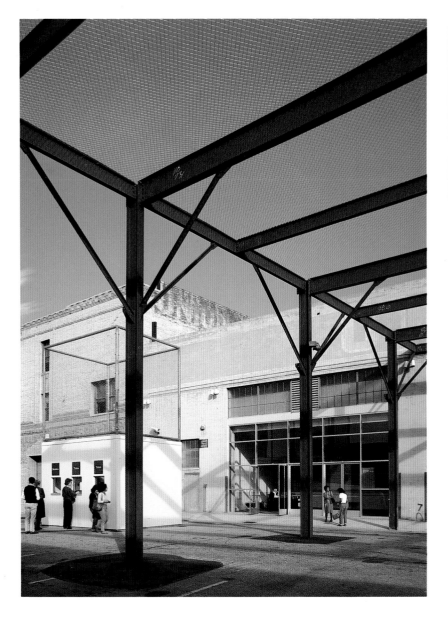

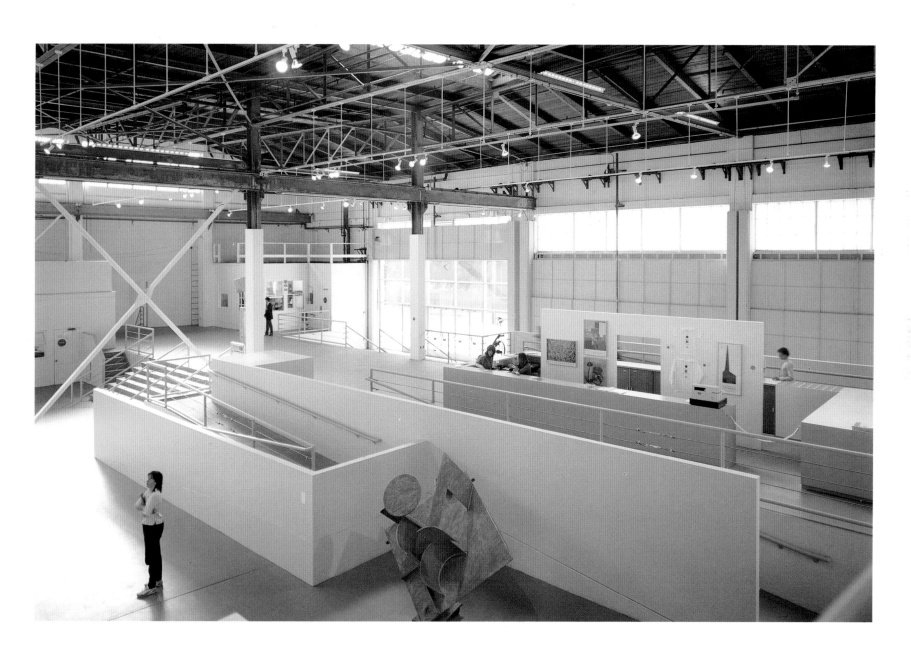

enveloped and entranced by the sheer vastness and integrity of the space. Gehry intuitively responded not only to its overwhelming scale, but also to its feeling—the "gritty and gutsy" patina accumulated over decades of unglamorous use. Rather than succumb to what for many architects might have been a natural urge to polish and sanitize, Gehry cautiously chose his moves in deference to what was there. "There was a certain logic of the building, a certain logic of the building code, a certain logic of the use, and I just played with that."

Masonry walls were reinforced to meet structural codes, and ramps were installed to provide wheelchair access, but the building's original skeleton of steel columns, trusses, and beams was essentially untouched. Vigorous steam-cleaning of the redwood ceilings was preferred to sandblasting; to preserve a faint vestige of accumulated experience was paramount. Existing skylights and clerestories were reglazed where necessary but otherwise unembellished. The most basic track-lighting system was added (though Gehry had hoped that the budget would allow for a more sophisticated and flexible theatrical-lighting grid).

Throughout the renovation process, the architect exercised impeccable judgment and discipline to avoid "overdoing it." He aimed for and succeeded in achieving a perfect balance between the old and the new, playing off the building's inherent strengths and augmenting existing features with the greatest care and respect. The result speaks for itself; today one would be hard pressed to identify where history left off and Gehry stepped in.

History plays a less immediate though in some ways more fundamental role in Isozaki's design for the new museum building. His architectural approach is often said to be one of quotation and metaphor, a rigorously honed synthesis of East and West, past and present. While he acknowledges a broad diversity of influences, including ancient Japanese temples, Palladian villas, and the classical fantasies of Claude-Nicolas Ledoux, he assesses their impact in more indirect terms: "In designing MOCA, I tried to distill only the profound essence of those influences, rather than quoting literally." He searches for something new in every project, seeking what lies at its very core, and hopefully banishing any "preconsciousness of that particular building type."[5]

While the museum clearly features familiar elements from Isozaki's established design vocabulary, they are configured in unprecedented ways and mingled with components that the architect has never utilized before. Upon first approach, one is struck by the monumentality of the building forms, and by the sheer weight and implied solidity of the red sandstone blocks that cloak most of the exterior walls. Isozaki has mitigated this massiveness by configuring the stone in an alternating pattern of cleft (natural) and honed (polished) horizontal bands of varying width, which tends to humanize the scale. Indian rather than American sandstone was selected for its greater richness of color and warmth.

Ever amused by twists of irony, Isozaki may well have specified sandstone in a mood of slight caprice, since it actually lacks the properties of strength and resilience normally associated with stone. In fact, because sandstone is known to be quite porous and susceptible to erosion by water, a protective polished-granite strip was specified at the base of the building along its entire perimeter. Though Isozaki's motivation in this instance remains a private one, a hint of puckish perversity would not be inconsistent with similar conceits to be found throughout his work.

Other prominent building materials and forms suggest their own inherent ironies. Sleek white panels of crystallized glass dominate the interior of the museum's lobby and the west wall of the entry court, extending just into the café; cool and stark, these perfect squares provide a gleaming surface geometry whose rigidity is belied by the softly undulating curves that Isozaki has modeled in the walls. The material's seeming imperviousness is also denied by a "tear" that occurs at the café's entrance, as the top rows of panels peel off in a

graceful marqueelike band which skims elegantly across the café facade.

The lobby facade is composed entirely of transparent glass, dematerializing the building's structure and subtly merging inside with outside. This transparency is further underscored by Isozaki's use of the same granite floor paving both inside and out, and by his mirroring of the café's curving facade outdoors with the information center's long, sinuous counter indoors. Isozaki effectively juxtaposes volumes of considerable weight and mass with spaces that practically appear to float.[6]

A touch of wry humor may be found, too, in Isozaki's choice of gravel to carpet the gallery roofs and surround the pyramidal skylights, which come to suggest a lost encampment of nomadic tents mysteriously pitched in the midst of downtown Los Angeles. The glass-block frame surrounding the entrance to the office wing is reminiscent of the Japanese *torii*, or gate, but is also meant to serve as a personal (and playful) tribute to the Shangri-La Hotel in Santa Monica, a favorite local building of Isozaki's.

A single column wrapped in crystallized glass stands prominent and sentinellike at the museum's entrance. According to Isozaki, its symbolism is deliberately ambiguous, denoting the introduction and acceptance of visitors as well as their rejection or departure. It may also relate indirectly to the archetypal heavenly column in Japanese mythology, which is said to represent the axis between heaven and earth, or the demarcation of a sacred place. Its prepossessing posture confers a ceremonious though somewhat mysterious air upon the entire entrance court.

Beyond whatever quips or ambiguities Isozaki may have intended, his precise choices of materials, and the way he has matched them with specific functions and ordained them to collide, are meticulously plotted and detailed. Combining the nontechnical with the high tech, the natural with the highly finished, he has achieved a sense of

wholeness through tactile and textural oppositions. The stunning contrast between the red sandstone and the white crystallized glass on the building's facade—materials Isozaki has employed extensively in the past, but always separately—creates a richly animated surface that alternately reflects and absorbs light.

Aluminum panels painted green sheath portions of the office wing, forming a diamond pattern delineated in bright pink. Their smooth surface and metallic luster contrast sharply with the warm-toned, deeply rustic sandstone and with the icy and gemlike glass block that Isozaki has used liberally on the wing's south front. Perforated stainless steel panels compose the ceilings in the main entrance lobby and office lobby, as well as providing acoustic wall panels in the auditorium and boardroom, where they are accentuated by elegantly imposing doors of the same metal, finely brushed.

Lightly sandblasted architectural concrete, which Isozaki has dubbed "travertine concrete," appears prominently in select spaces such as the auditorium, office lobby, and boardroom. But it is probably nowhere more dramatically featured than in the library's massive barrel vault, where it plays against a spectacular arching window of delicately veined onyx, whose pale translucency evokes the fragility of paper and the grandeur of stained glass. The copper cladding at the base of the rooftop pyramids and over the exterior of the barrel vault lend a burnished sheen, and the promise of ongoing change as natural oxidation takes its course. In its totality, then, the museum emerges as an elaborately polychrome structure whose exotic shapes, varied textures, and opulent colors suggest a multifaceted jewel amid a sea of more prosaic stone and glass towers.

The question of context, both immediate and broad, poses some intriguing issues to explore. On the most obvious level, both Isozaki and Gehry cite the overwhelming impact of Southern California's legendary light, each seeking to harness its remarkable energy. But while Isozaki appears to take a strictly architectural, almost engineerlike approach, devoting considerable attention to his

numerous skylight variations, Gehry's approach seems to reflect a greater affinity to art and artists. One suspects that if he were to design a new museum of contemporary art, among his primary goals would be to achieve the quality of light that would most effectively enhance the works of art rather than glorify the space itself.

Gehry readily acknowledges his close involvement with art, and ascribes many of his architectural inquiries to a fascination with painting and sculpture. He speaks of the "mystery of confronting a canvas with a paintbrush in hand," and of "how the expressive and compositional attitudes of painting can be explored in a building."[7] He admires the "intensity and directness of moves in someone like Richard Serra,"[8] who manages to deftly "encompass so many layers of meaning and ideas in one move." He is an architect who finds his primary inspiration in art: "When I feel stuck in my work, I go to the paintings. I always go to paintings." No wonder, then, that the Temporary Contemporary's kinship to the loftlike spaces of many artists' studios was so cautiously guarded and preserved. Though Gehry's projects are frequently marked by an aggressive design approach, sometimes sparring with their surroundings, in this particular situation he seems to have willingly submerged his professional ego in favor of the muse.

In this respect, Isozaki adopts the more aggressive stance. He concedes that throughout his career his intention has been to "provoke his surroundings,"[9] perhaps even to destroy their existing context. The irony here is that the context in question—Los Angeles—happens to be one that Isozaki finds virtually invisible. His first and lasting impressions of Los Angeles are of a place in which every element is ephemeral, mobile, often a mere copy of itself. He views the city as temporary, wholly without structure, "like a star exploding."[10] And with characteristic flourish, in the very heart of this swirling expansion he has embedded a striking centerpiece—not a towering monument, but a symbolic half-buried treasure.

There can be little doubt that the circumstances have been generous:

two architects of ascending mastery and eloquence; two buildings of overwhelming dignity and resonance; a stunning array of exhibition spaces to accommodate nearly limitless artistic expressions; and one very lucky museum indeed.

1. *Arata Isozaki*, videotape, 58 minutes (New York: Blackwood Productions, Inc., 1985).

2. Frank Gehry, interview with the author (Los Angeles, January 12, 1986). Unless otherwise specified, all quotations of Gehry are from this interview, with the exception of the epigraph, which comes from Peter Arnell and Ted Bickford, eds., Frank Gehry Buildings and Projects (New York: Rizzoli International, 1985), p. 17.

3. Arnell and Bickford, p. 13.

4. Arata Isozaki, interview with the author (Los Angeles, February 24, 1986). Unless otherwise specified, all quotations of Isozaki are from this interview, with the exception of the epigraph, whose source is the *Arata Isozaki* videotape.

5. *Arata Isozaki* videotape.

6. See Philip Drew, *The Architecture of Arata Isozaki* (New York: Harper & Row, 1982), p. 81.

7. Arnell and Bickford, p. 13.

8. Ibid., p. 17.

9. *Arata Isozaki* videotape.

10. Charles Fleming, "Isozaki," *California Magazine* (March 1986): 119.

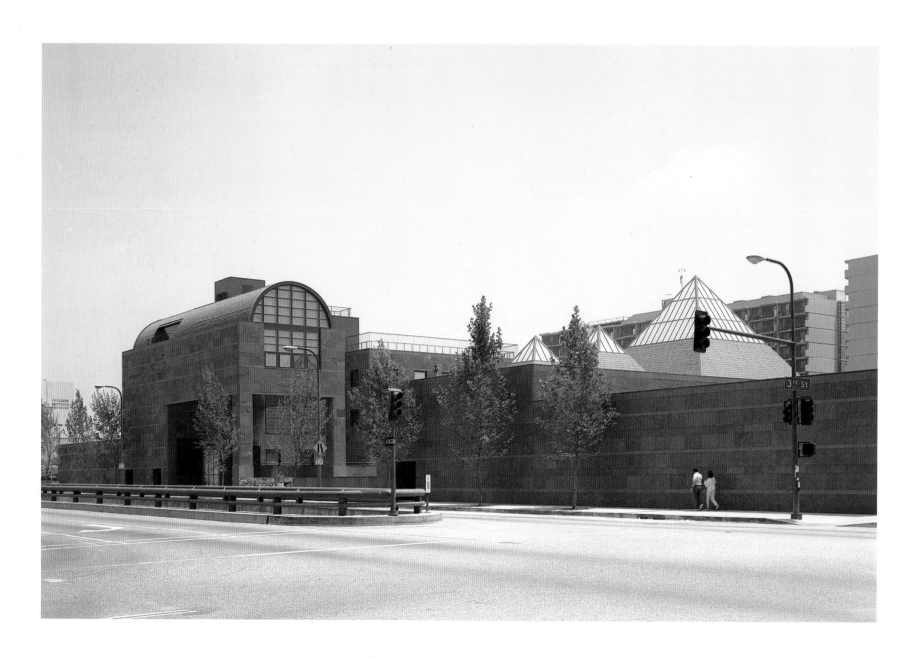

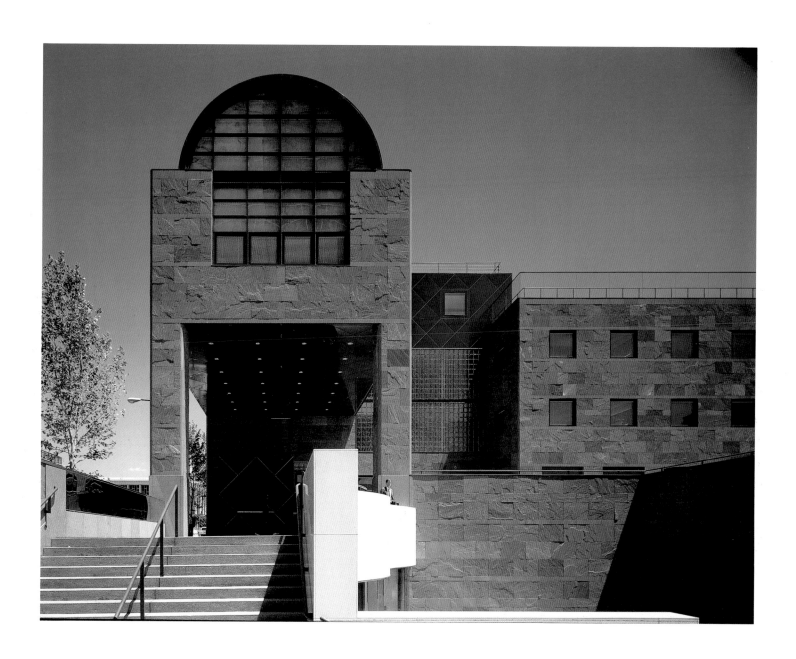

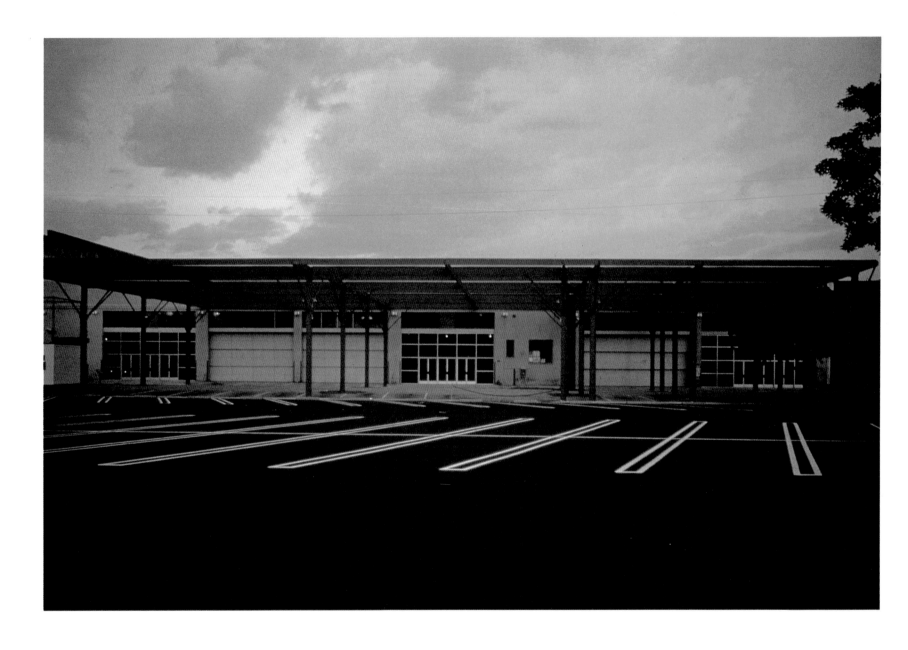

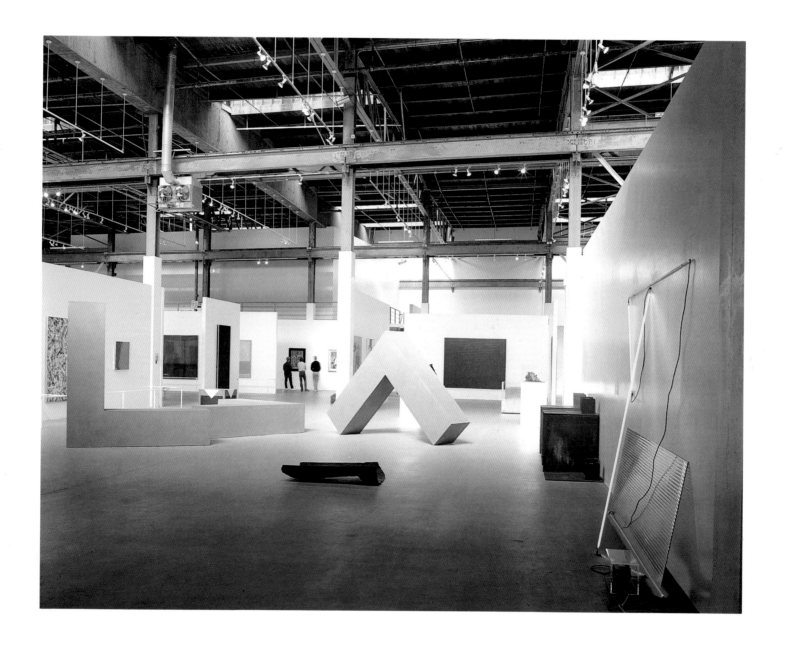

## Introduction
*Julia Brown Turrell*

All art is contemporary, made in and of its time. Art of power and meaning continues to move us, continues to influence what comes after and illuminate what came before. Bringing together over 400 works from the last four decades, this exhibition considers recent art less in order to tell a history—to be comprehensively told, that would demand many more artists and many more works—than to emphasize the contributions of individual artists and to suggest certain moments and turning points that inform a history. The exhibition is a presentation of focused selections of the work of eighty-one artists who have contributed to the dialogue and evolution of contemporary art. Each is represented by a substantial number of works, or by a single major installation that indicates one of the artist's primary concerns. And each artist's work, its subjects and means, is seen within a layered context of thought and influence.

The recent history of art has seen an extension of the visual language and an expansion of the field in which art is created and lives. This exhibition is an attempt to represent aspects of an evolution in which sculpture has moved away from its base and painting away from its frame, both physically and metaphorically. One can look at recent art through its subjects, and through its interrelationships of form and content. Herein lies the reflection of the culture and the expression of the individual.

"Individuals: A Selected History of Contemporary Art, 1945–1986" was organized through the selection of individual artists, a difficult task given the number of artists who have made substantial contributions to the art of the last forty years. By necessity, a few artists were chosen from many to represent certain ideas or approaches. Left out of the presentation, but to be considered elsewhere in the museum's program, is the work of photographers and of video and performance artists, work that has been of major importance in recent art. The limitation of space, and the desire to show each artist in some depth and focus, brought the final number of artists to eighty-one. Through the selection process certain shared and constant ideas became evident, and these provide a secondary

organizational structure for the exhibition and its catalogue. Rather than reiterating art-historical categories or demarcating decades, they establish a broad framework for considering the period, pointing to the conjunctions of ideas and means that span the postwar period. This framework is introduced below, and is elaborated in the essays that follow.

The exhibition surveys abstract painting beginning with the work of the abstract expressionists, which signaled a larger scale and space, a new approach to the materials of painting, and a consideration of the painting as an arena in which to act. The abstract painting is traced through forty years both as a concentrated field for emotion, a container for physical gesture, and as a material or purely visual object, a fusion of form and content exclusive of narrative or external reference.

The power and physical presence of material as container and catalyst for content is considered in a presentation surveying the broad current of contemporary sculpture. Employing materials both for their inherent force and character and for their metaphorical capacity, sculpture as a physical object evokes a multitude of associations, often referring to the body and its movements, to nature, and to architecture, and taking on biomorphic, ritualistic, or totemic form. Also considered is the idea of the self-contained object, its content held within the object itself: in its size, scale, and particular materiality as well as in its relationship to the space in which it is placed. This attitude has a long history and a close relationship to abstract painting.

A number of large-scale sited works have been commissioned for the exhibition. Extending the object into the space of the room or into the natural or urban environment, the works by artists directly involved with space and site elicit and encompass the physical, perceptual, and temporal participation of the viewer. These works involve an expansion of the choices and possibilities of materials, incorporating natural phenomena and building on the vocabulary,

material, and process of architecture and landscape architecture. The exhibition also includes a number of dramatic or staged spaces that involve the viewer with the projection or suggestion of an event, an activity, a story. Dramatic and allegorical content, a concern with myth and/or history, and a strong social and psychological commentary inform this work, as well as much of the recent painting presented in the exhibition. Other parts of the exhibition examine work that borrows and reconstructs imagery from the everyday and from the world created in the media and popular culture, and art based on the equivocal relationships between words and images, on the meanings carried by language on both a literal and visual level.

These overall ideas emerge from the work of the individual artists, and it is clear that they are interrelated and overlapping. No single artist's work can be seen in isolation, and the exhibition allows the opportunity to survey the period through individuals and works that have been important influences in the history of contemporary art. The catalogue is also organized through these broad ideas, and through the recognition that they are not exclusive, for they emerge from a complex history and spectrum of ideas. The historians and writers commissioned to write for this publication have been asked to reconsider and discuss the period, the artists and the work chosen for the exhibition, and the issues raised by their work within the ideas that structure this catalogue.

The time period designated in the exhibition title, 1945 to the present, is the period of concentration for the exhibition program and collection of The Museum of Contemporary Art, and, as such, is an appropriate focus for the exhibition inaugurating the museum's new building. The exhibition, covering over 70,000 square feet of gallery space, is housed in that building and in the converted warehouse known as the Temporary Contemporary. Spaces of very different characters, one formal and spare, the other raw and open, they point out the importance of installation and presentation in the experience of art. The exhibition has been installed chronologically, and following the broad outline introduced above.

**Abstraction: Form as Meaning**
*Kate Linker*

The postwar period witnessed the formation of a new mode of art and of a new ideology to support it. The work now referred to as "art since 1945" reflects the cultural reorganization of the years after World War II, and the political and social shifts this reorganization entailed. Not the least of the changes was geographic, for the art scene gravitated from Europe to the United States, lending a significant boost to the American ego and echoing the nation's postwar supremacy. What came to be called "American-type painting" was big, brassy, resolutely self-assertive, and above all abstract. This art isolated color, space, line, gesture—all the formal components of painting—as its means. But the whole period could be seen as an age of abstractions, bearing witness to the atomization of society. We see this today in the terms it hypostatized: Form. Meaning. Painting. History. Artist. Individual. Above all, the final term provides the great subject of postwar art.

Retrospectively, the art bracketed within this period appears as one that isolated consciousness as its theme, and focused on abstraction as the privileged language for articulating the experience of modernity. It was not, of course, the first practice to do so: postwar art developed in dialogue with an extensive European tradition which, since about 1850, had registered the individual's insulation from the forces of society and its claim over the plastic elements of art. The evolution of painting reflects an assimilation of this tradition, drawing in particular on the many European intellectuals who had emigrated to the United States in the 1930s and 1940s. However, there is no doubt that the period was the first to theorize the development of abstract painting and in this manner to provide a rationale for its ongoing process. The theory of modernism, elaborated at the time of abstract expressionism, presented art's retreat into its own terms as a historical formation proceeding from the opposition of self to society. The criteria the theory established— innerness, truth to material, formal closure—offer a set of assumptions enfolding the production of art, but they also represent an attempt to maintain the self's dominion, in fact, to emblematize the growth of consciousness in the guise of formal innovation. The

very image afforded by abstraction—one of art as autotelic, centered on its own processes—replicates a paradigm of inwardness that is fundamental to Western metaphysics. Whether as expressive subject or Hegelian Mind, the self is the great abstraction of the modernist period.

My words suggest that modernist abstraction carries a heavy weight of philosophical assumptions; that, indeed, it is impossible to grasp its formal accomplishments without view to the metaphysical ends that they fulfill. For the modernist self appears as a variation on the Western humanist subject, the centered, controlling, individual, and indivisible consciousness that stems from the Cartesian *cogito*. There are many names for this subject: the transcendental signifier, the privileged reference, the "founding and controlling first principle" or absolute *archia*.[1] All of them find echoes during the postwar period in allusions to the "One" and the origin, to being and self-reference. The terms are repeated in artists' statements. "Painting is . . . the mind realizing itself in color and space":[2] so one abstract expressionist would describe the privilege consciousness claims for itself as it installs itself in a position of command, free from the determinations of history. The status of this subject as "first principle" consists in a denial of history, an abstraction from time and social space, a refusal of the impure world imposed by the everyday domination of convention. This is what gives the modernist self its character of a fiction, a purposely unreal construction. Still, it also indicates something of modernism's transgressive edge, for the resistance modernism posed to the realization of mind was to make of painting "an ideal domain of freedom," even if abstract art's libertarianism was also to make it into a political tool.[3]

Such a privileged position is repeated on the level of language, for the subject is located at the center of the significations it generates, controlling language as the instrument of expression. The notions of organic form and expressive totality that modernism adopted from romanticism reflect its aspiration toward an indissoluble bond between form and meaning, by which the visual sign would be

transparent to thought. The notion of "natural" expression is a function of this distance from convention. Behind the desire for purified essences that motivates pictorial abstraction is the fantasy of a sign centered on its own terms—a sign that, in its immediacy, might re-present the purity of the isolated self.

Modernist painting, then, can be characterized by a dual incentive: by the dream of individuality—of a self realized originally, outside history, *ab nova*; and by a dream of language—of totalization or poetic closure.[4] This double imperative underlies the metaphysical and pictorial accomplishments of the postwar period, accounting for the heroic image attributed to the artist and the "triumphs" of the painting it produced.[5] Its terms would be reformulated in different decades, at times converging on the personal values of style, at others focusing on the reflexive self-containment of the artifact. However, it is important to recognize that the postwar period is already the late modernist period, and includes both the most resolved expression of the self's containment and the seeds of its dissolution. The complex historical developments of the 1960s and 1970s point toward the divisions that have come to characterize postmodernity, a phenomenon marked by the fragmentation and dispersion of the subject in the same forces from which it sought refuge. Postmodern decentering is a recognition not of the self's transcendence but of its inscription in history, and is marked by a decline of faith in the instrumental capacities of language. The postwar period thus witnesses a movement of systole and diastole, contraction and distension—a radical affirmation of autonomy yielding in the 1980s to an equally radical questioning of the possibilities of abstract form.

*Spiritually, I am wherever my spirit allows me to be, and that is not necessarily in the future.*
Willem de Kooning

*Today, every phenomenon of culture, even if a model of integrity, is liable to be suffocated in the cultivation of Kitsch. Yet paradoxically in the same epoch it is to works of art that has fallen the burden of wordlessly asserting what is barred to politics. . . . This is not a time for political art, but politics has migrated into autonomous art.*
Theodor W. Adorno

The retreat from history staged by abstract expressionism is, paradoxically, a historical formation. The development of what is called aesthetic autonomy, "art for art's sake," or, more frankly, romanticism can be seen as a response to specific social and economic situations. Interpretations of that response vary, reflecting the intellectual climate of the postwar period, which witnessed an accelerated production not only of art but also of art writing ranging from descriptive history to theory. However, most accounts converge on the importance of the role played by the image of the artist as unaffiliated, as apostate from society.[6]

This image is, of course, somewhat mythical, illusory, since the stance of the artist was part of a group identity; as Brian O'Doherty has commented, the unaffiliated artist was a member of the modernist community.[7] Moreover, as Jackson Pollock's example indicates, that image would play strong to the public, aiding in the commercialization of art. But there is no doubt that in the early years of abstract expressionism, American artists' feeling of displacement underlay their defiance of capitalist society, and motivated their flight into aestheticism and metaphysics. Behind them was the confusion of the 1930s, when the issue of the social role of the artist was hotly debated under the influence of Marxist thought. A sense of responsibility toward a populace then in the midst of the Great Depression impelled a desire for social and political engagement. However, in the 1940s the ideal of mass communication was largely subsumed under a feeling of inefficacy and marginality. At the crux of the matter was the placelessness of the artist, and the unconcern of American society for his existence. As Dore Ashton has remarked, the experience of artists involved in the Federal Art Project under the Roosevelt Works Progress Administration only confirmed the public's apathy to questions of culture. The sole example of "communicative" art, social

realism, seemed like mere illustration of common themes. To artists, the opposition between representation and abstraction emblematized the unbridgeable gap between society and themselves; the result of their isolation, Robert Motherwell noted, was "the tendency of modern painters to paint for each other."[8] As a measure of alienation, art would retreat into a serene aesthetic realm, furnished by timeless subjects and eternal values, far removed from contemporary history. But behind such refuge also lay the mass environment produced by industrial culture.

Artists of the postwar period could find echoes of their predicament in the crisis that gave rise to modernism in mid-nineteenth-century Paris. For underlying the romantic resistance to society (and with it the genesis of abstraction) was a series of dislocations in the conditions surrounding cultural production which threatened to detach the individual from established ways.[9] At the core of the matter were industrialization and the profound shifts in values that followed from the progressive mechanization of nineteenth-century society. The outcome, for the artist, was the rise of art as a commodity—the development of a new culture designed for mass consumption. The evidence of this emerging dominant order includes, for example, the rise of the newspaper and the mass-distributed novel; the new urban spaces crafted by Baron Haussmann's redesign of Paris; and the emergence of such architectural programs as the department store, which were dedicated to the culture of the commodity. For the artist, this mutation acquired the quality of a radical change of life: Charles Baudelaire noted that the social forces transcribed by these developments threatened to shatter the artist's ability to distill the significant unities of contemporary art.[10]

Thus the development of abstraction represented a response to a specific moment in capitalism, an estrangement from history that could be manifested in various ways: as a feeling of exclusion from the unfolding order of things; as hostility to the constraints that increasingly surrounded individual production; as a visceral reaction to a set of codes or conventions that contradicted previously accepted formulas. Most important, the replacement of traditional cultural forms by new means of entertainment eroded the views and functions that insured artistic identity; hitherto accepted notions of operation no longer bound the artist to his public, defining his aesthetic mission. It is in this context of the "ruins" of bourgeois culture, Walter Benjamin observed, that "art . . . begins to have doubts about its function"; indeed, it "ceases to be '*inséparable de l'utilité*' [inseparable from utility]."[11] And it is in this context that vanguard culture finally ruptures with a society now defined by its vulgar materialism.

The most influential theory of modernist aesthetics is found in the early writings of Clement Greenberg, and it is significant that his argument turns on the impact of consumer culture. As T. J. Clark has indicated,[12] one of the merits of his texts lies in their analysis of the malaise felt by leftist intellectuals in the 1940s at the advance of what Theodor Adorno described as the culture industry, the mass production of uniform, pseudo–art objects designed for the expanding social ranks. In various essays, Greenberg described this phenomenon as an intensified repetition of the formative experience of modernism. Mass culture is conceived as exerting a continuous pressure on the artist, a pressure necessitating a countermove, a radical retreat into aesthetic autonomy as a means of preserving the values of established culture. And, more explicitly, of stripping art of the character of the commodity. Modernist art's withdrawal into its legitimate boundaries ("disciplinary autonomy") and into conventions specific to itself ("inner laws") is described as cultural salvation: "The arts, then, have been hunted back to their mediums, and there they have been isolated, concentrated and defined."[13]

Such resistance would lead to painting's cultivation of its inherent demands—surface, edge, line, and pure, unrelieved color. These are also demands that the aesthetics of the 1960s would reduce to the tautologies of formalism, in which the visual signifier refers only to itself, eliding questions of content. Greenberg was pivotal in this process: there is a striking difference between his early writings,

which address the status of humanistic culture, and his later proscriptive criticism. But what is important in early modernism is that painting's elements were conceived as language, that is, as a means to a meaning, and to a meaning that could find articulation only in pictorial terms. Indeed, what is staged is the very crisis of language, as Stéphane Mallarmé indicated in his essay "Crise de vers": the protection of the instruments of individual expression against corruption by external rule. Mallarmé's definition of his literary mission—"to give a purer sense to tribal word"—rephrases the opposition between the crystalline inner domain of essences ("*l'essentiel*") and the inherently vulgar world represented by "journalism." The irreducible, singular, or natural in a medium is contrasted to the constructed, social, and conventional. This defense of autonomy would be phrased differently by different generations; what is salient is that the image of purified form that motivated modernist abstraction resulted from a conscious exclusion of the social limits that increasingly dominated nineteenth- and early twentieth-century culture.

Baudelaire articulated the program of abstraction in a note in his essay on the Salon of 1859. Speaking of the imagination, "Queen of the Faculties," he wrote that "it decomposes all creation, and with the raw materials accumulated and disposed in accordance with rules whose origins one cannot find save in the furthest depths of the soul, it creates a new world, it produces the sensation of newness."[14] It is all there, phrased as a dialectic of form and meaning: abstraction, material specificity, inner laws, inner feeling, autonomy, wholeness, newness. Modernism would make from these dictates its own teleology, stressing formal innovation and self-expression, and taking as its foundation both truth to the medium and inner truth. But it is important that the initial phrasings of the modernist paradigm were not confined to the level of material substance: form, as the language of the isolated self, was to be the instrument of absolute feelings, of pure thought, uncorrupted by external interventions. The pursuit of these feelings, repressed in daily life, offered redemption to a society increasingly dominated by convention.

All of postwar abstraction thus converges on an image of psychic and cultural autonomy, of individual and aesthetic delineation. The retreat from history it stages represents an effort to recenter the self, to preserve the integrity of humanist culture. And, thus, to forestall the forces of fragmentation. The self's centering is aimed at the maintenance of control: control over language, which now serves purely as the self's instrument, and over its operations, to which end it builds its own citadel, the domain of Art, with its own codes and regulating terms. The sheltering function suggested in Greenberg's diction of "refuge" links modernism to the language of Western metaphysics. The closure of modernist individuality (which underlies its chilly hermeticism) was aimed at a program of subjective liberation.

The result of this program is that abstract painting came to appear as a domain of freedom, the symbol of "an individual who realizes freedom and deep engagement of the self within his work."[15] The words are by the art historian Meyer Schapiro, who, in a group of articles published in the 1930s, articulated the libertarian values of abstraction. Schapiro encapsulates the values that society would bestow upon the artist; in its assumed spontaneity and expression, modern painting seemed to counter the degradation of experience in industrial society, opposing its uniformity and mechanization. This attitude would find its privileged signifier in action painting:

*The consciousness of the personal and spontaneous . . . stimulates the artist to invent devices of handling, processing, surfacing, which confer to the utmost degree the aspect of the freely made. Hence the great importance of the mark, the stroke, the brush, the drip, the quality of the substance of the paint itself, and the surface of the canvas as a texture and field of operation. . . .*[16]

All these qualities are perceived as so many signs transparent to the singular and creative subject, centered on its own activity, its language unmediated by constraints. The pictorial signifier affirms the presence of the artist; gesture, the mark of the hand, is taken to refer metonymically to the whole self, the unified subject unfragmented by the forces of convention. These qualities are

compressed into the paintings directly following World War II, but they find expression throughout modernism. And behind them is the preindustrial image of the craftsman, ceaselessly at work on the medium.

*[My paintings] are my mirrors. They tell what I am like at the moment.*
William Baziotes

*Color helps to express light, not the physical phenomenon, but the only light that really exists, that in the artist's brain.*
Henri Matisse

*Unmediated expression is a philosophical impossibility.*
Paul de Man

The situation met by art in 1945 involved a series of assumptions about the nature of aesthetic modernity. One might call it a legacy, for the first generation of expressionists, all of whom were born between 1880 and 1922, inherited a current of thought that had been developing through the late nineteenth century. The channels of its ideas were varied: one might cite, among the more obvious, the oeuvres of Henri Matisse, Wassily Kandinsky, Joan Miró, and Pablo Picasso; pure poetry in the tradition of Mallarmé and Paul Valéry; the concrete music of Arnold Schönberg and Erik Satie; and the mixture of studio talk and café aesthetics that was transported to America by European émigrés. These conduits were strengthened by the growth of art history, informed by theory, which would rationalize the evolution of abstraction. The develpment of postwar art occurred in the context of an extended discussion on the relationship between form and meaning in the plastic object.

One of the central influences on this process was the complex of theorization and plastic research conducted at the nineteenth century's end under the aegis of the symbolist movement. What is suggested is not a direct filiation or interconnection, but that symbolist speculation infuses, and suffuses, most of our thinking on the abstract sign. Similarly, at issue is symbolism not in its mystical, otherworldly dimension, but rather as a specific moment of reflection on the concrete qualities of a medium, on the moving power of color and shape, and on how these elements might function *as language* in the articulation of meaning. Indeed, one of the driving questions behind symbolist thought is that of the meaning immanent in the structure of form. There are two salient elements here: one, symbolism's reflection on the autonomy of the object; the other, its idea of the mimetic motivation of the sign.

Any examination of the symbolist notion of autonomy must deal with the semantics of the word "crystal," which moves quickly from mineral substance to glass and, with it, to mirror.[17] There are repeated references in discussions of abstraction to form's "crystalline" quality—to what is perfect, irreducible, without fault; similarly, symbolist diction alludes to art's function as that of "crystallizing" essences by rendering them as clearly defined shapes. Underlying this is the sense of a small world, closed in upon itself and firmly separated from its exterior by the dividing line of form. The generation of the crystal by its own laws, native or "natural" to itself, indicates the image's debt to the romantic theory of organic form.

The vitreous or reflective quality of crystal also links it to the mirror, which served the symbolists as an emblem of aesthetic transformation. Mirroring equals doubling: reality would be mirrored in the formal structure of art, or art would mirror its own entity, a practice that would ultimately lead to formalist self-reflection, to art's circling around itself. Moreover, art would mirror the self, doubling the life of the mind, and lending to form a "physiognomic" character. In each case, the value of the mirror as an image of aesthetic transposition depends on a conceptual distinction by which the image is not identical to its origin but is projected onto a plane. In being made over into form, the image is reduced to a two-dimensional surface, mutated into spots and patches of color, whatever the illusion of depth. What is reflected in the mirror is refracted, transformed

into a flat simulacrum, made over into a sign. Mirroring, therefore, both parallels the process of picture-making and declares pictorial structure; furthermore, it affirms the necessity of passing through signification, through specifically pictorial practices of meaning.

In Mallarmé's "Crise de vers," the mirror image is spatialized: the poem/glass becomes a volume, a crystalline chamber in which words "illuminate each other with reciprocal reflections." Mallarmé's image, the ultimate in formal closure, is also a model for the internal production of meaning, for the facets of the crystal interread and interpret one another, so that meaning can only be internally discerned. In this manner, external reference gives way to inner, abstract value. This has nothing to do with balance or composition, and everything to do with self-definition, with the capacity of the language-self to constitute its own world, subject to its inner laws. Significantly, Mallarmé confers a double mission on the poem: through the ability of this world unto itself to operate analogously, in parallel to the external world, the poem will provide the "orphic explanation of the Earth," reflecting the structure of the universe and explaining its hidden meaning through language's refractions. The theme of the cosmogonist, the explorer of the void of space, surfaces repeatedly in postwar abstract art.

The semantics of the crystal do not stop here, for form and word appear as a glass or gloss to meaning, which shines through their transparent surfaces as if through an ideal limpidity. Matter at once declares and negates itself; form and meaning are joined in a perfect fit, a seamless unity of signifier and signified. This copresence of terms defines the symbol. Its valorization is not confined to the symbolist period, for the symbol extends through centuries as a kind of linguistic paradise or visual utopia, the end point of creative striving. Significantly, this vision turns on the question of convention.

In a remarkable series of articles, Gerard Genette has described the search throughout literature for a pure or ideally expressive language as Cratylism.[18] Genette's reference depends on a distinction made in Plato's *Cratylus* between mimetic motivation and conventionality in language, between a relationship of resemblance between word and thing and one that is arbitrarily or socially imposed. In this manner, the polarity witnessed on the social level is repeated on the plane of language, resulting in disquiet at language's historical nature. As Genette observes, the pursuit of an abstract or "mythically original" language was basic to the aesthetic research of the symbolist poets. Aesthetic lucidity—true expression—would be achieved only through an attempt to repair what Mallarmé termed the "defect" of language, which is its social character. In another comment the poet describes this ideal, otherworldly, ahistorical fit with a pictorial metaphor. Writing of the word's "double status" in "Crise de vers," he notes that *Imperfect languages in that they are several, the supreme one is missing. . . . But, at once, turned toward the aesthetic, my sense regrets that discourse fails to express objects by strokes that correspond to them in the instrument of the voice. . . .*[19] It is a hallucination on the power of sound to convey feeling, and to play on the reader's sensations directly, without the mediation of convention. Mallarmé goes further in describing this "incantatory" power of language, allying it to a "sovereign stroke," and noting that this stroke denies "the element of chance remaining in the terms"— i.e., the arbitrariness of the sign. The stroke is therefore absolute. We find echoes of it in the "absolute" colors—the pure, "true" hues— that suffuse the canvases of postwar abstraction.

Symbolist resistance, like that of modernism in general, consists in an effort to overcome the bonds of convention. In so doing, it becomes yet another convention: Genette notes that the ideal of poetic immediacy is now accepted, "our Vulgate, the . . . fundamental article of our literary aesthetic." Still, he charts its legacy as it extends, for example, to Jean-Paul Sartre, who separates "prosaic, conventional and exterior *signification*" from "poetic *meaning*." "*Signification*," he writes in *Saint Gênet*, "is conferred upon an object from the outside by a signifying intention, but *meaning* is a natural quality of things."[20] The natural, immediate, and centered is thus contrasted to what is historical, coded,

decentered. Given the impact of Sartre's existentialist philosophy on the first postwar generation, we can find something of this pure, indivisible language of the individual in their abstractions.

We must pass through one more transparency. In one of the notes collected in *Tel Quel*, Valéry, the apostle of pure poetry, invokes an image of the closed self-reflection that constitutes the form-world of the poem. Mallarmé's crystal becomes the substance to which language must reduce the world, *pureté*:

*I should have liked to dedicate you to forming the crystal of each thing, my mind, so that you might divide the disorder presented by space and developed by time, so as to draw from them the purities which form your own world, so that your light within this refractive structure might return and close in upon itself instantaneously, substituting for space, order, and for time, eternity.*[21]

Crystalline order, purity, light, the closure of a structure: the mind realizing itself in eternity. The mind makes the stuff of life—of convention—over into its "own world," and it is a very proper world indeed, bearing all the connotations of cleanliness and exactitude of fit. Valéry—whose "place" lies in the extreme regions of the formal imagination, where the poet disappears into his medium—delineates a poetic mission in which the language-self (like the form-self) establishes the network of its operations, an autonomous sphere of irradiations. This world, for all its icy cool, is not without emotion, for the language-self distills its sensations from the external world of "things." Still, the capacity of the mind to establish its own laws is paramount. The pictorial analogue of Valéry's purity is a meditation on painting's inherent qualities—pure space, pure color, pure light, which cohere within art's crystalline structure as its interreflective facets.

*We are asserting man's natural desire for the exalted, for a concern with our relationship to the absolute emotions.*
Barnett Newman

*The irreducible essence of pictorial art consists in but two constitutive conventions or norms: flatness and the delimitation of flatness. . . .*
Clement Greenberg

The ideas passed down through symbolism establish form as the site of meaning, as the location of a struggle for the expression of meaning. (It is not, however, the grounds of meaning, which are inner law and emotional truth.) During the postwar period this struggle would develop less through decades than through generations of artists that straddle chronological boundaries but share common assumptions. My recourse here to periodizing devices—the 1940s, the 1950s, and so on—is a somewhat necessary concession to the order imposed by art-historical practice. Yet one period—1944–47—emerges in startling relief as the beginning of the "picture boom." Bounded respectively by the end of World War II and Pollock's drip paintings (the paintings that, as Willem de Kooning remarked, "broke the ice"), these years mark a turning point in the forms and focus of abstraction. They also mark a turning point in geography: with them we witness the diversion of the modernist mainstream from Europe to America and, more specifically, to New York.

Filtering through the literature of the early New York school are repeated demands for a new beginning.[22] It is clear that this new origin was to be in America, and to reflect both the American character and American liberal values. Much of the American artists' disagreement with European culture was a function of their isolation, which they would expand and generalize into a symbol of individuality. Behind many statements lies a sense of Europe as overcivilized, its art a refined cuisine that found its diminutive emblem in easel painting. The result is that the American image became big and commanding; as O'Doherty has noted, abstract expressionism marks the first modernist occasion when size became as much a material as paint.[23] Its large canvases were to be vehicles of large emotions, emblems of an attempt to attain the level of universal thought. The concern with vast, echoing subject matter

*Jackson Pollock*
Guardians of the Secret, *1943*
*Oil on canvas, 48⅜ × 75⅜"*
*San Francisco Museum of Modern Art*
*Albert M. Bender Collection*
*Albert M. Bender Bequest Fund*
*Purchase*
*45.1308*

that informed the period impelled a leap over small details and circumscribed objects in pursuit of abstract symbols.

The art of the 1940s reflects an assimilation of a range of ideas that is oblique and, one might say, American; even existentialism was transformed into a romantic, universalizing attitude to establish the ethical function of the creative act. On the American side, the painters were informed by a predisposition to vast horizons and transcendental yearnings, by the literary romanticism of Herman Melville and Edgar Allan Poe, and by the mysterious night skies of Albert Pinkham Ryder. But it can also be said that their art aimed to synthesize or reconcile two European aesthetic traditions, the formal/rational and the poetic/instinctual.[24] On one hand, abstract expressionism was indebted to cubist structure. The cubist syntax of multiple parallel planes disposed in shallow space was passed on through many sources, most notably Picasso; the New York school could find further examples in the work of the American cubists of the 1920s. On the other, there is the sizeable influence of surrealism, whose elusive strains were passed along by André Breton, Matta, and other surrealist émigrés to New York.

Surrealism's net to abstract expressionism was vast, a capture of psychological and philosophical concepts supplemented by formal conceits. It was a highly personal one, for, as Ashton has remarked, American painting, with its grave seriousness, lacks the intellectual play of European surrealism.[25] The surrealist themes of nature, organicism, and metamorphosis are yet in evidence; adaptations of biomorphic form range from Arshile Gorky's eroticism to Clyfford Still's craggy, reduced works. But surrealism's major instruction to American artists was its attention to the unconscious and to myth. For example, cultivation of the unconscious as the source of art lies behind their interest in the device of automatic writing. Inasmuch as automatism presents the artwork as a transcription of the unconscious, unaided by analytic reflection, so it supports the fantasy of immediacy, of the immanence of meaning in the visual sign. This notion of a direct connection with the self would become the basis of

action painting in the early 1950s. Furthermore, since the unconscious is what is repressed by society, automatism appeared to offer a link to "authentic" emotions and pure, fundamental truths. The importance accorded to myth is evident from Mark Rothko's reference to Adolph Gottlieb, Barnett Newman, and himself as "a band of mythmakers."[26] A general recourse to myth recurs in paintings of the period, many of which literally figure myths (e.g. Pollock's *Pasiphaë*, 1943), and most of which rely on the notion of a universal, spiritual language embodied in mythic form. Fundamental to myth is its antagonism to history, for mythic time shuns our linear *chronos* for eternity or "other" time, much as it transcends the chaos of space in search of unity. There is no doubt that this ideal vision was persuasive to the troubled 1940s generation. But as Serge Guilbaut has noted, myth also presented a means to retain the 1930s desire to communicate with the masses, through a style that was universal rather than illustrative. The artists were impelled by a search for universal symbols, marks at once timely and transcendent that would express their anxiety with the modern world.

Pollock's well-known assertion "I am Nature" links his art to the romantic fascination with the instinctive, the immediate, and the unconscious—with everything that seems to exceed civilization's grasp.[27] Pollock would make this into his own myth, playing the rebellious frontiersman, and that myth would in turn contribute to the public myth of the inspired creative artist. Freely acknowledging his debt to surrealism, Pollock began using the technique of automatic drawing in paintings from the late 1930s. The notion of the "inner landscape" is evident in the mid-1940s in darting lines and curvilinear shapes equally distributed through space. Floating eyes, limbs, and biomorphic forms, all drawn from the organic vocabulary of surrealism, coexist with angular totemic images. The linear lace of imagery at once defines the pictorial surface and seems to strain the canvas frame. The surrealist idea of formal metamorphosis—which Ashton has convincingly linked to the abstract expressionist notion of all-over space[28]—is implicit in the sense of shifting motion through time.

*Jackson Pollock*
Mural, *1943*
*Oil on canvas*
*97¼ × 238"*
*University of Iowa*
*Museum of Art*
*Gift of Peggy Guggenheim*
*1959.6*

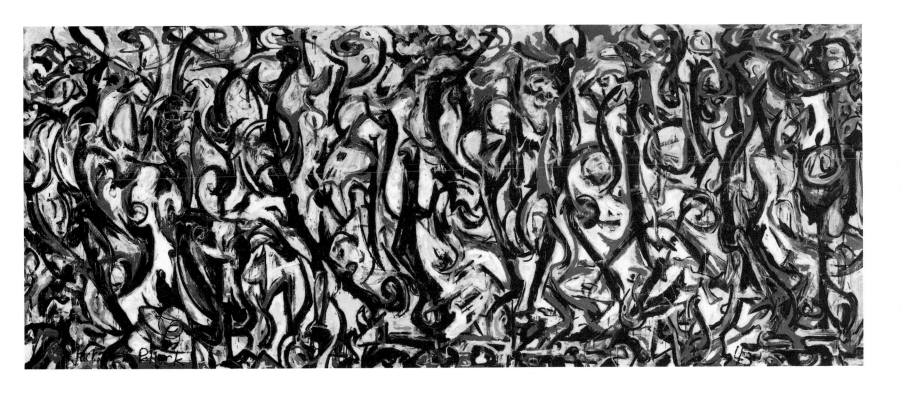

Pollock's "breakthrough" paintings of 1946–47, in which paint was dripped and poured directly onto unprimed canvas laid on the floor, resolved a dual imperative. On one hand, emotion was freed from the constraints of figuration, as the canvas became the vehicle of abstract thought. On the other, line was freed from the function of depiction: the skeins of paint on the canvas neither represent objects nor bound shapes nor delineate figures from grounds.[29] This breakthrough into abstraction left behind a cargo of conventions, including easel painting, composition, and hierarchical structure, for each area of the canvas is equally important and, in consequence, equally animated. Pollock's major accomplishments are evident in the drip canvases executed between 1947 and 1950. Of these, *No. 1* (1949) is exemplary: size, frontality, and resolutely formal concerns meet in a single striking image. The skeins of paint that loop and curl over the canvas read as a continuum, a seemingly endless line that moves through pictorial space, defining its breadth. Line here does not structure space: it demarcates neither parts nor parallel planes, with the result that space appears in all its ambiguity, at once flat and irresolutely deep. Patches of red, yellow, and brown paint, along with areas of bare canvas, are interspersed through the predominantly black and white lines. These juxtapositions, as well as the intersections of lines, create a kind of optical flicker, releasing light, so that the painting appears as if bathed in a shimmering atmospheric effect. Behind it is the rhetoric of gesture, of the mark of the hand, whose impulsive variations indicate the governing subjectivity of the artist.

Reviewing Pollock's first exhibition, in 1944, James Johnson Sweeney described his work as informed by "inner impulsion."[30] The term, pervasive in 1940s studio talk, is a recasting of Kandinsky's principle of inner necessity, and indicates the degree to which his ideal of spirit and spiritual freedom had permeated abstract expressionist ideology. As Thomas Hess has commented, it marks a shift from beauty to truth: the painting was now to be "an accurate representation or equivalent of the artist's inner sensation and experience."[31] Kandinsky's terms can be extended farther, for in *Concerning the Spiritual in Art* he parallels inner necessity in art with inner

freedom in ethics. Primed by existentialist philosophy, American artists were to attribute an ethical and social role to their art, making universal claims for individual experience. As always, there is a mix of sources: Ashton, for example, sees the artists as following "the romantic assumption that . . . (individual) aesthetic revelation can be generalized as a statement of human experience."[32] But on another level, the New York school viewed the artist hero as an exemplary figure, the pure or perfectly sentient individual who participates in the defense of freedom. Something of modernism's utopianism is conveyed in this statement by Newman: "If [my] work were understood, capitalism and oppression would disappear."[33]

Newman's often oracular words reflect the role that he bestowed upon himself as his generation's aesthetic voice. Similarly, his art mirrors the desire of the period for an irreducible formal sign. It is an art of enormous perversity. On one hand, it is of the utmost simplicity: each painting consists of one or more vertical bands cutting through a broad colored field. But the paintings resist this level of reading and encourage complexity, for the "zip" that divides the field quickly takes on metaphysical dimensions. Employing the anthropomorphic references implicit in verticality, and appropriating Judeo-Christian theology, Newman would invoke Genesis, turning his paintings into celebrations of the creative act. As Hess has written, Newman's zip is both an affirmation of the artist and a

*symbol . . . of Genesis itself. It is an act of division, a gesture of separation, as God separated light from darkness, with a line drawn in the void. The artist, Newman pointed out, must start, like God, with chaos, the void; with blank color, no forms, textures or details. Newman's first move is an act of division, straight down, creating an image. The image not only re-enacts God's primal gesture, it also presents the gesture itself, the zip, as an independent shape—man— the only animal who walks upright, Adam, virile, erect.*[34]

Hess is describing *Onement I* (1948), the first in a group of identically titled paintings prototypical of Newman's work. Its red brown field, the support for a single orange red stripe, also bears intimations of

the Cabala, witnessing Newman's attention to Jewish mysticism: "red-brown is the color of earth; Adam is the man created by God; the Hebrew word for earth is *adamah*; and Adam was made from the matter of earth, literally from the clay."[35] In this small painting—far smaller than Newman's succeeding works, which strain toward rhetorical immensity—the red brown pigment is identified with the surface, reinforcing pictorial reality. The edges of the stripe are textured, raw, sensuous, standing out in contrast to the homogeneous field. The painting's "pure" symmetry, centered by the dividing stripe, eliminates composition—or, rather, it reduces composition to the simple zip separating itself from space. As the painting's title suggests, the work represents wholeness, harmony, the individual or that which is indivisible: the whole or unified self.

Newman's insistence on the necessity of subject matter underscores the fact that the subject in these paintings is the human subject, centered and creative Man. In his paintings from the late 1950s the void of space is given out in pure, uninflected color disposed over large dimensions. The capacity of color-space both to affirm surface and to suggest indeterminate extension confirms a basic pictorial fact: we know by the most primitive acts of vision that flat color plays optical trickster, implying, through its absence of calibration, regions of infinite depth and lateral reach. Newman's use of this modernist device, later codified in formalism as "opticality," would win him a role as a forerunner of 1960s color-field painting. His reductive formats would be annexed by minimalism, much as his thematic variations would contribute to systemic painting. But all these derivations are incidental to Newman's intentions: he saw as his main contribution a new kind of drawing, conceived as formal and metaphysical delineation. Newman's reduced means are indices of the Cratylean values that he attributed to his art.

In a 1947 essay Newman described the primitive shapes devised by the Kwakiutl Indian artist as "a vehicle for an abstract thought-complex, a carrier of the awesome feelings he felt before the terror of the unknowable."[36] Newman's invocation of the sublime introduces a major motif of early postwar art; indeed the sublime, the void, the tragic and transcendent constitute the dominant themes of the 1940s. The proceedings of a symposium published in the December 1948 issue of the magazine *Tiger's Eye* demonstrate the vagueness with which artists interpreted the concept, using it generally and according to their own needs, touching freely on Longinus, Edmund Burke's reading of Longinus, and Nietzsche's idea of *terribilità*. The focus throughout is not only on communication with the absolute, but also on an absolute statement, commingling emotion and form; lying behind many comments is Longinus's sense of the sublime as "the echo of a great mind." But the fusion of dread and wonder underlying *terribilità* is clearly evoked in the works that Still painted on the West Coast in the late 1940s and early 1950s. These paintings, all untitled, are invocations of awestruck reverence before terrestrial immensity. They make specific references to nature, interpreted in its most terrifying effects. Dark, ragged surfaces built up from thick impastos are wrenched by chasmlike faults or lightning-bolt gaps. These crevices, which open onto abyssal depths, are often cut through a single spreading hue. That Still's symbolic, atemporal works have been described as suggesting primordial spasms indicates the apocalyptic element underlying some of abstract expressionism. The clotted surfaces show no tolerance for material suasions. Although immense, the paintings are always scaled to the figure; the viewer is overpowered, seemingly engulfed in endless space.

Another proponent of the sublime, Rothko, interpreted it equivocally, accenting the wondrous, the exalted, and above all the mysterious. Rothko carefully courted ambiguity. The abstraction of his art, which consists in a single image repeated and inflected in series, nevertheless resists definition. Although he insisted on "materialism," Rothko moved toward transcendentalism: transcendence of the object by form, of the detail by the large, abstract thought—and of course *the* transcendence, for he took the "human condition" as his subject. Much of his painting's equivocal majesty arises from his commitment to the power of light as articulated through color. The sheer evasiveness of light is, perhaps, one reason why Rothko was little

acknowledged in the formalist canon, which lionized Pollock and Newman.

Rothko's break from, or transcendence of, the object occurred around 1950. Before that his work had been informed by surrealism: paintings like *Slow Swirl by the Edge of the Sea* (1944) show the standard repertory of mythlike symbols skidding through lambent space. These forms are disposed—precariously—on horizontal color zones that alternate between dark and light. As O'Doherty notes, the number of zones varies; sometimes there are two, more frequently three, and they devolve around rudimental horizons. By the turn of the decade, the forms have vanished into space, which appears to move forward, hovering, taking the forms' place as color bars. Many works of the early 1950s, like *Violet and Yellow on a Rose* (1954), use clarion colors: crepuscular pinks and yellows, purple haze, greens, and aqueous blues. By mid decade sharp contrasts are frequent, for example between yellow and dark red; then the colors progress through somber ranges, reflecting Rothko's increasing attention to the tragic (*Black, Ochre, Red over Red*, 1957; *Purple Brown*, 1957). The flat, broad bands, weighty and processional, are crafted from multiple washes of paint, so that glints of interior color show through. The borders of these interior rectangles echo the painting's perimeter, staunchly declaring its materiality, but the feathery blurring of their edges detaches them from the surrounding ground. Rothko lavished care on these edges: the careful muting of colors releases a dim, tremulous, flickering light, in which the molten colors appear suspended. The rectangles float unmoored, equivocal planes in an equally irresolute space. The formal syntax, then, is traditional: a variation on late cubism.

Rothko's paintings of the late 1950s in particular are examples of significant reduction. Their obsessively repeated structure suggests something of Mallarmé's incantatory vocable. Starkly frontal, they reduce composition to a suite of rectangles apprehended as a single form. Similarly, they condense color to its maximum concentration, which is also its point of maximum luminosity. Indeed, Rothko's art, like much postwar chromaticism, is indebted to Matisse's studies of the light inherent in chroma as its "crystalline consistency" and of the light that is released in the interplay of disparate abutting hues. The halolike luminosity of these works—always described as the source of their mystery—is thus preeminently pictorial. To this, Rothko adds another element: his paintings visibly respond to their environments, gathering and releasing luminosity according to the ambience in which they are placed.

The works of Franz Kline bear witness to the range of temperaments deceptively united within the New York school. Unlike the painters so far mentioned, Kline's impulse is urban, not natural, specific rather than universal; he was drawn, wrote Frank O'Hara, to the style of the boulevardier.[37] O'Hara also describes him as the consummate action painter, at once allied to and different from Pollock and de Kooning: he wished "to create the event of his passage, at whatever intersection of space and time, through the world." The focus encapsulated here—the transcription of individual sensation, encoded as feeling—informs the group of austere black and white paintings that Kline exhibited in New York in 1950.

An anecdote recalls their derivation: the artist, having completed a naturalistic drawing, magnified a small section, noticing how the linear detail acquired a strong, simple, gestural quality when blown up to large proportions. The image—a mass of heavy black strokes—became the prototype for all Kline's efforts. There is much of the 1950s in Kline's action: the part reads for the whole, the sensation for the experience, and (of course) art for the artist, since the stress is on formal signature, on a reduced matrix of means that defines the self's arena. Each painting consists of a small number of slashing strokes, grandiloquently large, that cut across the canvas, simulating raw sensation. Many strokes are diagonally arrayed, adding to the high-speed image, while others nest together, establishing massive, ponderous forms. Occasionally, strong beams of black seem to teeter precariously against their surround—a nod to the period's obsession with tragedy. In some works, broad horizontals suggest Manhattan's

bridges (*Hazelton*, 1957). Others evoke the crumbling structures of New York's transit system (Kline's affection for the old Third Avenue El is legendary). Still others are more oblique—sheer intimations of motion. Throughout, the focus is on what is sensed, not seen—or, rather, on sensation as it is derived from seeing (among other senses) and "immediately" transcribed through gesture. Nevertheless, Kline's work indicates a consciously defined semiotic. Its off-center compositions and transverse lines are methodical signs for urban dynamism. Similarly, in keeping with period style, the image is hieratic, imposing, its scale dramatically amplified so that it appears to impinge on the viewer. There is a studied unconcern for finish: the brushstrokes and occasional dribbles of paint are inscriptions of the painter's process.

Kline frequently described his paintings as "situations," open-ended and fluent ones initiated by his opening strokes. The obvious echoes are with existentialism, which, as Ashton remarks, was invaluable to artists' reflection on the choices inherent in painting.[38] Existentialism's role in formulating the ethical function of the artist in the 1940s is clear, as is the importance of the idea of subjective definition. For many members of the New York school, the canvas became the locus of that process. Further, as Ashton notes, Sartre's emphasis on ambiguity and duality was a specific subject of discussion; that irresolvable contradiction was "appreciated as a positive value"[39] is evident in the admiration accorded to de Kooning.

The multiplicity of de Kooning's work is well acknowledged. In his 1968 study on the artist, Hess noted of his disparate and often intersecting styles, "The artist keeps himself open, available to all possibilities and any contradictions."[40] The statement hints at a specifically romantic fascination with liberty. In pursuit of a particular vision of space, the painter mingles genres (abstraction and figuration), scrambles spatial modes (flatness and depth), and ransacks art history, culling modeling, cubism, mannerist light. De Kooning's flight through history is a thorn for formalism, since it defies art's presumed inner logic and courts regression, which it

exalts. ("Spiritually, I am wherever my spirit allows me to be, and that is not necessarily in the future. . . .") However, de Kooning's ideal of freedom also articulates a prison-house, existentialist reading—whence his famous "anxiety," recorded in his assiduous canceling of strokes.

De Kooning's history bears out his paintings' heterogeneity. His early works, beginning with his emigration from Amsterdam to New York in 1934, were abstract landscapes and figure studies, painted concurrently. Increasingly, drifts of Picasso and surrealist biomorphic form appear, lodged in a shallow, cubist space. In *Pink Lady* (1944), Picasso prevails in the figure's doubled head and curving members, but the cupboards and shelves are rectangles—rectilinear geometric forms—and the breasts are circles. Once named, the breasts pursue a metaphorical route (circles, peaches . . . ripe fruit?) and the surrounding space refuses fixity. Hess has remarked of the early "Women" studies that the pieces of furniture that should serve to indicate "the volume that is supposed to contain them take on the independent intensity of abstract forms and often seem to push in front of the figures."[41] The women inhabit space ambiguously, much as the paintings oscillate between figuration and abstraction.

*Dark Pond* is one of a series of black-and-white works that de Kooning painted in 1948. Their effect startled his contemporaries. Everything is given in a variable white line that darts, meteoric, throughout the canvas, suggesting angular and rounded forms. The black-and-white scheme contributes to this dynamism, destabilizing figure and ground, but line is the central agitator. It at once describes and disrupts shallow overlapping planes; its breaks and discontinuities allow space to escape definition and to pervade the boundaries of forms. Space, then, becomes equivocal, and forms evanesce in the ambiguous environment. De Kooning carries this shifting instability into the chromatic register of *Asheville* (1949). Here there are curving forms—buttocks and other members—along with floating eyes and mouths. Something of a grid implies an organizing structure, but since the shapes are at different scales, the sense of

*Willem de Kooning*
Dark Pond, *1948*
*Enamel on composition board*
*46¾ × 55¾"*
*Weisman Family Collection—*
*Richard L. Weisman*

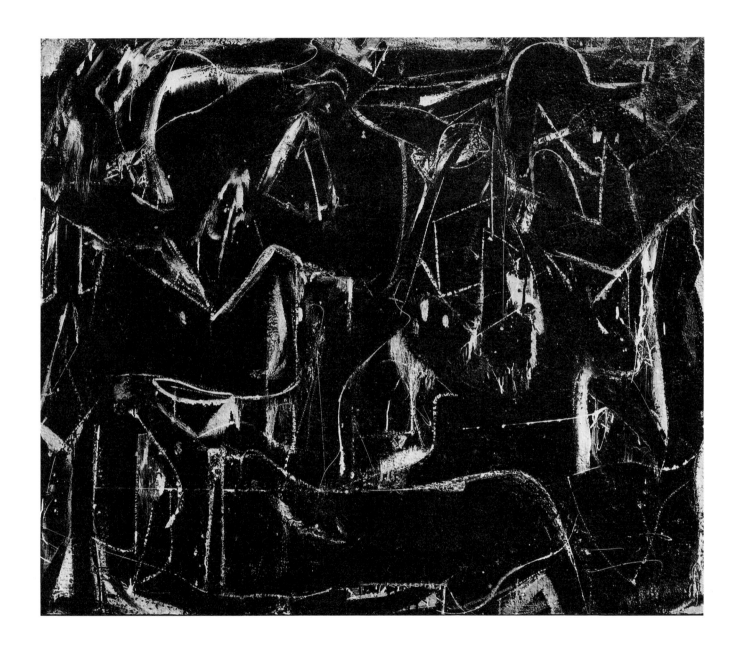

Willem de Kooning
Door to the River, *1960*
*Oil on canvas*
*80 × 70"*
*Whitney Museum of American Art, New York*
*Purchase, with funds from the*
*Friends of the Whitney Museum of*
*American Art*
*Acq.# 60.63*

Hans Hofmann
Table–Version II, *1949*
*Oil on canvas*
*48 × 36"*
*San Francisco Museum of Modern Art*
*Gift of Mr. and Mrs. William C. Janss*
*78.203*

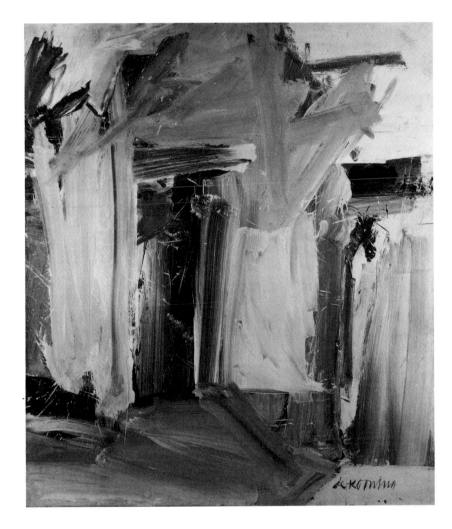

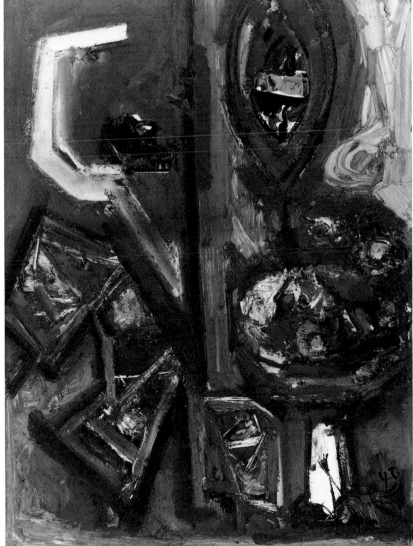

order is negated. As with *Excavation* (1950), the effect is very flat, very frontal, but the forms oscillate as line slides through different levels of space. The feeling is less either/or ("classic" existentialism) than everything—a surfeit of choice. *Excavation* resembles a frieze with the figures moving in all directions.

De Kooning has written on the disparity between the Renaissance sense of space, informed by clarity and order, and his own ambiguous regions. Space, he notes, is the artist's subject, at once his own, that of others, and of *the* other: "The subject matter in the abstract is *space*. He [the artist] fills it with an attitude." [42] The result of that injection with attitude—perpetual equivocation—demonstrates the degree to which the formal, rational structure of cubism was put to expressive ends. Cubism is at once constructed and deconstructed, for the hooks and gaps of de Kooning's line buckle the containing system. This is clearest in the 1950s, when figure studies (the famous "Women") and landscapes again alternate promiscuously. More precisely, they interpenetrate: when de Kooning paints a woman on a bicycle (*Woman and Bicycle*, 1953), the landscape shoots through her as much as she through it. Fixed identities dissolve as forms collide with a space whose very discontinuity is the artist's theme. The paintings of the late 1950s and early 1960s are distinguished by the values attributed to the brushstroke, which crosses the canvas in broad, looping lines, its bristles soaked with paint. These gestural strokes, which win de Kooning his central place in action painting, are extremely self-conscious in the awareness they demonstrate of the constraints imposed by the medium. They play with flatness, and with its ambiguities: *Door to the River* (1960), as its title suggests, avails itself of painting's historical function as an opening onto an illusion of space, but insists that access to that illusion is imposed by the two-dimensional reality of the plane.

One of the major sources for the New York school's ideas on pictorial language was the studio that the German painter Hans Hofmann conducted in the West Village from 1936 until 1958. Hofmann's school is important not only for the students who attended it

(including Lee Krasner and Greenberg), but also for its role in disseminating a broad scope of European culture. Through an idiosyncratic synthesis of aesthetics, Hofmann conveyed a "grammar" of painting that descended from early modernism. Throughout his teaching, his stress was on the specificity and expressive language of the medium, whose "inner laws" he detailed. Some of his concerns would become aesthetic axioms: they include the distinction between positive and negative space; the inviolability of the picture plane; a focus on spatial illusion created through the optical interaction of warm and cool hues (Hofmann's noted "push-and-pull"); and an insistence that all composition be determined in relation to the frame. Hofmann's overriding assertion—that a painting is a two-dimensional illusion derived from the supporting terms of flatness—manifests the merger of formal syntax and expressive ends that, as I have noted, was fundamental to the period. Many of his recorded statements dwell on painting's metaphysical implications. Throughout, there are references to musicality, to inner essences opposed to outer appearances, and to the need to "see to the core and grasp the opposing forces and the coherence of things." [43] Implicit in such suggestions that pictorial tensions parallel larger natural rhythms is, again, the influence of romantic subjectivist theory.

Much of this insistence on the painting as an organism—whole, integral, and centered on itself—can be found in Krasner's paintings from the late 1950s and early 1960s. Krasner's early works were directly informed by Hofmann: her student paintings from the late 1930s are cubist-based studies drawn from the model or motif, in which nature is "abstracted" into form. All are on a small scale, with line and color isolated as separate elements, and only after a complex trajectory marked by the introduction of automatic drawing would Krasner transcend these divisions. *The Gate* (1959–60) is the first in a group of large-scale works that includes *Primeval Resurgence* (1961) and *Polar Stampede* (1960). These paintings rely for impact on gesture, on painterly drawing with pigment-loaded strokes. All illusion is internally engendered: there are no defined shapes, but

rather contours that suggest pulsating rhythms developed through contrapuntal curves. Similarly, color is borne by sharply framed oppositions. Barbara Rose has noted that the contrast of dark to light in the group seems to fashion a Manichaean opposition,[44] suggesting the primordial forces that echo in the title of *Primeval Resurgence.* Krasner's references are to raging storms, glaciations, and geological catastrophes. As with Pollock's works, the compositions are all-over, affording the eye no resting place from the centripetal motion of forms. Their vast scale lends them environmental dimensions; in keeping with the "big paintings" of the 1950s, they seem to envelop the viewer in the immensity of their rhetoric.

The theme of nature as experienced by the subject finds many echoes in the period. Exemplary here is the group of monochrome canvases painted by Sam Francis in the early 1950s, which approach the evanescence and mutability of light. These white or pale-toned paintings were made in Paris, where the artist moved from California in 1950, and seem to continue the legacy of impressionism, of Matisse's condensations of sensations, and, to a degree, of Rothko. They are abstractions of atmosphere—of the ephemeral motion of light over water, for example, or of its obstruction in foggy skies— which deploy tremulous strokes over colored fields that seem to exceed the painting frames. There are no clear forms, only dissolving unformed shapes that float across and off the surface of the plane. This natural impulse is mirrored in a group of large-scale canvases painted by Helen Frankenthaler in 1957, in which transparent washes of color formed by thinned pigment soaked into unprimed cotton duck convey intimations of sky, clouds, luminous fields, and vistas over sea and land. More precisely, however, they evoke a sensibility at play in the landscape. There are Miróesque conceits in the sunlike forms and punning lines that swirl across the canvases.[45] *Eden* evokes the primeval garden: a sinuous form suggests a snake, while a circular red shape in the center intimates something of the apple of Eve. As one title, *Seven Types of Ambiguity,* implies, these works are studies in the suggestiveness of abstract forms. But they are also indirect homages to the equivocal powers of technique.

Like all Frankenthaler's mature practice, the 1957 works are indebted to the method first announced in *Mountains and Sea* (1952). As with Pollock's dripped and poured paint (of which she was markedly conscious), the artist's reliance on diluted pigment stained directly into the canvas, without the mediation of a brush, indicates the primacy that modernism accorded technical innovation in the development of pictorial expression. The technique was to prove formative for much later art, in particular for 1960s color-field painting. To Frankenthaler, it answered demands of emotion: significantly, she aligned it with a landscape motif. But the diction of Kenneth Noland's account of a visit he and Morris Louis made to Frankenthaler's studio in 1953 records the impact of *Mountains and Sea* on these Washington, D. C.–based painters: his description of its "one-shot" imagery accents immediacy, presence, the synthesis of form and meaning, as meaning takes on the quality of a formal idea, eclipsing expressive content.[46]

What are the implications of staining for the formal imagination? The technique answered a host of pictorial questions, only one of them how to move beyond the sterile mannerism that was increasingly evident in abstract expressionist art. On one hand, the suffusion of thinned pigment into unprimed canvas yielded a seamless coincidence of paint and support, making possible an unmodulated color field. On the other, the demands of truth to the medium were met, since the rough weave of the cotton duck showed through the paint, declaring the materiality of the surface. As opposed to the encrusted canvases of abstract expressionism, the unified surface afforded by the stain technique promised a purely "visual" texture, free at once of the brush's mediations and of the tactile illusionism of three-dimensionality. By sinking the image into the support, distinctions between figure and ground were eliminated; similarly, the antinomy of line and color was sundered by the extension of color out to the defining edge of form. The tenets of cubism were thus dispelled, ushering in another suite of reductions as well as an increase in pictorial effect, for the technique would lead to the resonance of pure, uninflected, saturated hues over broad expanses.

*Helen Frankenthaler*
Before the Caves, *1958*
*Oil on canvas*
*102⅜ × 104⅜"*
*University Art Museum*
*University of California, Berkeley*
*Anonymous Gift*

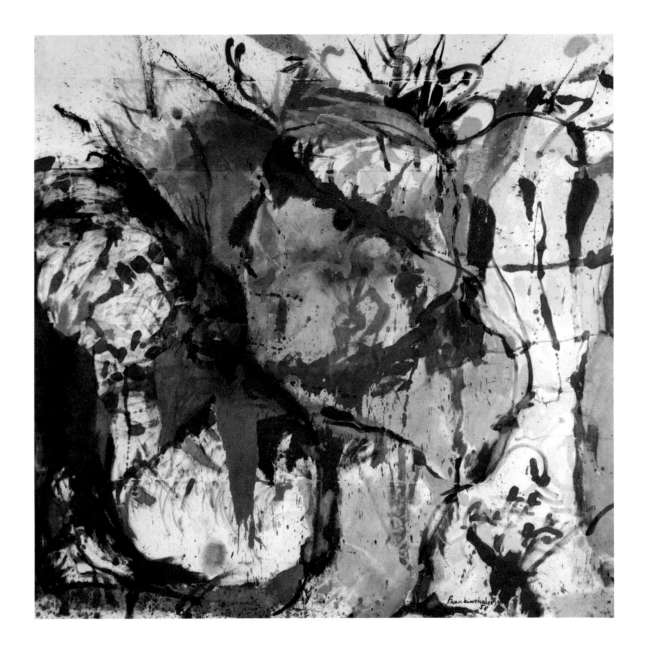

Louis quickly assimilated the stain technique: by 1954 he had embarked on a series of paintings in which the image and its raw canvas ground are indissoluble. However, the specific import of these paintings, in which color is poured and floated over and into the canvas ground, lies in their renunciation of drawn line. As the formalist critic Michael Fried has noted, the line that bounds color resists being read as drawn:

*this is important: because as soon as the periphery, or part of the periphery, of one of Louis' stain images strikes us as drawn—as soon as we are made to feel that the painter's wrist, and not the relatively impersonal process of staining itself, determined its configuration— the image tends to become detached from its ground, and to be perceived in tactile terms.*[47]

In renouncing line, gesture is abandoned, and with it the painterly marks of the expressive artist. In Louis's "Veil" series of the late 1950s (e.g. *Spark*, 1958), the canvases register the vertical course of curtains of color poured from their upper edges, and because they have been rubbed and rolled with commercial rollers, considerable surface variation occurs. An insistence on the physical activity of staining looks forward to the process-oriented work of the late 1960s. Despite their supposed purely "optical" qualities, these are images of enormous imaginative suggestion, implying rivers, canyons, or, as their titles intimate, veils. In the "Unfurl" series of 1960–61 (including *Nu*, 1960), the image is constructed through brilliant rivulets of color flowing in loose diagonals inward from the vertical sides of the frame toward the floor. The clear consciousness of the framing edge serves to affirm the pictorial support. Between these stained triangles is a larger, open triangle of raw, unpainted canvas. It is everything other than the expressionist void: a sheer unrelieved surface, broad and luminously bare.

Louis's paintings trace a trend evident in the late 1950s toward bigger paintings, simpler compositions, and high-keyed hues that contrast sharply with 1940s sobriety. What his career announces is late-modernist formalism, the rigorously logical pursuit of aesthetic definition that would dominate 1960s practice. The general shift from content to formal structure, or from individual expression to the expression of aesthetic law, has made the 1950s appear as a time of transition, posed around the watershed year 1955. This view has obscured the merits of many artists who matured in the 1950s—the so-called "second generation" of abstract expressionists—just as it has encouraged neglect of the acute formal thinking that underlies the abstract expressionist symbol. Something of the unevenness of official history is visible from the paintings of Cy Twombly, which span from the late 1950s to the present. Here the flat plane of the canvas is interpreted as a writing surface, the support for a remarkably subtle variation on abstract expressionist gesture. Whether in the early white paintings (e.g. *Sahara*, 1960, and *Bay of Naples*, 1961) or in the "blackboards" of the late 1960s (*Untitled*, 1969), this surface functions as a register responding to the slightest fluctuations in sensibility, recording graffitilike scrawls, scribbles, and script in a pictographic ensemble. The effect—expressionism in its most muted and intimate refraction—suggests the irruptions traversing the smooth fabric crafted by the convention of decades; these irruptions also include a range of evocations of nature that continue the abstract imperative to give states of feeling form. Furthermore, the 1950s also encompass both formalist exclusiveness and the kind of catholic inclusiveness that characterizes Robert Rauschenberg's career. Rauschenberg's apotheosis of the everyday looks toward the pop art of the 1960s, much as his "journalistic" transcription of the ephemeral displays the point against which formalism would marshal its essentialism, recharging the old opposition. The late 1950s and 1960s thus contain both the impulse toward the figure and its negation, the endeavor to purify form. But in the realm of abstraction, the decade's shifts are undeniable. Not the least is a change in elocutionary mode, for abstract expressionism had privileged the "voice" of the artist, ascribing to it the values adhering in Western discourse to the notion of individual speech. By the start of the 1960s that voice had dwindled to a whisper, to be replaced by the impersonality of formal law. Touch—the mark of individual sensibility—was succeeded by seemingly mechanical facture. Moreover, the privilege accorded to the irrational, risk, and

*Frank Stella*
Die Fahne hoch!, *1959*
*Black enamel on canvas, 121½ × 73"*
*Whitney Museum of American Art, New York*
*Gift of Mr. and Mrs. Eugene M. Schwartz and*
*purchase, with funds from the John I. H. Baur*
*Purchase Fund, the Charles and Anita Blatt Fund,*
*Peter M. Brant, B. H. Friedman, the Gilman*
*Foundation, Inc., Susan Morse Hilles, the Lauder*
*Foundation, Frances and Sydney Lewis, the Albert A.*

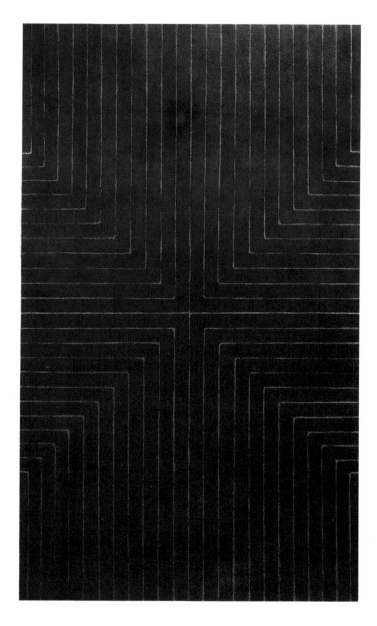

prelogical thought was ceded as inner logic came to direct the enterprise of art, proposing as its motor the immanent dialectic of reduction.

The abstraction of the 1960s is coded with the rhetoric of Greenbergian formalism, the self-critical and proscriptive pursuit of pictorial essences that is an intensification of Greenberg's initial concepts. The term "formalism" is, of course, imprecise, since it describes only one avenue within the dialectic of form that crosses modernist thought. However, what the *theory* of formalism presented to the 1960s generation was a context—or, better, a system—within which to develop aesthetic practice. It redefined the discursive space of modernism, reifying its pictorial emphasis into a fundamental concept: the opacity or obdurate hardness of the plane, its empirical core as a "continuous, bounded, detachable, flat surface"[48] destined for a beholder. As Rosalind E. Krauss notes, formalism embodies a search for the originary status of the picture plane. But, as she also notes, its search for a pure, nonrepresentational sign is a semiological impossibility: the signifier is transparent both to the formal ideology that underlies it and to an "already-given decision to carve it out as the vehicle of a sign."[49]

On a more important level, formalism betrays its historical continuity with earlier modernism in its focus on an inner dialectic premised on the individual subject and on the closure of the sign. The terms valorized by formalism—immediacy, unity, formal closure—repeat those of the Western metaphysical dialectic, much as its insistence on self-criticism, ethics, and the "morality" of formal decision reflects the idea of sovereign individuality. And it is predicated on the model of the sign's depth, as a union of dual terms, which serves to maintain the very notion of autonomy. As opposed to what is usually assumed, the referent is not bracketed in formalism; instead, formal law, substituting for content, assumes the position of the signified. The literalness of the picture plane serves as painting's "fact," its irreducible founding principle. In its format and signifying implications, then, the formalist sign adheres to the model of

*List Fund, Philip Morris Incorporated, the National Endowment for the Arts, Sandra Payson, Mr. and Mrs. Albrecht Saalfield, Mrs. Percy Uris, and Warner Communications, Inc.*

humanist thought: formal law becomes the transcendental signified.

Late-modernist formalism is characterized by the negation of modernism's transgressive edge: by the 1960s, art's withdrawal into its own demands had denuded its capacity for subversion. "The essence of Modernism," Greenberg wrote in 1965, ". . . lies in the use of the characteristic methods of a discipline itself not in order to subvert it, but to entrench it more firmly in its area of competence."[50] The specialized nature of this endeavor is evident in the references to "formal intelligence" and "visual skills" that run through 1960s diction. The proceeds of such pictorial reflection are visible in the works painted by Frank Stella between 1958 and 1970. Stella's particular accomplishment is the development of a mode of structure that relates all composition to the configuration of the frame, thereby acknowledging the painting's limits. The major influence on this practice was Jasper Johns's first exhibition of flag and number paintings, held in New York in 1958. By Stella's own account, he was impressed by Johns's way of marking his surfaces with rows of stripes, and began to think of repetition as a means of pictorial structure. More precisely, he was informed by Johns's identification of the motif with the literal shape of the field. In the "Black Paintings," begun later that year, repeated rows of stripes either echo the framing edge or are rotated, inverted, or arranged in stepped recessions to form relatively simple patterns. *Die Fahne hoch!* (1959), for example, is split symmetrically along its horizontal and its vertical axis; because the stripes are pure repetitions of the frame, the internal elements have no relation to one another. Moreover, the regularity of the pattern, as Stella noted in a 1960 lecture, "forces illusionistic space out of the canvas at a constant rate."[51]

The "Black Paintings" are illuminations of the elements that Greenberg defined as normative to painting—flatness and the delimitation of flatness, two-dimensionality and its boundaries. The parallel bands are painted with commercial enamel, applied with house painter's brushes of a standard 2½-inch width. Their texture conveys the record of their facture. The stretchers are made of one-by-three-inch lumber placed in depth against the wall, emphasizing the painting's character as an object. Stella's acknowledgment of the shape of the support as the central determinant of pictorial composition is amplified in a series of metallic paintings from 1960–61, in which notches cut from the support are echoed in linear patterns traversing the visual field. Surface pattern and framing edge work together, elucidating one another; the metallic pigment creates a flickering, impermeable, self-contained space that invites apprehension in exclusively visual terms.

In the catalogue for an exhibition held at the Solomon R. Guggenheim Museum, New York, in 1961, H. H. Arnason employed the term "abstract imagist" to refer to painters who were not expressionists. The exhibition included work by Al Held, Ellsworth Kelly, Noland, Stella, Jack Youngerman, and other artists who avoided gestural painting for even surfaces, reduced imagery, and clean lines. These stylistic constants earned this work the more descriptive label "hard-edge." In an early discussion, Lawrence Alloway elucidated its defining characteristics: "forms are few in hard-edge and the surface immaculate. . . . The whole picture becomes the unit; forms extend the length of the painting or are restricted to two or three hues. The result of this sparseness is that the spatial effect of figures on a field is avoided. . . ."[52]

Some of the implications of hard-edge style can be seen in work by Kelly, whose first single-panel, single-color paintings date from 1952–53. Kelly's paintings of the 1960s are made of one or two bright colors applied to the canvas in uninflected fields. The flatness of these works is so extreme that the surrounding wall reads as a ground. More important, the color extends to the edge of the plane, defining that plane; if two colors cover the surface of the painting, abutting along a seam, the seam is marked by a division in the panel. Color is declared to be coextensive with its support. Similarly, because plane and color are fused, the function of line in delimiting shape is subsumed within the larger enterprise of pictorial construction. The reductions of Kelly's paintings, then, create complex relations

between color, line, form, and plane (as well as depicted and literal shape), all of which cohere within the work as its interreflective elements. And behind them all is the impact of color, in its pure austerity, as an unmodulated field.

Because of their adherence to the terms of pictorial logic, Kelly's works appear as discrete objects; their detachment from the wall is the emblem of their autonomy. Similarly, their apparently anonymous facture removes any biographical reference. However, Kelly's works do refer to their perceptual status as visual objects. They pertain to an essentialist focus that takes the experience of seeing as its subject, and entails a range of perceptual and optical experimentation that constitutes a particular 1960s analytic. The study of the interaction of color and shape provides the continuity linking Kelly's early work to his paintings of the 1980s. Where in the earlier works he conjoined bright colors and quasi-geometric forms ranging from rectangles to diamonds and fan-shaped arcs, Kelly more recently deploys irregularly shaped canvases—skewed compositions of warped lines and slow, tilting curves, suffused in muted hues tending toward dark blues, grays, and browns. Line, again, is used rhetorically, as the boundary defining the extension of color, but the result is no longer a dynamic assertion of the impact of color/shape. Instead, Kelly's emphasis is on the adjustments the eye entertains as straight lines seem to bend under chromatic weight, or as planes curve into optical depth. Despite the explicitness of their structure, the paintings hover on indefinition, but these pictorial effects are always driven by their own logic. Whatever equivocation or visual warping occurs must be accounted for by the shape of the plane and by the interaction with color it implies.

The displacement of the personal aspired to in 1960s art was developed in two ways: by eliminating the physical "traces" of the artist, and by serial repetition and system. As Alloway notes, this cult of anonymity is paradoxical—"the artist's conceptual order is just as personal as autographic tracks."[53] Nevertheless, the elaboration of extended series provides a dominant 1960s thematic.

We find it in variations ranging from a matrix for the development of a formal motif (e.g. Jim Bishop and Jo Baer) to a structure for perceptual explorations (Robert Irwin's "dot" paintings of 1964–66) to the logical permutations and combinations afforded by the grid. Morever, the use of repetitive formats and hard-edged, impersonal techniques provides a link between 1960s abstraction and the cool aesthetic of pop art. The parallels are extended by the use of glossy paint and industrial finishes, which point to the intrusion of nonaesthetic codes into the sanctified domain of high art. Evident in Stella's paintings of 1960–61, the tendency is amplified in the lacquers, epoxies, and other synthetic materials employed by certain Southern California artists. We find it, for example, in the shimmering aluminum-and-spray-lacquer of Billy Al Bengston's paintings, which properly belong to California pop art. Bengston's characteristic motif—a chevron centered in a composition of circles, ovals, or other abstract images, all rendered in a crisp, commercial style—illustrates the tension between object and image, figuration and abstraction, that underlies certain 1960s art.

The continuation of analytic reductionism into present time is visible in the practice of the West Coast painter Ed Moses. Moses's works from the mid-1970s are stripped down and simplified to their empirical ground, at which the image is the two-dimensional plane. These paintings propose total abstraction, turning on the primary signified of a flat, bounded, beholdable surface, its visibility illumined by colored paint. In untitled works from 1985–86, paint is applied methodically, through a suite of repetitive motions, to form a gridded structure rotated on the diagonal. The series, which is related to an earlier group entitled "NY Tracs" (1975), is characterized by the use of broad and seemingly "emotional" strokes. Yet a closer look reveals the artist's ruse, for the inflections from canvas to canvas manifest deliberate strategies for covering different surfaces with paint. Moses's desire to avoid expression (or, as he puts it, the "reflection" of man) is matched by that of Robert Ryman, who for some twenty-five years has developed pictorial self-reflection, detailing the physical components of paintings and the processes by which they are made

*Robert Ryman*
Untitled, *1958*
*Casein and graphite pencil on newsprint*
*13¾ × 13½"*
*Collection of the artist*

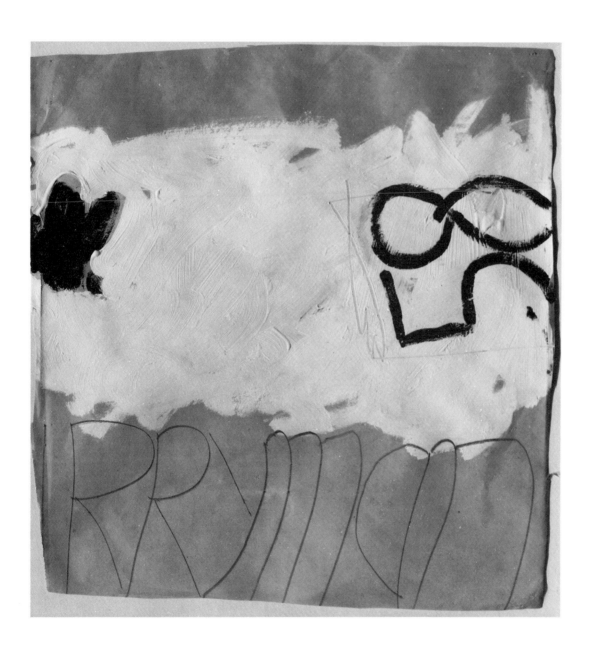

into visual objects. Ryman's paintings, which resist idealist appropriation, catalogue pictorial factors—the nature of the support, the application of paint, the depth of the stretcher, the frame or the relationship to the wall—all factors that are singular, "different," variable from artwork to artwork, but that are inscribed within the same structure of repetition. Ryman's preferred format is a neutral square; his color, no color—white—the minimum needed to register the difference of paint on a support.

Ryman's enterprise, however, exceeds this literalist reading, for it is a reflection not only on the material essence of painting but also on its fundamental dependence for intelligibility on historical conventions or codes. His painstaking cataloguing reveals the conventions that define the work of art and provide the ground for our readings of pictorial meanings. Thus *Untitled* (1958), an early painting consisting of Ryman's name and the painting's date drawn large enough to occupy the major portion of the canvas, is a representation of the ideological action of the signature as the bearer of meaning in Western aesthetics; it also comments on the primacy of the human subject in abstract expressionism. In a painting from 1960, Ryman's signature is located on the edge of the stretcher, declaring the stretcher's depth as part of the signified and referring the material propositions it stages to a central authorial source. In recent works like *Resource* (1984) and *Bender* (1984), painted fiberglass panels of differing dimensions are affixed by specially designed fasteners either flat against the wall or at determinate intervals from it. Just as the visibility of these fasteners is emphasized, so the thinness of the fiberglass calls attention to the minimum material required both to support a painted surface and to distinguish an object from its surround. Light playing over the edges crafts different coefficients of shadow and focused light, so that several works appear as shallow, "sculptural" reliefs, while in others the surface is only minimally, but precisely, divided from the space in which it rests. Ryman's scrutiny of his means elucidates the arbitrariness of aesthetic categories, questioning the definition of a painting as a wall-bound object, destined for a beholder, which underlies modernist convention. Yet more important,

Ryman also suggests that it is only the specific cultural configuration of modernism—in other words, its historicity—that gives his works meaning as paintings.

Modernism's grounds for meaning remain truth to the medium and inner truth, and many practices in the last third of this century match pictorial reflection with expressive sensibility. The merger is evident in the work of Robert Therrien, whose colored reliefs occupy a territory between sculpture and painting and locate their abstraction in their suggestive power. The forms in Therrien's plaques, which concern relationships of color, plane, and shape, are chosen for the associations they carry; they are reduced, unspecific, highly generalized metaphors that develop the connotations of color and curve. The merger is also evident in the paintings of Brice Marden, which join minimalist rigor to a romantic sensibility, dedicated to distilling experience in aesthetic form. Form again is the vehicle of personal meaning—of abstractions of space and atmosphere that take the individual subject as point of origin. Marden's paintings from the 1970s are informed both by an orthodox minimalist belief in the "indisputability of the plane" and by nature. ("A horizontal is a landscape image"; "I take nature as a reference.") Each of the two or more panels in these works is covered with a colored "skin" established by repeated applications of beeswax and oil paint with a brush. The opaque weight of this surface asserts the painting's physicality, but its handwrought quality also retains an allusive power. Much of this metaphoric power resides in Marden's colors: his hues are rarely pure, but rather are muted, in between— the green of moss or silvery sea foam (*Fass*, 1969–73), the pink beige of desert sand or beach (*Frieze*, 1979).

In their search for a signifier that would convey the sensation of experience, obviating inessential language, Marden's paintings approximate the symbolist attempt at a full or motivated sign. A related endeavor impelled the French artist Yves Klein, whose monochrome canvases are literal symbols, instruments of a vision of transcendental spirituality patterned on Rosicrucian doctrine.

Worked in red, white, gold, and a brilliant ultramarine that the artist patented as International Klein Blue, the paintings are contradictory. On one hand, they are reductionist objects—flat, identical, their surfaces roller-made to annihilate all personal marks. They are early instances of minimalism: even their mode of hanging, projected some eight inches from the wall, exemplifies the minimalist insistence on real objects in real space. But as Thomas McEvilley has argued, that hanging, if grasped in Rosicrucian terms, symbolizes the eclipse of gravity by the "age of levitation."[54] The International Klein Blue canvases in particular carry a heavy cargo of symbolic meaning. According to Rosicrucian cosmology they are symbols of the "blue period," the miraculous coming of the dissolution of matter into spirit or space. In addition, they evoke the romantic abstract infinite lying behind the parted curtain of reality. Somewhere in the package is Mallarmé's abyss—*l'azur*—and there are, of course, intimations of Matisse's quest for true blue, "the bluest of blues," the revery of every painter in the modernist era. Klein referred to his monochromes as "landscapes of freedom." They emblematize a pure immediacy, an absolute truth, a space beyond the restrictions of convention. Still, their aims are paradoxical: in his desire for sublimation in the depersonalized void of blue, Klein created one of the twentieth century's great self-affirmations—a variation on the dandy's soul. Moreover, his aspiration toward immediacy fronts on a reality increasingly evident in the late twentieth century: Klein's paintings are unintelligible without an awareness of the specific values he attributed to International Klein Blue. Without a context of interpretation, without a code, they are empty canvases, merely blue.

The modernist dialectic of self and structure, of individual statement and pictorial expression, is evident in Agnes Martin's grids. The grid is one of our century's paradigmatic schemes, one whose vertical and horizontal lineaments map the rectangular format of the canvas in a representation of pictorial form. Absent in the nineteenth century, it pervades the early twentieth, and in the 1960s it became a persistent theme, appearing in works by Carl Andre, Eva Hesse, Ryman, and others, and uniting practices as diverse as Sol LeWitt's conceptual permutations and Larry Poons's optical plays. One of its appeals is that of the formula, for its sameness and neutrality, which seemingly admit no references, provide a "pure" matrix against which formal preoccupations can attain their maximum clarity. Blank, uninflected, ahistorical, antireal, the grid describes a complete withdrawal into pictorial conventions, whose scope it represents.[55] Its material opacity is, therefore, the ideal modernist transparency. But this very sign of the picture plane and of the boundaries of inner law is, in Martin's case, made over into an analogue of imaginative space.

The grids that Martin has been making since 1962 are hazy, hovering veils of repeated forms, articulated in pencil lines over pale, luminous grounds. They vary in size, visual weight, and color, but each extends almost to the edges of the canvas, so that the painting reads as a unified field. Their individuality derives both from their suffused light (which results from the interaction of close-toned hues) and from the modulations of Martin's line. But the power of these grids depends on our tendency to read their repetitions as extending, logically, to infinity, and their vertical and horizontal coordinates as embodying age-old symbols of natural order. We read them, that is, by metonymy, taking them as parts of a whole that imaginatively expands to immensity. Grasped in this manner, the grid refers to the world beyond the frame, evoking natural rhythms and universal harmony—a continuum, then, of which the canvas's ordered expanse is an analogue.

The starting point for Martin's condensations of sensation is the bleached vastness of the New Mexico desert. Something of this feeling for stretches of light and land informs the paintings of Richard Diebenkorn, who works from a similar position of individual expression. Diebenkorn's art, which now covers four decades, is based in two traditions: the expressive formal tradition of early modernism, and the smaller tradition of postwar California art, encompassing the influence of Rothko and Still (who taught at the California School of Fine Arts in the late 1940s) and the chromatic

style of late-1950s Bay Area figuration. However, Diebenkorn's abstractions are most inspired by configurations of space and light characteristic of the Southern California landscape. The group of paintings entitled "Ocean Park," which extends from 1967 to the present, takes its name from the part of Santa Monica in which the artist's studio is located. As Susan C. Larsen has commented,[56] the title refers less to this locale than to the artist's biographical location: it can be construed as marking the origin of a sensibility (and, in consequence, of a response to space) of which the paintings are all an extension. Nevertheless, the name "Ocean Park" is highly evocative of the luminous greens, blues, sand yellows, and wave-crest whites that constitute the pictorial components of the works. These abstractions of color-light are organized into large, dominant planes often suspended from a high horizon. Their complex organization and scoring by modulated lines bespeak European, not American, art (there are parallels, for example, both to the draftsman's *pentimenti* and to cubist fractured planes), but these devices refer to a larger imaginative scheme. Many paintings are primed by specifically visual perceptions: the broad surfaces, with their linear definitions, suggest aerial views scanning expansive terrains, or the eye's reading of planes of space as they are flattened in intense light. Other works imply perspectives that shift into a variety of environments, hinting at a synoptically conceived vision of space. Most importantly, the paintings are not depictions, but rather metaphoric evocations of light's crystallization in specific atmospheres.

At a more intellectual range of the spectrum lie Johns's ambiguities, which problematize the boundaries between object and image, sculpture and painting, representational and abstract form. Yet Johns's main contribution to the art of the late century may be a surface that is virtually impenetrable—one whose meaning is the very impossibility of meaning, that is, its refusal to accede to depth. His games with facture, images, and objects (or, more recently, with traces of images and objects) are plays on the terms of modernist identity. If, for example, the surface is literalized, its planarity acknowledged, it does not function as a transparency giving onto

formal significance. Instead, the elements disposed upon it are related by myriad systems whose codes cannot be cracked, either by art-historical sleuthing or by the operations of a single logic. Similarly, the self is not individual, indivisible, but is represented as incomplete, for the human figure is splintered into fragments that occupy different sectors of the plane. Indeed, Johns's play with the convention of the self is evident in two themes: that of the ghost (or trace, or corpse), and that of the ventriloquist, who manipulates the very voice that was once an instrument of expression.

Signs of facture are used throughout these paintings as a way to question pictorial means. Thus the crosshatch pattern that appears in the 1970s and early 1980s (in *Corpse and Mirror*, 1974; *Weeping Women*, 1975; the three paintings that share the title *Tantric Detail*, 1981, and other works) is both an image lifted from reality and a device employed to unify a fragmented visual field. That field supports images and echoes from history, art history, and Johns's personal history, as well as signs from disparate semantic systems (e.g., the tantric illustrations in *Tantric Detail*); often, the field parodies itself, as in the double-panel "mirror image" of *Corpse and Mirror*. The mirroring alludes to Paul Cézanne, whose practice Johns describes as "each object reflecting each other," as much as to symbolism. But if the separate panels mirror one another, there is no illumination: they reflect neither the world, nor their own processes, nor the identity of the artist. Indeed, in the *Tantric Detail* paintings Johns implies that the artist's purpose is less to reveal than conceal meaning.[57] Several of the "Corpse and Mirror" paintings include the ghost outline of the Savarin can in *Painted Bronze* (1960), in which the artist's brushes appear as if embalmed. Johns's plays with meaning register the gradual evaporation of romantic myth, marking the route by which the artist evacuates the modernist stage.

*Alice thought she had never seen such a curious croquet-ground in all her life; it was all ridges and furrows; the balls were live hedgehogs, the mallets live flamingoes. . . . "I don't think they play at all fairly," Alice began, . . . "and they don't seem to have any*

*rules in particular; at least, if there are, nobody attends to them. . . ."*
Lewis Carroll, *Alice in Wonderland*[58]

Johns's position is doubly pivotal to postwar abstraction: if the mode of structuring in his 1950s work announces formalism and minimalism, it also foretells the destructuring, even the destruction, of the principle of autonomy that supported the aesthetics of modernism. For there is no doubt that the development of the modern tradition sketched out in this essay was accompanied in the 1970s by its erosion—or, rather, by the atrophy of the notions of personal and artistic individuality that were fundamental to modernist ideology. Indeed, the dispersal of 1970s art reveals the fragmentation of modernism's historical hold. We find it, for example, in the breakdown of essentialist categories as the purity of media became contaminated by relations with other fields. Sculpture, throughout the decade, nods toward architecture and collides with furniture; painting entertains relationships with photography that sully its crystalline means. It is also found in the importance accorded to photography as a mechanical mode of reproduction of images traced off the real rather than "invented." The rupture with modernism's timeless, eternalizing position is evident in the emergence of the narrative arts of film, video, and performance in 1970s practice. And it can be seen in the intrusion of the verbal into the domain of the visual arts. Indeed, the end of the 1970s is rich with work stressing the reality of mediation, reversing the disengagement from history that preoccupied nineteenth-century aesthetics. The 1970s are replete, as well, with impermanent, site-specific, and contextual works which have no inherent meaning but declare their meaning to be contingent on the external world that supports them. All of these directions can be perceived as questioning the "innerness" or transcendent interiority of modernism.

Site-specific art, for example, stages this process in its model of a work that is incomplete without its context and the participation of a viewer who moves through it. Its condition as a fragment has shifted

awareness away from the meaning immanent in an object toward consideration of the production of meaning, signaling a new attention to the roles played by reception and historical codes. This "open" sign is paralleled by a questioning of the integrated self: the self is now seen as decentered, as dispersed (rather like Johns's body) within a vast surface of interlocking codes that construct its momentary configurations.[59] In this disjointed view (which can properly be called postmodern), the self is anything but individual. Nor is it pure of, but rather subject to, the forces of society. This recognition of the fundamental historicity tying self and medium to the external world signals the fading power of pure abstraction.

Alice's dilemma describes a contemporary situation. Her problem is how to operate the flamingo mallets and hedgehog balls in the absence of fixed rules or definable logic. The flamingos function neither as the self's instruments (they will not do as she wishes), nor according to any discernible properties of the medium. Everything seems to be in random and disorderly movement, and to derive its meaning only from its temporal position in that movement; as Gilles Deleuze has written, Alice's discovery is the "discovery of surfaces," of how "the former depth has spread itself out" into breadth.[60]

It follows from this that most abstract painting of the 1980s is only conditional abstraction, its intentions always qualified by plays of abstract forms against figurative shapes, pure geometry against narrative structures, formal against historical concerns. Eighties painting is heteroclite, disjunctive, dispersed, *not* synthetic; indeed, it is arrested by checks and balances that maintain the separation of its elements, refusing ascendance to any term. "Central" to its imperative is an attempt to reverse the opposition of self to society so as to see the subject as it is informed by history, in its personal, social, and aesthetic dimensions. To this end, contemporary painting seeks to defy the boundaries of categories and to incorporate "postmodern" impurities.

Postmodern painting can, for example, annex Vija Celmins's

drawings, their barely relieved surfaces derived from photographs and hinting at a figurative content repressed beneath abstraction. It encompasses Therrien's mergers of media much as it includes the heterogeneity of Donald Sultan's art, which incorporates linoleum tiles and plaster along with oil paint, pencil, and watercolor. For Sultan, the manufactured tiles constitute an exchange with the material world; similarly, his plays with images that hover between abstract and figurative form are strategies to engage the viewer in a multiplicity of readings. The close relations between contemporary abstraction and figuration are evident in Elizabeth Murray's paintings, which scramble many references. Allusions to cubism, surrealism, and geometric abstraction collide with the vernacular tradition of comic strips; the picture plane receives equally circles, triangles, bars, bloblike forms, and discrete objects (e.g., the cups in *Just in Time*, 1981, and *Yipes*, 1982). It contaminates categories: a pink form may read as a female nude (*Parting and Together*, 1978), while figurative shapes are so distorted as to verge on abstraction. Moreover, Murray's choice of imagery is specifically grounded; the forms are not vehicles of "pure" emotions, but are inflected by concrete events, often of a domestic origin, and by an overwhelming sense of narrative. All of these practices, then, point to a collective mission—to see within the "presence" of expression the fact of contemporary history.

1. The words are those of Jacques Derrida. See his *Of Grammatology*, trans. Gayatri C. Spivak (Baltimore: Johns Hopkins University Press, 1976); also the excellent introduction by Josúe V. Harari, "Critical Factions/Critical Fictions," in Harari, ed., *Textual Strategies* (Ithaca: Cornell University Press, 1979), pp. 17–55.

2. Robert Motherwell, as quoted in Dore Ashton, *The New York School: A Cultural Reckoning* (New York: Penguin Books, 1972), p. 162.

3. The quotation is from Meyer Schapiro, "The Nature of Abstract Art," republished in *Modern Art: 19th and 20th Centuries* (New York: Harper & Row, 1985), p. 192. For discussion of the political use of abstract expressionism, see Serge Guilbaut, *How New York Stole the Idea of Modern Art* (Chicago and London: University of Chicago Press, 1983), and Max Kozloff, "American Painting during the Cold War," reprinted in Francis Frascina, ed., *Pollock and After: The Critical Debate* (New York: Harper & Row, 1985), pp. 107–23.

4. See Joseph Riddel, "Decentering the Image: The 'Project' of 'American' Poetics," in Harari, *Textual Strategies*, pp. 322–58.

5. See Irving Sandler, *The Triumph of American Painting* (New York: Praeger, 1970).

6. For discussion of the "disaffiliation" of American artists see in particular Ashton, *The Unknown Shore* (Boston: Little, Brown, 1962) and *New York School*. I am indebted to Ashton's books for information and insights on issues of the period.

7. Brian O'Doherty, *American Masters: The Voice and the Myth in Modern Art* (New York: E. P. Dutton, 1982), p. 102.

8. As quoted in Ashton, *New York School*, p. 162.

9. The role of industrialization and mass culture in shaping modern art has been discussed by various authors; my account is specifically informed by those of T. J. Clark and Thomas Crow as published in Benjamin H. D. Buchloh, Guilbaut, and David Solkin, eds., *Modernism and Modernity* (Halifax: Nova Scotia College of Art and Design, 1983).

10. As cited in David Deitcher, "Drawing from Memory," in *The Art of Memory, The Loss of History* (New York: The New Museum of Contemporary Art, 1985). The relationship between the development of modernism and the preservation of psychic autonomy is also the topic of an unpublished lecture of my own delivered at the Rhode Island School of Design, Providence, R. I., in March 1985.

11. Walter Benjamin, *Charles Baudelaire: A Lyric Poet in the Era of High Capitalism*, trans. Harry Zohn (London: Verso, 1973), p. 172.

12. Clark, "More on the Differences between Comrade Greenberg and Ourselves," in Buchloh, Guilbaut, and Solkin, *Modernism and Modernity*, pp. 169–187.

13. Quoted in ibid., p. 176.

14. Charles Baudelaire, "Salon of 1859," in Jonathan Mayne, ed. and trans., *Art in Paris 1845–1862: Salons and Other Exhibitions* (London and New York: Phaidon, 1965), p. 156.

15. Schapiro, "Nature of Abstract Art," p. 218.

16. Ibid.

17. For a further discussion of symbolist aesthetics dwelling specifically on the role of the images of crystal and mirror, see my "Meditations on a Goldfish Bowl: Autonomy and Analogy in Matisse," *Artforum* 18, no.2 (October 1980): 65–67.

18. Gerard Genette, "Valéry and the Poetics of Language," in Harari, *Textual Strategies*, pp. 359–73; see also Genette, *Figures* (Paris: Seuil, 1966).

19. Stéphane Mallarmé, "Crise de vers," in *Oeuvres complètes* (Paris: Pléiade, 1945), p. 364, as quoted in Genette, "Valéry," p. 364.

20. Jean-Paul Sartre, *Saint Génet* (Paris: Gallimard, 1952), p. 283, as quoted in Genette, "Valéry," p. 372.

21. Translation by the author. For further elucidation of the reference see my "Meditations on a Goldfish Bowl," p. 69.

22. See Ashton, *New York School*.

23. O'Doherty, p. 212.

24. See ibid., p. 118.

25. Ashton, *Unknown Shore*, p. 44.

26. Quoted in Guilbaut, *How New York Stole*, p. 112.

27. See O'Doherty, pp. 105–13.

28. Ashton, *Unknown Shore*, p. 44.

29. For a discussion of the specifically formal implications of Pollock's technique see Michael Fried, *Three American Painters* (Cambridge, Mass.: Fogg Art Museum, 1965).

30. Quoted in Ashton, *American Art since 1945* (New York: Oxford University Press, 1982), p. 21.

31. Thomas B. Hess, *Barnett Newman* (New York: Museum of Modern Art, 1971), p. 35.

32. Ashton, *Unknown Shore*, p. 73.

33. Quoted in O'Doherty, p. 121.

34. Hess, *Barnett Newman*, p. 56.

35. Ibid.

36. Quoted in Ashton, *New York School*, p. 143.

37. Frank O'Hara, *Franz Kline* (London: Whitechapel Gallery, 1974), p. 7.

38. Ashton, *New York School*, pp. 178–82.

39. Ibid., p. 181.

40. Hess, *Willem de Kooning* (New York: Museum of Modern Art, 1968), p. 26.

41. Ibid.

42. Quoted in ibid., p. 16.

43. Quoted in Ashton, *New York School*, p. 83.

44. Barbara Rose, *Lee Krasner* (New York: Museum of Modern Art, 1983), p. 122.

45. My readings of these paintings are informed by Rose, *Helen Frankenthaler* (New York: Harry N. Abrams, n.d.).

46. Ibid., p. 66.

47. Fried, *Three American Painters*, p. 19.

48. Rosalind E. Krauss, *The Originality of the Avant-Garde and Other Modernist Myths* (Cambridge and London: MIT Press, 1985), p. 218.

49. Ibid., p. 161.

50. Clement Greenberg, "Modernist Painting," in *Art and Literature*, no. 4 (Spring 1965): 193.

51. Republished in Brenda Richardson, *Frank Stella: The Black Paintings* (Baltimore: Baltimore Museum of Art, 1977), p. 78.

52. Lawrence Alloway, "Systemic Painting," reprinted in Gregory Battcock, ed., *Minimal Art* (New York: E. P. Dutton, 1968), p. 45. Alloway's quote is derived from a previous article, "On the Edge," from 1960.

53. Ibid., p. 55.

54. See Thomas McEvilley, "Yves Klein: Messenger of the Age of Space," *Artforum* 20, no. 5 (January 1982): 39–51, and "Conquistador of The Void," the catalogue for a Klein retrospective held at Rice University, Houston, and the Centre Pompidou, Paris, in 1982.

55. See "Grids" in Krauss, *The Originality of the Avant-Garde*, pp. 8–22.

56. Susan C. Larsen, "Cultivated Canvases," *Artforum* 24, no. 5 (January 1986): 68.

57. See Michael Crichton, *Jasper Johns* (New York: Harry N. Abrams/ Whitney Museum of American Art, 1977).

58. I am grateful to Anthony Vidler for this quotation, which he used, in another reading, in his essay "Trick-Track," in *Bernard Tschumi: La Case Vide* (London: Architectural Association Press, 1986).

59. For a discussion of this "production of the subject" see my "Representation and Sexuality," in Brian Wallis, ed., *Art After Modernism: Rethinking Representation* (New York and Boston: The New Museum of Contemporary Art and David R. Godine, 1984), pp. 391–415.

60. Gilles Deleuze, "The Schizophrenic and Language: Surface and Depth in Lewis Carroll and Antonin Artaud," in Harari, *Textual Strategies*, p. 280.

**Willem de Kooning**

Pink Lady, *1944*
*Oil and charcoal on composition board*
*48⅜ × 35⅜"*
*Collection of Betty and Stanley K. Sheinbaum*

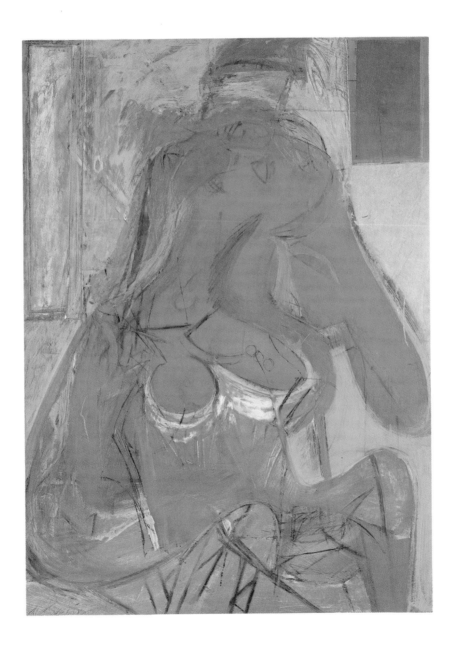

**Willem de Kooning**

Pink Angels, *c. 1945*
*Oil on canvas*
*52 × 40"*
*Collection of Frederick Weisman Company*

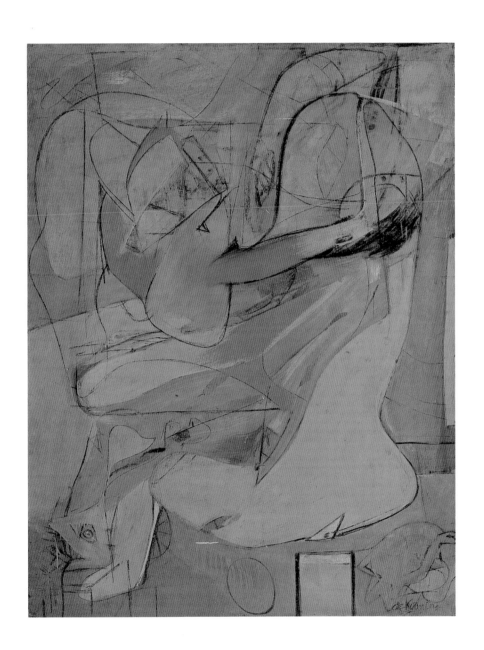

**Jackson Pollock**

*Enchanted Forest, 1947*
*Oil on canvas*
*83 × 45⅛"*
*The Peggy Guggenheim*
*Collection, Venice*
*Solomon R. Guggenheim*
*Foundation, New York*

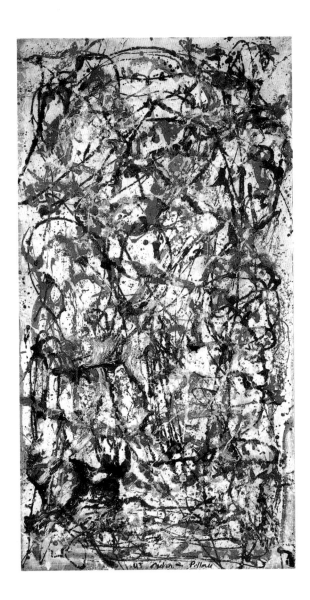

**Jackson Pollock**

Number 1, *1949*
*Enamel and aluminum paint on canvas*
*63 × 102½"*
*Rita and Taft Schreiber Collection*

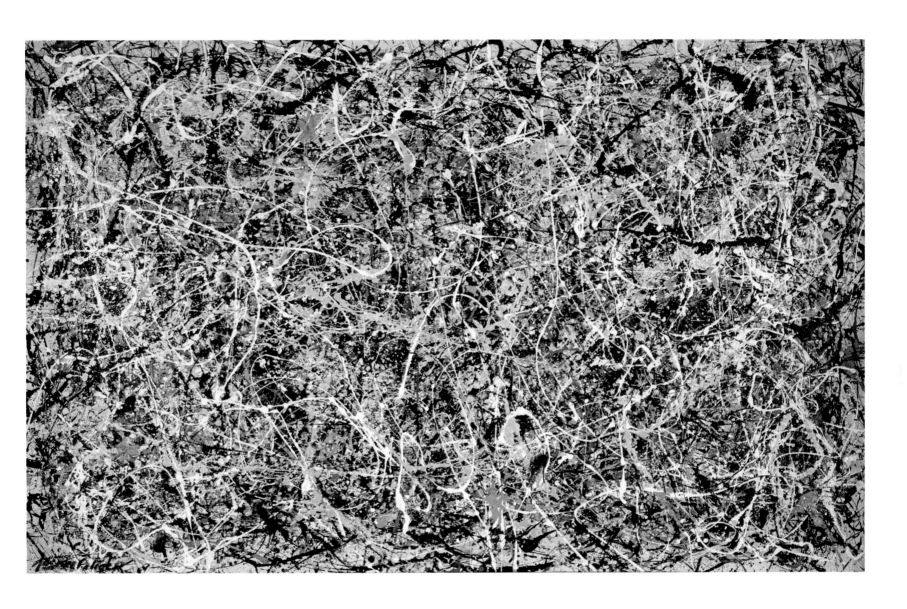

**Barnett Newman**

Onement I, *1948*
*Oil on canvas*
*27 × 16"*
*Collection of Annalee Newman*

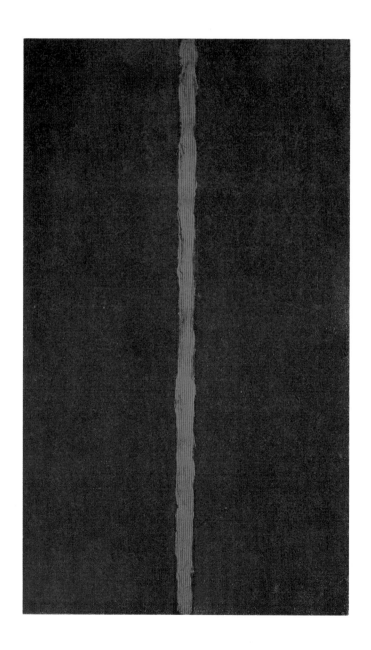

**Barnett Newman**

Onement VI, *1953*
*Oil on canvas*
*102 × 120"*
*Weisman Family Collection—*
*Richard L. Weisman*

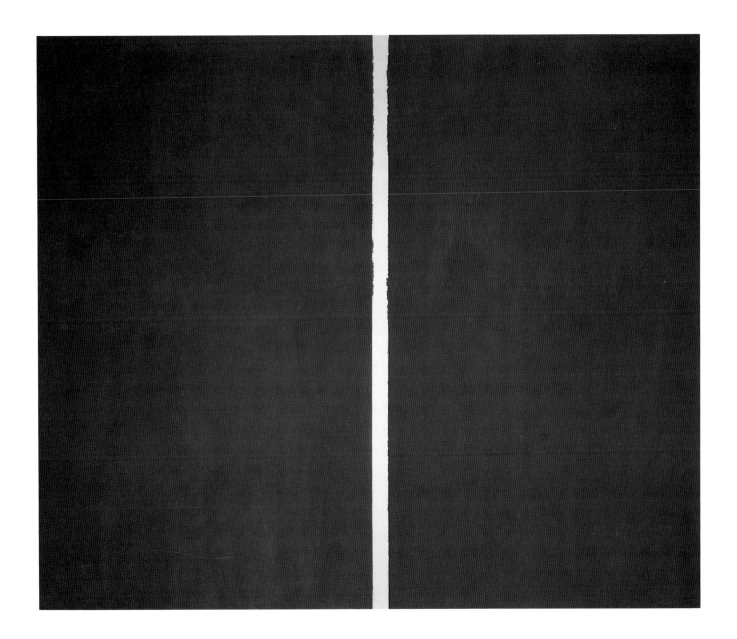

**Sam Francis**

White #4, *1950–51*
*Oil on canvas*
*69 × 59"*
*Collection of Eli and Edythe L. Broad*

**Sam Francis**

White, *1951*
*Oil on canvas*
*56 × 40½"*
*Frederick R. Weisman Collection*

**Clyfford Still**

Untitled, *1951*
*Oil on canvas*
*108 × 92½"*
*Collection of Marcia S. Weisman,*
*Beverly Hills, California*

**Clyfford Still**

Untitled, *1960*
*Oil on canvas*
*113⅛ × 155⅞"*
*San Francisco Museum of Modern Art*
*Gift of Mr. and Mrs. Harry W. Anderson*
*74.19*

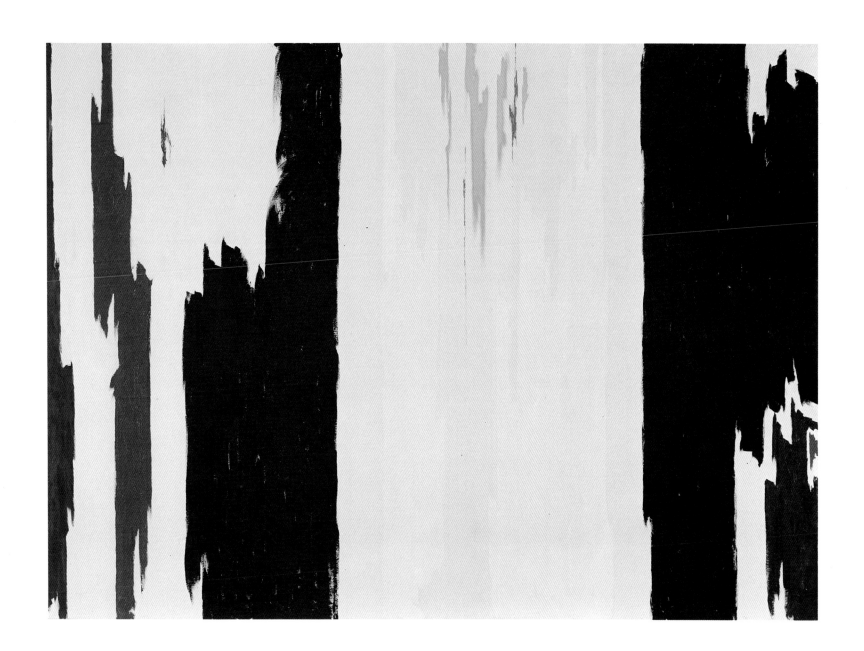

**Mark Rothko**

Brown, Blue, Brown on Blue, *1953*
*Oil on canvas*
*115¾ × 91¼"*
*The Museum of Contemporary Art,*
*Los Angeles:*
*The Panza Collection*

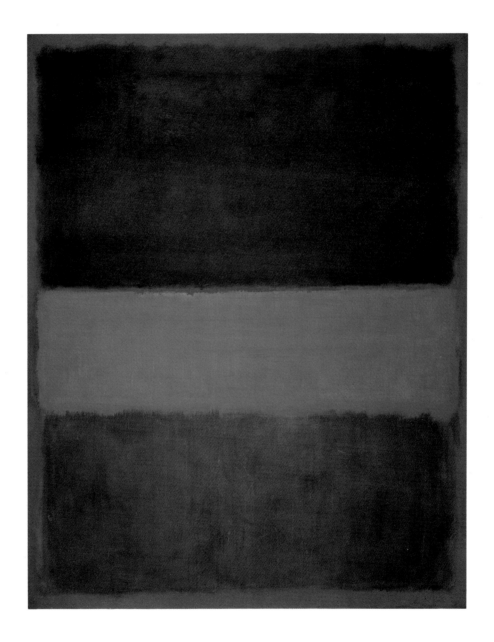

**Mark Rothko**

Black on Dark Sienna on Purple,
*1960*
*Oil on canvas*
*119¼ × 105"*
*The Museum of Contemporary Art,*
*Los Angeles:*
*The Panza Collection*

**Yves Klein**

M38 *(Untitled Red Monochrome)*, 1955
*Dry pigment in synthetic resin on fabric on board*
*19¹¹⁄₁₆ × 19¹¹⁄₁₆ × 2"*
*Private Collection*

**Yves Klein**

SE33, *1960*
*Dry pigment in synthetic resin on sponge*
*17" high*
*Private Collection*

72

**Yves Klein**

ANT 85, *1960*
*Blue acrylic pigment on paper on canvas*
*61¼ × 138¾"*
*Private Collection*

**Franz Kline**

Buttress, *1956*
*Oil on canvas*
*46½ × 55½"*
*The Museum of Contemporary Art,*
*Los Angeles:*
*The Panza Collection*

**Franz Kline**

Monitor, *1956*
*Oil on canvas*
*78¾ × 115¾"*
*The Museum of Contemporary Art,*
*Los Angeles:*
*The Panza Collection*

**Helen Frankenthaler**

Europa, *1957*
*Oil on canvas*
*70½ × 54¼"*
*Private Collection*

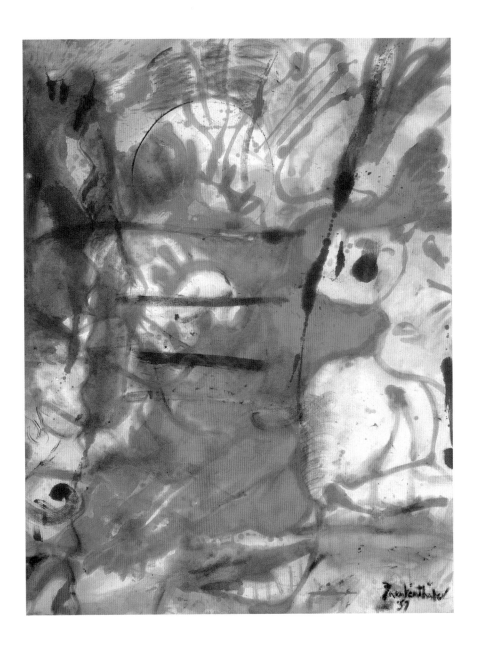

**Helen Frankenthaler**

Jacob's Ladder, *1957*
*Oil on canvas*
*113⅜ × 69⅞"*
*Museum of Modern Art, New York*
*Gift of Hyman N. Glickstein, 1960*

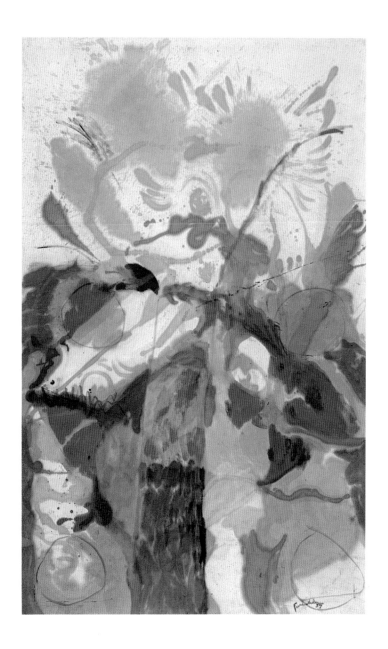

**Morris Louis**

Spark, *1958*
*Acrylic on canvas*
*91 × 144"*
*Collection of Mr. and Mrs. Robert J. Woods, Jr.*

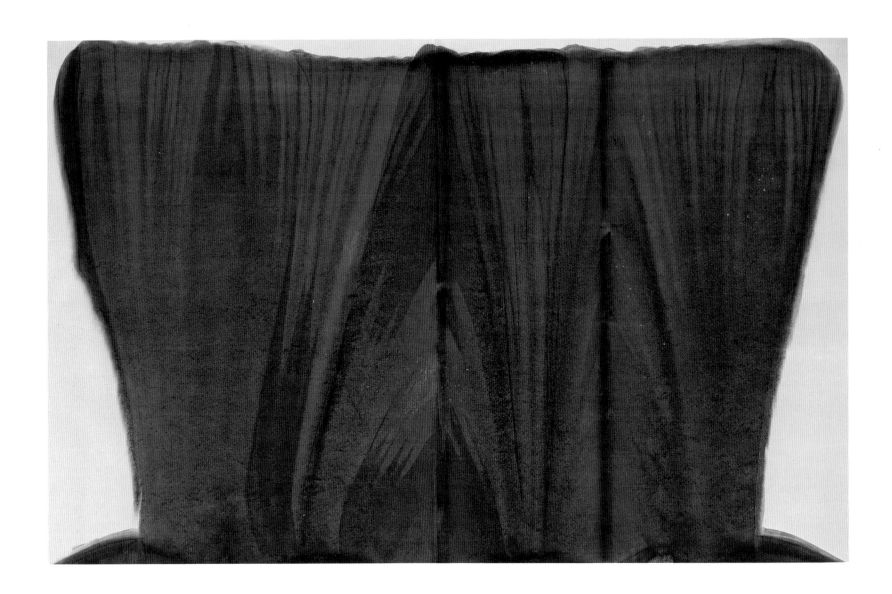

**Morris Louis**

Nu, *1961*
*Acrylic on canvas*
*103½ × 170"*
*Collection of Robert A. Rowan*

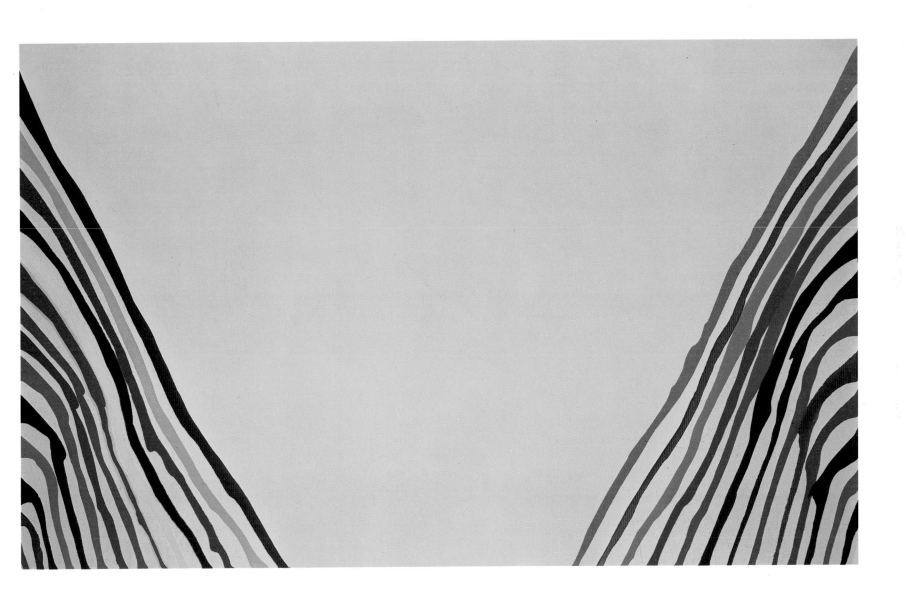

**Lee Krasner**

The Gate, *1959–60*
*Oil on canvas*
*92¾ × 144½"*
*Robert Miller Gallery, New York*

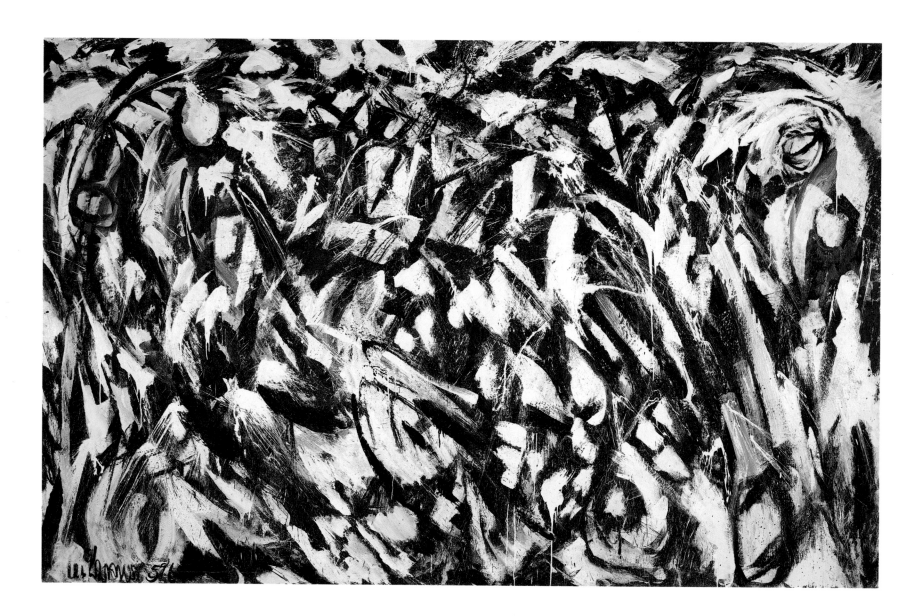

**Lee Krasner**

*Primeval Resurgence, 1961*
*Oil on cotton duck*
*77 × 57¼"*
*Collection of Gordon F. Hampton*

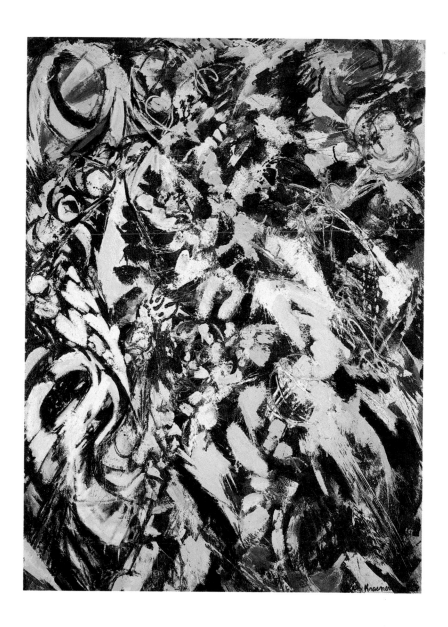

**Frank Stella**

Tomlinson Court Park, *1959–60*
*Enamel on canvas*
*84 × 108"*
*Collection of Robert A. Rowan*

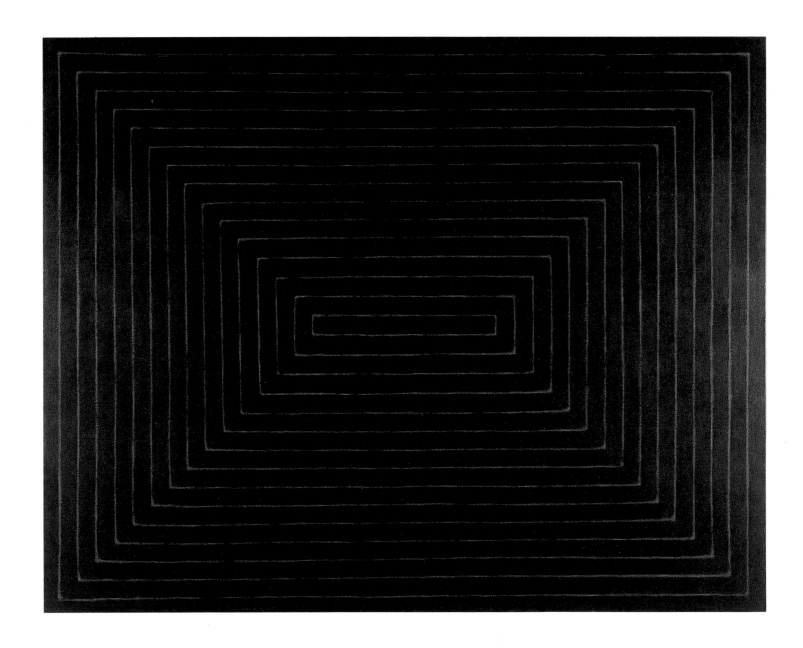

**Frank Stella**

Ouray, *1961*
*Copper paint on canvas*
*93¾ × 93¾"*
*Collection of Rita and Toby Schreiber*

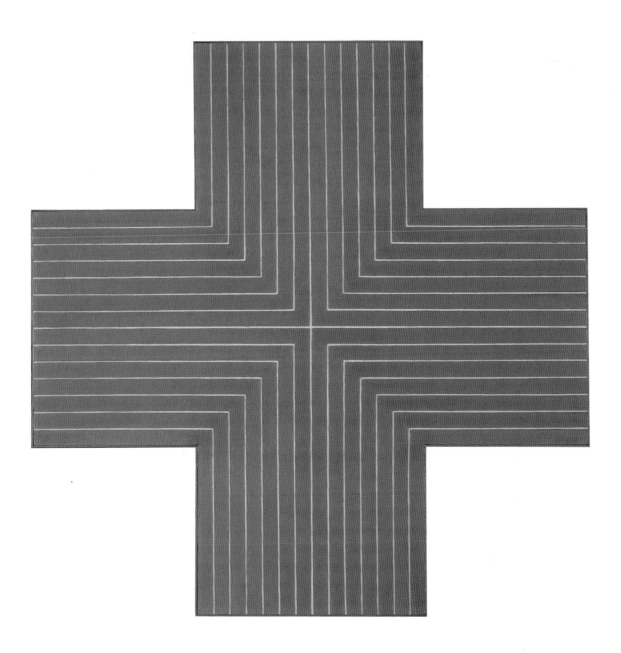

**Cy Twombly**

Sahara, *1960*
*Oil, crayon, and pencil on canvas*
*80 × 110"*
*Saatchi Collection, London*

**Cy Twombly**

Bay of Naples, *1961*
*Oil, pencil, and wax crayon on canvas*
*95¼ × 117⅝"*
*Dia Art Foundation, New York*

**Brice Marden**

*Fass, 1969–73*
*Oil and beeswax on canvas*
*53½ × 70½"*
*The Museum of Contemporary Art,*
*Los Angeles:*
*The Barry Lowen Collection*

**Brice Marden**

*Red, Yellow, Blue II, 1974*
*Oil and wax on canvas*
*74 × 72"*
*The Museum of Contemporary Art,*
*Los Angeles:*
*The Barry Lowen Collection*

**Jasper Johns**

Corpse and Mirror, *1974*
*Oil, encaustic, and collage on canvas*
*50 × 68⅛"*
*Collection of Mr. and Mrs. Victor W. Ganz*

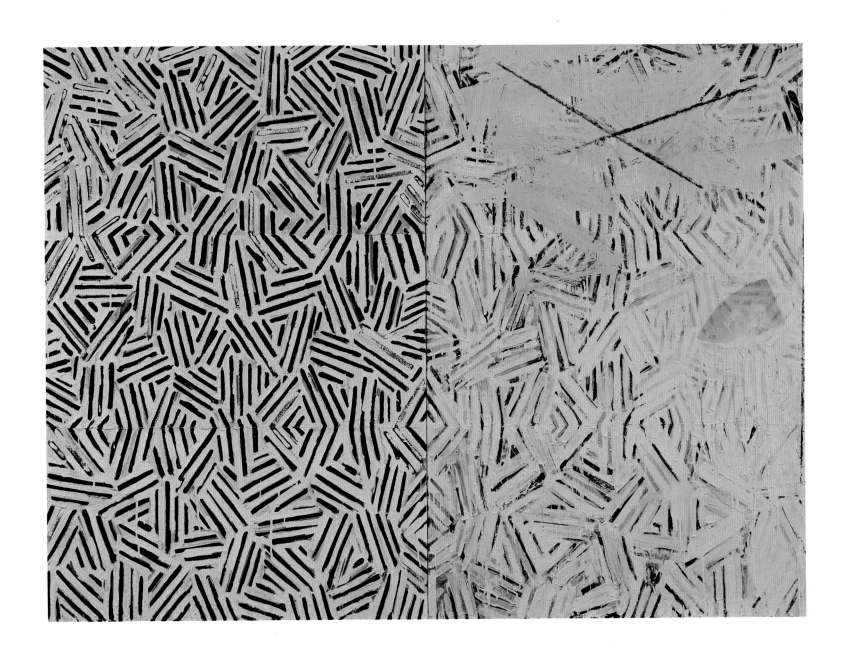

**Jasper Johns**

Tantric Detail II, *1981*
*Oil on canvas*
*50 × 34"*
*Collection of the artist*

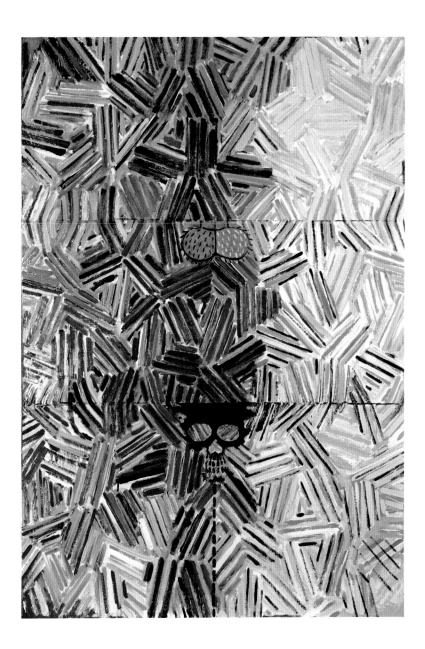

**Richard Diebenkorn**

Ocean Park #90, *1976*
*Oil on canvas*
*100 × 81"*
*Collection of Eli and Edythe L. Broad*

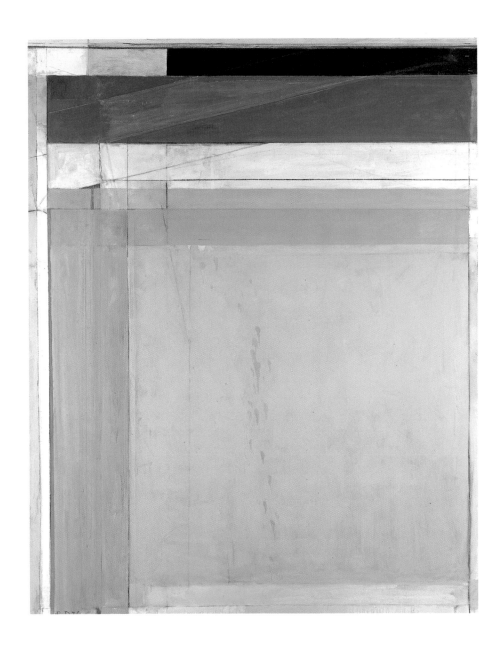

**Richard Diebenkorn**

Ocean Park #140, *1985*
*Oil on canvas*
*100 × 81"*
*Collection of Douglas S. Cramer*

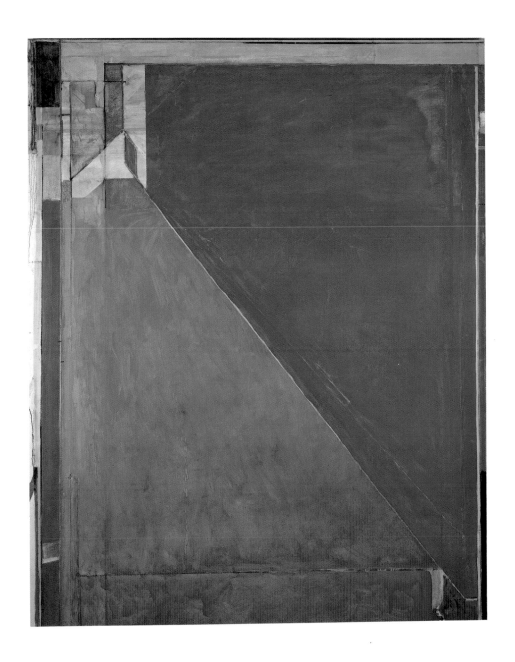

**Agnes Martin**

Untitled #2, *1977*
*India ink, graphite, and gesso on canvas*
*72 × 72"*
*The Museum of Contemporary Art,*
*Los Angeles:*
*The Barry Lowen Collection*

**Agnes Martin**

Untitled #4, *1980*
*Gesso, acrylic, and graphite on linen*
*72 × 72"*
*The Museum of Contemporary Art,*
*Los Angeles*
*Gift of the American Art Foundation*

**Ellsworth Kelly**

Dark Blue Panel, *1980*
*Oil on canvas*
*103½ × 146"*
*Collection of Stephen and Nan Swid*

**Ellsworth Kelly**

Red/Orange, *1980*
*Oil on canvas*
*91 × 113"*
*The Museum of Contemporary Art,*
*Los Angeles*
*Gift of Douglas S. Cramer*

**Elizabeth Murray**

Heart and Mind, *1981*
*Oil on canvas*
*111¾ × 114"*
*The Museum of Contemporary Art,*
*Los Angeles:*
*The Barry Lowen Collection*

**Elizabeth Murray**

Can You Hear Me?, *1984*
*Oil on canvas*
*106 × 159 × 12"*
*Dallas Museum of Art*
*Foundation for the Arts Collection*
*Anonymous Gift*

**Vija Celmins**

*Starfield, 1981–82*
*Graphite on acrylic ground on paper*
*19 × 27"*
*Collection of Mr. and Mrs. Harry W. Anderson*

**Vija Celmins**

*Moving Out (Starfield II)*, *1982*
*Graphite on acrylic ground on paper*
*21 × 27"*
*Collection of Mr. and Mrs. Robert K. Hoffman,*
*Dallas, Texas*

**Donald Sultan**

Harbor, July 6, 1984, *1984*
*Tar, spackle, and latex paint on*
*vinyl tile over wood*
*96 × 96"*
*Eli Broad Family Foundation,*
*Los Angeles*

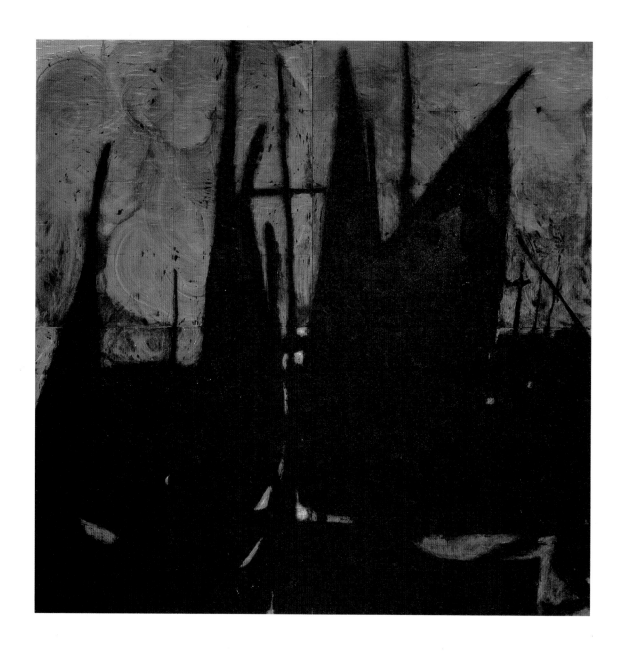

**Donald Sultan**

Black Egg and Three Lemons,
November 26, 1985, *1985*
*Oil, spackle, and tar on tile over masonite*
*96 × 98"*
*Private Collection*

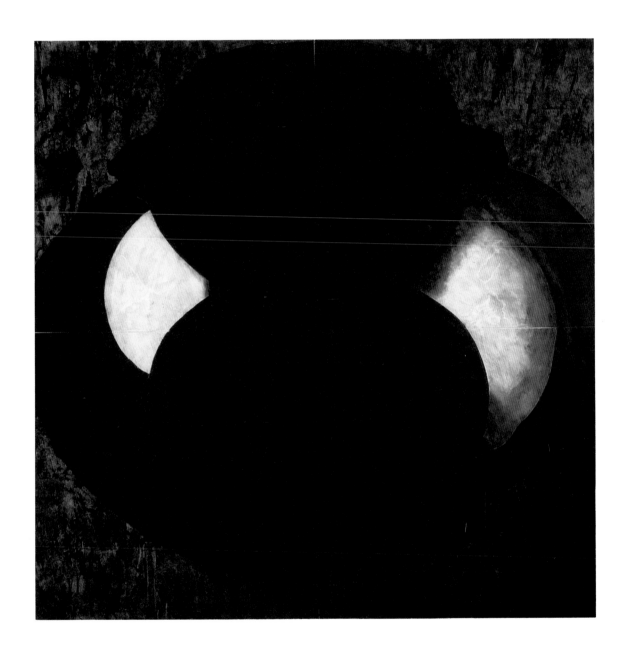

**Robert Ryman**

*Resource, 1984*
*Acrylic on fiberglass with steel*
*and aluminum*
*131¾ × 125⅝"*
*Collection Raussmüller*
*Hallen für Neue Kunst*
*Schaffhausen, Switzerland*

**Robert Ryman**

Distributor, *1985*
*Oil on fiberglass with wood and aluminum*
*48 × 43"*
*Refco Group, Ltd.*

**Ed Moses**

Untitled, *1985*
*Oil and acrylic on canvas*
*78 × 68"*
*Collection of David H. Vena*

**Ed Moses**

Untitled, *1985*
*Oil and acrylic on canvas*
*78 × 68"*
*Collection of Laura-Lee W. Woods*

# Material as Sculptural Metaphor
*Donald Kuspit*

*But it was not up to me to unilaterally address logic, it was up to me to break off all the residues present in the subconscious and to transfer a chaotically detached orderly procedure into turbulence; the beginning of the new always takes place in chaos. . . . My intention: healthy chaos, healthy amorphousness in a known medium which consciously warmed a cold, torpid form from the past, a convention of society, and which makes possible future forms.*
Joseph Beuys

*Ancient tongues and scripts . . . were originally designed as a means of communication; that is, they were intended to be understood, no matter what ways or means they had to employ. But just this character is lacking to dreams: their object is not to tell anyone anything; they are not a means of communication; on the contrary, it is important to them not to be understood.*
Sigmund Freud, *A General Introduction to Psychoanalysis*

*Being apprehends itself as not being its own foundation.*
Jean-Paul Sartre, *Being and Nothingness*

*By slaying the subject, reality itself becomes lifeless.*
T. W. Adorno, *Aesthetic Theory*

## I

Clement Greenberg, writing about the "new sculpture" during its heyday, asserted that "the human body is no longer postulated as the agent of space in either pictorial or sculptural art; now it is eyesight alone, and eyesight has more freedom of movement and invention within three dimensions than within two."[1] For Greenberg, sculpture was slower than painting to "renounce illusion and explicitness" and "achieve concreteness, 'purity.'"[2] Can sculpture ever be truly new and pure? Can it completely renounce its relation to the human body? Can it exist without spontaneously evoking the subjective sense of the body? When a sculpture—even an abstract sculpture—carries the kind of conviction we call "presence," we are unconsciously reading it as a metaphoric symbolization of the body's emotional meaning.

Such meaning is difficult to articulate, for it is fraught with the difficulty of knowing and mastering one's own body and the body of the other, especially an other to whom one is intimately related. As the symbol of one's self, one's body is privileged, and in a sense the first object in the world. As such, it is impossible to expunge, even through the pursuit of purity in art. Sculpture is optimally a metaphorical projection of bodily presence in alien material, a kind of phantasy introspection of the latently human in the manifestly inhuman. That displacement of material confirms the sculpture as a representation of the body's inner image, summarizing the most primitive experience of it.

In genuine sculpture outer appearance counts for less than the subtle sense of bodiliness conveyed. Sculpture may renounce the overt illusion of the body, but covertly it represents the most intimate conception of the body. Sculpture articulates infantile illusions about the human body, reflecting not only the infant's discovery of its own body, but its absorption in the ultimate and most privileged body— the mother's. That body of bodies articulates the infant's emotional needs and desires. As the most urgently needed and desired body, the mother's is the body of love. It unconsciously shapes the sculptural body, guiding the process by which matter is made metaphorically emblematic of emotion. Metaphor is the vehicle of subjectivity; to see matter unmetaphorically is to slay sculpture's profound subjectivity.

Sculpture may want to carry out "the modernist 'reduction,'"[3] but even the most intellectually rigorous sculpture finds that impossible to consummate, however hard it tries. For whether it wishes to be or not, sculpture is dependent on an unconscious, inner relationship to the body. The body may not be subject matter, but it is the implicit model for sculptural space. Since the body exists "speculatively" in imagination as well as empirically in the world, sculpture's space and its tactility are necessarily as subjective as they are objective.

"The desire for 'purity' works," Greenberg wrote, "to put an ever

higher premium on sheer visibility and an ever lower one on the tactile and its associations, which include that of weight as well as impermeability." In the "new sculpture," "matter is incorporeal, weightless and exists only optically like a mirage."[4] The "physical independence" of "the free and *total* medium of sculpture" aims "to provide the greatest possible amount of visibility with the least possible expenditure of tactile surface."[5] But to regard sculpture that attempts to exchange visibility for tactility as more authentically sculptural than sculpture that makes no secret of its tactility, to reduce tactility to a miragelike minimum that makes it almost impossible to discuss, is to betray the bodily essence of sculpture. Good sculpture has the ambition not to be free of tactility, but rather to vigorously assert it—even affording us an epiphany of it, symbolically engulfing us in it. In sculpture, tactility, the substratum of all sensing, becomes a sublime superstructure. It is not only a contradiction in terms to speak of a (new) sculpture that has no appeal to touch, that appeals exclusively to the eye, as "sculpture," but a complete falsification of the intentionality of sculpture: sculpture asserts the sense of bodiliness—the unconscious operation of a primitive sense of the body—fundamental to every sense perception, even the most self-conscious visual perception. This sense of bodiliness is inseparable from the unconscious experience of the body as fundamentally emotional, an experience conveyed through touch—the most sensuously direct avenue of approach to unconscious emotion, more direct than any other sense.

Modernist painting, Greenberg wrote, attempts "to overcome the distinctions between foreground and background; between occupied space and space at large; between inside and outside; between up and down."[6] But modernist sculpture can never overcome the distinction between visibility and tactility that Greenberg thinks is central to it. Sculpture brings this conflict into focus as perhaps no other art does. But the relationship between the two qualities is not even genuinely dialectical: in the last analysis, sculpture's visibility is derived from its tactility, rather than dialectically bonded to it. In sculpture the visible exists as a quality of touch, contingent upon the sense of

bodiliness that the sculpture conveys. Every sculpture proposes a mode of touch, which is the basis of its visual effect. And every mode of touch is rooted in an imaginative, unconscious sense of the body. Some sculpture seems untouchable, other sculpture seems to imply the passionate embrace of material; some sculpture is hard, other sculpture is soft. In either case sculpture suggests the possibility of real touch. Sculpture arouses the longing to touch (which it may frustrate), a symptom of the desire to regress to a primitive experience of bodiliness. Good sculpture exploits this desire to renew elemental bodily experience—to reexperience primitive bodily being—by generating a strong aura of memorable tactility.

Authentic sculpture bespeaks the actively possessed, internalized body rather than the passively contemplated, distanced one. Sculpture is optimally an act of imaginative "embodiment," which makes it peculiarly threatening. It tends to break down distance between the viewer and itself, demanding, as it were, that the viewer become more involved than "pure" viewing can ever be. Greenberg's "sheer visibility," "eyesight"—as a disciple put it, "opticality"—not only maintains the distance between the viewing subject and the art object, but reifies it by locating distance in the art object itself. Distance is postulated as the necessary condition for the viewing of art as art, that is, as autonomous. As such, Greenberg's "visibility" represses the subjective necessity in viewing, becoming so unconscious that it hardly knows its own name. Greenberg wants to preclude subjective involvement with the art object; he thinks that would lead one astray from the intuition of it as art. Yet art cannot begin to be known as art—as "representation"—without a process of subjective involvement in it, a process of transferential relation to it.

Sculpture attempts to represent what seems inherently unrepresentable, or, what comes to the same thing, representable only through metaphor: the primitive emotional character of basic bodily experience. Sculptural metaphor articulates the irreducible ambivalence of the infantile attitude to the body, which the child experiences as emotionally polarized, the field of a contradictory play

of emotions. Primitive subjective experience of the body is impossible to represent literally, not only because it is perversely intimate, but because it articulates itself in metaphorical terms. We are drawn to sculptural metaphors because they seem direct manifestations of intensely lived attitudes to the body, not simply subjective projections on objective material.

Greenberg's argument for an unmetaphorical sculpture (which is what his emphasis on sculptural purity amounts to) not only disavows the peculiar directness of our relationship to metaphorical sculpture, but repudiates our ambivalent experience of the body, the love/hate relationship with it that is the root of our subjective sense of sculpture. It is one thing to say that all sculpture loosely alludes to the body, another to say that a sculpture is a metaphorical rendering of the body's contradictory subjective givenness—that sculptural metaphor attempts to reconcile positive and negative attitudes to the body in a single structure. Such ambiguous integration undermines the kind of one-dimensional unity that Greenberg wants modernist sculpture to have.

Greenberg's concept of pure sculpture is not so much wrong as incomplete. He refuses to face the fact that even the purest sculpture is an analogue for primitive bodily experience. In fact, the replacement of tactile with visual values that he perceives in modernist sculpture can be understood as a metaphorical attempt to overcome the contradictoriness of our basic attitudes to the body. In modernist sculpture the tactile and visual become one through metaphor. They become qualities of the same body, and thus only superficially opposite. Just as modernist painting tried, as Greenberg wrote, "to approximate, by *analogy*, the way nature" at its most basic works,[7] so modernist sculpture tries to approximate, by analogy, the way the body given by nature is basically experienced. Where premodernist art struggled to a consciousness of the human body as objectively and "naturally" given, and so as directly describable, modernist art struggles to articulate the way the human body is given unconsciously, and so seemingly "unnaturally."

Unconscious experience of the body cannot be described, but only articulated metaphorically.

## II

It may be a mistake, a betrayal of the literal physicality of sculpture, to see sculpture as a metaphor for the body. To see sculpture's physicality as nothing more than the source of subjective bodily metaphor is perhaps to disrespect the physical before one really experiences it, to displace it into a meaning before one knows it as a material, to see it cavalierly as a depth before one knows it seriously as a surface. From one point of view, this is to be guilty of the cardinal sin of critical understanding: establishing the substance of the work of art as elsewhere than where it physically is, finding its meaning in its relation to a reality (in sculpture's case, the body) already given as (subjectively) meaningful, rather than within the literal work itself.[8] It is as though the sculpture's objective physicality followed from its subjective meaning rather than the reverse, as though the sculpture could be executed in any material as long as its meaning remained the same. In this construction, the physical material is only the arbitrary substratum of the sculpture, a pedestal supporting its meaning, while the meaning is what is truly "substantial" about it. The literal physicality of the sculpture is absorbed in its metaphoric meaning without a trace.

But the argument reverses itself, effortlessly. All objective material is implicitly meaningful subjectively, inherently metaphoric; its presentation through symbolic, metaphorical form is not an artificial imposition on it, but the spontaneous articulation of its subjective meaningfulness. Material is steeped in subjective meaning; its inseparability from subjective meaning is what gives it "presence"—makes its physicality seem a revelation. This is not to say that subjective meaning is the readily available "message" of the sculptural metaphor—easily graspable and simply stated, once it is noted. Like a dream, metaphor seems designed not to communicate—to obscure rather than to disclose complex meaning, or perhaps to tantalize with it. As a consequence, "the interpretation

of metaphors can be full of perils, and . . . the application of the wrong category or the use of the wrong attributes of the correct category can result in a completely inappropriate interpretation."[9] Like the interpretation of dreams, the interpretation of metaphors is difficult and susceptible to serious error.

But is there a perfectly appropriate interpretation of dream or metaphor? If the sculptural metaphor, like the dream and the symptom, is a compromise formation between repressed material and repressive metaphorical meaning (as though metaphor existed to repress or socialize feelings associated with material), then any interpretation that gives priority to the work's material literalness over the metaphorical meaning that can be conveyed through it, or, vice versa, to the work's metaphorical meaning over the subtle physicality that conveys it, is wrongheaded from the start. To say that either the material or the metaphorical meaning offers the best perspective on the sculptural metaphor as a whole is to deny its dialectical integrity as metaphor: to assume that one is more to the point of the metaphor than the other is to deny it any point.

Yet there is no guarantee that a metaphor will do what it is supposed to do, that it will hold together and evoke the semblance of sameness. It may fall apart—may seem an assertion of radical difference, or a forced conjunction of unjoinable, inherently disjunctive elements. In its marrying of elements that are ordinarily incommensurate, metaphor is a kind of "psychoanalytical action"[10] or conceptual "node," implying an invisible center where the elements ideally fuse.[11] That is, metaphor may—and ideally should—seem erotic and insane, an irrational intervention in rationality, a wildly speculative adventure in comprehension. Joseph Beuys regarded material as directly metaphorical. In his association of fat with chaos and felt with "inert chaos,"[12] and his assertion that "chaos can have a healing character, coupled with the idea of open movement which channels the warmth of chaotic energy into order or form,"[13] he saw unmediated subjective meaning in objective properties; his work makes clear the absurd character of all significant metaphor. It is the metaphor's absurdity or insanity—the way it seems to articulate integration and disintegration at the same time—that makes it psychologically effective or emotionally meaningful. The more impossible, "surrealistic," a metaphor is, the more it involves what Max Ernst calls "*systematic displacement,*" a deliberate cultivation of the effect of "*fortuitous encounter of two distant realities on an unfamiliar plane,*"[14] and the more to the subjective point it is: the more it is likely to be read as a representation of the "doubleness" of the subjective body, the enduring ambivalence of our primitive attitude to the body that mothers us, brings us into being.

A more particular way of describing the character of the subjective meaning that sculptural metaphor mediates is through a psychoanalytically conceived theory of object relations. At its most profound, the sculptural metaphor symbolically articulates the self's object relations: the sculptural metaphor represents inner space and its objects. Every sculptural space is unconsciously bodily space; sculptural metaphor represents the "bodies" that inhabit inner space. These "representative" or prototypical objects are not in the psyche simply because they were implanted there culturally and historically, but because we are existentially and experientially attached to them. They are the roots of our being. The unconscious is a structure of internal objects having a metaphorical existence, a metaphorical space constituted by internalized objects, meaningful because they are internalized and internalized because they are meaningful, that is, because we are irrevocably attached to them. Some art argues for closer attachment to the object representations that unconsciously shape every representation we have of the world, and some art argues for greater detachment from them. In general, art may enhance or dissolve our relations with these internal objects. Sculptural metaphor discloses their inescapability, whatever "artistic" attitude we finally take to them. Sculptural metaphor suggests that we cannot really enjoy or eliminate relating to them, but only endure them.

Sculptural metaphor represents the internal representations that constitute the self. It must accomplish this without any sacrifice of

the sense of sculpture as autonomous external object. The sculptural metaphor must successfully integrate emotionally charged internal objects—representations of beings that grant or defeat our wishes, that are embodiments of the emotions that accompany the success or failure of desire (and that we are thus identified with)—with a historically precise sense of external objects. The sculptural representation of internal objects may lead to revolutionary changes in the external object that the sculpture finally is, but such changes must make culturally convincing spatial sense. To be successful as a representation of internal objects, the sculptural metaphor must offer a "correct" interpretation of contemporary external objects. Such integration of internal and external objectivity is the inscrutable yet experienceable essence of the authentically aesthetic. It signals the self's autonomy, its ability to transcend, without disavowing, the internal objects that constitute it and the external body space in which it exists. A successful sculptural metaphor generates the aesthetic effect of autonomy that comes with genuine integration of the internal and external senses of the object—an integration that gives us the experience, however fleeting, of mastery of both inner and outer life-worlds. We seem to command them, rather than they us.

The autonomous sense of self can be regarded as what the philosopher Alfred North Whitehead calls the "subject-supereject" of the artistic process. And it is what Beuys articulates through his metaphorical use of material to heal. The powerful evocation of the sense of autonomous self is the aesthetic result of the struggle to master internal and external objects that is basic to art—that makes art a healing process. Aesthetic integration is an analogue for the autonomous self, a wishful form of it. What is special about aesthetic integration in sculptural metaphor is that it is experienced as palpably physical. Sculpture directly states the necessity of mastering outer and inner space, and their subtle inseparability.

In sculptural metaphor, material being spiritualizes itself by self-consciously searching for its foundation in the unconscious. Sculptural metaphor triumphs over the historical contents of the unconscious

self—contents involuntarily foisted on it by the "mothering" world—by integrating them aesthetically. If it is to be truly significant, this process also entails working through the received rhetoric of past modes of integration ("styles"). They also have an inner as well as an outer life, shape an inner as well as an outer world. A good sculptural metaphor may be a residue of unconscious, chaotic, infantile self-objects surfacing through spatially disconcerting material, but it must also articulate them in material space in such a way that they seem to be under the control of an autonomous adult self that seems to have been invented anew. Spatialization is crucial in the sculptural process: good sculptural metaphor seems simultaneously an internal and external object. It securely inhabits outer space and strongly evokes inner space.

## III

Claes Oldenburg's soft sculptures are well-known. Marcel Duchamp's exhibition of an Underwood typewriter cover has been regarded as their point of departure. Are Oldenburg's soft sculptures a similar art joke, in which we don't know whether the joke is art or the art is a joke? Is Oldenburg also simply exhibiting the mundane, and declaring that the act of exhibition makes it art, that is, aesthetically significant or perceptually extraordinary? Does Oldenburg offer a similar ironic epiphany of the ordinary object? Certainly Oldenburg is also subversive, but it is not the conventional idea of art that is subverted. Even though both artists, insofar as they can be said to make works of art, take the toy as their model, for Oldenburg tampering with the ordinary idea of art is, at best, a secondary ambition; it seems to have been a primary one for Duchamp. Oldenburg is subversive in a way that the best art always is: he converts ordinary things that we are conscious of into signifiers of what we are ordinarily unconscious of, namely, the body as it exists in the unconscious, the so-called "libidinal body." This transformation is so completely perverse, so ruthlessly contradictory of our conscious sense of objects, that it can be understood to indicate the return of repressed rage, even malevolent resentment of the adult world. By making rigid, solid objects soft and seemingly hollow, Oldenburg has

*Claes Oldenburg*
Falling Shoestring Potatoes, *1965*
*Painted canvas and kapok*
*108 × 46 × 42"*
*Walker Art Center, Minneapolis*
*Gift of the T. B. Walker Foundation, 1966*

made them infantile and libidinal: in the unconscious, the body is always the soft, fluid infant's body. At the least, Oldenburg has made nonhuman material fleshlike. He has taken familiar objects, which we are innocently at home with, and made them uncanny, but also profoundly "homely"—internal objects we feel more at home with than we do with external objects. He has relaxed them almost to the point where they are visually unrecognizable. This has made them generally more tactile, and more emotionally "touching." Oldenburg's soft sculptures invite us to touch them, even fondle them. His objects belong in a playpen; they are too soft to hurt the infant who plays with them. They not only have the same soft body as the infant, but seem to idealize its softness. Each object doesn't just lose its objective qualities, it regresses to the infantile state of softness. This must be the ideal state of bodiliness. Oldenburg has infantilized us all with his cuddly sculptures.

Oldenburg has created a kind of womblike sack. His soft sculpture is a body with a secret inside. Ordinary hard objects don't have insides, at least not with mysterious contents. A watch has an inside, a telephone has an inside, but we know how they work—mechanically, objectively. No matter how complex they are, they are still fundamentally simple, completely logical and intelligible on the inside. By softening hard objects Oldenburg has organicized them, making them mysterious, full of strange life; certain of his sculptures, such as *Falling Shoestring Potatoes* (1965) and *Giant Tube Being Stepped On* (1969), call attention to those insides. Melanie Klein, according to Jay Greenberg and Stephen Mitchell, has argued that the child's mental life is full of *mostly sadistic . . . complex phantasies specifically concerning the mother's "insides." The child desires to possess all the riches he imagines contained in the mother's womb, including food, valued feces, babies, and the father's penis. He imagines a similar interior to his own body, where good and bad substances and objects reside. . . . A complex set of internalized objects relations are established, and phantasies and anxieties concerning the state of one's internal object world are the underlying basis,* Klein *was later to claim, for one's behavior, moods, and sense of self.*[15]

*Claes Oldenburg*
"Empire" ("Papa") Ray Gun, *1959*
*Casein on newspaper over wire*
*35⅞ × 44⅞ × 14⅝"*
*Museum of Modern Art, New York*
*Gift of the artist*

Did Oldenburg's anxious sense of self lead him sadistically to soften hard, fatherlike objects—to victimize them into detumescent "subjects," unable to have intercourse with Mother World? Oldenburg decommissions objects, putting them out of action so that we cannot have mature social intercourse with them, only childish play. It is an incredible revenge on things: he has knocked the sense and stuffing out of them, leaving them invalids in the ward of art. They are as harmless as the infant himself—as unable to really participate in the world. In effect, Oldenburg castrates objects by making them grotesquely infantile. What they gain by becoming charismatic, they lose by becoming nonfunctional. In desocializing and thereby remythologizing them, Oldenburg makes them the embodiment of infantile libidinal flux. Dedifferentiated, they are reinvented as elemental internal objects, primitive signs of the self in fluid formation—too fluid to be named, to have "character." The objects in the womb of the world have gone soft—gone bad. At the same time, they have become good (if silly) little children from an adult point of view. Uncontrollably soft, they have become profoundly primitive.

Oldenburg's soft sculptures are fantastically significant, intensely ambiguous. They exemplify childhood's paranoid and depressive positions. According to Klein, initially "the child attempts to ward off the dangers of bad objects, both internal and external, largely by keeping images of them separate and isolated from the self and the good objects." This paranoid anxiety changes to depressive anxiety. *In the second quarter of the first year of life the infant develops the capacity for internalizing whole objects (as opposed to part and split objects), and this precipitates a marked shift in the focus of the child's psychic life. . . . Whereas paranoid anxiety involves a fear of the destruction of the self from the outside, depressive anxiety involves fears concerning the fate of others, both inside and outside, in the face of the phantasied destruction created by the child's own aggression. As a result of his rages in the face of oral frustration, the child imagines his world as cruelly depopulated, his insides as depleted. He is a sole survivor and an empty shell. The child attempts to resolve his depressive anxiety and the intense guilt that*

*accompanies it through "reparation," the repair of the mother through restorative phantasies and behaviors. He attempts to recreate the other he has destroyed, to employ his phantasied omnipotence in the service of love and repair.*[16]

Oldenburg's soft sculptures show us what is at the bottom of the artist's proverbial God-likeness—the infant's illusory, imagined omnipotence. This omnipotence both imaginatively destroys meaningful objects by making them grotesquely impotent, and recreates them in the infant's own image, that is, as soft and cuddly. It is just their impotence, their softness, that makes them infantile, toylike. The artist-self is afraid of these ambiguous (good-bad, internal-external) object representations, yet empty—not a self—without them. Oldenburg has given us an extraordinary illustration of Charles Baudelaire's conception of the artist as a child who through adult techniques recreates a child's "intoxicating," phantastic vision of the world. Art seems surprisingly new when it seems a child's creation; adult art is hardly surprising, because it has no phantasy.

Oldenburg is more aware of the libidinal than of the aggressive side of his art. Either way, it remains infantile. He has said that "the erotic or the sexual is the root of 'art,' its first impulse."[17] His ray guns of the early 1960s are sexual metaphors; barrel and handle become penis and testicles. He has also made androgynous objects in which female and male erogenous zones become materially synonymous. His sculpture demonstrates the Freudian truth that "true symbols and sexuality" have "a specially close relation."[18] Oldenburg follows "Freud's habit of naming character traits in terms of specific bodily organs," that is, of understanding character as metaphorically bodily.[19] The ray gun is a sexual organ with an aggressive character. It is at once a metaphor for moral character and a sexual organ. It suggests the oneness of sexuality and aggression in adult character as well as in the infantile id; the two qualities reinforce one another in the gun, as in both infant and adult. A "'displacement' of a bodily (broadly speaking, sexual) interest,"[20] a "saturated conductor" of "erotic tension" or "libidinal charge,"[21] it is

*Lucas Samaras*
Book 4, *1962*
*Assemblage: partly opened book*
*with pins, razor blade, scissors,*
*table knife, metal foil, piece of*
*glass, and plastic rod*
*5½ × 8⅞ × 11½″*
*Museum of Modern Art, New York*
*Gift of Philip Johnson*

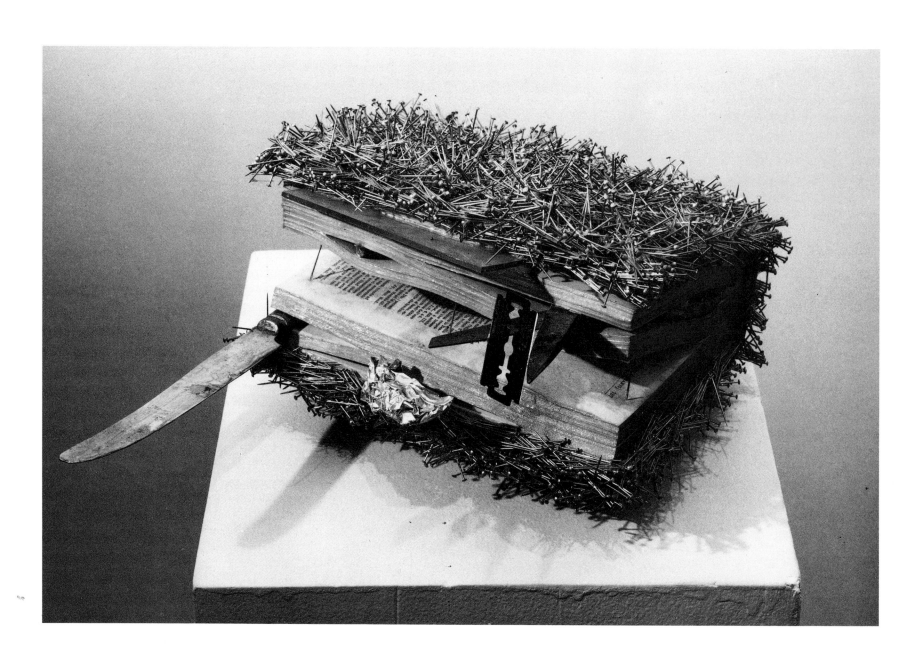

not always clear whether the ray gun is a gun or a genital first. Oldenburg has shown us just how completely bodily a sculpture can be, and how emotional the bodily is. He has shown that sexuality and aggression are simultaneously material and emotional. He has created exemplary sculptural metaphors.

## IV

Lucas Samaras's boxes make clear another major aspect of the sculptural metaphor: its fetishistic character. Describing his boxes, with their use of undisguised raw materials, Samaras has written, *Materials . . . looked fresh. Pragma. It was possible to territorialize a substance. Metaphoric meaning could not be totally expunged from anything because psyche-loaded qualities transposed themselves in all visible things; however, it could be made unconventional and thereby difficult to see and talk about. Consumption without exegesis.*[22] *(critical explanation/interpretation)*

But exegesis is possible, consuming the aesthetic consummation, or, rather, showing us that that consummation is unexpectedly about the unconsumability of material, whatever the efforts to consciously change it by integrating it "artistically," that is, by boxing or compartmentalizing it, mentally as well as physically. Material spreads emotionally beyond the aesthetic frame imposed upon it. Indeed, the nails Samaras uses in his boxes and books, in their tangled, anxiety-arousing intimacy and immediacy (they are like infant's fingers with adult nails, fragile yet dangerous), symbolize this psychic spill of material beyond the aesthetic limits imposed upon it. Samaras's boxes and books represent the uncontainability of the unconscious itself—the way the unconscious spreads like an uncontrollable, ineradicable stain through everything consciously known. It is not just unconscious associations that make Samaras's materials potent, but the way they violate boundaries. The knives of *Book 4* (1962) transgress the limits of the book as well as prohibit taking it in one's hand, just as the various things in *Box 1* (1962) keep the box from being closed. The openness of the book and the box signifies the uncontrollable infectiousness of the unconscious, against

which there is no immunity. And that openness also signifies the "openness" of the unconscious: every material is grist for its mill, every material is instantly embalmed in emotional meaning. The unconscious sickens everything with emotional meaning, makes it pathological with depth—quickly surfacing and as quickly receding, leaving material higher and drier than it found it.

Samaras's aggressive, even sadistic objects are antifemale. If, as Jean-Paul Sartre wrote, "the quality of 'smooth' or 'polished'" deeply symbolizes the fact that "'carnal possession' offers us the irritating but seductive figure of a body perpetually possessed and perpetually new, on which possession leaves no trace,"[23] then Samaras's objects can be said to violate woman's body and to be, by reason of the difficulty with which they are grasped (literally as well as psychically), anticoital. The nails are the masturbator's proliferating sperm, collected, treasured, and preserved in a box. Samaras's objects are profoundly autoerotic rather than other-erotic: they are anti-other. "What is smooth can be taken and felt but remains no less impenetrable, does not give way in the least beneath the appropriative caress—it is like water. This is the reason why erotic descriptions insist on the smooth whiteness of a woman's body."[24] Samaras's objects are not smooth, and far from caressable—impossible to appropriate in an embrace. Samaras has performed an extraordinary feat: he has metamorphosed Pandora's smooth box into the rough male penis. He has violated the other by turning it into an angry version of the self.

Samaras's composite objects have the fluidity not of water, but of feces. They are diarrhetic objects, containing nuggets of fool's gold—all the dangerous things a bad child has swallowed whole and miraculously not been hurt by, because he is a child and does not know what he is doing. Art for Samaras is child's play, a process by which the bad objects of life pass harmlessly through the psyche because they are played with. Artistic play is a way of digesting the indigestible, or, rather, of getting whatever nourishment one can from objects without digesting them, that is, without making them a

permanent part of oneself. One digests them by finding symbolic emotional meaning in them—a way of getting the best out of dumb material. Samaras, a Greek—proverbially, one must beware of Greeks bearing gifts—reminds us that in Greek the words for *box* and *stupid* are the same: he makes "stupid" boxes containing "stupid" things—toys he has finished playing with, perverse accumulations he is offering the world as artistic constructions, a "child's play" to create.

Janine Chasseguet-Smirgel remarks on the "two-fold property of the fetish: it is anal and shiny, often smelly and shiny," [25] and she connects the feeling the fetish gives us, of "a world not ruled by our common laws . . . a marvelous and uncanny world," [26] with "the dream of *an anal creation of the world*." [27] The fetish is surrogate feces, that most intimate of substances, that most spontaneous and natural of our creations. And Samaras's object is an anally created world, emotionally anal in meaning and aesthetically shiny or showy in effect.

The fetish object is the archetypal imitation, making clear that behind every semblance is a profound pathos. For Freud, "the edification of the fetish means at once the affirmation and the disavowal of the so-called castration of women." [28] Later psychoanalysts have argued that it signifies the disavowal of the father's genital penis and the affirmation of the mother's anal one. As Chasseguet-Smirgel tells us, "the fetish is an imitation of a genital penis, and . . . imitation, in general, is associated with anality." The fetish and the perversion it implies are thus "connected with sham, counterfeit, forgery, fraudulent, deceit, cheating, trickery . . . in short with the world of semblance." [29] Samaras's fetish object is a prosthetic penis for the imagined anal intercourse with the mother— a harsh, violent intercourse (penetration by nails) that would destroy her insides.

One can, perhaps, imagine Oldenburg's soft sculptures as Trojan horses containing Samaras's fetish objects. And if one can say that

Samaras's fetish objects are the bad internal objects found in Oldenburg's soft sculptures—sculptures as handbags for a giant woman, a bag-lady goddess (the woman the child imagines the mother to be)—then Samaras's creation of the fetish object is the creation of a bad external object to expunge the bad internal objects in the mother, which are also represented by the fetish object. Moreover, if, as Chasseguet-Smirgel states, "the fetish is the deposit of all the part objects lost during the subject's development . . . both content and container," [30] then Samaras's fetish objects, the turbulent residues that Beuys spoke of as present in the unconscious, are collections or accumulations of childhood things associated with his mother. She may have used the needles to make her clothes. (Samaras himself is a good tailor.) The fetish is, indeed, "a magic wand" whose "presence modifies reality." [31] It creates the illusion that the mother is there—repossessed through, or emotionally penetrated by, the fetish object, the perverse object for the perverse deed (necessarily perverse because it breaks the great Oedipal taboo). Such repossession turns her into what she is in emotional truth: the bad internal object, which she became by sleeping with the father rather than with the son. Thus, through the fetish, a taboo is successfully broken in phantasy. Samaras's fetish objects are, indeed, profoundly gratifying substitutions—imitations that concentrate in themselves a grand-manner phantasy.

The sculptural metaphors of Oldenburg and Samaras make clear that the metaphorical use of material involves a process of phantastic imitation that uncovers the material's unconscious import. Sandor Ferenczi has pointed out that imitation is the language of the unconscious: "*imitation magic*" involves (1) abreacting (reliving and releasing) "emotional impressions of the external (material) world by one or several repetitions"; and (2) imparting "to another person what has happened, as a complaint or to find sympathy and help." Imparting always involves diluting the original impression or impact of the external reality. Every "imparting" has two dimensions: (1) the "imitating of something *alien*," which is the "primitive form of objectification of the . . . external world"; and (2) "a *self-imitatory*

116

repetition of the emotional reaction experienced" in the face of the external world, in other words, an imitation that is an articulation of one's emotional response to the world.[32] From this point of view, every sculptural metaphor/fetish simultaneously abreacts the bad feelings about oneself that the external world arouses in one, and, paradoxically, appeals to that same world for sympathy and help; it articulates the subject's vulnerability and is a prayer to the world for the sympathy and help the subject needs to counteract the anxious feeling of vulnerability the world arouses in him. Oldenburg's and Samaras's phantasies have a relentlessly repetitive aspect which is crucial to their imitation magic. Repetition offers a semblance of control of anxiety, but actually articulates its uncontrollability. Repetition reinforces rather than purges the basic feeling of vulnerability to the world. Repetition articulates anxiety fixated on the world, inscribing itself in the worldly objects that arouse it.

The best metaphorical sculptors follow the lead of Oldenburg and Samaras in working through the original, half-true impression of the world as the primordial mothering body—and in finding that working through it is really a way of working themselves more deeply into it. Oldenburg and Samaras are each like a man who tries to dig his way out of a hole he has made in mother Earth, only to find that he is digging his way more deeply into it—digging his own grave in the alien yet profoundly intimate body of the mother. This compulsive, repetitive imitation of the initial moment of vulnerable recognition, angry destruction, and reparative recreation of the primordially concrete body—the body whose physicality and emotional meaning cannot be separated—is the final proof of the authenticity and power of the sculptural metaphor. It shows not only how the sculptural metaphor is other- and self-object in one, but how deeply rooted we are in the primordial material of this "other-self."

## V
Beuys made explicit the third element necessary for an understanding of sculptural metaphor: recognition of the world-historical character of the primordial material. The material world,

even at its most primordial, remains historically consequent. Its emotional significance is inseparable from its cultural significance: the one articulates it as an inescapable destiny, the other as a chosen history. As Franz Meyer has written about Beuys's *Lightning* (1985), the piece "stems from *Monuments to the Stag*, the work which Beuys carried out in 1982 for the 'Zeitgeist' exhibition"; in both installations, "work implements and objects with particular expressive potential served as working material. . . . Objects and implements embody plastic energy, and so the assembly becomes in a metaphorical sense an 'accumulator.'" The clay cone that formed the central image of *Monuments to the Stag* forms that of *Lightning* as well: the work's twenty-foot-high hanging centerpiece is a bronze cast of a section of the clay cone. "The stag," Meyer continues, "symbolizes for Beuys the supreme life-force to be found in the material world, transforming the latter by its spiritual powers. The clay cone . . . is the most fundamental expression of the material state in which the 'incarnation' should take place. The theme of the new work . . . is the translation of this elementary substratum into movement. The earthiness, still perceptible in the bronze reproduction, recalls *Mountain King* (1961), with its archetypal image of Man as a being still at one with Nature. On the other hand one experiences the bronze ribbon darting down from the sky and widening into a broad tongue as a release of energy, as a penetration of cosmic force into the material state. It is an image comprehensible as a 'flash of lightning.'"[33]

In fact, *Lightning* fuses nature and history. It is a symbolic restatement of the Blitzkrieg—in which Beuys participated, as a fighter pilot in World War II, and which has come to symbolize the power and inhumanity of Nazi Germany. By "naturalizing" the Blitzkrieg—by making it of the earth, not of the sky—Beuys made "reparation" for it. He restored the historical Blitzkrieg to the natural world in symbolic form. He made the historically bad the naturally good.

Like many other works by Beuys, *Lightning* is a kind of theodicy—

*Joseph Beuys*
Blitzschlag mit Lichtschein auf Hirsch, *1958–85*
*(Lightning with Stag in its Glare)*
*Environment with 39 parts*
*Detail:* Hirsch *(Stag)*
*Aluminum, 19 × 41 × 67¾"*
Urtiere *(Primeval Animals)*
*Bronze*
*35 different casts*
*Dimensions variable*
*Anthony d'Offay Gallery, London*

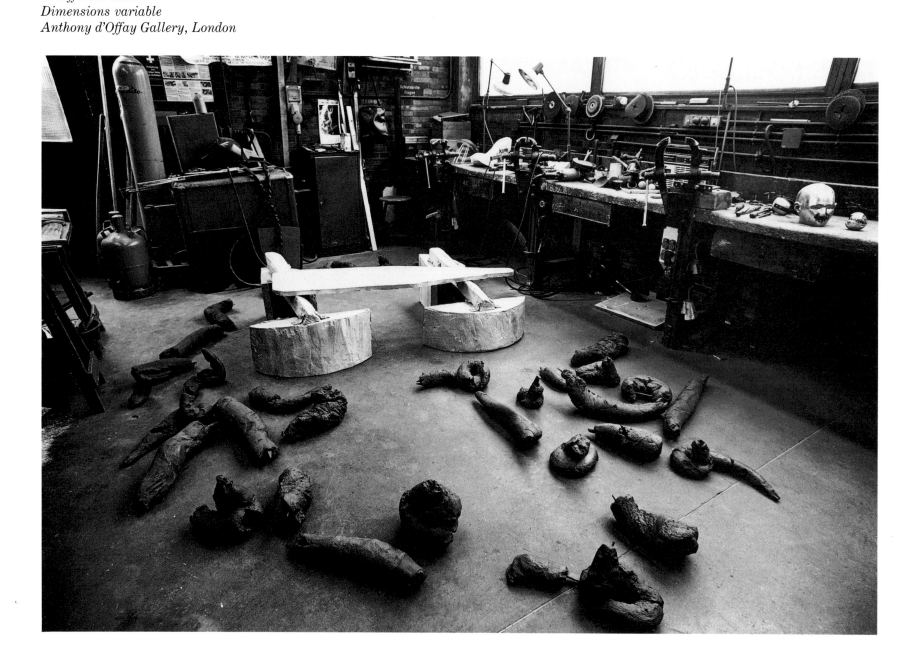

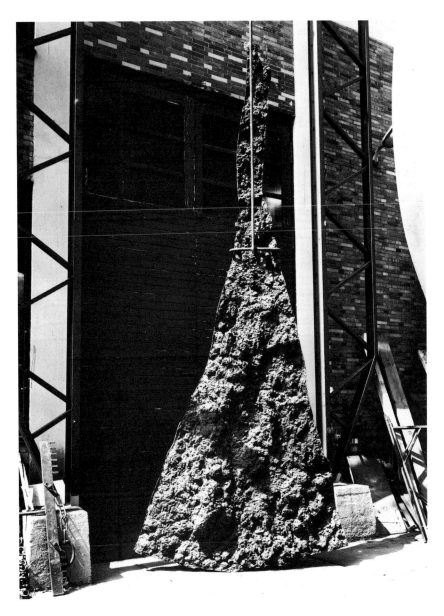

*Joseph Beuys*
Blitzschlag mit Lichtschein auf
Hirsch, *1958–85*
*(Lightning with Stag in its Glare)*
*Environment with 39 parts*
*Detail:* Bothia felix
*Bronze*
*63 × 15¾ × 15½"*
*Anthony d'Offay Gallery, London*

an attempt to "justify" the ways of historical man by showing their rootedness in nature, showing them as historical extensions of natural realities. By recreating the unity of man and nature, Beuys redeemed man's bad nature, "made it good." Much of his art involves this wishful or magical thinking. The life force restores to freshness and cleanness the natural force that world history has tainted by misunderstanding and misusing it—using it for inhuman, destructive purposes.

History is always a bad imitation of nature, while art is a good imitation of nature. The artistic or phantasy imitation of nature can be magically overlaid on the bad, historical imitation not only to make it good—to heal the wounds it has caused—but to show that the imitation of nature as such, by which man tries to become one with it, is the only way to human health and goodness. Beuys wanted to make credible, as a way of living, the imitation of nature in general. He had to root out—repress?—bad historical reality to do so: replace the bad, external objects of history with the good, internal objects of nature, the historical Blitzkrieg with the natural one.

## VI

There is always a repressed or unacknowledged world-historical dimension to the sculptural metaphor—a world historical element that the metaphoric or phantastic transformation of the sculpture tries to root out. Metaphoric sculpture tries to externalize infantile feelings about the body, feelings it has to articulate through objects in the world. If the contemporaneity of these objects can be undermined, the feelings will seem eternal—fixated in their infantilism.

Oldenburg's metaphoric objects finesse contemporary reality. Similarly, Samaras's metaphorical objects "reevaluate" everyday materials from the contemporary world. In abstract works historical contingency is explicitly expunged, but its traces remain in the material. The lead that Richard Serra uses and the found objects that David Smith incorporated in his figures are the identifiable traces of

*Richard Serra*
Belts, *1966–67*
*Vulcanized rubber with neon tubing*
*84 × 288 × 20"*
*Panza Collection*

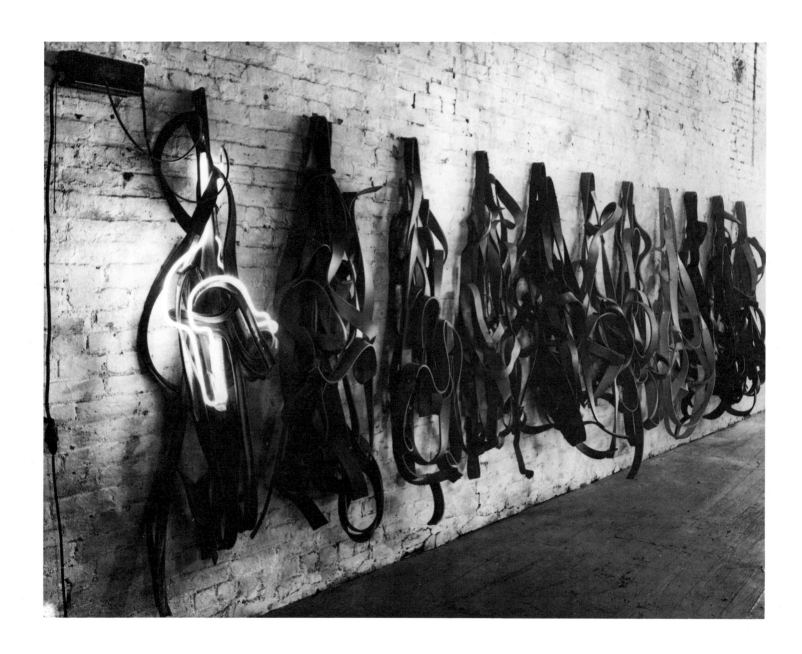

contemporaneity: they are externalized parts of residual internal objects, their historical identity lost in the process of their sculptural integration into the space of a new body. Their historicity has been subsumed in their abstract form, whether geomorphic or schematically anthropomorphic.

In the majority of such abstract works, the tension between the pursuit of aesthetic form and the unconscious residue of historical content—which will find its way to the surface of the work one way or another—can be spelled out in the terms T. W. Adorno used to measure the success of authentically modernist art (rather than Greenberg's inauthentic, abbreviated version of it). Adorno has written, "The quality of an art work is largely determined by whether or not it meets the challenge of the irreconcilable. In the so-called formal moments content, far from being expunged, surfaces again as a result of form's relation to the irreconcilable," that is, to the "unreconciled world."[34] Adorno puts this another way. After insisting that "without a heterogeneous (empirical) moment, art cannot achieve autonomy," he asserts, "In art, the criterion of success is twofold: first, works of art must be able to integrate materials and details into their immanent law of form; and, second, they must not try to erase the fractures left by the process of integration, preserving instead in the aesthetic whole the traces of those elements which resisted integration."[35]

It is worth noting that the split between form and content, and the difficulty of integrating them, that Adorno describes can be understood as a sign of just how primitive—how basic—modernist art thinking is. Otto Kernberg has pointed out that splitting is "the crucial mechanism for the defensive organization of the ego" at its most basic (pre-oedipal) level. It is the most infantile organization of an identification system.[36] The world is initially divided into irreconcilable opposites—into opposing archetypal fragments reified as stereotypes.[37] The first sense of self is a split sense of self. Unless the fragments are made whole through an integration that is as formal as it is material—a consummate aesthetic integration—the

individual will feel himself crumbling, and will suffer throughout his life from a sense of being fragmented, shallow, and/or hollow.[38] With varying degrees of success, art offers what Sander L. Gilman has called "the illusion of integration"[39]—a substitute integration, a semblance or imitation of the integration pursued throughout life. Art represents the perpetual reintegration of the self in the face of disturbing new evidence of the other. Art's attempt to integrate historical content into aesthetic form is a metaphor for the ongoing and ambiguously successful project of self-integration. Works of art that are too successful in their integration—that completely subsume content into form (showing the dominance of the pleasure principle)—seem vacuous, because there is no sign of conflict and struggle in them. There is no tension between bad history and good style. They seem emptily sublime—naively, even dumbly immaterial. Works of art that have too obvious a historical content (reality principle), with their formal resolution radically incomplete—works that lack any significant sign of dialectical integration, that seem like wild eruptions of content—look fragmented and ineffective, that is, dumbly material.

In object-relations terms, form is generally perceived as "good," content as "bad." By being subsumed or aesthetically integrated into form, bad content—historical, empirical reality, what Sartre has called the practico-inert—becomes good or redeemed ("repaired," repatriated), and, as such, emblematic of the good self. But some of the badness remains, as a content irreconcilable with the work as a whole. This content is irreconcilable in two senses. It reminds us that art cannot subsume the empirical world, or reconcile us to it as style. And it makes the work of art itself fragmentary or split, a reflection of the tension of the historical world. This irreconcilable, heterogeneous historical-empirical content is the chaotic, unconscious element with which Beuys was obsessed. The final task of art is to redeem it, by imaginatively acknowledging its irreducible reality—the memory permanently stuck in the maw of the unconscious, impeding self-development and self-integration, social development and integration. Irresistible, it must make itself into art. *Lightning*

is exactly that—a residue of historical-empirical heterogeneity that becomes "direct" art, the irreconcilable incarnate.

Other sculptors do not make this irreducible residue, simultaneously world-historical content and unconscious memory, as directly manifest as Beuys did. They pursue form, as well they should; but nonetheless, what makes their work significant is the way its formal integration is incomplete. In Serra's work the lead, which is like an unmoving, dense residue in the unconscious, undermines the naive integration afforded by the unstable cube form, always about to disintegrate into square planes. The lead is the vehicle for historical and unconscious heterogeneity—it gives the work its power. The same thing can be said of Keith Sonnier's neon sculpture, where the neon tubing at once transcends its formal arrangement and becomes a world-historical and libidinal signifier in one. In Jannis Kounellis's work the spread of the "flame-throwers," "formalized" by being aimed in the same direction (a minimal, dubiously aesthetic integration), is secondary to their repetition, to Kounellis's obsession with them as "raw" material. Such repetition of material signifies its radical power over the unconscious: it is a historical-empirical reality fascinating in and of itself. Material heterogeneity is not made formally homogeneous by the erratic serial alignment of the flame throwers, nor by the alignment of Serra's *Belts* (1966–67) where it becomes clear that serial form does not really integrate material, but rather "re-marks" it. Form, such as it is, "marks" the already "marked" material as heterogeneous and irreconcilable. Form heightens the historicity of the material and marks the work as unconsciously meaningful. Formal "integration" makes material recognizable in ways we were unaware of or indifferent to in ordinary experience.

Similarly, in Mark di Suvero's work the heterogeneous effect of the girders vitalizes the neat splay of the constructed form. The rust especially signals the material heterogeneity of the work; it functions as the unconscious "betraying" the conscious construction. William Wiley's *Ship's Log* (1969) uses both raw material and objects as material to make the heterogeneous point that the simultaneity of the world-historical and the unconsciously "memorable" precludes the work's formal closure. Wiley's fetishistic use of the triangle form hardly begins to integrate the diversity of the materials that constitute the work: canvas, leather, wood, lead, paper, watercolor, cotton webbing, latex rubber, plastic, salt licks, wire, ink, and nautical and other kinds of hardware. These materials both constitute and resist the two triangles—the canvas wall and the floor frame. Each bit of material remains a "distraction" within the totality, fascinating us, luring us to an intimacy that makes the formal configuration seem trivial. It is this intimacy with the material "residue" that creates the real "integration" of the work: it integrates the work with the viewer, on the profoundest historical and subjective level.

The same thing happens, in different ways, in the sculptural metaphors of such diverse artists as Louise Nevelson, George Herms, Louise Bourgeois, Isamu Noguchi, and Eva Hesse. The grid container and the uniform blackness of Nevelson's work are minimal techniques of formal integration that maximize the effect of the work's material heterogeneity, making it more rather than less psychosocially evocative. For Herms, formalization hardly begins to control the anxiety aroused by the abundance of material. This is particularly clear in *Secret Archives* (1974) where the grid with its cubbyholes is a found form, as well as a found object like the other objects in the work. It is form that is not form—form that is not worked at, not deliberately created, but that offers itself as a display case for the material. Form is not so much the result of deliberate technique in Herm's work—or in the serial work of Serra and Hesse—as it is a casual way of articulating material.

The real source of form in Herms's sculpture is the metonymic organization of found materials. As Jonathan Culler has pointed out, the distinction between metonymy and metaphor—between "accidental" relationship grounded in contiguity and "essential" relationship grounded in similarity—has increasingly come to be blurred, if not mistaken. "Metaphor is not something that we could

see clearly if only we could resolve" the problem of their relationship. *It may be, rather, that the domain of metaphor is constituted by these problems: the unstable distinction between the literal and the figurative, the crucial yet unmasterable distinction between essential and accidental resemblances, the tension between thought and linguistic processes within the linguistic system and language use. The pressure of these various concepts and forces creates a space, articulated by unmasterable distinctions, that we call* metaphor.[40]

It is perhaps in seriality, where more or less similar elements are arranged contiguously, that we see how metonymy functionally becomes metaphor. To deconstruct every metaphorical relationship is to find a metonymic one. To construct a metaphorical relationship, one needs a metonymic condition. It is as though by bringing different things together contiguously, one is proposing their essential, if secret, similarity. Through metonymic intricacy one is trying to spark a metaphorical intimacy between materials. They "progressively" become metaphorically related, but they can always "regress" to a metonymic state. The interplay between the metonymic and the metaphorical condition is crucial to the effect of these works. It finally becomes hard to tell whether the metonymic exclusively articulates the heterogeneous and the metaphorical the homogeneous, for the tension between the elements that constitute each, while different in appearance, is basically the same. That is, they both involve an unholy mix of the world-historical and the unconscious; every element in them has this split charge. Metonymy and metaphor are both attempts at integration that fail to create completely resolved form. They are thus both essential to the success of art.

Whether contiguity is established between divergent (if not widely divergent) materials, as in Bourgeois's totemic, phallic-oriented work, or between more or less similar materials, as in the work of Serra and Hesse, seriality is a mode of pseudointegration that makes material metaphorically emphatic. The various figure-oriented works by Noguchi, Smith, and Joel Shapiro are essentially metonymic

constructions that have a metaphorical effect—even when the units of construction are more or less similar to one another, as in Smith and Shapiro. From an object-relations point of view, incidentally, these figural works show the body as a projection of a sum of "good" objects, because all the parts are under control, that is, integrated into a cognizable structure—again, even when the work's whole is seemingly fractured into units, as in Robert Graham's work. In contrast, in integration by seriality there is no real control, or rather, the lack of control—the anxiety—is disguised by the alignment of the units, which offers the illusion of control, of formal integration. Lack of control—randomness of "organization"—and the illusion of control provided by serial arrangement indicate that the material units to be brought under control are "bad," which is why, tautologically, they cannot be brought under control or truly integrated. Hence their presentation through pseudoform, or through the dubiously systematic measuring and cataloguing of, for example, Bruce Nauman's *Collection of Various Flexible Materials Separated by Layers of Grease with Holes the Size of My Waist and Wrists* (1966). One can say that a work where there is pseudointegration—where "bad" internal objects are to be integrated—is more likely to be read as metonymic. A work where there is genuine integration, where a more rather than less stable and delimited structure is created—a body structure rather than an open-ended series (the genuinely integrated structure should seem closed in on itself like a body)—is more likely to be read as metaphorical, and its material units as "good" internal objects.

Finally, the sculptural metaphors of John Duff, Robert Therrien, Mark Lere, Martin Puryear, and Ken Price offer the illusion of basic material aesthetically adjusted so as to appear eccentrically integral in itself. Starting from widely different material "premises"—from materials that "originated" in different processes—each artist creates an object that seems to make a metaphorical point simply through its presence. The object, even when it is clearly constructed of different materials, as in Puryear's *Seer* and *Keeper* (both 1984), or when it juxtaposes radically different surfaces, as in Price's works,

does not seem to force the structure of relations that make it operational. Rather, it seems to exist as a tension within itself, which is what makes it seem inherently metaphorical, apart from its allusions (in Lere's work, for example, to flowing water). The point of these works is to give us a sense that every material has a spontaneous metaphorical effect simply by being shaped. The idea that metaphor inheres in a material, or that every material has a metaphorical potential that has to be lured out of it and made articulate through art, suggests that the aesthetic integration of the sculptural metaphor must be read as a metaphorical way of articulating the "difference" its material makes.

1. Clement Greenberg, "The New Sculpture," in *Art and Culture* (Boston: Beacon Press, paperback edition, 1965), p. 143.

2. Ibid., p. 139.

3. Ibid., p. 140.

4. Ibid., p. 144.

5. Ibid., p. 145.

6. Ibid., p. 144.

7. Greenberg, "On the Role of Nature in Modernist Painting," in *Art and Culture*, p. 172.

8. Roland Barthes, "The Two Criticisms," in *Critical Essays* (Evanston, Ill.: Northwestern University Press, 1972), p. 253.

9. Morse Peckham, "Metaphor: A Little Plain Speaking on a Weary Subject," in *The Triumph of Romanticism: Collected Essays* (Columbia: University of South Carolina Press, 1970), p. 411.

10. Caroline Tisdall, *Joseph Beuys*, exhibition catalogue (New York: Solomon R. Guggenheim Museum, 1979), p. 17.

11. Rudolf Arnheim, *The Power of the Center* (Berkeley: University of California Press, 1982), p. 154.

12. Tisdall, *Beuys*, p. 152.

13. Ibid., p. 21.

14. Max Ernst, "Beyond Painting," in *Surrealists on Art*, ed. Lucy R. Lippard (Englewood Cliffs, N.J.: Prentice-Hall, 1970), p. 126.

15. Jay R. Greenberg and Stephen A. Mitchell, *Object Relations in Psychoanalytic Theory* (Cambridge: Harvard University Press, 1983), pp. 124–25.

16. Ibid., pp. 125–26.

17. Claes Oldenburg and Emmett Williams, comps., *Store Days* (New York: Something Else Press, 1967), p. 15.

18. Sigmund Freud, *A General Introduction to Psychoanalysis* (Garden City, N.Y.: Garden City Books, 1952), p. 149.

19. Philip Rieff, *Freud: The Mind of the Moralist* (Garden City, N.Y.: Doubleday & Co., Anchor Books, 1951), p. 48.

20. Ibid.

21. Rieff, *Freud*, p. 22.

22. *Lucas Samaras*, exhibition catalogue (New York: Whitney Museum of American Art, 1972), unpaginated.

23. Jean-Paul Sartre, *Being and Nothingness* (New York: Philosophical Library, 1972), p. 579.

24. Ibid.

25. Janine Chasseguet-Smirgel, *Creativity and Perversion* (London: Free Association Books, 1985), p. 88.

26. Ibid.

27. Ibid., p. 80.

28. Ibid., p. 81.

29. Ibid.

30. Ibid., p. 87.

31. Ibid.

32. Sandor Ferenczi, "Notes and Fragments," in *Final Contributions to the Problems and Methods of Psychoanalysis* (New York: Brunner/Mazel, 1980), p. 266.

33. Franz Meyer, "Joseph Beuys," in *German Art in the 20th Century: Painting and Sculpture 1905–1985*, exhibition catalogue (London: Royal Academy of Arts; Munich: Prestel Verlag, 1985), p. 472.

34. T.W. Adorno, *Aesthetic Theory* (London: Routledge & Kegan Paul, 1984), p. 271.

35. Ibid., pp. 9–10.

36. Otto Kernberg, *Object Relations Theory and Clinical Psychoanalysis* (New York: Jason Aronson, 1984), p. 26.

37. Sander L. Gilman, *Difference and Pathology* (Ithaca, N.Y.: Cornell University Press, 1985), p. 17.

38. Heinz Kohut, *The Restoration of the Self* (New York: Analytic Press, 1976), p. 286.

39. Gilman, *Difference and Pathology*, p. 17.

40. Jonathan Culler, *The Pursuit of Signs* (Ithaca, N.Y.: Cornell University Press, paperback edition, 1983), p. 207.

**Louise Bourgeois**

The Blind Leading the Blind, *c. 1947*
*Painted wood*
*67⅛ × 64⅜ × 16¼"*
*Robert Miller Gallery, New York*

**Louise Bourgeois**

Pillar, *1949–50*
*Painted wood*
*64⅜" high*
*Robert Miller Gallery, New York*

**David Smith**

Tanktotem III, *1953*
*Steel*
*84½ × 27 × 20"*
*Collection of Mr. and Mrs. David Mirvish*

**David Smith**

Sentinel, *1961*
*Stainless steel*
*106 × 23 × 16½"*
*Collection of Candida and Rebecca Smith,*
*New York*
*Courtesy M. Knoedler and Co., New York,*
*and the National Gallery of Art,*
*Washington, D.C.*

**Louise Nevelson**

Moon Fountain, *1957*
*Black painted wood*
*43 × 36½ × 34"*
*The Museum of Contemporary Art,*
*Los Angeles*
*Gift of Mr. and Mrs. Arnold Glimcher*

**Louise Nevelson**

Sky Cathedral: Southern
Mountain, *1959*
*Black painted wood*
*114 × 124 × 16"*
*The Museum of Contemporary Art,*
*Los Angeles*
*Gift of the artist*

**Isamu Noguchi**

Mortality, *1959*
*Bronze*
*74 × 20 × 18"*
*Walker Art Center, Minneapolis*
*Gift of the T. B. Walker Foundation*

**Isamu Noguchi**

The Cry, *1959*
*Balsa wood on steel base*
*84 × 30 × 18"*
*Solomon R. Guggenheim Museum,*
*New York*

**George Herms**

All I Wanna Do Is Swing n' Nail, *1960*
*Assemblage*
*31½ × 18½ × 10"*
*University Art Museum*
*University of California, Berkeley*
*Gift of Alfred Childs, Berkeley*

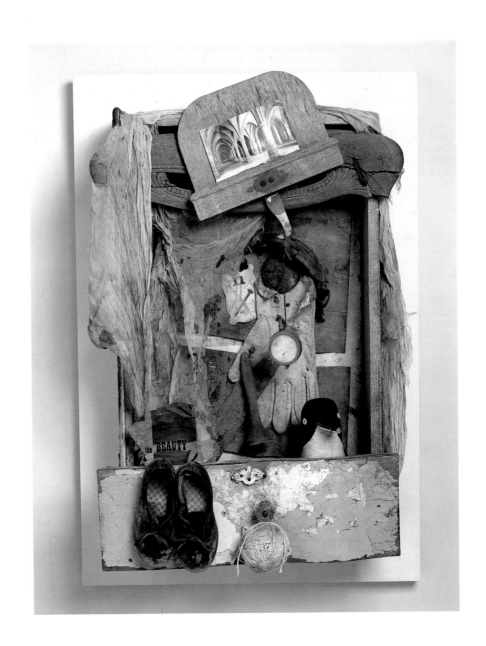

**George Herms**

Secret Archives, *1974*
*Assemblage*
*66 × 69 × 18"*
*Collection of the artist*
*Courtesy L.A. Louver Gallery,*
*Venice, California*

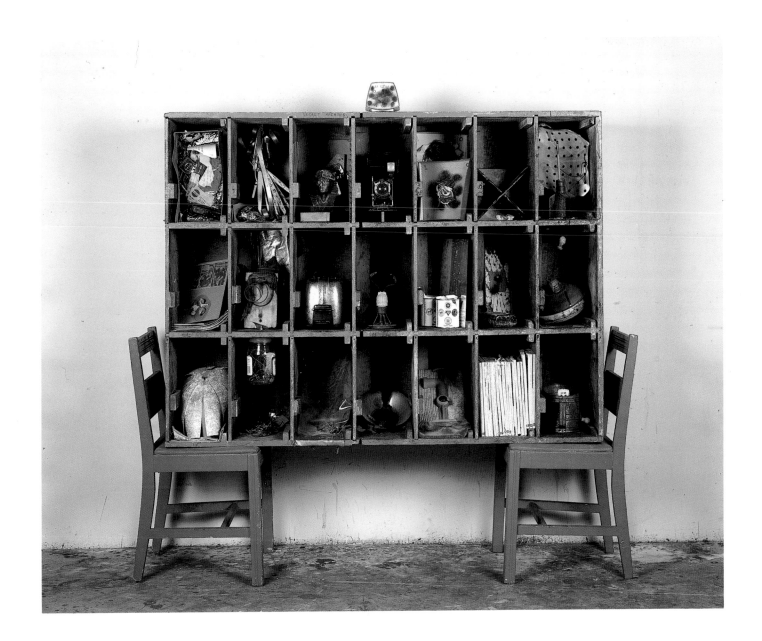

**Lucas Samaras**

Untitled Box No. 3, *1963*
*Pins, rope, stuffed bird, and wood*
*24½ × 11½ × 10¼"*
*Whitney Museum of American Art,*
*New York*
*Gift of the Howard and Jean Lipman*
*Foundation, Inc.*
*Acq. # 66.36*

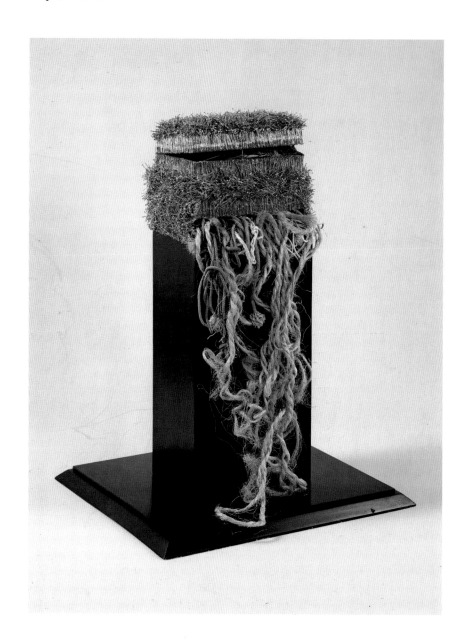

**Lucas Samaras**

Box #43, *1966*
*Mixed media*
*9 × 12 × 9"*
*Collection of Mr. Robert H. Halff*

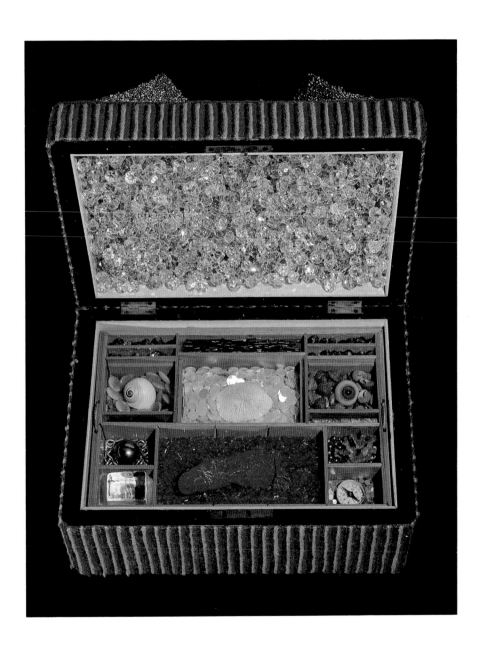

**Eva Hesse**

Hang-Up, *1966*
*Acrylic on cloth over wood and steel*
*72 × 84 × 78"*
*Collection of Mr. and Mrs. Victor W. Ganz*

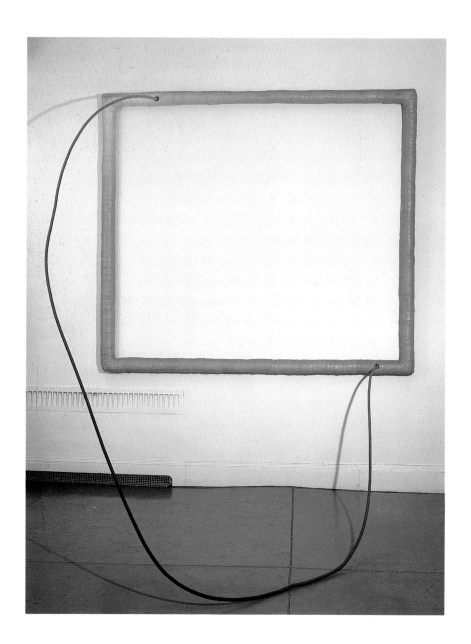

**Eva Hesse**

Repetition 19, III, *1968*
*Nineteen tubular fiberglass units*
*19 to 20¼" high × 11 to 12¾" in diameter*
*Museum of Modern Art, New York*
*Gift of Charles and Anita Blatt, 1969*

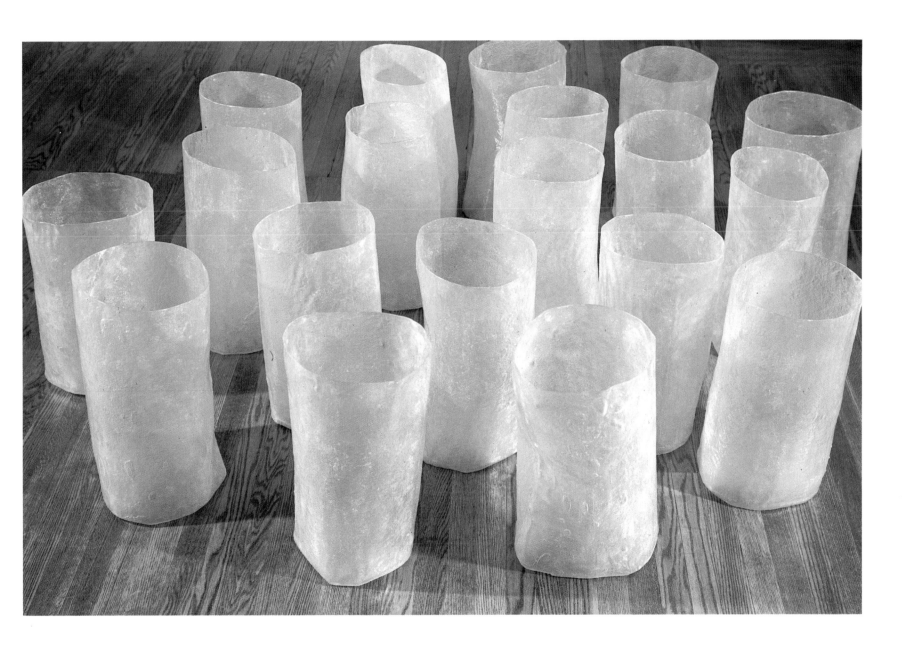

**Bruce Nauman**

Collection of Various Flexible
Materials Separated by Layers of
Grease with Holes the Size of My
Waist and Wrists, *1966*
*Aluminum foil, plastic sheet,*
*foam rubber, felt, and grease*
*1½ × 90 × 18"*
*Saatchi Collection, London*

**Bruce Nauman**

Neon Templates of the Left Half
of My Body Taken at Ten Inch
Intervals, *1966*
*Neon tubing*
*70" high*
*Collection of Philip Johnson*

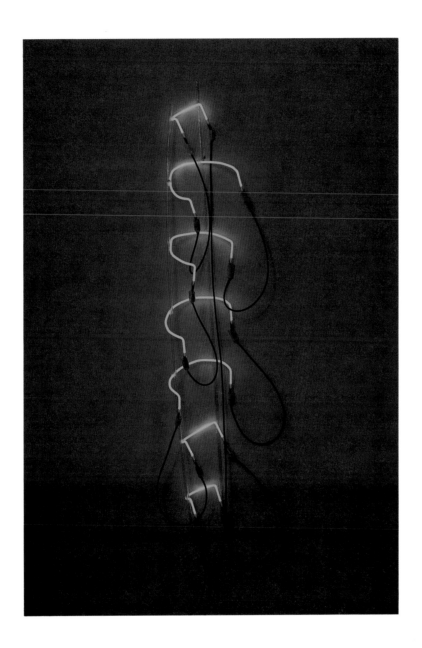

**Keith Sonnier**

BA-O-BA IV, *1969*
*Neon and glass*
*96 × 96 × 120"*
*Collection of Syd Goldfarb*

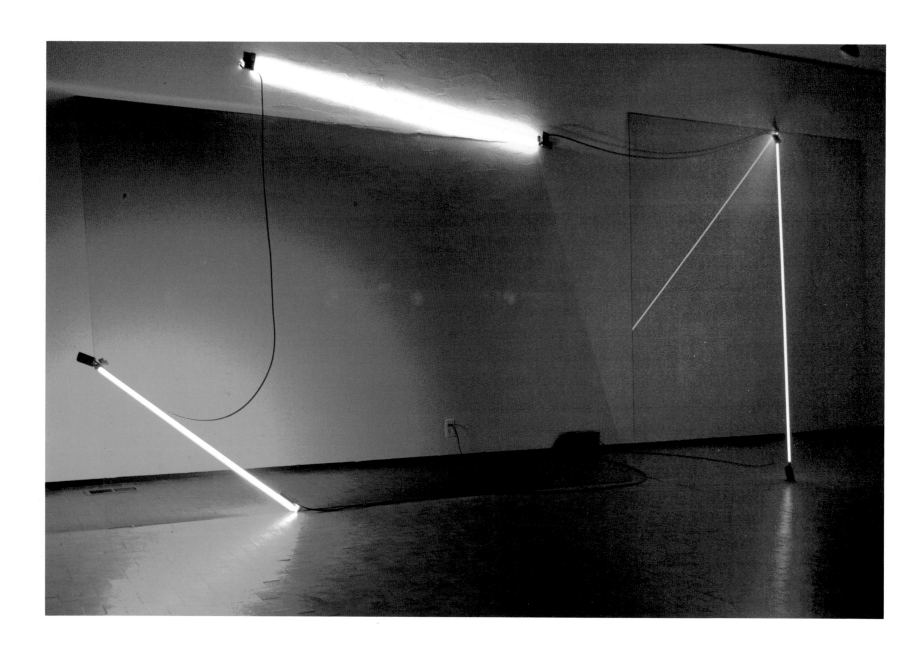

**Keith Sonnier**

*Neon and Scoop Lights, 1969*
*Mixed media*
*Dimensions variable*
*The Museum of Contemporary Art,*
*Los Angeles*
*Gift of Rose, Feldman, Radin,*
*Feinsod, and Skehan*

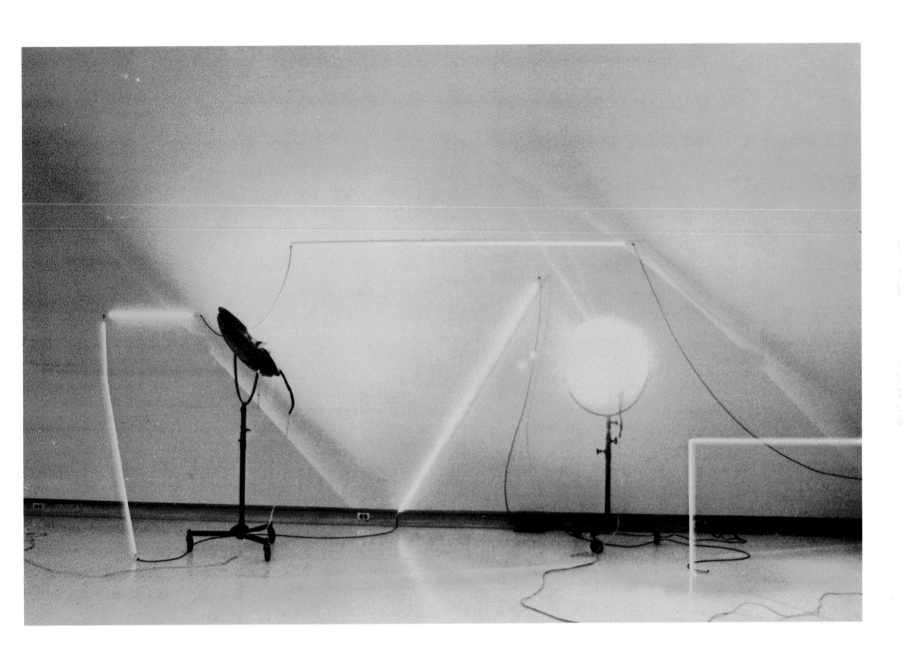

**Mark di Suvero**

Pre-Natal Memories, *1976–80*
*Cor-ten steel*
*264 × 482 × 110½"*
*The Museum of Contemporary Art,*
*Los Angeles*
*Gift of Robert A. Rowan*

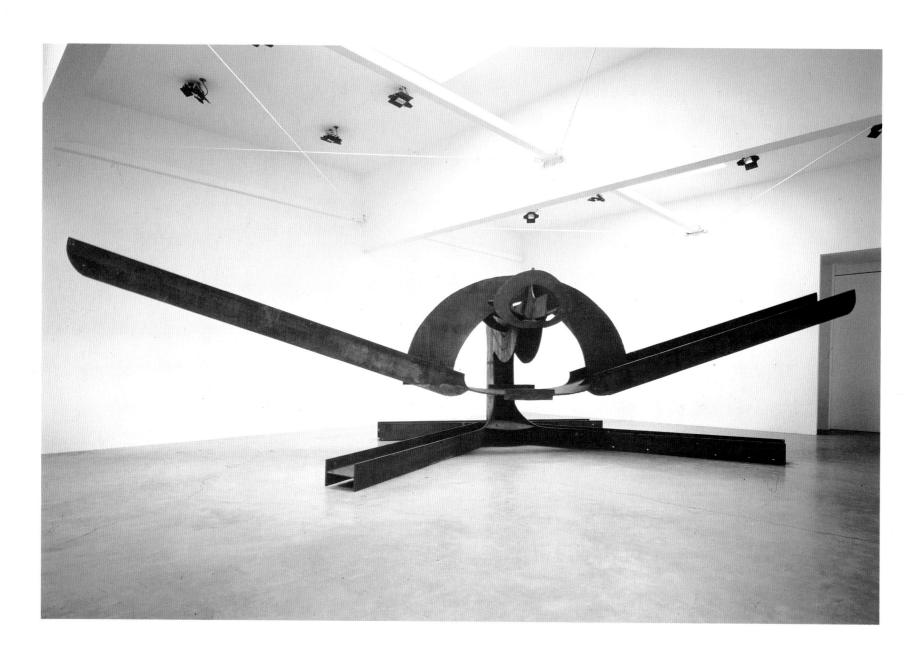

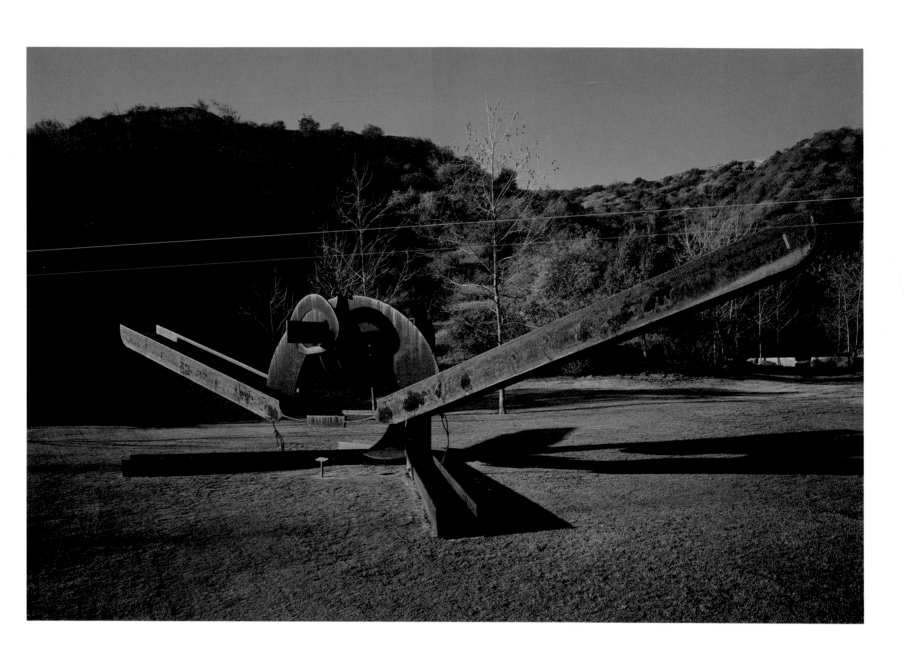

**Joel Shapiro**

Untitled, *1980–81*
*Oil and acrylic on poplar*
*54 × 42 × 37"*
*The Museum of Contemporary Art,*
*Los Angeles:*
*The Barry Lowen Collection*

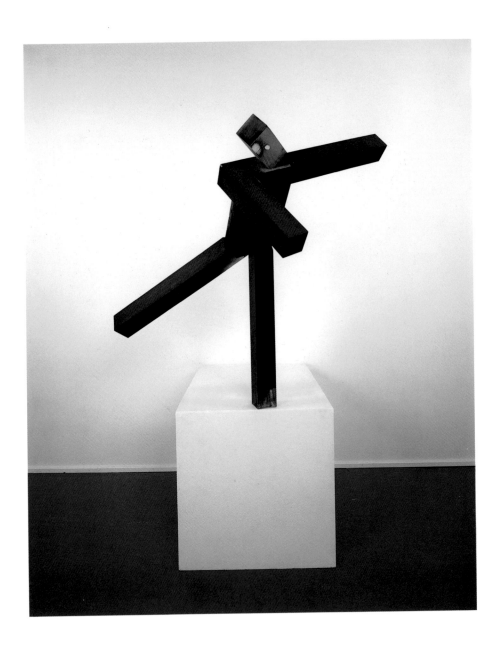

**Joel Shapiro**

Untitled, *1985*
*Bronze*
*36¼ × 53 × 40"*
*Paula Cooper Gallery, New York*

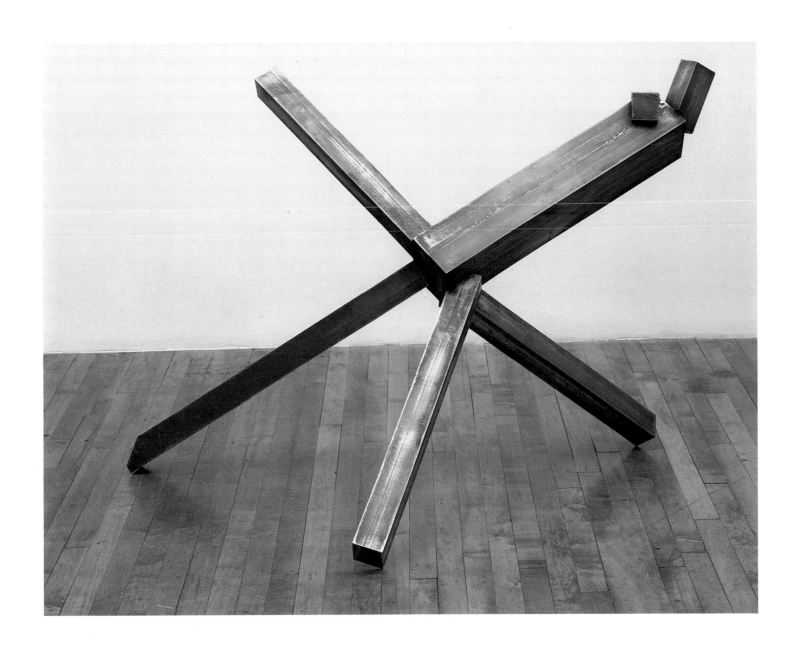

**Robert Graham**

Spy/Stephanie, *1980–81*
*Figure: cast bronze with gold leaf*
*69½ × 11½ × 7½"*
*The Museum of Contemporary Art, Los Angeles*
*Gift of the Stark Fund of*
*the California Community Foundation*
*Horse: cast bronze*
*47¼ × 55 × 14"*
*Collection of Roy and Carol Doumani*

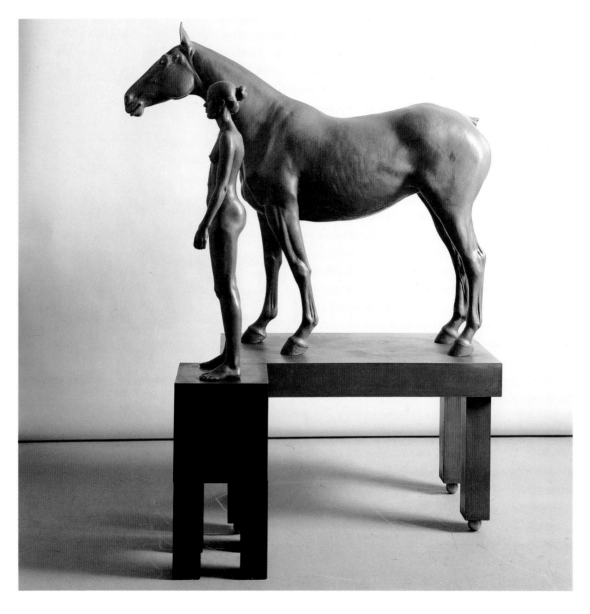

**Robert Graham**

Untitled, *1985*
*Cast bronze with silver plating*
*36½ × 12 × 12"*
*Collection of Earl McGrath*

**Robert Graham**

Untitled, *1985*
*Cast bronze with silver plating*
*40½ × 9½ × 9½"*
*Collection of Joan and Jack Quinn*

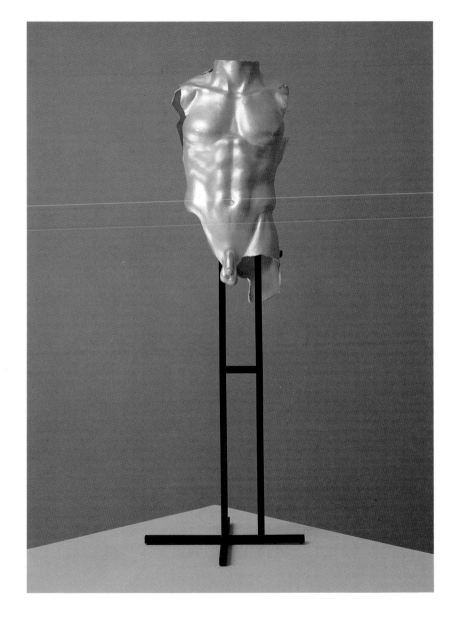

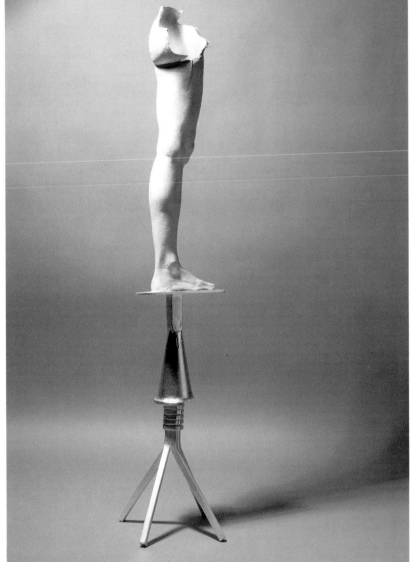

**Joseph Beuys**

Blitzschlag *(Lightning), 1982–85*
*Bronze*
*246 × 98 × 20"*
*Installation view:*
*"German Art in the Twentieth Century,"*
*Royal Academy, London*
*Anthony d'Offay Gallery, London*

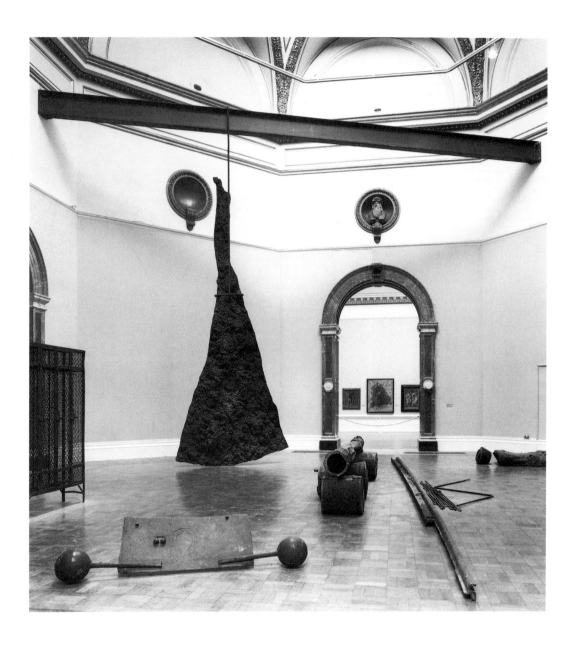

**Joseph Beuys**

Blitzschlag mit Lichtschein auf
Hirsch, *1958–85*
*(Lightning with Stag in its Glare)*
*Environment with 39 parts*
*Detail:* Ziege *(Goat)*
*Bronze*
*19¼ × 36½ × 28¼"*
*Anthony d'Offay Gallery, London*

**Joseph Beuys**

Blitzschlag mit Lichtschein auf
Hirsch, *1958–85*
*(Lightning with Stag in its Glare)*
*Environment with 39 parts*
*Detail:* Bothia felix
*Bronze*
*63 × 15¾ × 15½"*
*Anthony d'Offay Gallery, London*

151

**John Duff**

White Oracle, *1983*
*Painted fiberglass*
*71½ × 12¼ × 14½"*
*Collection of Councilman Joel Wachs,*
*Los Angeles*

**John Duff**

Double Tongue, *1985*
*Fiberglass and enamel paint*
*61 × 28 × 12"*
*Collection of Roger I. Davidson*

**Robert Therrien**

No Title, *1983–84*
*Oil on cardboard*
*52 × 40"*
*The Museum of Contemporary Art,*
*Los Angeles*
*Gift of Carl and Roberta Hartnack*

154

**Robert Therrien**

No Title, *1985*
*Wood, enamel, and bronze*
*50 × 12½ × 3¾"*
*Collection of Diane and Steven M. Jacobson*

**Martin Puryear**

Greed's Trophy, *1984*
*Wood, steel wire, and plastic relief*
*153 × 20 × 55"*
*Museum of Modern Art, New York*
*David Rockefeller Fund and purchase, 1984*

**Martin Puryear**

Keeper, *1984*
*Wood and steel wire*
*100 × 34 × 37"*
*Collection of Alan and Wendy Hart*

**Ken Price**

The Pinkest and the Heaviest, *1985*
*Fired clay with acrylic and metallic paint*
*Two parts: 8 × 8½ × 7½"; 7 × 4 × 4"*
*Willard Gallery, New York*

**Ken Price**

Blumpo, *1985*
*Fired clay with acrylic and metallic paint*
*Two parts: 7½ × 6½ × 7"; 6½ × 3½ × 4"*
*The Edward R. Broida Trust, Los Angeles*

**Mark Lere**

*Drawing for* Strut, *1986*
*Graphite and acrylic on herculene*
*42¼ × 37½"*
*Margo Leavin Gallery, Los Angeles*

**Mark Lere**

Standard, *1986*
*Aluminum*
*204 × 30 × 15"*
*Margo Leavin Gallery, Los Angeles*

**The Crux of Minimalism**
*Hal Foster*

ABC art, primary structures, literalist art: even the relatively neutral terms for the minimalist work of Donald Judd, Carl Andre, Robert Morris, Larry Bell, Dan Flavin, Sol LeWitt, Richard Serra, and others betray a negative cast. Typically regarded in the 1960s as reductive and nihilistic, minimalism is now in the 1980s often seen as tedious and irrelevant. Though this trashing does not bear on the museum status of minimalism (which now seems assured),[1] it is too vehement to be only art-world polemical, and too conscious to be only symptomatic of consumer-society amnesia. Both more and less is at stake here, and to show my hand at the start, I will claim that, beyond the vested interests of formalist critics then and image artists now, the trashing of minimalism is conditioned by two related events: in the 1960s by a recognition that minimalism threatens modernist practice—more, that it consummates it, completes and breaks with it at once; and in the 1980s by the implementation of a cultural policy in which a general trashing of the 1960s is used to justify a return to tradition. (It is no secret that, as McCarthyites in the 1950s sought to bury the radicalism of the 1930s, so Reaganites in the 1980s seek to cancel or at least curtail the cultural claims and political gains of the 1960s, so traumatic were they to these neoconservatives.)[2]

In short, what is at stake in this trashing is history, in which minimalism is hardly a dead issue, least of all to those who would make it so. It is, however, a perjured one, for today the minimalist art of the 1960s is used as a foil—reductive, rule-bound, retardataire—for the pluralistic, painterly art of the 1980s.[3] In this way the different cultural politics of the minimalist 1960s and the expressionistic 1980s are misconstrued: for all its apparent freedoms, the latter participates in the cultural regressions of the Reagan era,[4] while the former, restrictive though it may seem, opens up a whole new field of art, one that advanced art of the present continues to explore. Or so it will be the burden of this essay to prove. To do so, the reception of minimalism must first be set in place, then a countermemory posed via a reading of its most important texts. This countermemory will next be used to define the dialectical involvements of minimalism with both (late) modernism and the (neo) avant-garde, which in turn will

suggest a genealogy of art from the 1960s to the 1980s. In this genealogy minimalism will figure not as a distant dead end but as a *brisure* of (post)modern art, an in-between moment of a paradigm shift (in which advanced art of the present will emerge as its complex displacement, not its simple antithesis). Finally, this genealogy will lead us back to the moment of the 1960s and to speculations on the place of minimalism in the greater cultural conjuncture of late capitalism. (Such, in any case, is what I think should be attempted. After two decades minimalism can be grasped objectively, even historically: it is too late in the day for another play-by-play monograph on this minimalist or that movement.)

### Reception

*I object to the whole reduction idea.*   Donald Judd
On first glance it all looks so simple: the "specificity" of Judd's Plexiglas boxes, the "presence" of Morris's polyhedrons, the "immediacy" of Serra's iron slabs, the "logic" of LeWitt's white lattices, the "self-referentiality" of Bell's glass cubes, etc., etc. Yet in each case a subtle ambiguity complicates things. At odds with Judd's specific objects is his often nonspecific composition ("one thing after another").[5] And just as Morris's gestalts are more contingent than ideal forms, so Serra's structures are continually redefined by our perception of them in time. Meanwhile, LeWitt's logic is as madly obsessive as Lewis Carroll's;[6] and even as Bell's glass approaches the autistic, it reflects the outside world. So what you see is what you see, as Frank Stella famously said, but things are not as simple as they seem: the positivism of minimalism notwithstanding, perception becomes reflexive in these works, and renders them complex.

Though the experiential surprise of minimalism is difficult to recapture, its intellectual surprise remains, for minimalism breaks with the formal space of modern sculpture (if not definitively with the immanent spaces of the dadaist readymade and the constructivist relief). Not only does it reject the anthropomorphic basis of most traditional sculpture (still residual, as Judd saw, in the "gestures" of Mark di Suvero's beams), but it also refuses the transcendental realm

of most abstract sculpture. In short, with minimalism "sculpture" no longer stands apart, on a pedestal or as pure art, but is repositioned among objects and redefined in terms of place. In this transformation the viewer, refused the safe, sovereign space of formal art, is cast back on the here and now; and rather than scan the surface of a work for a topographical mapping of the properties of its medium, he or she is prompted to explore the perceptual consequences of a particular intervention in a given site.

Made explicit only by later artists, much of this was glimpsed by early critics (though usually in terms of what was "lost" for art). For example, in the ethical charge that minimalism is reductive and nihilistic lay the critical perception that it pushes art toward the quotidian, the utilitarian, the non- or antiartistic. For Clement Greenberg, the minimalists confused the innovative with the outlandish and so pursued such "aesthetically extraneous" things as "presence" rather than the essential qualities of art. This, he believed, was why they worked in three dimensions (note he does not say "in sculpture"), a zone in which what is "specific" for Judd is "arbitrary" for Greenberg: "Minimalist works are readable as art, as almost anything is today—including a door, a table, or a blank sheet of paper."[7] Greenberg, of course, intended this as a scourge, but to the likes of John Cage it was an avant-gardist challenge ("we must bring about a music which is like furniture"[8]), one that was taken up, via Robert Rauschenberg, Jasper Johns, Cage and Merce Cunningham, in minimalist art, music, and dance (if rarely in the interests of a restored use value of culture).[9] Now in all of this Greenberg smelled a rat: the arbitrary, the avant-gardist, in a word, Marcel Duchamp. And this recognition of a return of the readymade paradigm and of the avant-gardist attack on the institution of art, a general one among early critics of minimalism, is one we shall want to retain.

For Richard Wollheim, too, the art content of minimalism was precisely minimal (it was he who gave us the term); yet this suggested to him that the "work" of art be considered in terms less of execution or construction than "of decision or dismantling."[10] Of course, this aesthetic possibility is still taken by most in the guild of high art as a threat; here it is defended against by Greenberg: "Minimal art remains too much a feat of ideation." So runs the other great misreading of minimalism: that it is overly conceptual, cerebral, diagrammatic. This is no less a misreading, made by many conceptual artists, too, when meant positively—i.e., that minimalism captures ideal forms, maps logical structures, or somehow depicts thought. For it is precisely such idealist or metaphysical dualisms (primarily of subject and object) that minimalism seeks to overcome in experience. Thus, far from cerebral, minimalist work corrects the ideality of conception with the contingency of perception—of the senses in the body in a particular time and space (the correction of the concept "cube" by Serra's *House of Cards*, 1969, a massively fragile structure of propped iron slabs, is a good example).[11] And far from diagrammatic, minimalism is precisely not, as "European art" was, "based on systems built beforehand, a priori systems" (or so Judd argued as early as 1966).[12] However, more important to minimalism than even this positivism is the avant-gardist comprehension of art not simply in terms of its materiality (and still less in terms of its conceptuality) but in terms of its conventionality.[13] In short, minimalism is as self-critical as any "Greenbergian" or late modernist art, but its analysis tends toward the epistemological more than the ontological, for it focuses on the perceptual conditions and conventional limits of art, not on its formal essence or categorical being. Perhaps, finally, it is this orientation that confused critics about the "conceptuality" of minimalism and its progeny.

More than any other critic, Rosalind Krauss has taken the minimalist rejection of the a priori to heart; as a result, there is little confusion in her work about the conceptuality of minimalism. Indeed, in her phenomenological reading what is most at stake in minimalism is the nature of meaning and the status of the subject, conceived as public, not private, produced in experience in the world, not in a hypothetical pure and prior space of intentionality. This minimalist model contradicts the two dominant models of abstract

*Donald Judd*
Untitled, *1966–68*
*Stainless steel and Plexiglas*
*6 units: 34 × 34 × 34″ each*
*Layton Art Collection*
*Milwaukee Art Museum*

*Robert Morris*
*Installation view of one-person exhibition*
*Green Gallery, New York, 1964*

*Carl Andre*
Zinc-Lead Plain, *New York, 1969*
*Zinc and lead*
*36 units, 18 plates each metal alternating*
*⅜ × 12 × 12" each; ⅜ × 72 × 72"*
*Paula Cooper Gallery, New York*

*Sol LeWitt*
13/11, *1985*
*Paint on wood*
*60 × 120 × 60"*
*John Weber Gallery, New York*

*Dan Flavin*
the nominal three (to William of Ockham), *1963*
*Daylight fluorescent light*
*Six units: 96" high*
*Panza Collection*

*Richard Serra*
One Ton Prop (House of Cards), *1969*
*Lead antimony*
*Four plates: 48 × 48"*
*Collection of the Grinstein Family,*
*Los Angeles*

expressionism—that of the expressive artist and that of the formal critic of the medium—presented respectively by Harold Rosenberg and Greenberg. Yet it challenges more, for this figure of the artist-actor and this imperative of a categorical approach to art are important aspects of modern formalist aesthetics. Thus, as Michael Fried was quick to see, minimalism, with its stress on the temporality of perception, threatens the disciplinary order of this aesthetics, in which visual art is purely and entirely visual. As is well known, it is primarily for this "category mistake" that Fried condemned minimalism—and rightly so, from his position, for minimalism did in effect release temporal concerns into art[14] (process, performance, the ephemeral, the allegorical, etc.) to the point where, soon after minimalism, it was difficult to see a given work of art as purely present, to be grasped in a single glance, a transcendental moment of grace. As minimalism challenges this order of modern aesthetics, it also contradicts its idealist model of consciousness, and this, Krauss argued, is the real import of the famous minimalist attack on the anthropomorphic and the illusionist: that they constituted not simply a dated abstract expressionist or "European" paradigm of art, but an ideological model of meaning. In "Specific Objects" (1965) Judd had already made the analogy between a relational composition and a "discredited rationalism." In "Sense and Sensibility: Reflection on Post '60s Sculpture" (1973) Krauss posed a related analogy between illusionism and intentionality: the idea of intentionality, she argued, presupposes an "illusionist" space for consciousness, one that is idealist and ideological. Thus, to (a)void the relational and the illusionist, as minimalism sought to do through an insistence on nonhierarchical orderings and literal readings, was in principle to (a)void the aesthetic correlates of idealism.

This is a strong reading of minimalism, and yet it seems paradoxical (in ways provocative enough, I hope, to warrant a digression). As noted, Krauss's is a phenomenological account of minimalism, of minimalism as a phenomenology—an art that insists on the inseparability of the temporal and the spatial in (any reading of) art. In her 1977 book, *Passages in Modern Sculpture* (the title of which

proclaims this inseparability), Krauss uses this point to rethink the modern history of the medium: in effect, she gives us a minimalist history of modern sculpture in which minimalism emerges as its penultimate achievement.[15] (Of art that follows directly on minimalism, such as Robert Smithson's *Spiral Jetty*, 1970, Serra's *Shift*, 1970–72, and Bruce Nauman's video *Corridor*, 1968–70, she writes, "The transformation of sculpture—from a static, idealized medium to a temporal and material one—that had begun with Rodin is fully achieved."[16]) Here, rather than posit minimalism as a break with modernist practice (the conclusion to which her later criticism tends), Krauss seems to project its recognition back into modernism so that she can then read minimalism as its epitome. This, I think, is only partly correct: minimalism is this apogee, but it is no less this break.

What interests me here, however, is the anachronism of this minimalist reading of modern sculpture, which early in her book Krauss justifies in this way:
*The history of modern sculpture coincides with the development of two bodies of thought, phenomenology and structural linguistics, in which meaning is understood to depend on the way that any form of being contains the latent experience of its opposite: simultaneity always containing an implicit experience of sequence.*[17]

Now phenomenology and structural linguistics (in the persons of Edmund Husserl and Ferdinand de Saussure) were roughly contemporaneous with high modernism, yet neither discourse became generally current—the first in the United States, the second in France—until the 1960s, that is, the time of minimalism. This conjuncture is an intellectually contradictory one, for the two discourses are in tension (especially so in this second moment of the 1960s). For example, (post)structuralism is far more critical of idealist consciousness and humanist history than phenomenology ever was; indeed, phenomenology was attacked because such notions were felt to be residual in it. And so, if one agrees that minimalism is phenomenological at base, one might ask how radical is *its* critique of these notions.[18] For instance, just as phenomenology undercuts the

idealism of the Cartesian "I think," so minimalism undercuts the existentialism of the Pollockian "I express"—but do not both substitute an "I perceive" that leaves meaning lodged in the subject?

On another level, one might question if there is not a strange "return" of the body to sculpture in the very minimalist work that proclaims its total effacement from art—not, to be sure, in the explicit representation of an image or a gesture, or even in the implicit suggestion of a prior system or space of consciousness, but rather in the "theatrical" presence (as Fried called it) of the minimalist objects, unitary and symmetrical as they often are . . . just like a person. This leads in turn to the conception of the perceiver in this work. In phenomenological terms the minimalist delineation of perception is said to be "preobjective," which is to suggest that perception is somehow before or outside history, language, sexuality, power—that the perceiver is not a sexed body, that the gallery or museum is not an ideological apparatus. Here I am the one who is anachronistic (not to say perverse) to question minimalism on matters developed only by later art, and yet such an inquiry does point to the historical and ideological limits of this art, limits expanded by its critical followers. These questions, however, must await a more thorough analysis of the discourse of minimalism in its own time.

## Discourse
*There is no way you can frame it.*   Tony Smith
There are three crucial texts on minimalism written in its own time: Judd's "Specific Objects" (1965), Morris's "Notes on Sculpture" (1966), and Fried's "Art and Objecthood" (1967).[19] Though well known, they present the original claims of minimalism, and manifest its historical contradictions, in ways that are not well understood.

The year of "Specific Objects," 1965, was also the year of the Greenberg position paper "Modernist Painting" (which followed by four years his collection of essays *Art and Culture*). In this context the first two claims made by Judd—that minimalism is neither "painting nor sculpture" and that "linear history has unraveled

somewhat"—read as a defiance of both the categorical and historicist aspects of Greenbergian formalism. Yet this defiance developed as an excessive devotion. For example, the reservation voiced by Greenberg about some cubistic painting—that its content is too governed by its edge ("American-Type Painting")—is elaborated by Judd into a brief against all modernist painting: its flat, rectangular format "determines and limits the arrangement of whatever is on and inside it." Here, as Judd extends Greenberg, he breaks with him, for what Greenberg regards as a definitional essence of painting Judd takes as a conventional limit—literally a frame to exceed. Judd attempts to do this, of course, through a turn to "specific objects," which, he makes clear, are discursively closer to late modernist painting than to late modernist sculpture (which, in the figures of David Smith and di Suvero, remains mired in "anthropomorphic" composition). In short, Judd reads the (putatively) Greenbergian call for an objective painting so literally as to exceed painting altogether in the creation of objects. For what, he asks, can be more objective, more specific, than an object in real space? Moved to fulfill the late modernist program, Judd breaks with it, as is clear from his list of "specific object" prototypes: Duchamp's readymades, Johns's cast objects, Rauschenberg's combines, John Chamberlain's scrap-metal sculptures, Stella's shaped canvases—hardly the Greenberg canon.

This list suggests another consequence of the minimalist supersession of formalist art. As Judd implies, all of these avant-gardist precursors assume to different degrees that "painting and sculpture have become set forms," forms whose historicity, conventionality, *institutionality* can no longer be ignored. "The use of three dimensions," Judd claims (note that he, no more than Greenberg, terms minimalism "sculpture"), "isn't the use of a given form," isn't reified in its conventionality. Indeed, in this realm of objects, Judd suggests, any form, material, process can be used. This expansion opens up criticism, too, as Judd is led by his own logic to this infamous avant-gardist recognition: "A work of art needs only to be interesting." Here, consciously or not, "interest" is posed against the great Greenbergian shibboleth "quality": whereas quality is assessed by

critical reference to the works of the great moderns and to the standards of the old masters, interest is apparently to be judged according to the self-consciousness of a given art work or form regarding its own conventionality. In short, if quality is a criterion of normative criticism, an encomium bestowed upon aesthetic refinement, interest is an avant-gardist term, often measured in terms of epistemological sophistication. Far from normative, it licenses intensive critical inquiry and transgressive aesthetic play.[20]

In "Specific Objects" the mandate that late modernist art pursue the objective is completed only to be exceeded, as Judd and company come out the other side of the objecthood of painting into the realm of objects. Morris's "Notes on Sculpture" presents a different scenario, one even more contradictorily bound up with late modernist discourse.

As Morris retains the category "sculpture," he implicitly disagrees with Judd on the genesis of minimalism: sculpture was never "involved with illusionism," pictorial as it is, and neither is minimalism. Far from a break with sculpture, minimalism realizes "the autonomous and literal nature of sculpture . . . that it have its own, equally literal space." At first, this statement seems contradictory—indeed, it seems to conflate, in its first two adjectives, the Greenberg and Judd positions: the demand for autonomy and the demand for specificity. Yet the contradiction lies in the demands, not in the statement. Morris believes—rightly, I think—that minimalism is a provisional resolution of this contradiction, for the minimalist "gestalt" or unitary form is defined (at least by Morris) as precisely both autonomous and literal. With this gestalt, Morris writes, "one sees and immediately 'believes' that the pattern of one's mind corresponds to the existential fact of the object." Morris's is the most detailed discussion of this quintessentially minimalist tension between "the known constant and the experienced variable," and though he sometimes seems to privilege the general unitary form as prior to the specific particular object (in a way that Krauss argued was not the case with minimalism), he usually presents the two as bound, qua gestalt, "cohesively and indivisibly together." This unity is necessary

for Morris to retain the category "sculpture," and, more, to posit shape as its essential characteristic.

And yet is this argument not slightly circular? Morris first defines modern sculpture in terms of minimalism (that it be literal) and then defines minimalism in terms of modern sculpture (that it be autonomous); and, more paradoxically, he arrives at the very property (shape) that a year later Fried will pose as the essential value of *painting*. Part one of "Notes on Sculpture" ends thus: "The magnification of this single most important sculptural value— shape—. . . establishes both a new limit and a new freedom for sculpture." The paradoxicality of this argument—or, rather, the instability of the categories of art, and perhaps even the contradictions of minimalism—begins to be evident. For minimalism seems simultaneously to be a contraction of sculpture (to the modernist pure object) and an expansion of sculpture (beyond recognition?).

In part two of his "Notes," Morris explores this paradoxical situation. First he defines this "new limit" for sculpture by reference to a Tony Smith remark that implicitly positions minimalist work between the object and the monument.[21] (Significantly, Fried also uses this remark not only to circumscribe minimalism but also to argue that, between the object and the monument, it is simply an art of abstract statues— and so again is hardly as antianthropomorphic, as radical, as is claimed.) In a brilliant move, Morris then redefines this object/ monument scale in terms of private and public address, in terms, that is, of *reception*—a shift in orientation that turns the "new limit" for sculpture into its "new freedom." One intermediate step is needed, however, and so Morris returns to the minimalist gestalt, which, he says now, was developed not only to "set the work beyond *retardataire* Cubist [i.e., relational] esthetics," but, more importantly, to "take relationships out of the work and make them a function of space, light, and the viewer's field of vision." In this way, as Judd exceeded Greenberg, so Morris exceeds both, for here a new space of "object/subject terms" opens up. The minimalist suppression of the anthropomorphic is more than a reaction against

abstract expressionism; it is a "death of the author" (as Roland Barthes would call it two years later) that is at the same time a birth of the reader:

*The object is but one of the terms of the newer esthetic. . . . One is more aware than before that he himself is establishing relationships as he apprehends the object from various positions and under varying conditions of light and spatial context.*

Here we are at the edge of "sculpture in the expanded field" (as Krauss would call it thirteen years later). And yet, even as Morris announces this new freedom for sculpture, he seems ambivalent about it: in a flurry of contradictory statements he both tentatively pulls back ("That the space of the room becomes of such importance does not mean that an environmental situation is being established") and impulsively moves forward ("Why not put the work outside and further change the terms?").

Finally, "Notes on Sculpture" is caught in the contradictions of its moment: on the one hand, Morris insists that sculpture remain autonomous, and on the other, that "some of the new work has expanded the terms of sculpture" to the point where the object is "but one of" them. It is this expanded field, foreseen by "Notes on Sculpture," that Fried's "Art and Objecthood" is pledged to forestall. More than the other two texts, this famous essay fully comprehends minimalism in its threat to (formalist) modernism; indeed, Fried prosecutes minimalism—arraigns it, cross-examines it, finally condemns it. First, he details the minimalist crime: an attempt to displace modernist art by means of a literal reading that confuses its transcendental "presentness" with mere objecthood. According to Fried, the essential difference between minimalism and (late) modernist art is that minimalism seeks "to discover and project objecthood as such," whereas (late) modernist art aspires "to defeat or suspend" it. Here, Fried contends, "the critical factor is *shape*," which, far from an essential sculptural value (as Morris would have it), is an essential pictorial value. Indeed, it is only by its ability to "compel conviction as shape" that late modernist painting (e.g., that of Kenneth Noland, Jules Olitski, Stella) is able to suspend its

objecthood, transcend the literalism of minimalism and so achieve presentness.[22]

Given this, Fried must next show why minimalist literalism is "antithetical to art." To do so, he argues that the vaunted presence of the minimalist object (which acts, Fried believes, as a surrogate person) sets up a *situation* extrinsic to art. The point here is not simply to show up minimalism as anthropomorphic (as minimalism finds sculpture in general) but rather to present it as "incurably theatrical," for, according to the crucial hypothesis of the essay, "theatre is now the negation of art." To back up this hypothesis, Fried makes a strange detour: a gloss on an anecdote told by Tony Smith about a ride on the unfinished New Jersey Turnpike one night in the early 1950s. For Smith, the protominimalist, this experience was somehow aesthetic but not quite art:

*The experience of the road was something mapped out but not socially recognized. I thought to myself, it ought to be clear that's the end of art. Most painting looks pretty pictorial after that. There is no way you can frame it, you just have to experience it.*

What was here revealed to Smith, Fried writes, was "the conventional nature of art." "And this Smith seems to have understood not as laying bare the essence of art, but as announcing its end."

Here, I believe, is the crux both of the Fried case against minimalism and of the minimalist break with late modernism. For in the Smith epiphany about the conventionality of art is foretold the heretical stake of minimalism and its avant-gardist successors: not to discover the essence of art à la Greenberg but to transgress its institutional limits ("there is no way you can frame it"), to sublate its formal autonomy ("you just have to experience it"), precisely to announce its end. For Fried as for Greenberg, such avant-gardism is infantile: hardly a dialectical sublation of art into life (not that this was truly the aim of minimalism), minimalist transgression obtains only the literalism of a frameless event or object "as it *happens*, as it merely *is*." It is for these reasons that Fried terms minimalist literalism "theatrical": because it involves mundane time, a property, he argues,

improper to visual art. Thus, even if the institutional autonomy of art is not threatened by minimalism, the decorum or order of the arts (i.e., the temporal versus the spatial) is; and this is both why "theatre is now the negation of art" and why minimalism must be condemned.

At this point, the prosecution of minimalism becomes a testament to (formalist) modernism, replete with a set of now famous principles to the effect that "the concept of art" is "meaningful only *within* the individual arts" and "what lies *between* the arts is theatre."[23] Here, then, even as the order of modern (Enlightenment) aesthetics is disrupted on all sides in practice, it is reaffirmed in theory. And, finally, against this practice, against the hellish "endlessness" of minimalist "theatre," Fried opposes the sublime "instantaneousness" of the modernist work "which at every moment . . . is wholly manifest." More than a historical paradigm, more even than an aesthetic essence, this becomes, for Fried at the end of "Art and Objecthood," a spiritual imperative: "Presentness is grace."

It is appropriate that at its summation the theological motives of this legal brief be revealed. (Indeed, with its condemnation of theater and its insistence on direct grace, the essay is distinctly puritanical.) And yet this revelation only remarks its desperation, for in the end this argument depends on an act of faith. Against avant-gardist atheism, we are asked to believe in consensual quality, "specifically, the conviction that a particular painting or sculpture or poem or piece of music can or cannot support comparison with past work within that art whose quality is not in doubt. . . ." As Judd implicitly countered "quality" with "interest," so here Fried explicitly counters "interest" with "conviction," which, like Greenberg, he attempts to save from subjectivism by reference to quasi-objective (i.e., conservative) standards of taste. In short, beyond respect for the old decorum of the arts, Fried demands Devotion to Art; and in the words "compel conviction" are exposed both the disciplinary and the religious underpinnings of his aesthetic. Apparently, the real threat of the minimalist paradigm is not only that it disrupts the autonomy of art but that it corrodes belief in art—that it saps the conviction-value (and so the ideology-value?) of art. Indeed, is it too much to suggest that "art for art's sake" returns here in its authoritative (authoritarian?) guise, a guise which reveals that, far from separate from power and religion (as Enlightenment philosophy would have it), bourgeois art is a displaced will to power and a secret substitute for religion—and ultimately *is* a religion?[24]

## Ruptures, Repetitions, Genealogies
*Root, hog or die.*   Donald Judd

In a way, Michael Fried is to minimalism what Edmund Burke was to the French Revolution: its best critic because its most serious, conservative, and foreign. Like Burke, Fried appreciates the threat of his adversary, which he regards as a corruption of (late) modernism "by a sensibility *already* theatrical, already (to say the worst) corrupted or perverted by theatre." In this reading minimalism develops out of (late) modernism only to "corrupt" it, literally to break it apart (in the Latin, *corrumpere*, to break), contaminated as minimalism already is by theater. Now "theater" here represents more than a concern with time alien to visual art; it is also, as "the negation of art," a code word for avant-gardism. We arrive, then, at this equation: *minimalism breaks with (late) modernism in part via a reprise of avant-gardism* (specifically its disruption of the formal categories of institutional art). To understand minimalism fully—which is to say, to understand its significance for advanced art since its time—both parts of this equation must be grasped at once.

First, the minimalist break. As we saw, minimalism begins with Judd as a reading of (late) modernism so literal that its call for a self-critical objectivity is answered perversely by "specific objects." Morris seeks to reconcile this new minimalist literalism with the old modernist autonomy via the "gestalt," only by this very concept to shift attention away from the object to its perception, to its situation. Fried then rises to condemn this "theatrical" move as a threat to artistic decorum and a corruption of artistic conviction; in so doing, he exposes the disciplinary and religious basis of (his own) formalist

aesthetics. In this scenario minimalism emerges as a dialectical moment of "a new limit and a new freedom" for art, in which, for example, sculpture is reduced one minute to the status of a thing "between an object and a monument" and expanded the next to an experience of sites "mapped out" but "not socially recognized" ("turnpikes, air strips, drill grounds"—the very expanded field considered preposterous by Fried but soon explored by Smithson and others). In short, minimalism appears as a historical crux in which the formalist autonomy of art is at once achieved and broken up, in which the ideal of pure art becomes the reality of just another specific object among serial others, one thing after another.

This last point leads to the other side of the minimalist rupture, for if minimalism breaks with (late) modernism, by the same token it allows for the postmodernist art to come; and, indeed, even as minimalism consummates the "empirico-transcendental" analytic of (late) modernism (its concern with the material and present aspects of art), it also initiates the "system-immanent"[25] critique of postmodernism (its analysis of the institutional and discursive conditions of art). But before this genealogy is sketched, we must come to terms with the avant-gardist part of the minimalist equation, an aspect disdained, as we saw, by most early critics of the art.

Immediately, this "return" of avant-gardism poses the problem of its "delay" throughout the 1930s, 1940s, and 1950s—that is to say, of its repression by fascism, Stalinism and, in the United States, by social realism, formalism, etc. Indeed, the American repression of the transgressive avant-garde (i.e., dadaism, productivism, surrealism) was instrumental to the dominance of Greenbergian formalism, which not only overbore this avant-garde institutionally but also redefined it almost out of existence. Thus, for Greenberg in "Avant-Garde and Kitsch" (1939, 1961), the only true avant-garde is the aestheticist, not the anarchic, one, and its aim is not at all to sublate art into life but rather to purify art from life. According to Greenberg, advanced art turned to its own internal forms and processes in order to maintain the standards of past art in the face of debasement by mass-cultural kitsch and abandonment by the middle class—to ensure quality, purity, competence. In effect, then, this formalist avant-garde sought to preserve precisely what the transgressive avant-garde sought to transform or destroy: the institutional autonomy of art.

Now this American "transformation" of the avant-garde answered certain needs: on the one hand, the need to depoliticize advanced art so as to suit the tastes of a renewed middle class of postwar prosperity, and on the other, the need to repoliticize it so that it might serve, recoded as an American project, as a cultural-political example, in the Cold War, of the freedom of American expression (the Triumph of American Painting, etc.).[26] Finally, however, this transformation is at one with the repressive delay of the transgressive avant-garde, regarding which a couple of other factors should be mentioned here, as they bear on minimalism. One is the historical immaturity, relative to Europe, of American institutions of high art, which, of course, had to be established before they could be embattled. In this eventual enshrinement modern art was also enshrined, and this, along with the wartime presence of European modernists in the United States, allowed for the recognition of modern art as a discourse, as an institution, as a period. (After all, the minimalists did draw on moments of this repressed modernism, in part as a way to think through its formalist reading: Judd/Duchamp, Flavin/Vladimir Tatlin, etc.) All of which set up the return of avant-gardism in minimalism—a return that, with the force of the repressed, was able to break up the order of late modernism.

This avant-gardist connection may explain why, in the very first sentence of "Art and Objecthood," Fried brands minimalism as "largely ideological" (even though, like its literary contemporary the *nouveau roman*, it sought a zero degree of "ideological" content). Apart from the suggestion here that minimalism is an aesthetic fraud that corrodes conviction in art, there is the intimation that minimalism is a self-conscious position *on* art—and that this self-consciousness allows minimalism not only to comprehend modern art as an institutional discourse (an array of other "largely ideological"

positions), but also to intervene in this discourse *as* a position. Again, this is an avant-gardist recognition (Fried smelled the same rat: Duchamp and his disciples), but minimalism does more than hollowly repeat it, for it is only with minimalism, I want to argue, that this understanding becomes self-conscious. To argue this, the stake of the historical (transgressive) avant-garde must first be grasped, and here Peter Bürger's *Theory of the Avant-Garde* (1974, 1984) is useful.

In this important, problematic essay, Bürger applies to art history the Marxian discovery that the degree of theoretical understanding of any cultural object depends on the degree of its historical development. This premise allows him to argue that art became an autonomous institution only in capitalist society, for only then was it relieved, by the ideology of fair exchange, of its role as a means of legitimation. The achievement of this institutional autonomy set up in turn the avant-gardist critique: indeed, the autonomy of art is both precondition and target of its attack. Now in this critique, Bürger argues, artistic means are revealed as such, i.e., as historical conventions (and not, say, as natural creations or zeitgeist expressions). And it is this recognition that enables, at least in principle, the radical redefinition of these means and the potential reintegration of them into social practice.

Now, for Bürger, the failure of the historical avant-garde—of the dadaists to destroy the traditional art categories, of the surrealists to reconcile art, desire, and politics; of the productivists to transform the cultural means of production, etc.—makes any further attempts not only futile but meaningless: "Since now the protest of the historical avant-garde against art as an institution is accepted as art, the gesture of the neo–avant-garde becomes inauthentic." And yet the full mission of the avant-garde is understood only in its neo–avant-garde repetition, for *it is only in the 1950s and 1960s that the institutionality not only of art but also of the avant-garde is appreciated and exploited*. Here, however, two different moments of the neo–avant-garde must be distinguished. The first moment (that

of Rauschenberg, Yves Klein, etc.) is more simply a reprise of the historical avant-garde attempt "to reconnect art and life," and inasmuch as this is so, its failure, after that of the historical avant-garde, does read as farce, in which it is not the institution of art that is transformed, but the avant-garde—into an institution. (Thus one could speak, as early as Johns, of a Duchampian "tradition.") And yet this farce has value, precisely for this reason: rather than doom all avant-gardism to mere repetition, the very failure of the first neo–avant-garde prompts a more practical critique of the institution of art, the tradition of the avant-garde, and other discourses. In the second neo–avant-garde moment—that of minimalism and pop art— the aim is not naively to reconnect art and life but, on the one hand, to reflect on the perceptual conditions of art (minimalism), and on the other to exploit the conventionality of the avant-garde (Andy Warhol, Roy Lichtenstein). (Indeed, with the perverse integration in pop of art and life, a new object of avant-gardist critique emerges: the culture industry.)

In short, the very failure of the historical avant-garde and of the first neo–avant-garde to destroy the institution of art enables the practical criticism of this institution by the second neo–avant-garde, a critique that in turn enables the analysis of other institutions in the advanced art of our own time. For Bürger, however, this failure leaves us in a state of pluralistic irrelevance:
*Through the avant-garde movements, the historical succession of techniques and styles has been transformed into a simultaneity of the radically disparate. The consequence is that no movement in the arts today can legitimately claim to be historically more advanced as art than any other.*[28]
Though this is a good description of the "posthistorical" attitude of many contemporary artists, it neglects the very lesson of the avant-garde taught by Bürger: the historicity of art. It also neglects the fact that the critique of the institution of art, and of other institutions, continues in advanced art,[29] and that this critique may well be a criterion according to which art can be "legitimately claimed" to be "advanced."

Finally, my claim that the mission of the avant-garde is comprehended, if not completed, only with the minimalist neo–avant-garde rests on the belief that the "break" that Bürger considers the ultimate significance of the avant-garde is only achieved by this neo–avant-garde, in its contestation of formalist modernism:

*The meaning of the break in the history of art that the historical avant-garde movements provoked does not consist in the destruction of art as an institution, but in the destruction of the possibility of positing aesthetic norms as valid ones. This has consequences for scholarly dealings with works of art; the normative examination is replaced by a functional analysis, the object of whose investigation would be the social effect (function) of a work, which is the result of the coming together of stimuli inside the work and a sociologically definable public within an already existing institutional frame.*[30]

To repeat: it is only with minimalism that such "normative examination," in its extreme guise in Greenbergianism, is completely revealed as prejudicial (indeed, as a prejudicial defense against avant-gardism). With this revelation, "quality," also exposed as an imposition of a set of norms, is displaced as a criterion by "interest," and art is henceforth seen to develop less by formal historicist refinement (as in "pursue the pure, extract the extraneous") than by structural historical negation (as in "how can I as an artist expand the aesthetic and ideological limits of the artistic paradigm that I have received?")[31] At this point, too, the object of critical investigation becomes less the essence of a medium than "the social effect (function) of a work" in the present, and, perhaps most important, the intent of artistic intervention becomes less to secure a transcendental "conviction" in art and its institutions than to undertake an immanent critique of its rules and regulations. Indeed, this last may be seen as a provisional distinction between formalist-modernist and avant-gardist–postmodernist art: "to compel conviction" versus "to cast doubt"; "to seek the essential" versus "to reveal the conditional."[32]

None of this develops as smoothly or as completely as is suggested here; and yet, if minimalism is indeed a historical crux, it must suggest not only a perspective on modernist art but also a genealogy of postmodernist art. This genealogy cannot be a formal history of influence or evolution (such as the story of a "dematerialization" of art after minimalism that continues the banal thesis of modernism as a process of reduction), nor can it be simply a psychological or stylistic account of generational conflicts or periodic reactions (as in the trashing of the 1960s with which we began). Indeed, I hope it is clear that only an analysis that computes (among other things) both parts of the minimalist equation—the break with late modernism and the return of avant-gardism—can adequately account for the advanced art of the last twenty-five years or so. There are a few readings of art from the 1960s to the 1980s that treat minimalism as such a crux—either as a break with the modernist aesthetic order *or* as a reprise of strategies of the readymade—and I want to rehearse them briefly here, for they are significant (as much for what they exclude as for what they explain).

Both Douglas Crimp and Craig Owens take as a point of departure the aesthetic order mapped out by Fried in "Art and Objecthood."[33] Whereas for Crimp it is precisely the theatrical, repressed in late modernism, that returns in the performance and video art of the 1970s (to be later recontained in the "pictures" of Cindy Sherman, Sherrie Levine, Robert Longo, Troy Brauntuch, and Jack Goldstein), for Owens the repressed that erupts to disperse the old visual order is "the word": textual art (e.g., the radical modes of Smithson), allegorical art (e.g., the rhetorical collisions of Laurie Anderson). And yet, if the first scenario overlooks the institution-critical art that develops out of minimalism, the second neglects the historical forces behind this "textual" fragmentation of art. (Indeed, neither scheme fully analyzes the historical conditions of these artistic transformations.)

Now as an analysis of perception, minimalism is also an analysis of the conditions of perception. This leads logically to a critique of the spaces of art (e.g., Michael Asher), of its exhibition conventions (e.g.,

Daniel Buren), of its commodity status (e.g., Hans Haacke): in short, a passage from perceptual critique to institutional critique. For Benjamin Buchloh, this history is essentially a genealogy of the presentational strategies, at once constructive and allegorical, of the readymade. And yet such a narrative also leaves out a crucial element: the concern with the constitution (sexual, linguistic, etc.) of the subject. This concern is also left out of the art, for, as we saw, even as minimalism turned from the object orientation of formalism to the subject orientation of phenomenology, it tended to treat the perceiver as historically innocent, sexually indifferent—as did the institution-critical art that developed out of minimalism. For later (especially feminist) critical art, the constitution of the subject is of the utmost importance, and it has led disparate artists (Barbara Kruger, Mary Kelly, Martha Rosler, Louise Lawler, Silvia Kolbowski, etc., etc.) to discourses adjacent to the art world—most obviously, to the representation of women in mass culture. It is largely in the ramifications of this dialectical argument (within and without the art world) that contemporary critical art is still engaged.[34]

Nevertheless, *all* these genealogies, too schematically sketched here, neglect crucial contextual forces. It is important, then, to return briefly to the moment of the 1960s and to attempt to place minimalism provisionally in this context. For only so placed will minimalism, its artistic legatees, and, to some degree, our own historical conjuncture begin to be clarified.

### Art in the 1960s: A Pop-Mini-Series

One way to clarify the place of minimalism is to see it in conjunction with pop art, as different responses to the same moment in the dialectic of modernism and mass culture. Both minimalism and pop confront, on the one hand, the rarefied high-artistic order of late modernism and, on the other, the spectacular mass-cultural world of late capitalism, and both are soon overwhelmed by the contradictions that prompted them in the first place. For example, if pop seeks to use mass-cultural representations in order to test high-artistic categories, it does so, finally, only to recoup the former for the latter (whose forms remain intact). And if, for its part, minimalism refuses both mass mediation and high rarefaction in an attempt to restore a transformative totality to art, it does so, finally, only to see this totality dispersed at the moment of its achievement across an expanded field of cultural activity.[35] On the one hand, then, the fabled integration of high and low is attained in pop—but only in the interests of the culture industry (to which, with Warhol, the avant-garde becomes a subcontractor more than an antagonist);[36] and on the other, as we have seen, the fabled autonomy of art is consummated with minimalism—and immediately corrupted.

But what effects this "corruption," that "integration"? The minimalist refusal, and the pop embrace, of the mass-cultural may be a clue, for the first may reflect negatively what the second represents positively, namely, the rise of a new order of serial production and consumer culture. For example, is the minimalist stress on presence and perception not in part a resistance to a world of ubiquitous representation and intensive mediation? Moreover, is the minimalist insistence on specificity not in part a response to a world of serial copies without originals (even as minimalism, like pop, employs serial techniques)? Surely the emphasis in minimalism on the here and now cannot be explained simply as an enthusiasm for phenomenology, nor can its critique of both subjectivity and history (as the grounds, respectively, for the production and the understanding of art) be reduced to structuralist positions of the time. Again, are these critiques not, in some way, responses (the first a kind of resistance, the second a kind of reflection) to historical processes of fragmentation (of the subject) and reification (of history)? After all, Fredric Jameson has argued, it is in the 1960s that these processes, associated since Marx with the logic of capitalism, reach a new intensive level, and indeed effect an "eclipse, finally, of all depth, especially *historicity* itself, with the subsequent appearance of pastiche and nostalgia art."[37] Is not some such partial "eclipse" announced in minimalism and pop, with each, in its very different way, so insistent on the externality, the superficiality, of contemporary images, meaning, experience? (Certainly the putative reaction to this eclipse—

"pastiche and nostalgia"—is evident in the cultural wares of the present.)

However, our analysis will remain conjectural (at the homological level of "reflections" or the mechanistic level of "responses") unless a more local link between 1960s artistic forms and socioeconomic forces is found. One such link is suggested by the use, in both minimalism and pop, of the readymade. As might be expected, these uses are dialectically different: minimalism considers the industrial readymade not, like pop, "for its thematic implications" but "as an abstract unit," as a way, one thing after another, to avoid the idealism of composition.[38] But to what *order* does this one-thing-after-another-ness tend? To work in a series, to serial production (the minimalist industrial object, the pop simulacrum). Serial art precedes minimalism and pop, of course. According to Jean Baudrillard, the serial principle invades art when its transcendental orders (God, Nature, Ideas) fall, at which time "the oeuvre becomes the original" and "each painting [becomes] a discontinuous term of an indefinite series, and thus legible first not in its relation to the world but in its relation to other paintings by the same artist."[39] And yet with the impressionists, and even with abstract artists, seriality pertains more to the development of the motif than to the technical process of the work.[40] Moreover, even as a principle, it is difficult to conceive of seriality before industrial production, for is it not such production that ultimately eroded those old artistic orders (e.g., that "opacified" nature even as Claude Monet tried, time and again, to seize from it a single, original impression)?

In time, recognition of this serial logic of art led to demonstrations of it (they become almost rote with Rauschenberg); but it is not, I would argue, until minimalism and pop (or maybe the Rauschenberg combines) that *serial production is made consistently integral to the actual technical production of the work of art*. It is finally this that makes the art of the 1960s "signify in the same mode as objects in their everydayness, that is, in their latent *systematic*."[41] And it is finally this that severs art not only from the subjectivity of the artist

(the last order or origin to which abstract expressionism held, in the form of the gesture) but also from the representational paradigm of art. Indeed, it is not the "antiillusionism" of minimalism that "rids" art of the anthropomorphic and the representational, but its serial mode of production: for abstraction *sublates* representation, preserves it even as it cancels it, whereas repetition, the (re)production of simulacra, *subverts* representation, undercuts its referential logic. In any serious social history of paradigms, repetition, not abstraction, may well supercede representation.[42]

Almost since the industrial revolution a contradiction has existed between the anachronistic craft basis of visual art and the advanced industrial order of social life; since Auguste Rodin, sculpture in particular can be read as so many partial, provisional resolutions of this contradiction between "individual aesthetic creation" and "collective social production."[43] With minimalism and pop this contradiction is at once so attenuated (as in the minimalist concern with subtle nuances of perception) and so collapsed (as in Warhol's "I want to be a machine") that it stands revealed for the first time as a principle dynamic of modern art. In this regard, the seriality of minimalism and pop is suggestive locally in relation to art, but it is also more generally indicative of the socioeconomic order of our time. For both minimalism and pop provide evidence of the penetration, in late capitalism, of industrial modes into spheres (such as leisure, sport, and art) previously somewhat preserved from them. As the Marxist economist Ernest Mandel has written,
*Far from representing a "post-industrial society," late capitalism thus constitutes* generalized universal industrialization *for the first time in history. Mechanization, standardization, over-specialization and parcellization of labour, which in the past determined only the realm of commodity production in actual industry, now penetrate into all sectors of social life.*[44]

Now even as minimalism and pop may resist some aspects of this logic (e.g., artistic overspecialization), they exploit others (e.g., mechanization) and announce or foretell still others. For in serial

production (which in some respects goes beyond mass production) a certain degree of difference between image-commodities is allowed;[45] indeed, it is necessary because in our differential series of image-commodities it is largely difference, artificially produced, that we consume. (The Warhol Campbell's soup cans make this point almost didactically: this is also how we consume news, as his 1963 "Disaster" paintings show too.) This logic of difference and repetition structures minimalist and pop work (it is evident, for example, in the minimalist tension between different objects and repetitive ordering). So too, as suggested above, it is this serial structure that integrates minimalism and pop—like no other art before them—into our systematic world of serial objects, images, people. And finally, more than any mass-cultural content in pop, or industrial technique in minimalism, it is this logic, now general to both high art and popular culture, that redefines the lines between high and low culture. Though involvement with this logic must ultimately qualify the transgressivity of minimalism and pop, it is important to stress that they do not merely reflect it: they exploit this logic, which is to say that, at least potentially, they release difference and repetition as subversive forces.[46]

Finally, the break of minimalism and pop must be seen in mediation with other ruptures of the 1960s—social, cultural, political, economic. The best such account of this conjuncture is Jameson's "Periodizing the 60s," in which certain developments remarked here (e.g., the corruption of artistic autonomy[47]) are connected discursively with others. Jameson ultimately refers these ruptures to the end, at this time, of a "long wave"[48] of economic expansion, an expansion that effected the present economic order (electronic, nuclear, etc.) with its strange social sensorium (spectacular, serial, etc.). Yet the diagram of these interconnected breaks is difficult to produce. (For example, Jameson suggests that in the 1960s capital penetrated the last enclaves of "nature"—the unconscious and the third world. Does this suggestion find support in the hypothesis, proposed by Leo Steinberg in relation to Rauschenberg, of a shift at this time from the "natural" paradigm of painting [the vertical picture as window or landscape] to a "cultural" paradigm [the picture as horizontal site for textual images]?[49] If so, how is this distant connection to be mediated, and what would it finally mean?) Difficulty aside, the new immanence of art with minimalism must somehow be seen in conjunction *not only* with the new immanence of critical theory (e.g., the turn, with Michel Foucault and others, from questions of transcendental being, origin, and cause to questions of immanent fields of effects), *but also* with the new immanence of (American) capital (e.g., the transformation of old colonies into new markets). So, too, in the same impossibly(?) dialectical way, the transgressions by minimalism of institutional art must be grasped in connection *not only* with the transgressions (on the part of women, blacks, students, etc.) of chauvinist and racist institutions (of work, class, party, university, etc.), *but also* with the transgressions of American power, for example, in the Vietnam war (which transgressed traditional battle lines, social distinctions of military and civilian, cultural orders of east and west, *people*).

The risk of such an investigation is, of course, the loss of specificity of the art. And yet is it too conjectural to suggest that however critical minimalism and pop are, they still in one way or another carry forth the American order: pop (ironically but brazenly) with its consumer-culture icons, minimalism (connotatively) with its "universal" forms that conjure up the architectural monoliths and corporate logos of American business?[50] In the last analysis it may be that the very historical consciousness for which I have celebrated minimalism and pop—the recognition of the conventionality of art—depends on the privileged, almost posthistorical perspective granted our culture by the near totality of its capital.

1. This trashing *does* bear, however, on the museum status of work that develops the minimalist critique of perception into a critique of art institutions: the work of Michael Asher, Daniel Buren, Hans Haacke, etc.

2. Will the repressed return in the 1990s as it did in the 1960s? On the 1960s conjuncture, see Fredric Jameson, "Periodizing the 60s," in Sohnya Sayres, et al., eds., *The Sixties without Apology* (Minneapolis: University of Minnesota Press, 1984).

3. The stake of this revisionism is suggested by an analogy from conventional art history, in which neoclassical painting is presented as the academic foil for the radical advance of romantic art. Yet if the two are considered as cultural formations, this judgment is qualified: as part of the Enlightenment, neoclassicism advanced the values of the bourgeois revolution, while romanticism, for all its rhetoric of liberation, participated in aristocratic reaction. (The celebration, especially in romantic poetry, of the rustic, the archaic, the feudal is evidence of this.)

4. Donald Judd, "Specific Objects," in *Complete Writings* (New York and Halifax: The Press of the Novia Scotia School of Art and Design, 1975). Unless otherwise stated, all other Judd quotations are from this source, except the two Judd epigraphs, which are from Bruce Glaser, "Questions to Stella and Judd," in Gregory Battcock, ed., *Minimal Art* (New York: Dutton, 1968).

5. See Benjamin H. D. Buchloh, "Figures of Authority, Ciphers of Regression," *October* 16 (Spring 1981); and my "Between Modernism and the Media," in *Recodings: Art, Spectacle, Cultural Politics* (Port Townsend, Wash.: Bay Press, 1985).

6. Or, as Rosalind Krauss suggests, as obsessive as Samuel Beckett's narratives. See her "LeWitt in Progress," in *The Originality of the Avant-Garde and Other Modernist Myths* (Boston: MIT Press, 1984), for a critique of the idealist reading of minimalism.

7. Clement Greenberg, "Recentness of Sculpture," in *Minimal Art*, Battcock, p. 183. All other Greenberg quotations are from this source.

8. John Cage, *Silence* (Middleton, Conn.: Wesleyan University Press, 1961), p. 76.

9. Yvonne Rainer even compared the factory fabrication, unitary forms, and literalness of minimalist art to the found movement, equality of parts, and tasklike activity of Judson Theater dance; see her "A Quasi Survey of Some 'Minimalist' Tendencies in the Quantitatively Minimal Dance Activity Midst the Plethora, or an Analysis of Trio A," in Battcock, *Minimal Art*.

10. Richard Wollheim, "Minimal Art," in Battcock, *Minimal Art*, p. 399.

11. See Krauss, "Sense and Sensibility—Reflection on Post '60s Sculpture," *Artforum* 12, no. 3, November 1973.

12. In Glaser, "Questions to Stella and Judd," in Battcock, *Minimal Art*, p. 156.

13. Both positivist and avant-gardist aspects of minimalism develop in part out of the epistemological skepticism of Johns.

14. See Douglas Crimp, "Pictures," *October* 8, Spring 1979.

15. In this history Krauss favors sculpture which, like minimalism, is materialist (its meaning "opaque," carried on its surface) as opposed to idealist (its meaning "transparent" to its structure). But is not this very opposition idealist?

16. Krauss, *Passages in Modern Sculpture* (Boston: MIT Press, 1977), pp. 292–93.

17. Ibid., pp. 3–4.

18. One way out of this bind is to argue that in certain respects minimalism is conjuncturally closer to structuralism than to phenomenology—to the structural analysis of the (pictorial or sculptural) signifier. Some artists (e.g. Robert Irwin) then develop the phenomenological analysis, others (e.g. Asher) the structural.

19. The latter two essays can be found in Battcock, *Minimal Art*; all Morris and Fried quotations are from this source.

20. Perhaps "interest" does not displace "quality" so much as provide the first term of its normative scheme. In this scheme Judd now occupies the position of "quality" and defends it accordingly. See his "A long discussion not about master-pieces but why there are so few of them," *Art in America* 72, nos. 8 and 9, September and October 1984. I am indebted to Howard Singerman for this point.

21. The remark is a response to questions about a six-foot steel cube by Smith:
Q: *Why didn't you make it larger so that it would loom over the observer?*
A: *I was not making a monument.*
Q: *Then why didn't you make it smaller so that the observer could see over the top?*
A: *I was not making an object.*

22. Even late modernist sculpture such as Anthony Caro's suspends its objecthood, Fried argues, by an emphasis on opticality and "the *efficacy* of gesture."

23. In his historical work Fried reads these principles back into the origins of modernism—a reading symptomatic, Craig Owens has suggested, of an inability to accept its passing.

24. Fried buries in a footnote a gloss on a remark by Greenberg that "a stretched or tacked-up canvas already exists as a picture—though not necessarily as a *successful* one" (in "After Abstract Expressionism," *Art International* 6, no. 8 [October 25, 1962]: 30). Fried must qualify the notion suggested here that modernist art reduces out the conventional because he senses that it prepares, even demands recognition of minimalism as (advanced) art. So, first, he distinguishes between the "irreducible essence of art" and the "minimal conditions" for its recognition as such. Then he argues that this "essence" is conditional—but not to the point where it becomes merely conventional, to the point where artistic autonomy is threatened: "This is not to say that painting *has no* essence; it *is* to claim that that essence—i.e., that which compels conviction—is largely determined by, and

therefore changes continually in response to, the vital work of the recent past." This formula is an affirmation of categorical limits ("painting") and institutional norms ("the vital work") in the face of minimalism. As such, it is an attempt to resolve the contradictions of late modernist discourse inherited from Greenberg—and to resolve them is a way that remains *within* this discourse and stands *against* its supersession in minimalism.

25. The first term in quotation marks is from Michel Foucault, *The Order of Things* (New York: Vintage Books, 1970), where it describes the duality of modern thought; the second is from Peter Bürger, *Theory of the Avant-Garde*, trans. Michael Shaw (Minneapolis: University of Minnesota Press, 1984).

26. See Serge Guilbaut, *How New York Stole the Idea of Modern Art* (Chicago: University of Chicago Press, 1983).

27. Bürger, *Theory of the Avant-Garde*, p. 53.

28. Ibid., p. 63.

29. Indeed, Bürger neglects the institution-critical art contemporaneous with his own text; see Buchloh, "Theorizing the Avant-Garde," *Art in America* 72, no. 11, November 1984.

30. Bürger, *Theory of the Avant-Garde*, p. 87; for a contrary reading of this passage, see Buchloh, "Theorizing the Avant-Garde," p. 21.

31. See Buchloh, "Michael Asher and the Conclusion of Modernist Sculpture," in Chantal Pontbriand, ed., *Performance, Text(e)s & Documents* (Montreal: les éditions Parachute), p. 65.

32. Jameson has discussed this distinction in relation to Hans-Jürgen Syberberg and Jean-Luc Godard: "The essential difference between them, however, is in their relationship to what is called the 'truth content' of art, its claim to possess some truth or epistemological value. This is, indeed, the essential difference between post- and classical modernism (as well as Lukács's conception of realism): the latter still lays claim to the place and function vacated by religion, still draws its resonance from a conviction that through the work of art some authentic vision of the world is immanently expressed. Syberberg's films are modernist in this classical, and what may now seem archaic, sense. Godard's are, however, resolutely postmodernist in that they conceive of themselves as sheer text, as a process of production of representations that have no truth content, are, in this sense, sheer surface or superficiality. It is this conviction which accounts for the reflexivity of the Godard film, its resolution to use representation against itself to destroy the binding or absolute status of any representation." (Jameson, "'In the Destructive Element Immerse': Hans-Jürgen Syberberg and Cultural Revolution," *October* 17 [Summer 1981]: 112).

33. See, in particular, Crimp, "Pictures," and Craig Owens, "Earthwords," *October* 10, Fall 1979. Inasmuch as these critics assume this strict aesthetic partitioning as distinctly modernist, they contradict the "minimalist" reading of modern sculpture (as inseparably spatial *and* temporal) proposed by Krauss.

34. See Buchloh, "Allegorical Procedures: Appropriation and Montage in Contemporary Art," *Artforum* 21, no.1, September 1982; and my "Subversive Signs," in *Recodings*.

35. The different positions of advanced film in the 1960s—on the one hand, the American Independents (Michael Snow, Hollis Frampton, Paul Sharits, etc.) and on the other, Godard and company—are somewhat analogous. To Annette Michelson, the two are dialectical responses to a "trauma of dissociation" suffered by cinema in the course of its industrial division of labor—a division that enforced the conventions and genres of Hollywood film. While Godard and company collide these forms as readymades in a critical montage, the American Independents refuse them and, in a properly modernist reflection on the medium, seek to rearticulate the totality of the art. See Michelson, "Film and the Radical Aspiration," in G. Mast and M. Cohen, eds. *Film Theory and Criticism* (New York: Oxford University Press, 1974).

36. See Owens, "The Problem with Puerilism," *Art in America* 72, no. 6 (Summer 1984): 163.

37. Jameson, "Periodizing the 60s," p. 195.

38. Krauss, *Passages*, p. 250.

39. Jean Baudrillard, *For a Critique of the Political Economy of the Sign*, trans. Charles Levin (St. Louis: Telos Press, 1981), p. 104.

40. See Owens, "Allan McCollum: Repetition and Difference," *Art in America* 71, no. 8 (September 1983): 132.

41. Baudrillard, p. 109. He continues: "It is this serial and differential organization, with its own temporality punctuated by fashion and the recurrence of behavior models, to which art currently testifies."

42. See Jacques Attali, *Noise*, trans. Brian Massumi (Minneapolis: University of Minnesota Press, 1985). On this reading, the so-called "new abstraction" is not about abstract art at all; it develops out of work concerned with spectacular simulation and serial repetition—work that was first posed in part as a critique of representation. See my "Signs Taken for Wonders," *Art in America* 74, no. 6, June 1986.

43. Buchloh, "Michael Asher," p. 58.

44. Ernest Mandel, *Late Capital* (London: Verso, 1978), p. 387.

45. See Owens, "Allan McCollum," and my "Readings in Cultural Resistance," in *Recodings*.

46. As quoted by Owens in "Allan McCollum," Gilles Deleuze writes at the end of *Répétition et différence*, "The more our daily life appears standardized, stereotyped, submitted to the accelerated reproduction of

consumer goods, the more art must become part of life and rescue from it that small difference which operates between levels of repetition, making habitual consumption reverberate with destruction and death; linking cruelty to insanity; discovering, beneath consumption, the chattering of the schizophrenic; and reproducing aesthetically, beneath the ignoble destructions of war (which are still processes of consumption), the illusions of mystifications which are the real essence of this civilization, so that, in the end, Difference can express itself."

47. Jameson traces this "corruption" in a reading of (post)structuralism as symptomatic of the penetration of the sign by capital—to the point where the sign is first fragmented into autonomy (i.e., separated from reference) and then plunged, dispersed, back into social space: "With the eclipse of culture as an autonomous space or sphere, culture itself falls into the world, and the result is not its disappearance but its prodigious expansion. . . ." (p. 201). This acculturation, Jameson concludes, "places acutely on the agenda the neo-Gramscian problem of a new cultural politics today." And yet, in his essays on postmodernism, he neglects the authentically critical—neo-Gramscian—art of the present, and tends to read *all* contemporary American culture as a mere reflection of the logic of late capital.

48. Here Jameson follows Mandel in his rearticulation of the Kondratieff theory of "long waves."

49. See Leo Steinberg, *Other Criteria* (New York: Oxford University Press, 1972).

50. For more on these mediations, see Karl Beveridge and Ian Burn, "Don Judd," *The Fox* 2 (1975).

**Dan Flavin**

pink out of a corner (to Jasper Johns), *1963*
*Pink fluorescent light*
*96 × 3¾″*
*Collection of the artist*
*Courtesy Leo Castelli Gallery, New York*

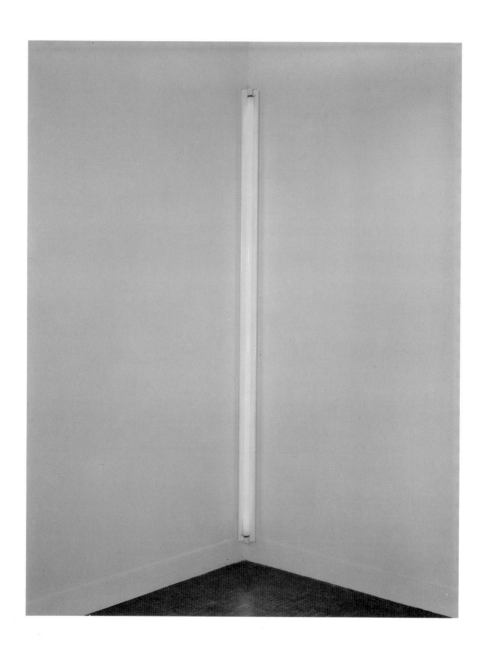

**Dan Flavin**

*"monument" for V. Tatlin, 1969*
*Cool white fluorescent light*
*96 × 32"*
*Collection of Lenore S. and*
*Bernard A. Greenberg*

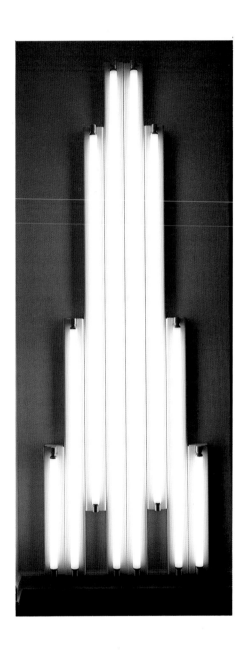

**Larry Bell**

Leaning Room, *1970*
*Installation*
*Artist's studio, Venice, California*

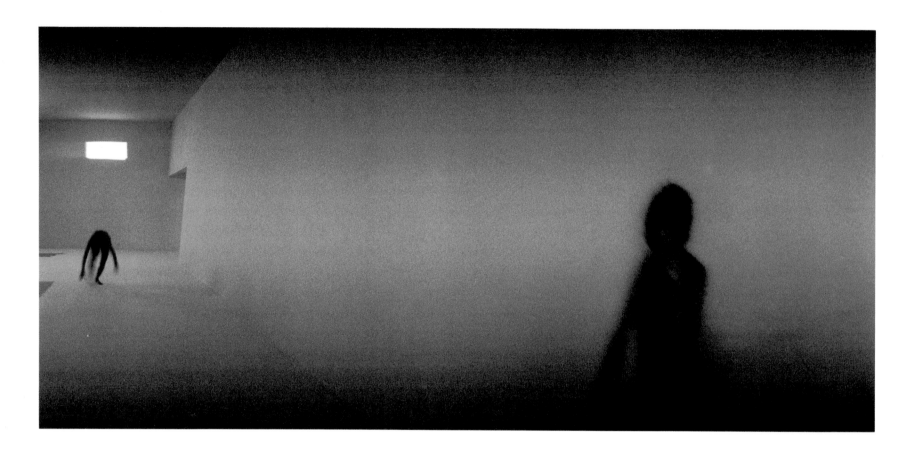

**Larry Bell**

Untitled, *1985*
*Quartz and silicone monoxide on glass*
*cube: 36 × 36 × 36"; base: 36 × 36 × 36"*
*The Museum of Contemporary Art,*
*Los Angeles*
*Gift of the artist*

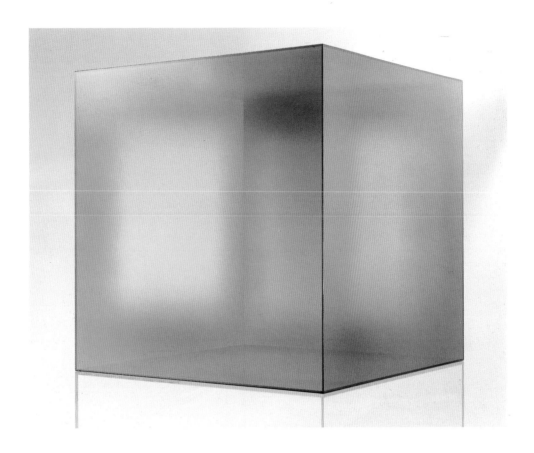

**Richard Serra**

Tilted Arc, *1981*
*Cor-ten steel*
*144 × 1,440 × 2½"*
*Federal Plaza, New York*

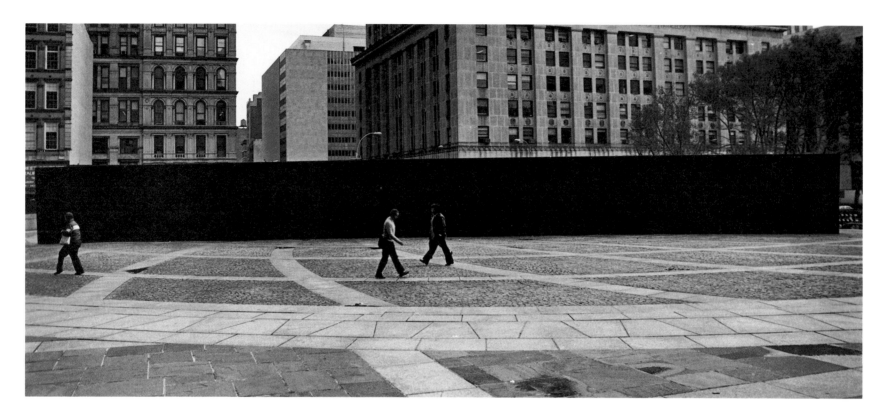

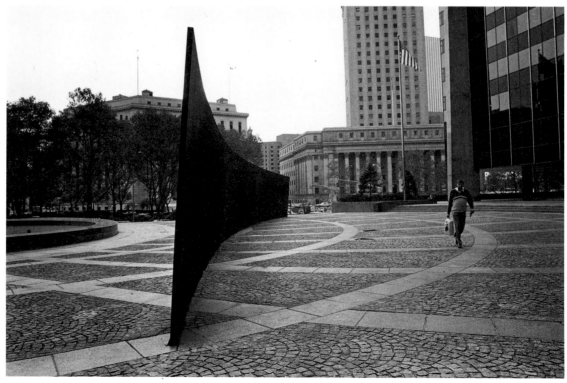

**Richard Serra**

Clara-Clara, *1983*
*Cor-ten steel*
*Two elements: 144 × 1,440 × 2" each*
*Photo of temporary installation:*
*Place de la Concorde, Paris, 1983–84*
*Permanently installed:*
*Square de Choisy, Paris*
*Collection of the city of Paris*

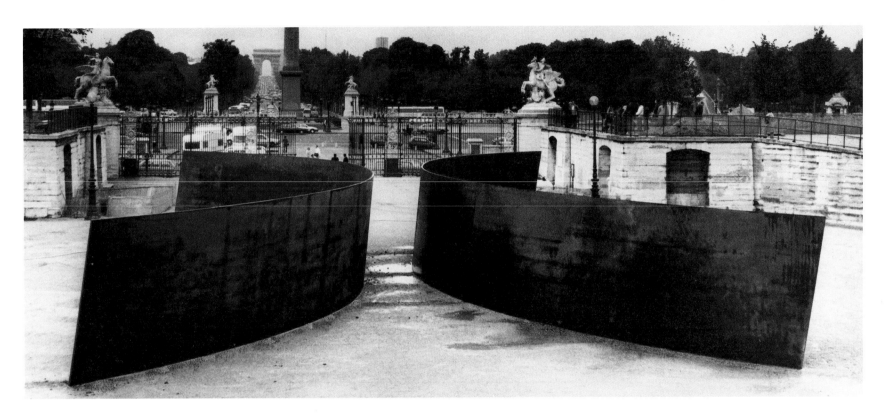

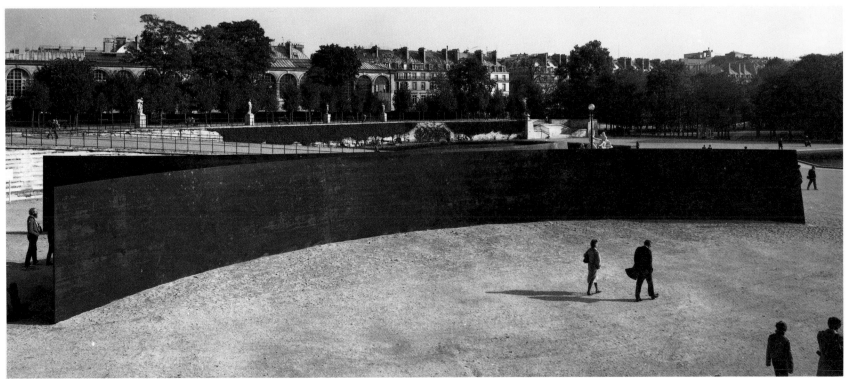

**Donald Judd**

Untitled, *1984*
*½" milled aluminum*
*39³/₈ × 39³/₈ × 13¹/₈"*
*Leo Castelli Gallery, New York*

**Donald Judd**

Untitled, *1985*
*Marine plywood*
*Three units: 39⅜ × 39⅜ × 9⅞" each*
*Waddington Galleries, London*
*Courtesy of the artist*

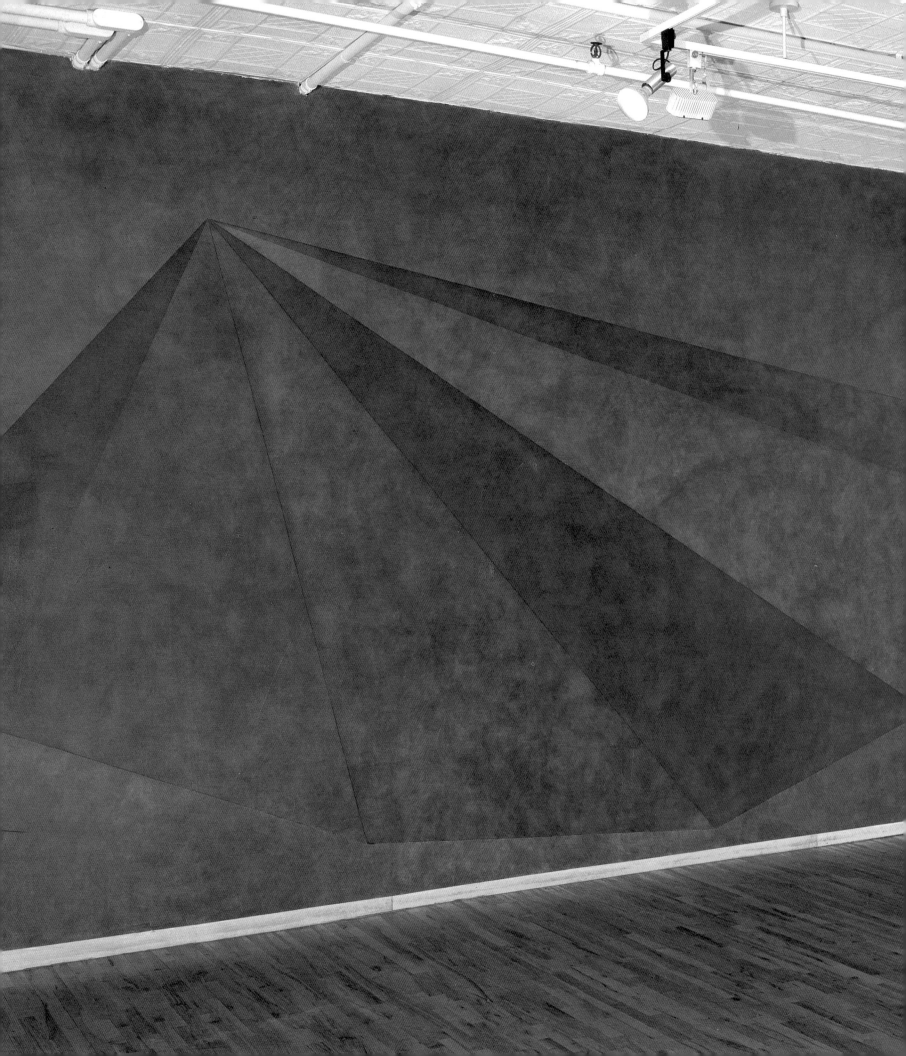

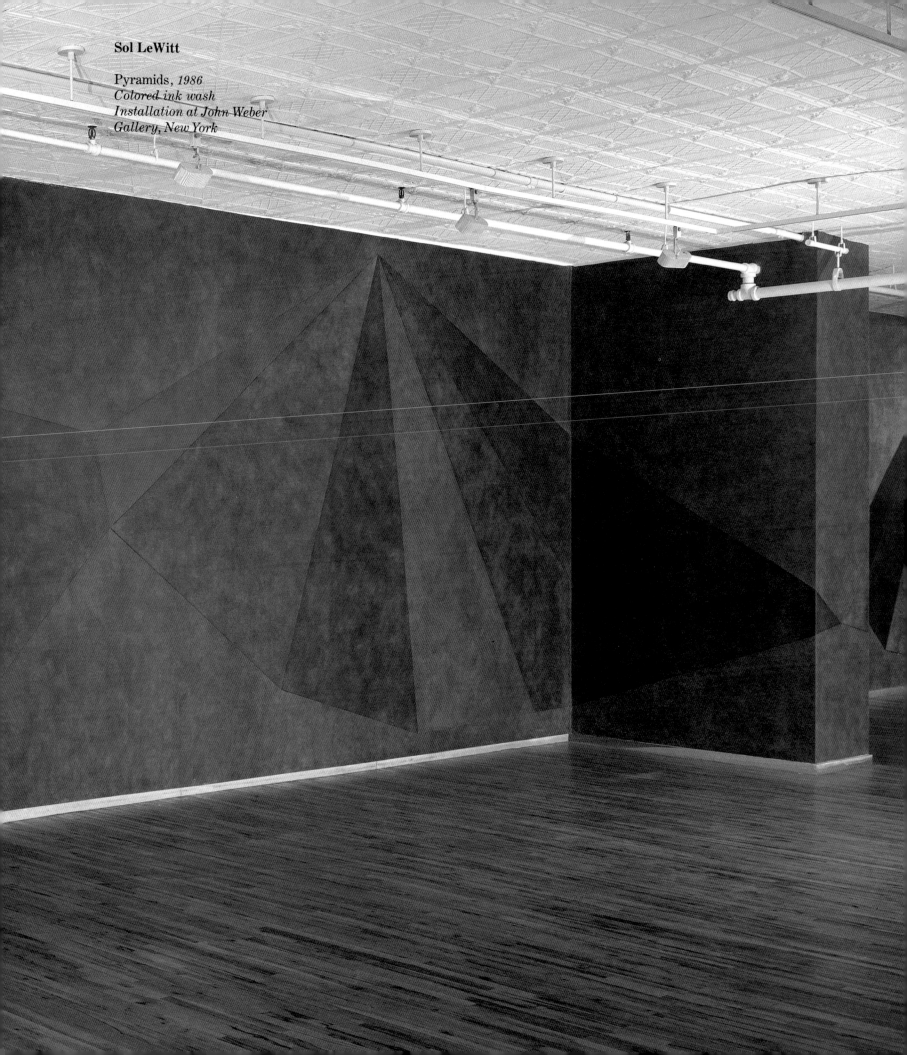

**Sol LeWitt**

Pyramids, *1986*
*Colored ink wash*
*Installation at John Weber*
*Gallery, New York*

## Being There:
## Context, Perception, and Art in the Conditional Tense
*Ronald J. Onorato*

At the edge of a broad, flat expanse of mesa top in southern Nevada is one of the signal artworks of the past several decades. Barely perceptible until one approaches the scalloped lip of the mesa, Michael Heizer's *Double Negative* is carved into the sere earth of the plateau itself. Two gigantic excavated slashes face each other across the indented scarp, roughly paralleling the gorge eroded by the Virgin River, which flows across the valley floor hundreds of feet below. The negative volumes are indeed monumental, displacing some 240,000 tons of earth, which have been pushed into a hollow between the cuts to form on the sloping cliffs a new positive, a rubble ledge.

Conceived and completed in 1969 and 1970, following a series of much smaller cuts in the ground (such as *Isolated Mass/Circumflex*, *Dissipate*, and other works from 1968 that Heizer collectively called "depressions"), *Double Negative* remains, even in its naturally decayed state, the ultimate heroic gesture, and the harbinger of the ideas of a subsequent generation of artists who work on site. While Heizer has denied that the piece was meant to involve the kind of site specificity so prominent in environmental works of the past fifteen years, any on-site experience of *Double Negative* demands that it be read in concert with its surrounds.

The unity implied by the two massive cuts is *Double Negative's* most striking characteristic, but the otherwise uninflected acreage provides a matrix of references for the piece. Approached from the side, each cut reveals in its far wall the geological forces that created the mesa, the river valley, and the neighboring mountains, recorded in stratified cross section. In turn, the landscape's formations bear witness to the upheavals and sedimentary processes unearthed in the trenches of Heizer's art: the syncline strata exposed in the excavation bind his man-made cuts to the ancient mountain shapes across the valley.

Heizer's excavation underlines the most dominant sense of the place; the long horizontal of the mesa top frames and is echoed in his rectilinear chasms. But the severe cuts contrast sharply with the plain's other forms: the meandering curves of the winding river below, the eroded mountains in the distance, and, most immediately, the scalloped escarpment worn into the walls of the mesa. Ancient natural forms created over great expanses of time, they stand in counterpoint to the purpose and the technology that constructed *Double Negative* within the relative immediacy of contemporary artistic practice. In no other landscape could *Double Negative* have been created so successfully, or even realized at all. The geography, geometry, and isolation that charge the place, as well as the way Heizer positioned and constructed *Double Negative* within it, dramatically confirm his axiomatic statement that "anything is only a part of where it is."[1]

From the unique vantage of that mesa we can survey how a number of artists have worked in the same conceptual arena. Artists as diverse as Robert Smithson, Carl Andre, Robert Morris, Dennis Oppenheim, Robert Irwin, and Mary Miss, to name but a few, have created an art that is responsive to the physical, perceptual, and often the cultural essences of sites and audiences. The generation of artists surrounding *Double Negative* is less involved with the tradition of metaphorical spaces and precious objects than they are with heightening our awareness of how we perceive the spatial and temporal continuum of experience. They challenge us to reconsider how we live with the consequences of the assumptions we make about real time and actual space as we move in our everyday worlds. Be they realized through Heizer's heavy earth-moving machinery or James Turrell's projected light, Richard Fleischner's dressed stone or Robert Irwin's fabric scrims, Alice Aycock's rough wooden framing, the auditory electronics of Michael Brewster, or the fluorescent hardware of Dan Flavin, these situational works are part of an experiential investigation that has located a rich and common ground for art-making, one largely untapped before the mid-1960s. They may most often be based on a frankly architectural vocabulary of floors, windows, and walls, but it is really light, topography, ambient noise, the spaces between things, and the scale of their relationships that are the raw materials this generation uses to create its participatory,

*Michael Heizer*
Double Negative, *1969–70*
*240,000 ton displacement in rhyolite and sandstone*
*1,500 × 50 × 30′*
*Mormon Mesa, Overton, Nevada*
*The Museum of Contemporary Art,*
*Los Angeles*
*Gift of Virginia Dwan*
*left photograph: 1970*
*right photograph: 1986*

Robert Morris
Three Rulers, *1963*
*Painted wood*
*17 × 11½ × 1¼"*
*Leo Castelli Gallery, New York*

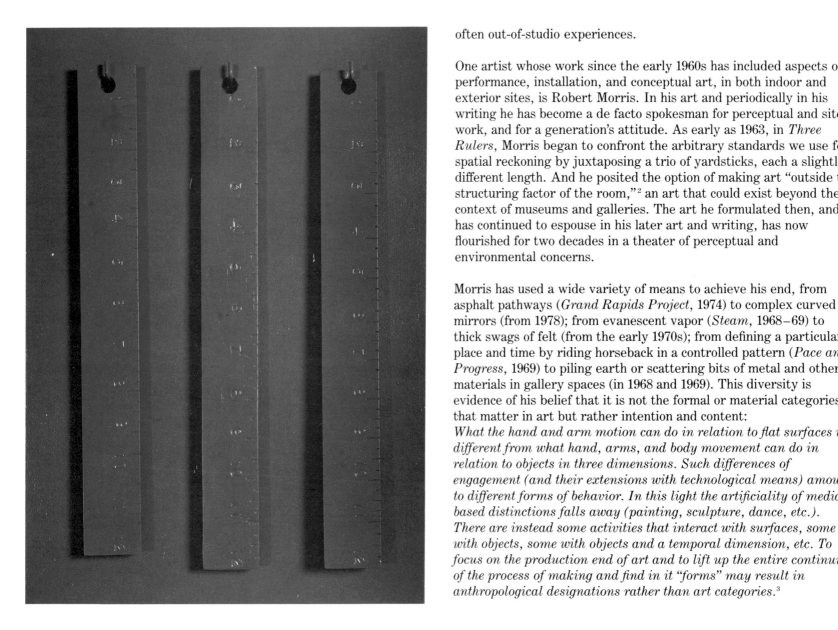

often out-of-studio experiences.

One artist whose work since the early 1960s has included aspects of performance, installation, and conceptual art, in both indoor and exterior sites, is Robert Morris. In his art and periodically in his writing he has become a de facto spokesman for perceptual and sited work, and for a generation's attitude. As early as 1963, in *Three Rulers*, Morris began to confront the arbitrary standards we use for spatial reckoning by juxtaposing a trio of yardsticks, each a slightly different length. And he posited the option of making art "outside the structuring factor of the room,"[2] an art that could exist beyond the context of museums and galleries. The art he formulated then, and has continued to espouse in his later art and writing, has now flourished for two decades in a theater of perceptual and environmental concerns.

Morris has used a wide variety of means to achieve his end, from asphalt pathways (*Grand Rapids Project*, 1974) to complex curved mirrors (from 1978); from evanescent vapor (*Steam*, 1968–69) to thick swags of felt (from the early 1970s); from defining a particular place and time by riding horseback in a controlled pattern (*Pace and Progress*, 1969) to piling earth or scattering bits of metal and other materials in gallery spaces (in 1968 and 1969). This diversity is evidence of his belief that it is not the formal or material categories that matter in art but rather intention and content:
*What the hand and arm motion can do in relation to flat surfaces is different from what hand, arms, and body movement can do in relation to objects in three dimensions. Such differences of engagement (and their extensions with technological means) amount to different forms of behavior. In this light the artificiality of media-based distinctions falls away (painting, sculpture, dance, etc.). There are instead some activities that interact with surfaces, some with objects, some with objects and a temporal dimension, etc. To focus on the production end of art and to lift up the entire continuum of the process of making and find in it "forms" may result in anthropological designations rather than art categories.*[3]

Like Morris, Robert Irwin is a progenitor of an attitudinal shift in art of the 1960s that placed motivation over technique and experience over metaphor. Maturing in Los Angeles in the late 1950s, when artists in the area were just beginning to crystallize into a community, Irwin began his career as a painter whose canvases—like those of his colleagues John Altoon, Ed Moses, and Billy Al Bengston—evinced a reverence for abstract expressionist handling. In the early 1960s Irwin's art, like Morris's, began to move toward a more reductive format, exorcising the idiosyncracies of the previous generation.[4]

In at least one sense, Irwin's line paintings from the early years of that decade are his initial forays into an arena where the standard conventions of art-making are questioned rather than accepted. In these paintings the horizontal canvas, with its implicit landscape cues, is abandoned for a less connotative square shape, and in place of the gestural, biomorphic markings of action paintings, Irwin's images develop within a spare, geometric formula. With these works Irwin confronts his audience's expectations about what constitutes a painting, how a painting is perceived, and, by extrapolation, how anything is perceived visually. The viewer is left with only the fundamentals to consider—the effect one color has on another, the way one line or edge inflects the set of elements on the canvas.

The iconic presentation of Irwin's fields allows little external reference to be attached to the works; the surfaces are not worked into an illusion of something else, but are images in their own right—presentations rather than representations. It is almost as if Irwin were heeding the advice of the French philosopher Gaston Bachelard, who believed that "a phenomenologist should go in the direction of maximum simplicity" so as not to be distracted from his own meditations.[5] In the end, these paintings are visual corollaries for Irwin's own absolutism, best explained by his assertion that "there is no such thing as a neutral gesture, because by the very fact of its being there, it draws a certain amount of perceptual attention."[6]

Painting did not prove, however, to be the most efficient way for either Irwin or his contemporaries to analyze the phenomenological dynamics of this "perceptual attention," and consequently he began working more environmentally and empirically to engage directly our systems of perception. One of the most dramatic efforts he made to produce a situation within which the viewer's perceptions could be addressed in a more objective, controlled context was his collaboration, in 1968 and 1969, with James Turrell, another Los Angeles–area artist. Instigated by the Art and Technology project of the Los Angeles County Museum of Art, this was perhaps the most fruitful of all the efforts made in that attempt to link artists with scientists and technicians from the corporate world.

Irwin and Turrell, whose education had focused on psychology, set out to investigate systematically certain human cognitive capabilities, and to address, among other concerns, the ways in which certain stimuli (visual, aural, tactile, spatial, even gustatory and olfactory), or their absence, affect our senses.[7] They, along with the participants in their art, would undergo these experiences in a controlled environment, one that would allow "people to perceive their perceptions—making them aware of their perceptions . . . conscious of their consciousness."[8] By "refining methods of entrance, exit, control of elements, input of stimulus, etc.,"[9] they would tailor the physical space to affect the mental space of those involved. Instead of building such an environment, however, the two artists and their scientist collaborator, Ed Wortz, an experimental psychologist and head of the Garrett Corporation's life sciences department, depended on an anechoic chamber used for psychology experiments at the University of California, Los Angeles. This highly controlled environment and the tightly planned procedures that Irwin and Turrell used characterize much of their subsequent work.

Since 1970 Irwin has eschewed the aesthetic conventions and the traditional confines of the studio to conceive artworks based largely on the conditions of their particular sites. Emanating from the matrix of environmental factors, Irwin's art since the late 1960s has been a "non-object situation . . . setting up the boundaries of experience to

*Robert Irwin*
Untitled, *1982–83*
*(Two Running Violet V Forms)*
*Blue-violet plastic-coated fencing*
*and stainless steel posts*
*Stuart Collection*
*University of California, San Diego*
*La Jolla, California*

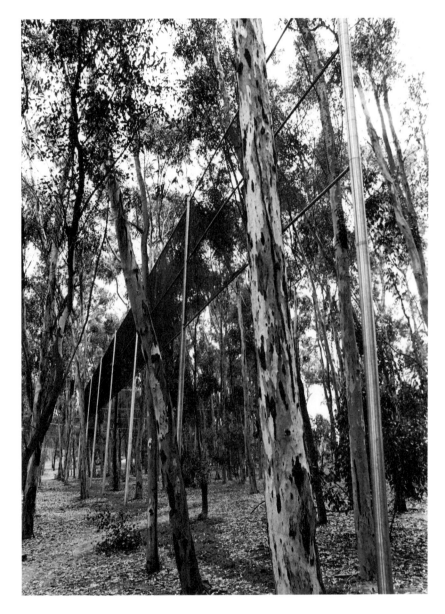

be perceived."[10] Initially creating installations for gallery settings, as in the Museum of Modern Art, New York (1970), the Walker Art Center, Minneapolis (1971), and the Museum of Contemporary Art, Chicago (1975), Irwin has for the past decade moved increasingly into a public arena. Projects like *Two Running Violet V Forms* (1982–83), for the Stuart Collection at the University of California, San Diego, or Seattle's *9 Spaces, 9 Trees* (1983) are fabricated in a wide range of materials, with enclosures, landscapings, light fixtures, plantings, and planes of stretched fabric or colored chain-link fencing all operating in concert with one another and with the phenomena—optical, social, political, topographical—of a given site.

Irwin's proposal for downtown Los Angeles's Central Avenue, commissioned by The Museum of Contemporary Art, continues this open-ended vocabulary. He has bisected the wide, open street that creates the entry *allée* for The Museum of Contemporary Art's Temporary Contemporary building with two long, narrow parterres, dividing it into the two sides of a more formal entryway. On each of the islands, narrow planters filled with tall bamboo plants are halved lengthwise by a chain-link fence plumbed to spray continuously a fine mist of water. The work is designed as a barrier to both cars and pedestrians, and is set in a predominantly Oriental inner-city neighborhood, surrounded by abandoned buildings and parking lots; its combination of the delicate bamboo and the unforgivingly urban chain-link fence has a natural and contextual rationale. And its gentle spectacle of foliage, fountains, and fencing, all melded into a coherent whole, is appropriate for a museum entrance. The work makes use of reflected light, of both constructed and organic elements, and of such perceptual delights as the gentle spray of water, with its auditory and color accents.

Using the insights gained from his earlier, highly controlled experimentation to fine-tune his art to the open places now tied to its experience, Irwin calls attention to the special qualities of a locale, to what he finds there, and, by extension, to what we might better perceive after experiencing the site simultaneously with his overlay.

In this regard, his art reflects the same iconoclastic sense of responsiveness to site as Morris's or Heizer's. Both his approach and theirs can be defined as experimental, preanalytic, participatory, and primary.

Since before his collaboration with Irwin on the Art and Technology project in the late 1960s, Turrell has been interested in the way that manipulations of light and space affect his audience. His work has long involved the construction of controlled visual environments in which viewers can contemplate both what they are seeing and how they see it. Beginning with a series of light projections exhibited at his Santa Monica studio and at the Pasadena Museum of Art in 1966 and 1967, much of Turrell's earliest work used electric light projected onto a preexisting architectural surface. Perceived from a variety of vantage points, these projections seemed to picture geometric volumes, some floating in space, some hugging the plane of the wall, readable at once as both solid and void. These "Projection Series" pieces constitute a visual primer on figure-ground relationships, and on the interpretive—or misinterpretive—capabilities of human sight. Still, with their high-intensity glow and implicit frontality, as well as their ability to be resituated, early works like *Afrum Blue*, with its clean-edged color cast into a corner, or *Decker*, with its flattened and shaped light, remain more things to look at than ambient spaces affecting how the viewer's senses operate.[11]

Simultaneously with these projections, Turrell began developing larger, room-sized installations where light (either man-made or natural), in concert with a reworking of the architecture, created experiences for his viewers that were more fully spatial. Works like *Laar* (1976) and *Batten* (1983) retain much of the iconic frontality of a thing to be looked at: both are "windows" cut in a wall, allowing us to see but not physically enter another space. We do not look out of these windows at an ensemble of recognizable objects or into them at a graphic representation of those objects; rather Turrell offers space and light in a purer, nonreferential form. What seems a definite flat rectangle *on* the wall in a work like *Laar* soon shifts toward the

illusion of an infinite void *behind* the wall, and we can no longer be assured of the accuracy of our own senses as we approach it. Our confidence in moving around everyday spaces is challenged as Turrell's apparently empty tableau affects the sensate envelope on our side of the wall. Light and void take on a kind of tactility; many viewers reach into the other space, as if to grab the light. All of this precipitates an introspective mood and heightens a reflexive awareness of our senses—optic, haptic, spatial—as we become enmeshed in *how* rather than *what* we see.

In *2nd Meeting*, a work commissioned for The Museum of Contemporary Art's inaugural exhibition and housed in a small building adjacent to the Temporary Contemporary, Turrell allows natural light to flood and inflect a discrete chamber. In doing so, he transforms the low brick structure into a room-scope, a unified architectural instrument. Extending the building's vertical dimension, Turrell completes a cube of space within the original confines. Inside the cube, a built-in bench runs along each wall, interrupted only by the entrance to a small vestibule that screens the interior space from the outside. Above, a large square aperture pierces the roof, and the thin perimeter of ceiling that remains overhangs the benches like eaves. The room changes with the day as shifts in light and weather create new patterns for us to perceive. While Turrell retains the rectangle of light that marked *Laar* and *Batten*, he has moved it overhead and out-of-doors, erasing the distinction between interior and exterior and focusing our attention on the ambient effects of light.

Three installations included in a survey of Turrell's work at The Museum of Contemporary Art in 1985 carried his concerns to fruition. *Jadito's Night*, *Pleiades*, and *Akar's Visit* were chambers where all light but Turrell's was eliminated. As their celestial titles imply, these rooms were observatories, but they were designed to connect us to the inner realm of our own consciousness rather than to the outer reaches of the galaxy. To the viewer seated in *Akar's Visit*, what appeared to be a faint circle of dappled gray light was barely but immediately apparent. After a few minutes, once one's eyes had adjusted to the almost complete darkness, the circumference of the circle appeared to undulate, and washes of color began to float toward the circle from the periphery of one's field of vision. Were these effects contained within Turrell's projection, or were they the products of the viewer's own optic system, primed to respond by what Turrell created? These dark rooms were the visual equivalents of the anechoic chamber Turrell had used in the Art and Technology collaboration with Irwin and Wortz. The space of *Akar's Visit* surrounded the viewer, even as the light and image floated before his eyes unanchored by the usual formulations of scale, distance, and direction.

Another Californian, Doug Wheeler, has produced works similar in their concerns to those of Irwin and Turrell. Both in his early "light paintings" and in his larger roomscapes, Wheeler considers some of the same perceptual assumptions addressed by his contemporaries. Instead of isolating perceptual cues in the manner of Irwin's line paintings or Turrell's light spaces, however, Wheeler eliminates—illusionistically—the very bases upon which our visual experiences are founded.

Wheeler's light paintings, first shown in the late 1960s, are constructed in such a way that an even, uninflected illumination emanates from the depth of a boxlike support to blur the demarcation between artwork and context. Wheeler does with light what Morris began to do at the same historical moment with his "scatter-and-spread" pieces. While Morris used heaps of material to take over the space traditionally set aside for the viewer, depending on chaos and happenstance to construct each installation, Wheeler's works are more carefully tailored in all their details, from the color of the illumination to the translucency of the light-emitting surfaces and, in his later works, to the perfection of his cove-cornered spaces. In the light paintings the edges blur, and the cool and glowing surface seems to bleed onto the gallery wall, obliterating our all-too-facile categorizations of object and environment.[12]

Douglas Wheeler
RM 669, *1969*
*Vacuum-formed translucent Plexiglas*
*96 × 96"*
*The Museum of Contemporary Art,*
*Los Angeles*
*Purchased with funds provided by*
*Bullock's/Bullock's Wilshire*

The experiments Wheeler initiated with the light paintings were fully refined by the mid-1970s. In *SA MI DW SM 75* (1975) Wheeler combined various gaseous lights (halogen, neon, and fluorescent) in a sequential concert of color within a seamless interior environment, developing a kind of nether space in which the viewer is enveloped in a homogeneous, unified experience that is nevertheless in constant flux. No orientation of up or down, no corner breaks, no cognitive clues that might lend themselves to specific, referential interpretations are provided. Space and light commingle in a temporal flow: nothing breaks the continuity of our perceptions except the limits of our attention. Wheeler makes his gestures seem nonspecific even as he very carefully controls all the parameters of what we sense in his staged environs.

The introduction here of Maria Nordman, an artist often grouped with Irwin, Turrell, and Wheeler, might help to clarify certain shared priorities, but it locates, as well, distinctions among their works and intentions. A revealing example of Nordman's work is a space she constructed at the Newport Harbor Art Museum in 1973, a space whose interior was accessible only visually, and only from a vantage in the alley behind the museum. From inside the building, the hallowed confines of the traditional art space, all one could see was the wood-frame exterior of the wedge of space and light she had created. This gentle subversion of art-world conventions was also apparent in *Trabajos en la Ciudad* (1985): designed to be relocated to a sequence of public places throughout the city of San Diego, this exquisitely carpentered structure of wood and cloth was initially installed at the La Jolla Museum of Contemporary Art.[13] In the large gallery overlooking the Pacific where the piece was positioned, a door was left open at all times, allowing into the space the breezes, sounds, and aromas of the street and shoreline below. In effect, Nordman used the museum building and the wood-and-cloth construction as a kind of receptor, a machine for manipulating the senses.

Unlike her colleagues, Nordman has never used artificial illumination in her works, relying instead on natural light and its permutations. Light—direct and indirect, baffled or translucent, in minute color gradations from local reflections—and most emphatically private spaces (clean, contemplative, tailored, and spare) that open onto public places (lively, circumstantial, unpredictable) are central to her art. She creates spaces in dualities: open and closed, in and out, fabricated and natural, Eastern and Western. If her constructions, which have included a stone wall built across the German landscape and a reconstructed freight barge in which she plied European rivers, suggest a Western heritage, her manipulations of light seem both Eastern and intuitive. Gone are the specifics of psychological investigation found in the work of Irwin or Turrell. Nordman's spaces often feel like sacred precincts, buffered from the outside world and yet made available through the illumination she admits.

Much has been made of the connections among Irwin, Turrell, Wheeler, and Nordman (as well as with such artists as Eric Orr and Larry Bell), with the shared interest in light seen as the motivating factor in their art. Despite the similarities, however, distinctions must be made within this group of West Coast artists. Where Irwin and Turrell maintain iconic spaces that continue to refer (at least vestigially) to the starting point of painting, Wheeler and Nordman create situations that are more fully inhabitable. We are often unable to enter the space behind an Irwin scrim or fence, just as we ideally see Turrell's projections and optical effects from a restricted vantage point, predetermined for the best resolution. There are fewer imperatives in Nordman's art than in Irwin's or Turrell's, for she often evokes rather than states, poetically rendering spaces into a kind of ideal fragility where the senses can discern subtle variations of light. In these chambers, thought and contemplation are encouraged. We may be challenged by the fluctuations of light, color, and volume in a Turrell work or perceptually massaged by a Wheeler piece, but we nestle quietly into one of Nordman's rooms.

Nordman is one of many contemporary artists who create spaces that appear all but vacant. What Melinda Wortz has referred to as "radical

*Alice Aycock*
A Simple Network of
Underground Wells and Tunnels, *1975*
*Environmental installation*
*Merriewold West, Far Hills, New Jersey*
*Area above ground: 20 × 40'*
*Underground structure: 28 × 50 × 7'8" deep*
*John Weber Gallery*

emptiness, spiritual experience," however, is not always confined to the works of those who manipulate light like Nordman, Irwin, or Flavin.[14] Throughout the 1970s and up to the present, participatory performances like Vito Acconci's *Seedbed* (1972) or Chris Burden's *White Light, White Heat* (1975), in each of which the artist remained hidden from view in a seemingly empty gallery, have been centered on just such vacant spaces. Installations like Richard Fleischner's *Wood Interior* (1980) and Bruce Nauman's various rooms and corridors, as well as structures like Sol LeWitt's large, modular cube (1969), all contain this emptiness even as they call attention to boundaries of wall, floor, edge, and corner. All of these, as well as architectural constructions like Alice Aycock's *Simple Network of Underground Wells and Tunnels* (1975) and Mary Miss's *Perimeters, Pavilions, Decoys* (1978), with its pits, towers, and bounded fields, have presented their emptied interiors as refuges or as arenas where something has occurred—or will—rather than as containers for objects.[15] While some commentators correctly find sources for these clear spaces in minimalism, orientalism, or more traditional models of spiritual architecture, most often the emptiness is only a starting point, a tabula rasa onto which these artists scribe the charged geometries, performances, or perceptual effects that are the core of their aesthetic concerns.

It would be wrong to assume that only this group of California artists has understood the potential of projected or ambient light as a resource for art-making. Dan Flavin, working in an entirely different geographic milieu, understood the power of light as early as 1965, when he discussed the possibilities of "playing" with the structure that bounds a room by "destroying corners, disintegrating walls," or complementing the diagonal rise of a stairwell with the placement of fluorescent light fixtures.[16] Morris, too, as aligned as he was with those who used performance and monumental materials to interact with space, knew well that "ultimately, the consideration of the value of sculptural surfaces is the consideration of light, the least physical element, but one which is as actual as the space itself."[17] He went on to critique his own contemporaries of 1966:

*The better new work takes relationships out of the work and makes them a function of space, light and the viewer's field of vision. . . . One is more aware than before that he himself is establishing relationships as he apprehends the object from various positions and under varying conditions of light and spatial context.*[18]

What distinguishes the artists based on the West Coast from those, like Morris, working out of the Northeast is not their results, but their means. Nourished by the relatively unfettered situation of Southern California art in the 1960s and divorced from the New York mainstream, these artists defined areas for aesthetic explorations that were affected by the shifts that occurred in the broader culture during the late 1960s, shifts marked by an interest in experiencing anew the natural environment, by a concern for self-awareness, and by the expansion of the field of human knowledge through various psychospiritual means.

In his own way, Bruce Nauman has always worked with the duality of concept and percept that characterized that decade of cultural change. His works operate in the space between the intellectual predetermination of a system and the individual perceptual experience of that system.[19] This is true for his many graphic and neon works, which employ puns and homophones, hybrid words and anagrammatic phrases, often with great wit. Meaningless similarities like "Violins, Violence, Silence" seem to poetically exploit real patterns in our system of words where none in fact exist.

Similarly, in his corridors and rooms Nauman constructs special spaces where our senses are forced to discern new experiences. We see ourselves walking in ways we don't expect in works such as *Lighted Center Piece* (1967–68) and *Corridor with Mirror and White Lights* (1971). Nauman embellishes the relatively claustrophobic spaces he builds and extends our perception of them through various technological means both low and high, from neon lights to closed-circuit video systems. Unlike Wheeler or Nordman, whose rooms may envelop the viewer in their totality, Nauman, in his corridor

*Bruce Nauman*
*Plan for* Kassel Corridor Elliptical Space, *1977*
*Ink on paper*
*35 × 45"*
*Panza Collection*

*Bruce Nauman*
Room with My Soul Left Out/
Room that Does Not Care, *1984*
*(indoor version)*
*Celotex*
*If made to full scale: 48 × 48 × 48'*
*At Leo Castelli Gallery, 1984:*
*34 × 48 × 30'6"*
*Destroyed after exhibition*
*Leo Castelli Gallery, New York*

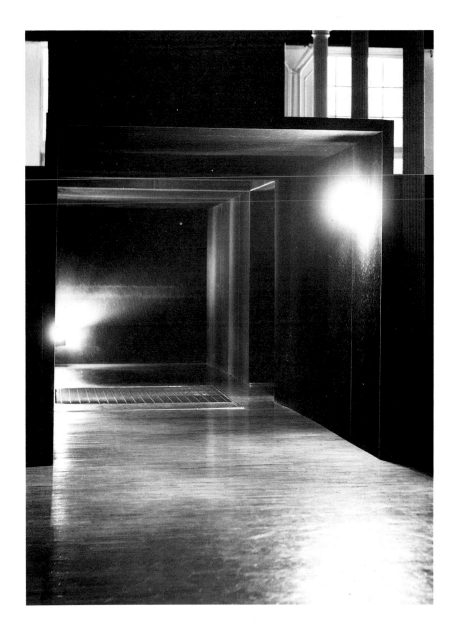

works, separates the audience from what might be felt as a "normal" rectangular space as he carefully directs the viewer on how the piece is to be experienced: the viewer sees what Nauman wants him to see, walking down the corridor and then retracing his steps to walk out. It is no coincidence that the greater number of his environment pieces are, like *Triangular Yellow Room* (1973), titled with descriptive adjectives and that many are pathways with a singular access and egress—for example *Video Corridor* and *Diagonal Sound Wall* (both 1970), *Acoustic Corridor* (1973), and *Kassel Corridor Elliptical Space* (1977). Spatial discomfort, disorientation, sound manipulation, and visual echoes all demand of Nauman's audiences active intercourse.

In a work like *Kassel Corridor Elliptical Space*, reconstructed by the artist for The Museum of Contemporary Art, these demands are made by the way the walls and spaces are designed: a curved walkway narrows impossibly toward either end, and is entered and exited only through a central doorway. *Room with My Soul Left Out/ Room That Does Not Care* (indoor version, 1984), a complex series of connected spaces inserted into a New York gallery, was an equally simple but discomfiting environment. Here, roofed corridors constructed of rough Celotex led the viewer to a central chamber where a metal grate set in the floor and an opening in the roof revealed two equivalent empty spaces that extended above and below this crucial junction. The cruciform space Nauman constructed in the conventional rectangular box of the gallery evoked a sense of insecurity. One felt caught in an intersection charged not by the use of lighting elements or electronic systems but by the design of the structure itself.

Nauman's spaces are at once more crudely fashioned and more aggressively interactive than the more meditative chambers of Turrell or Nordman. His are not spaces of comfort, habitation, or stasis; we feel none of the attractions offered by the quiet of a Nordman room or by the elegant proportions of a work like Richard Fleischner's *Wood Interior* (1980). Where Fleischner and Nordman

restructure the sites they find in response to them, Nauman fashions his spaces to illustrate a vocabulary of ideas he brings with him to the site. In this way his spatial works are almost antithetical to the dominant mode of his generation: he positions concept before percept, conjuring images for us to see rather than allowing us to see more clearly what is already there, making our experience reinforce his model.

Another body of recent work intersects with both the earlier, monumentally scaled, isolated "earth works" of Smithson, Heizer, and Oppenheim and the more perceptual pieces of Irwin, Turrell, Wheeler, and Nordman: the built environments of Aycock, Miss, Fleischner, Siah Armajani, and George Trakas.[20] These artists and still others share a similar manner and a more urban and accessible location, most often an extant building, plaza, or city street. Their concerns, however, range over a wide spectrum of the visual, spatial, and social. While an artist like Aycock is most often seen as the author of structures of literary fantasy imbued with highly personalized narration, Trakas, because of the materials he uses and the way he fabricates them, is more often connected with a tradition of sculpture-making whose lineage derives from David Smith and Mark di Suvero. What is consistently overlooked is these artists' common intention: to enhance our comprehension of the physical, social, and psychological parameters of particular places.

These site-responsive artists have connections with practitioners in such disparate fields as anthropology, urban planning, architecture, and the performing arts. Trakas, for example, was actively involved with the world of dance during the 1960s (as was Morris) and even choreographed several works; Miss has been an amateur gymnast for many years, an activity surely affecting the way she measures and traverses the environments she reworks. Perhaps the clearest example of an artist who flourishes at the intersection of sculpture, architecture, and landscape architecture is Fleischner. Since 1970 he has managed to propose and erect a large body of permanent work, often in concert with architects.

Fleischner begins his aesthetic process by spending a great deal of time at the place where he will work in order to better understand its physical essence. In a large work next to a federal building outside Baltimore, Fleischner placed a number of stone or metal elements in a wooded grove, designating various aspects of the site's natural composition. Some of these markers "calibrated" the site in terms of its boundaries, natural vistas, and its junctions between open and overgrown spaces; others acted as transitional planes between the huge building and the front line of the thicket. In this *Baltimore Project* (1978–80) and in other works realized during the late 1970s and early 1980s, Fleischner was discovering a vocabulary of forms and gestures that he could overlay on a given site. More recently, in a project at the Massachusetts Institute of Technology, Cambridge, he used a broad variety of means to clarify and revitalize a difficult, amorphous urban site. Here, between complex buildings designed by I. M. Pei and and the architectural firm of Mitchell/Giurgola, Fleischner used paving patterns, landscape gradations, street furniture, lighting, planting, and, of course, an overall plan to rectify his space in both bold and subtle ways. While we might never see one of Smithson's or Heizer's works unless we made a special pilgrimage (or unless it was made for us by a photographer), we can walk through this recent Fleischner space without focusing on the work's manipulations, without reading it as art. Rather, Fleischner replaces our daily indifference to natural and man-made proportions, craftsmanship, and spatial intuition with his own reverence for just those things, which make memorable places out of generic spaces, and he reminds us of what is often lost in environmental designs dictated by speed and economics.[21]

Fleischner deciphers a site by accepting or establishing a given—the proportions of a room, the measurements of a set of modular blocks, the configuration of a ground plane—and then inflects the space with boundaries, axes, and volumes, all worked into a coherent syntax. This concern for balance, variety, and situationally determined juxtapositions is evident in his proposal for an installation, conceived early in 1986, at The Museum of Contemporary Art. Here, typically,

*Richard Fleischner*
**M. I. T. Project**, *1980–85 (detail)*
*2½ acre site*
*Plantings, furniture, paving,*
*granite inlays, steps, lighting,*
*and all aspects of the site*
*Cambridge, Massachusetts*
*Photo copyright © 1985 Steve Rosenthal*

he establishes a floor inlay in relationship to an extant wall, and all other aspects of the situation are keyed to that initial move. His "room" is built—or, rather, expressed—not with four walls but with elements rich in their specific textures and materials. These markers are meant as embodiments of the artist's intuitive spatial experiences: the sawn face of a rough boulder and a plaster wall each signify the same architectonic value, the edge separating this special place from the general museum surround.

Despite such installations tailored for interior sites, Fleischner and many of his colleagues working in public situations often avoid, like their predecessors of the 1960s, the traditional gallery format. Unlike those who have sought remote rural locales, however, today's site artists embrace the notion that art can make a difference in our everyday lives. In that sense, too, they have inherited the cultural priorities of the 1960s, which form the backdrop for much contextually responsive art. When Fleischner or Irwin, Miss or Armajani work on public spaces, they apply the experimental notions of space, light, and perception generated over two decades ago by Heizer, Morris, Smithson, Irwin, and others. They have become real-life practitioners, and they share with such seemingly different artists as Helen and Newton Harrison, whose work more insistently addresses socio-political and ecological issues, an ambition for the kind of grass-roots public action that emerged during the 1960s.

Early in 1976 the critic Brian O'Doherty, writing on the relationship between the neutrality of contemporary art spaces and modern art, introduced his analysis, so pertinent to artists who work on site, by evoking a space familiar to us all:
*An image comes to mind of a white, ideal space that, more than any single picture, may be the archetypal image of 20th-century art. . . . The ideal gallery subtracts from the artwork all cues that interfere with the fact that it is "art." The work is isolated from everything that would detract from its own evaluation of itself. This gives the space a presence possessed by other spaces where conventions are preserved through the repetition of a closed system of values. Some of*

*the sanctity of the church, the formality of the courtroom, the mystique of the experimental laboratory joins with chic design to produce a unique chamber of aesthetics.*[22]
Creating what Irwin has termed "a conditional art," all of the artists discussed above have managed to break out of the self-generated sterility of modern art so cogently symbolized by that "chamber of aesthetics." Their audiences are no longer limited to experiencing only visual sensations, for all the optic, haptic, and auditory senses are enlisted in their quest to reinsert art into a total, vital context.

What these artists have done is examine the ways we build the world around us. In their art, they have chosen—often preserved or resurrected—traditions that have less to do with aesthetic theory or economic constraints than with practice: with the choice of optimum materials, the coincidence of craft with design, and the use of the macroscopic resources of the documented past or the imagined future. As the contemporary critic Guy Davenport has astutely remarked, "art is the replacing of indifference with attention." As we stand on the mesa top of *Double Negative* or in one of Nordman's light-filled rooms, amid the planes and points of a Fleischner field or within Turrell's celestially scaled Roden Crater project, we find that this art reminds us of our position in the world; the vectors of experience converge in our awareness of being. These artists have replaced an aesthetics of attainment, of virtuosity and conventionality, with an aesthetics of desire, with the search for a primal sense of space and the communal memories of how the world could, and should, be known. As Morris said about sculpture almost twenty years ago, "the situation is now more complex and expanded." This expansion, at once both revolutionary and optimistic, may be the most enduring legacy of art produced during the last half of the twentieth century.

1. Quoted in Ellen Joosten and Felix Zdenek, *Michael Heizer* (Essen: Museum Folkwang; Otterlo, the Netherlands: Rijksmuseum Kröller-Müller, 1979), p. 26. See also Julia Brown, ed., *Michael Heizer: Sculpture in Reverse* (Los Angeles: The Museum of Contemporary Art, 1984), for an updated treatment of Heizer's art and a full bibliography.

*Following pages:*
*Michael Heizer*
Double Negative, *1969–70*
*240,000 ton displacement in rhyolite and sandstone*
*Mormon Mesa, Overton, Nevada*
*The Museum of Contemporary Art, Los Angeles*
*Gift of Virginia Dwan*

2. For two of his earliest essays containing this and other considerations on the aesthetic climate of the mid-1960s, see Robert Morris, "Notes on Sculpture," *Artforum* 4, no. 6 (February 1966): 42–44 and "Notes on Sculpture, Part II," *Artforum* 5, no. 2 (October 1966): 20–23. For more on his colleague Robert Smithson, who also championed this stance, see Nancy Holt, ed., *The Writings of Robert Smithson* (New York: New York University Press, 1979), and Robert Hobbs, *Robert Smithson: Sculpture* (Ithaca, N. Y.: Cornell University Press, 1981).

3. Robert Morris, "Some Notes on the Phenomenology of Making: The Search for the Motivated," *Artforum* 8, no. 8 (April 1970): 62. For more on Morris see Annette Michelson, *Robert Morris* (Washington, D. C.: Corcoran Gallery of Art, 1969); Marcia Tucker, *Robert Morris* (New York: Whitney Museum of American Art, 1970); and Marti Mayo, *Robert Morris, Selected Works 1970–1980* (Houston: Contemporary Arts Museum, 1981).

4. The best overview of Irwin's career is Lawrence Weschler, *Seeing Is Forgetting the Name of the Thing One Sees* (Berkeley: University of California Press, 1982); see also Robert Irwin, *Being and Circumstance, Notes Toward a Conditional Art* (Santa Monica and San Francisco: Lapis Press, 1985).

5. Gaston Bachelard, *The Poetics of Space* (Boston: Beacon Press, 1969), p. 107.

6. Weschler, *Seeing Is Forgetting*, p. 60.

7. For more on this collaboration, and on the entire Art and Technology program, see Maurice Tuchman, *A Report on the Art and Technology Program of the Los Angeles County Museum of Art, 1967–1971* (Los Angeles: Los Angeles County Museum of Art, 1971). See especially pp. 127–143 for the section on Irwin and Turrell, compiled by Jane Livingston.

8. Turrell, quoted in ibid., p. 131.

9. Statement by Irwin, Turrell, and Dr. Ed Wortz, quoted in ibid., p. 129.

10. Turrell, quoted in ibid., p. 131.

11. The fullest treatment of both these early pieces and Turrell's career (including a good introduction to his Roden Crater project) is Julia Brown, ed., *Occluded Front: James Turrell* (Los Angeles: Fellows of Contemporary Art, Lapis Press, and The Museum of Contemporary Art, 1985).

12. Wheeler remains the least discussed of his colleagues in published writings. The best texts on his work are Michael Compton and Norman Reid, *Larry Bell, Robert Irwin, Doug Wheeler* (London: Tate Gallery, 1970), and a shorter piece by John Coplans, "Douglas Wheeler: Light Paintings," *Artforum* 7, no. 1 (September 1968): 40–41. See also Kim Levin, "Narrative Landscape on the Continental Shelf: Notes on Southern California," *Arts Magazine* 51, no. 2 (October 1976): 94–97, for a discussion of his work in the context of what the author defined as "California immateriality." For more on Wheeler's work and on the environmental works of a number of the artists discussed, see Germano Celant, *Das Bild einer Geschichte 1956/1976: Die Sammlung Panza di Biumo* (Milan: Gruppo Editoriale Electa, 1980), and *Ambiente/Arte dal Futurismo* (Venice: Alfieri Edizioni D'Arte, 1977).

13. See Ronald J. Onorato, *Maria Nordman, Trabajos en la Ciudad* (La Jolla, Calif.: La Jolla Museum of Contemporary Art, 1985), for an extended analysis of this piece and of the artist's career. On the Newport Harbor Museum piece see Peter Plagens, "Maria Nordman," *Artforum* 12, no. 6 (February 1974): 40–41.

14. Melinda Wortz, lecture at the La Jolla Museum of Contemporary Art, La Jolla, Calif., May 25, 1983.

15. On the relationship between the performance idiom and artworks that define places see Hugh M. Davies and Ronald J. Onorato, *Sitings* (La Jolla, Calif.: La Jolla Museum of Contemporary Art, 1986), especially the chapter "Real Time—Actual Space."

16. Dan Flavin, ". . . In Daylight or Cool White. An Autobiographical Sketch," *Artforum* 4, no. 4 (December 1965): 24.

17. Morris, "Notes on Sculpture," p. 43.

18. Morris, "Notes on Sculpture II," p. 21.

19. For this duality in Nauman's art see Robert Pincus-Witten, "Bruce Nauman: Another Kind of Reasoning," *Artforum* 12, no. 6 (February 1972): 30–37. A broader review of his work is contained in Jane Livingston and Marcia Tucker, *Bruce Nauman: Work from 1965 to 1972* (Los Angeles: Los Angeles County Museum of Art, 1972), and also in the catalogue *Bruce Nauman: 1972–1981* (Otterlo, the Netherlands: Rijksmuseum Kröller-Müller, 1981).

20. See Davies and Onorato, *Sitings*, which provides an extended look at the art of Aycock, Fleischner, Miss, and Trakas as representative of an interest shared by a broad group of artists in site-responsive, public, and collaborative issues.

21. See *Artists and Architects Collaborate: Designing the Wiesner Building* (Cambridge: Massachusetts Institute of Technology Committee on the Visual Arts, 1985) for more on Fleischner's participation in this innovative design process and on his own concerns while working on site.

22. Brian O'Doherty, "Inside the White Cube: Notes on the Gallery Space, Part I," *Artforum* 14, no. 7 (March 1976): 24; see also the same author's "Inside the White Cube, Part II: The Eye and the Spectator," *Artforum* 14, no. 8 (April 1976): 26–34.

**James Turrell**

Skyspace I, *1972*
*Interior light with open sky*
*Panza Collection*

214

**James Turrell**

*Plan for* 2nd Meeting, *1986*
*Collection of the artist*

Douglas Wheeler

SA MI DW SM 75, *1975*
*8-kw quartz halogen lights,*
*black ultraviolet fluorescent light,*
*white ultraviolet neon light,*
*and automatic dimmer*
*Two rooms: 312 × 360"; 390 × 570"*
*Panza Collection*

**Richard Fleischner**

*Untitled, 1981*
*Graphite on paper*
*22⅝ × 28½"*
Baltimore Project, *1978–80*
*(detail)*
*Granite and Cor-ten steel*
*Two of ten elements on two-acre wooded site*
*Woodlawn, Maryland*

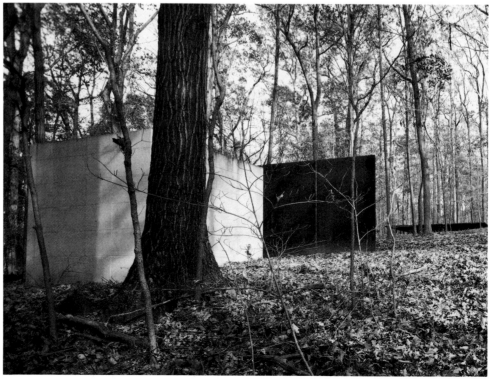

**Richard Fleischner**

*La Jolla Grove Proposal Drawing, 1982*
*Conte, pencil, and chalk on diazo print*
*30 × 42¼"*
Wood Interior, *1980*
*Installation*
*204 × 744 × 408"*
*Museum of Art, Rhode Island*
*School of Design*
*Providence, Rhode Island*

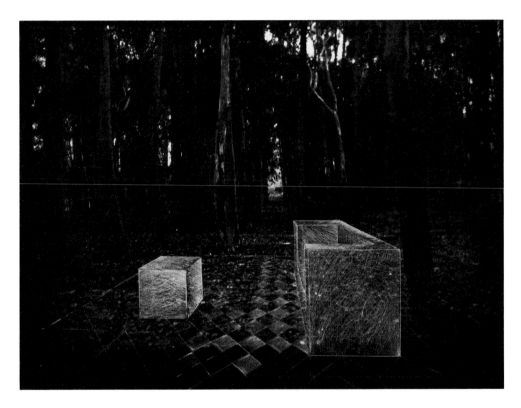

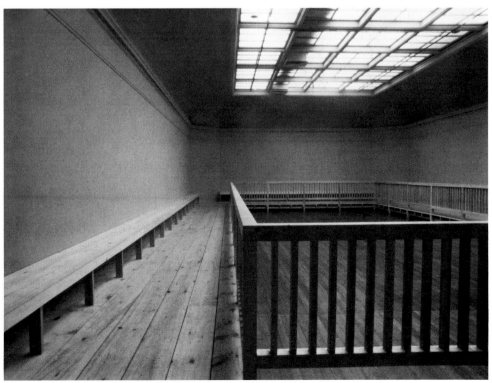

**Robert Irwin**

Central Avenue Meridian, *1986*
*Plan and elevation*

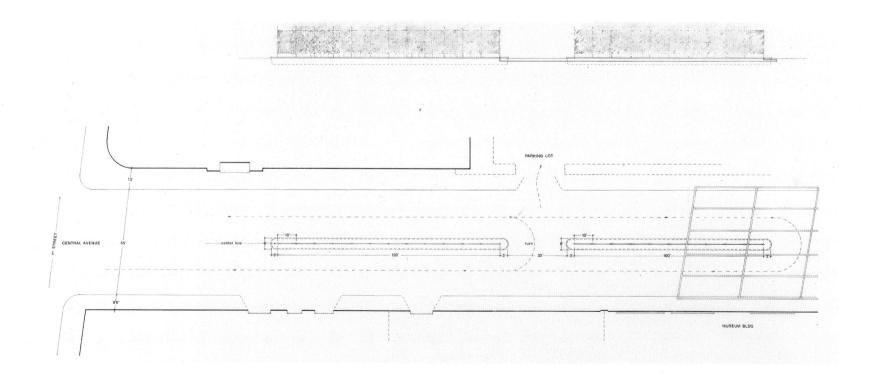

**Robert Irwin**

Central Avenue Meridian, *1986*
*Plan for plantings and*
*distribution of water atomizers*

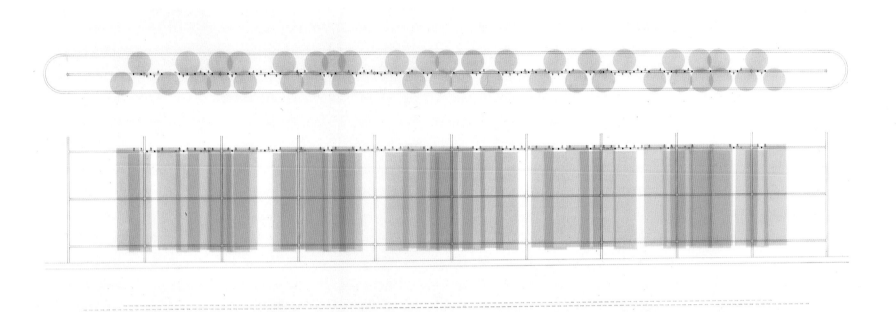

# Isolation Cells
*Germano Celant*

Up until World War II, modern art attempted a dialogue, both approving and dissenting, with and about society, and involved itself in a utopian way with the destiny of the social group. But the renewed crisis of values brought about by the war severely damaged the idea of art's social responsibility, and art turned in on itself, concentrating on and exploring its own essence. Where modern industry and machines, and their effects on society, had once seemed a source of hope, they now became profoundly disturbing. Social commitment fragmented after 1945, and the prewar years' fusion of art and politics was replaced by separatism. Art had once sought to integrate itself within the structure of society; now it withdrew deeper and deeper into its own ghetto within that structure—a ghetto, paradoxically, of consumerism. For if the artist had no other raison d'être, no other social purpose, than the study of his own existential and linguistic problems, his work became a symbol of values that were superfluous in terms of social function. Such work was easily appropriated as a commodity of exchange.

Demanding an autonomy for himself and his activity that he had once renounced in pursuit of social integration, the artist excluded himself from the world. Liberated from social concerns, rejecting instrumentality and function as possible dimensions of his activity, and rejecting as well any subordination to ideas external to the artistic process, he now endured the existential torment of being. Social involvement to him was a hypocritical illusion; meaning had to be found in his own existence. Art became a refuge, a delimited space which afforded to the artist the possibility of action as a specific, isolated, separate entity—just such an entity as the work itself was understood to be. From Joseph Cornell to Jackson Pollock, this premise indicated a distrust of the external and a faith in the internal, in the artistic individual and the media of art. Painting such as Pollock's was a kind of isolation cell, though one in which the artist could give free rein to his impulses, passions, obsessions, and desires. Conflating the macroscopic and the microscopic, Pollock's work became an arena in which the artist, perhaps somewhat contradictorily, sought to affirm an autonomy deriving from his own

individuality as an intense, energetic, authentic being.

Cornell too felt compelled to seek isolation from the world, creating an almost physical void around himself, a nirvana of space and the art object in which he could feel like, and regard himself as, a human being. As early as the 1930s, he had begun to insert his own, personal reality into art. Cornell's desperate enterprise was not so much to discredit the external universe as to produce a "second world," a world of windows through which to observe magic symbols and signs. These betokened a desire for visual and intellectual flight, for voyages whose course was determined by the winds rather than by the goal of a set destination, for the traverse of constellations of the imagination, for the construction of ancient histories through narratives in both image and language, for fantastic worlds in which true meets false. With his immobile mobility, Cornell opened up a private world of dreams and a positive kind of delirium. His box works are the expression of a self whose authenticity, whose simple action of being, depends on the construction of impenetrable lairs, of handmade objects comprising secret, closed-off areas and labyrinths through which only the builder can find his way. The totality forms a calendar, an object diary, corresponding not to any objective ends but solely to the narration of the artist's self, his "I." Sculptural articulation is of little importance in Cornell's work, for what counts here is the allegorical and symbolic reflection of the artist's immersion in his own fantastic voyage.

Cornell's legacy to American art includes not only a vision of a possible form for the art object, but also a dimension of theater, of the stage. By constructing a handmade object that strongly recalls the theatrical auditorium, Cornell declared his rejection of any interest in painting. His work is related to Pollock's in its insularity, but unlike Pollock he showed no interest in the play of chroma and viscosity established by the medium of paint. Instead, he chose the object, and created scenarios for it; it became an actor traversing his stage in unique patterns of motion. The springs, marbles, cutout parrots, rings, and shadows in Cornell's boxes are theatrical

materials. Now circling, now heading straight, now developing a new story line, now adding to or shifting the sequences of an old one, they unfold a visual narrative. They shun any rational, objective logic and invent their own. On stage, they are free, acting in a kind of commedia dell'arte between dada and surrealism. Cornell's aim was to allow his materials to present themselves for their own sake, their movements improvising their own story. The ideal viewer of Cornell's play is equally alone, developing his responses within himself rather than in relation to others.

Where Cornell challenged the stability of signs, the later generation that included Jasper Johns and Robert Rauschenberg saw it as utterly in doubt. "I think," Johns has said, "the object itself is a somewhat dubious concept." Rauschenberg's response to this situation, a response he shared, if in different ways, with artists such as Allan Kaprow, Jim Dine, and Claes Oldenburg, was to think in terms of the "action object." In Rauschenberg's work, and in the happenings and environments of the early 1960s, the object is infused with action; as with Cornell's boxes, the material is theatrically transformed into an expression of a personal practice. An artistic dialogue takes place between objecthood and individuality. Johns took the opposite tack, revamping the object so as to integrate it within a fixed, secure, static system of measures: art. Where a Cornell or Rauschenberg object is theatrically active, a Johns piece is inert. Cornell, and, earlier, Marcel Duchamp, had removed art from exterior life, supposing that it was not the function of the one to describe the other, but both artists had incorporated objects from the world beyond art in their work. Johns went further—he removed reality from art, even when he referred to it. Where Duchamp would take an object like a bottle rack and exhibit it as art, Johns would cast an object like an ale can in bronze and then exhibit the bronze, minus its original. In a way, the static materiality of his work constitutes a medium through which to analyze the functioning of images and objects. It establishes itself as a reciprocity between reality on the one side and painting and sculpture on the other.

Instead of putting his emphasis on being, as did Pollock and the other abstract expressionists, Johns readdressed the meanings of being. "I'm interested in things which suggest the world rather than suggest the personality," he has said; the sign has changed from the personal to the impersonal. When Johns executed an exact copy of an image or object, his effort was not so much to be aware of objects—flags, maps, targets, flashlights—as to rediscover them in the artistic sphere, to dissolve and reconstitute them through a method simultaneously impressionistic and realist. Here he was influenced by the sculpture of Medardo Rosso more than by Duchamp. Indeed, the "thereness," the presence, of Johns's objects has a sensual character as much as an intellectual one; the images painted in wax, the objects cast in bronze, depend for their intelligibility on their sensual charge. They are offered as virtually inert signs, yet their rendering is organic. The ambiguity of this "organic" existence is the basis that has made it possible for Johns to continue to present art and reality, which in his work are dependent on yet independent of each other. He seems to prefer neither of the two; though he perhaps leans closer to art, he leaves open the doubt.

Pop art's conception of the object extended Johns's sense of its stasis into a feeling of its actual death. The work of Andy Warhol, Roy Lichtenstein, and James Rosenquist reentered the contact with the social world that had been broken in 1945; the chain of gesturalism and solipsism between Pollock and Cornell was interrupted by a politics that transplanted present-day conditions into art. The distrust of extraartistic reference was replaced by a concern with the culture of the street. It would be a mistake, however, to believe that the pop artists sought to bridge the abyss that had opened between art and the world in the postwar years. Their work was not a return to commitment to the social sphere; it assumed a cynical, hopeless attitude toward personal reality and the artistic horizon, and the urban themes it described were those of an industrialized landscape where profit was king. Believing that in contemporary society any opposition to the dominant cultural order is old-fashioned romanticism, and rejecting Pollock's or Cornell's supposition of an

independent realm of art that depended not on external conditions but only on the self, the pop artists submerged themselves in the modern world. Shunning the personal, they explored the seductive monster that the city had become. And their motivation was not fundamentally rebellious; the art was not subtle enough to create from its audience a community of negation of contemporary society. Hollywood, television, comic strips, posters, current body language, the star system, and all the still-life images that make up the squalid urban scene were reexperienced not in order to undermine or destroy them, but out of a kind of necrophilia.

Repudiating the vitality of images, the pop artists sacrificed art to the mediocrity of a world dominated by the machine. In a culture of commodities, they felt, the oasis of freedom implied by the existence of the art object was a mirage. To attempt to diverge from the discourse that originated with the industrial revolution was a dead-end street. Pop art's attack—or, rather, its struggle—concerned profit, and the way modern society turns everything into a commodity, but pop worked toward social absorption rather than rejection. Its artists believed that it was useless to circumscribe their activity in an orbit of powerlessness and valuelessness; far better to let their work be absorbed in the commodity market. If artistic rebellion is a commodity, then to be a commodity is to rebel; so ran the equation. Warhol was the Marx of pop, exalting the profiteer, the star, the businessman, the fashion designer, the boxer, and the rock singer, and injecting the turmoil of glamour into the orthodox system of art.

Of all the pop artists, Oldenburg alone allowed, and continues to allow, an active role for the object. From the beginning of his career, he has had no faith in the individually invented, personal image; like the other pop artists, he has thrown himself on the terrain of everyday existence, the world of common, mass-reproduced objects distinguished not by quality or originality but by quantity, series, and scale. Unlike his peers, however, he has seized on the drama and spectacle of these objects as a way of bestowing upon them a magnification of their significance. A shirt, a hamburger, a toothpaste tube, a clothespin, a typewriter, a fan, an ice cream cone, a saw, a baseball bat, a flashlight, a button, a knife—focusing on these things and emphasizing their particularity, Oldenburg has plucked them from the anonymous flow of daily life. He has transformed them into unique objects, anomalous, extraordinary. His process here is reminiscent of the dadaists attempt to remove things from the homogeneous everyday and insert them into art, but where those artists saw the entity extracted from the world as a generic fragment of it, whose role was to vanish into a collage of generic fragments of painting and sculpture, he exalts it for its identity, for its fascination and distinctiveness, for what distinguishes it from other entities. To achieve this personalization of the common object, he does not humble it as Duchamp sometimes did, by distorting its function (by mounting a bicycle wheel on a chair, for example); on the contrary, he extols it in its most absolute singularity. He builds a monument to its identity, which, as in the better psychological literature, is always frail and hidden, defective and defenseless. The devices Oldenburg has used to achieve this emotional, sensory, personal identification are largeness of scale; soft, very sensual materials; and, in his site work, a finely tuned sense of the history of a location. Heightening the object's tactile and environmental values, he transforms the everyday into the "original." In modern art's continuing dialectic between the theatrical and the static object, he leans to the theatrical. Though he has expelled the human figure from his work, he has retained and emphasized its soft, mobile physicality—he makes the object his actor. In his work it is capable of playing comedy and tragedy, obscenity and sentimentality. By intensifying its corporeality and its potential for gesture, he casts it in an oddly glorious role.

For Oldenburg, the terrain of everyday life in our century is the city, and in the city everything exists but nothing is visible, for it is all indifferent, beyond the responsibility or control of the individual. Oldenburg's first extrapolation of these ideas was *The Street* (1960), an environment made from drab-colored cloth and cardboard. The work was intended as a symbolic "mural" of the anonymity of

everyday life on New York's Bowery. The agony and squalor of the place and its people are reflected in the peeling, crumbling material of the walls, floor, and ceiling. Everything is nondescript and flat, like a bag of trash. *The Street* is an antierotic work. It mirrors no existential conflict; it is simply, and therefore cruelly, a statement of fact, beyond tragedy, lying in a theatrical terrain somewhere between Antonin Artaud, Alain Robbe-Grillet, and, in its compositional intricacy, Samuel Beckett. The whole environment is a portrait, on waste paper, of the cold, undramatic condition of a marginal but hardly violent Bowery bum. In 1961, on New York's Lower East Side, Oldenburg opened *The Store*, a shop filled with objects of greed and angst—all in plaster. Where *The Street* is a kind of report on a certain urban condition, *The Store* was a Disneyland of American banality, a maze of display cases full of what satisfies the common taste. This small storefront became a gullet, swallowing and digesting all the creations of the city, all its signals and desires. Again, the images and objects here lay somewhere beyond tragedy; they were monuments to common obsessions—the shirt and tie, the canvas shoes, the slice of cake, the wedding gown, the 7-up, the ice cream. The resulting environment was a baroque brothel of class pleasures, a brothel reinvented and crystallized in plaster and violent colors, a cadaverous reincarnation of everyday life. Where the rest of the pop artists interred the object like a corpse in a morgue, Oldenburg, in *The Street* and *The Store*, created a mute theater of the transformation into art of the common and banal. These are the fields from which he continues to draw his stories and characters, silent objects whose dramatic import is carried by his bestowal on them of a kind of enhanced presence.

It must be said that despite the inertness of the art object in their work, the pop artists' goal was the liberation of artistic practice. Seeking to deal with a catastrophic social reality by accepting it rather than by exorcising it, they attempted a contact, an osmosis, between the transformations of society and those of visual experience. Yet they believed that it was the function of the avant-garde to create a kind of memento mori of the object, and here they risked turning the avant-garde itself into a memento mori, a moral and spiritual rear guard that in some way had given up the ghost of its vitality. This danger was felt acutely in Europe, where it was hard to believe any longer either in a utopian art or in an art that involved itself with existing cultures, whether elite or popular, after the stench they had been giving off for so many years. Unlike American artists, who have tended to group themselves by generation through a succession of widely accepted practices, so that at any one time the art produced is fairly homogeneous (or was until the 1970s, at least), European intellectuals form antagonistic dialectical groups. Lines of artistic descent in Europe are much less distinct, and the ideological line of march—the passively absorbed mainstream—almost unknown. Europeans tend to see the world as problematic rather than pragmatic, and their efforts toward renewal are seldom concentrated on a single aspect of social reality, but are instead antidogmatic, opposed to any rigid ideological system. Generally speaking, the individual European artist's activity has been more rigorously interdisciplinary than in America; the artistic matrix is never univocal, for each thesis is modified by interference from and with others—the serial with the random, the material with the pictorial, the figurative with the abstract. Thus European art declares that it cannot be reduced to a single process of analysis. It surpasses style, and develops in spirals, living on incoherence and continual transformation—the conditions for a critical interpretation of reality.

This dialectical process, necessarily active rather than static, must pass through the fields of linguistics and ideology, which dictate the process through which discourse becomes object. Artists like Joseph Beuys, Piero Manzoni, Jannis Kounellis, Giulio Paolini, Yves Klein, Mario Merz, and Rebecca Horn have tried to reveal these fields; in seeking to bring to consciousness the intellectual raiments that clothe artistic practice, they have charged that practice with new meanings. Beuys, for example, was intensely concerned with social values, and his work's expressive use of artistic media spreads into the social realm. Starting in 1963, he gave his actions an emotional public dimension, drawing partly on artistic tradition and partly on his

own invention and personal experience. Art history gave Beuys a means to affirm a particular manner of communication; his own vision involved the formulation of ideas of social action. It is the combination of these two possibilities that gives his art its power. To write about Beuys, more than ever after his death, is to find meanings in his work that are reshaped continually as changes take place in our social and aesthetic life.

The twofold articulation of Beuys's approach appeared very early, while he was growing up, in Kleve, in what is now West Germany. During these years he pursued interests in both alchemy, Rosicrucianism, and anthroposophy, on the one hand, and the natural sciences on the other, developing a balance of feeling for both cultural texture and the natural world. Both are manifest in *Lightning* (1982–85), a work that incorporates much from Beuys's four decades as a sculptor and artist. Here, nature is defined as a "field of encounter (or collision) for the perceptional techniques and observations available to man." The "perceptional techniques" in question are those of seeing and sensing in a way uninformed by dogmas or abstract hierarchies. In the late 1940s Beuys had done drawings on paper of elks, rabbits, and other animals; he had also experimented with such natural phenomena as pine needles and bark. On one level, his works are figurative and organic "tracings" that implicated a free play of sensations, but at the same time they are based on the notion of art as an "energy field" that stages a living, active space. For Beuys, art demanded the establishment, through the assemblage for both historical and quasi-magical objects (including things with personal associations for Beuys from events in his own past), of a situation that realized a tension, a charge of energy. The reasons behind his choices and combinations of objects remained open, ambiguous in the positive sense, for his works had many connotations that he intentionally made no effort to explain. The viewer could not grasp their meanings through passive contemplation; an active process was necessary. What was the significance of *Lightning*'s trolley rail? Where did it come from? Why a cage and a knife? Whose bust was that on the barrels? And what was the reason for that suspended

quasi-triangular shape? In Beuys's view, this kind of free association constituted the difference between science and art: art made no claim to embrace the absolute; rather, it developed a fantastic consciousness in each individual viewer. In this sense, Beuys saw art as a bridge toward a collective community. His idea was to recover subjectivity in himself and in social behavior, as well as in his art—subjectivity as part of an overall process that excluded no living being.

Beuys had a vision of a popular art that could bring into being a permanent state of creativity, and I would use the word "state" in its political as well as its phenomenological sense. Although the powerful influence of German expressionism led him to an art that emerged from and celebrated his own individuality rather than from a social or group practice or ceremony, he sought a "choral" enterprise. Affirming a social creativity that would turn the world into a sculpture ordered creatively and democratically, he produced artworks symbolizing this process of transformation. He metaphorically descended to nature, to animals and plants, acting as the medium for a nonhuman, natural sensibility. He constructed energy fields of primal sensuality, using malleable, formally indefinable materials such as fat and felt. On these, and often with the help of blackboard diagrams that demonstrated the immaturity and powerlessness of both capitalist and Marxist culture against the disruptive force of individual creativity, he established a system of symbolic relations that touched on fields from mythology to geophysics.

Jannis Kounellis's goal is to emphasize the distance and difference between, on the one hand, the political, artistic, linguistic, and technological elements of today's worldwide cultural scene, and on the other the person or practice seeking polyvalence on all cultural levels. Every aspect of his work is informed by the reflective thought and sense of responsibility of an intellectual aware of his activity as a practice situated between the social and the aesthetic. These dimensions are often articulated by symbols, for example fire, a force of creation and transformation which appears and reappears in

precise locations over space and time—the flower of revolutionary fire that was kindled in 1967 and went out during the 1970s, for example, or the sacrificial flames that Kounellis has installed in various gallery spaces over the years as a kind of signature, a token of the sacredness of the artist's activity. Kounellis's work refers to art-historical manifestations from classicism to surrealism, and also to a set array of cultural, social, and psychological conditions. The individual work or installation implies the existence, somewhere, of a world of incessantly renewable forms—like musical instruments, but with ancient roots; however, through its inscription in ordinary objects and contexts (Kounellis has shown not only in galleries and museums but in inns, hotels, private homes, and outdoors), it develops simultaneously on the level of everyday existence and history, and constitutes a direct emotional and political situation.

The active space of Kounellis's art is a kind of world unto itself, a world uncolonized by the agents of contemporary culture. Here, past and present, although distinct from each other, are inseparably entwined—as when a broken fragment of classical statuary shows long hair growing from its head, an atavistic reference to the tradition that assigned women the task of remembering, that is, of recording the passage of time through the telling of stories, histories. In contrasts like this between opposite but complementary forces, Kounellis develops his work on two levels: it is both a challenge and an ideological counterpoint to the dominant cultural system. In this sense, he makes himself a source of "responsible" art. He searches within his own past for the warning fire, or for the remnants of classical culture. And he recognizes in it the catastrophe of a broken body, a destroyed civilization which still lives on in memory, in the head of hair. Kounellis accepts responsibility for what European culture has done, and his work awakes consciousness of both its different phases and its continuity. The playing of instruments is never over; the fire of artistic prophecy can always inspire them anew. They continue their song. Kounellis translates the tension of certain historical values into irreconcilable juxtaposition in the present. He casts roles in contradiction with each other, sets up conflicts. When

he introduces fire to the gallery or museum space, the site of the culture market, the disjunction he creates between the natural or organic and a rigid, crystallized structure makes public the rifts in our monolithic culture.

Since 1968, Rebecca Horn has been working with mythic images and memories which she translates into objects and films that communicate marvelous equivalents of her experience. Her works move in a kind of *temps perdu*, as if reality were caught in a continuous extension between mythology and history. Some of her works take the form of archaic, magical machines; obsessively and energetically repeating themselves, their cycles have no end. A needlelike pendulum perilously grazes the surface of a frail egg or a sheet of calm blue water, suggesting erotic and symbolic passages from object to object, situation to situation, male to female. Yet no transformation occurs; it remains only a possibility, a threat. Sometimes the machines are camouflaged zoologically, imitating a peacock or some other animal; sometimes they remain blades, needles, wheels. They become terrible wonders at the extreme limit of human relations. They invade one another psychologically and visually, but never touch, evoking cold, lucid paradises of mating, a metallic love affair.

European art often focuses on history, not as something remote and finished but something whose traces continue to transform and mutate today. In the United States, however, this kind of awareness of the past tends to be overwhelmed by the immediacy of the present. In part, this may be because American cities are perceived as more dangerous than European ones; there's more of a feeling of insecurity, less of continuity. The mobility of American society is also a contributing factor. The consequences for art can perhaps be seen more clearly in Californian production than in that of New York—for example, in the San Franciscan William Wiley's concern with the nomadic, with travel. Generally speaking, California artists put up monuments to precariousness. Their concern is not so much with the historical constants of the social or political system as with their own

immediate experience of environment. Los Angeles is a city with two cars for every three inhabitants, and people spend hours a day driving on freeways and through city streets, often alone. Solitude, one's only company the machine, becomes a dominant experience, and the continuous rhythm of motion tends to make one lose one's place in space and time. Artists like Ed Kienholz (a California artist at the beginning of his career, if no longer) and Chris Burden often treat the themes of solitude and unreality; in their work, space—cars, bars, squalid rooms—can be identified with their sense of their own bodies, their own organic and psychological limits.

The social isolation that both Kienholz and Burden reveal and emphasize derives from a vision of the city as a tyrannical place, culturally, physically, and economically oppressive and inhospitable to life. The urban landscape's impersonal mass of people and buildings, its congested streets, threatens the annihilation of individuality; yet the individual is the only possible source of resistance to its spread. And yet he has only two choices. He can remain psychically bound within his small private territory—his own home, his own room; or he can aggressively go outside, out in the open, to combat the destructive mechanisms of everyday life.

Kienholz, starting with *Roxy's*, in 1961, has chosen this creative struggle. Yet he does so by concentrating on the interior, the private. In the city's "human desert," the personal comforts of the home, small though they may be, provide a context in which the individual can survive. And Kienholz's sculptural installations such as *The Wait* (1964–65), *The Beanery* (1965), *The State Hospital* (1966), and *Sollie 17* (1979–80) are panoramic documents of this intimate social landscape. They are a depiction of urban man, the city dweller whose human dignity has been swallowed up in the energy of the street. The encounter or unity in these pieces between people and objects— the bodies seem part of the fabric of the rooms that house them— suggests the nightmare of existence in inhuman conditions: the characters in Kienholz's scenarios, miserable captives of their environments, are like embodiments of the yearning to flee (or adjust

to) the rhythms of urban life, a life based on the void, on absence. Kienholz's imaginary museums of everyday banality balance cold function with emotion. They are accumulations of the manifestations of instinct and memory as instruments of survival. His spaces form the nuclei for constellations of signs and objects, symbolic networks which for all their associational density are telling reflections of certain kinds of actual urban space. These interiors describe the chaos of the exterior, the public, conveying a sense of mortal malaise.

The tragedy of the man who withdraws into the private finds a contrast, or perhaps a violent correspondence, in that of the traveler through the public realm, the man who confronts the terror of the city streets, expanding his territory and taking on the intensity of the urban experience. Burden's work from *Shoot* (1971) to *Dead Man* (1972), from *Through the Night Softly* (1973) to *B-Car* (1975), suggests that he feels secure only outside his personal space. He faces danger, allowing the injuries that the city can inflict to lacerate his own body. In his work Burden intentionally creates physical and psychological encounters and collisions with the city. He turns violence into an artistic medium; he sets up the dehumanized conditions for an art of aggression and lifelessness, exposing the moral and formal emptiness of a cautious, reasonable art based solely on appearance. In the place of a "civilized" performance of communication, Burden provides an outlet for his culture's real hostility.

Burden's visualization of the kind of social aggression now implicit in the city, an aggression we cannot efface and that will not dissipate of its own volition, softened somewhat during the late 1970s, when his work became less violent, more metaphorical. Perhaps affected by the less radical social climate of those years, his reflections on the threat to the individual took the form not of attacks on the body but of clumsy-looking instruments of war. In *The Big Wheel* (1979), Burden provides a glimpse of the dark shadow of mechanization, which, with its overwhelming speed and force, is a threat to anyone who tries to mediate or control it. Its already sinister presence announces future apocalypse. In *The Reason for the Neutron Bomb*

(1979), the proliferation of nuclear weapons and energy is shown to lead to a final disappearance, an ultimate void. Nothing and no one can successfully oppose this arrogant brutality, including the artist— yet the artist does possess the strength of subtle, ironic criticism, which, in *The Glass Ship* (1983), transforms the tragedy into comic play. This terrible game serves to bare the foundations of cultural and social power.

The California artist, then, throws himself into the existential and environmental reality of modern life, and particularly of California. He is completely absorbed in its everyday presence, yet he does not exalt it; he has no illusions of preserving the possibility of individuality by avoiding the presence of conflict in the social sphere. He merely seeks an awareness and consciousness of existence. He is in no way isolated from society, as Pollock and Cornell were. In fact, what is crucial for the California artist is a kind of conscious social participation, a convergence of the subjective and the objective, of the individual and the public vision. For both must contribute to the theater of everyday life, and the theater of everyday life is inseparable from art.

Translated from Italian by Joachim Neugroschel

**Joseph Cornell**

Hotel de l'Etoile, *c. 1950–54*
*Construction with wood, paper*
*collage, bangle, rod, wire mesh,*
*tempera, and glass*
*16½ × 10½ × 4¾"*
*Frederick R. Weisman Collection*

**Joseph Cornell**

Trade Winds #2, *c. 1956–58*
*Construction*
*11 × 16¹³⁄₁₆ × 4¹⁄₁₆"*
*Collection of Edwin Janss*

**William Wiley**

Ship's Log, *1969*
*Cotton webbing, latex rubber, salt licks, leather,*
*plastic, wood, canvas, lead wire, nautical and*
*assorted hardware, and ink and watercolor on paper*
*82 × 78 × 54"*
*San Francisco Museum of Modern Art*
*William L. Gerstle Collection*
*William L. Gerstle Fund Purchase*
*70.37 A-L*

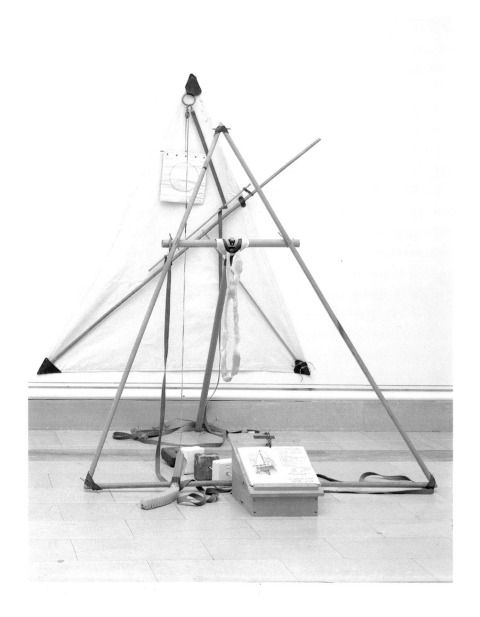

**William Wiley**

Thank You Hide, *1970–71*
*Construction with wood, leather,*
*pick, found objects, and ink and*
*charcoal on cowhide*
*70 × 64"*
*Des Moines Art Center*
*Coffin Fine Arts Trust Fund*

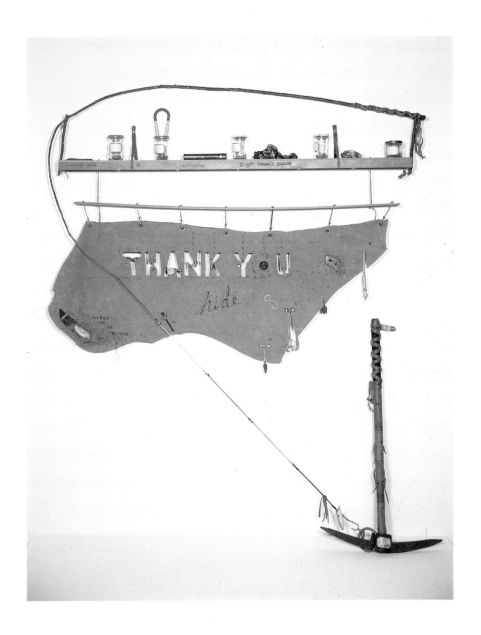

**Jannis Kounellis**

Untitled, *1969*
*Installation of twelve live horses*
*Dimensions variable*
*Collection of the artist*

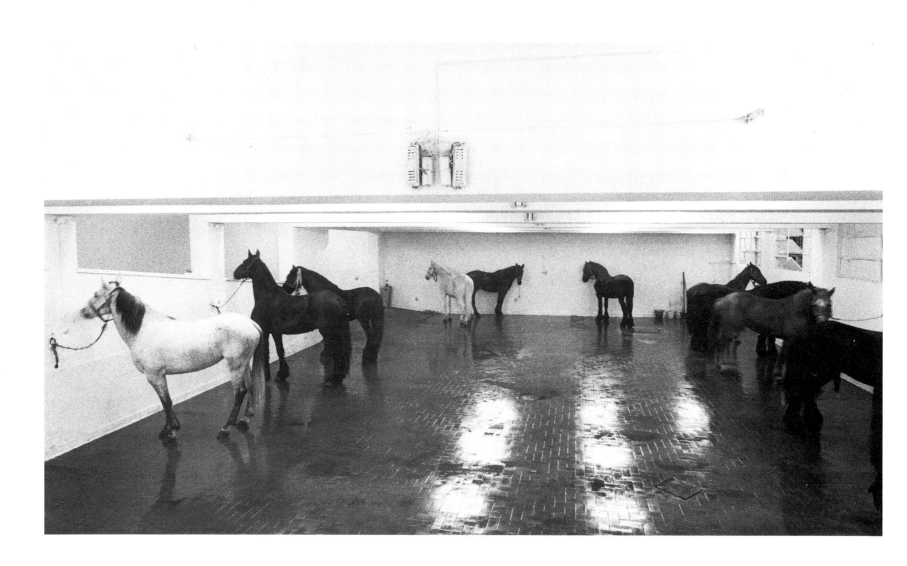

**Jannis Kounellis**

Untitled, *1971*
*Installation at Galleria Sperone,*
*Turin*
*Propane gas torches on floor*
*Dimensions variable*
*Collection of Annie and*
*Anton Herbert, Ghent*

235

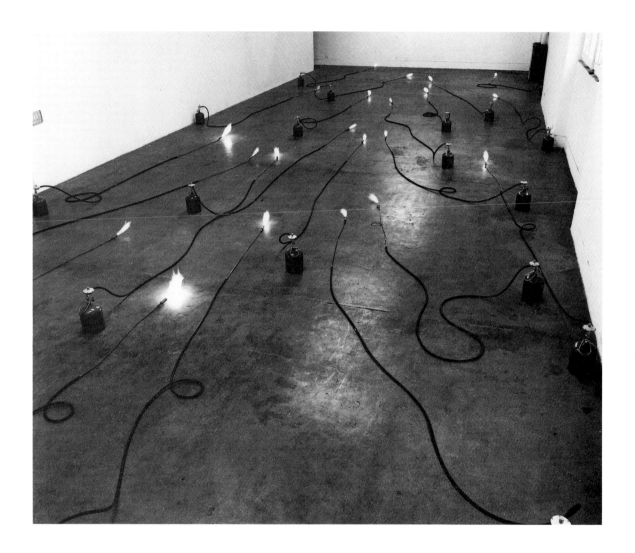

**Edward Kienholz and
Nancy Reddin Kienholz**

Sollie 17, *1979–80*
*Mixed media environment*
*120 × 336 × 168"*
*Private Collection*
*Courtesy L.A. Louver Gallery,*
*Venice, California*

**Rebecca Horn**

Black Bath with Two Simultaneous Waves, *1986*
*Installation*
*Theater Steinhof Festival*
*Vienna, Austria*

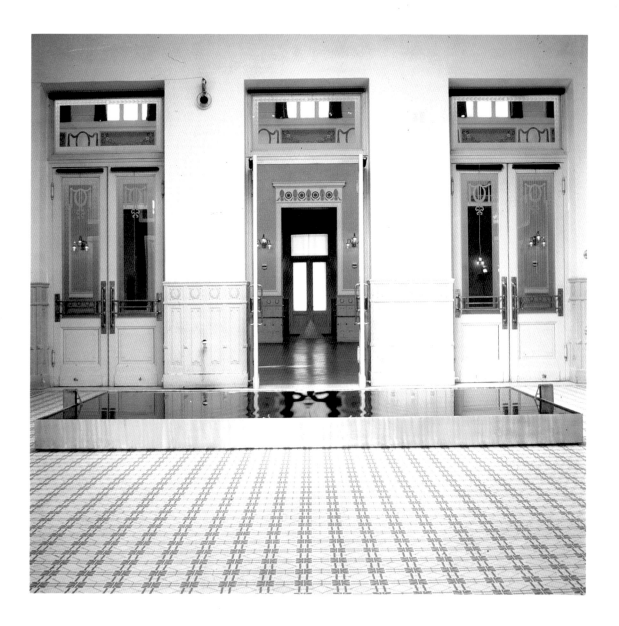

**Rebecca Horn**

Pendulum with India Yellow Pigment, *1986*
*Installation*
*Theater Steinhof Festival*
*Vienna, Austria*

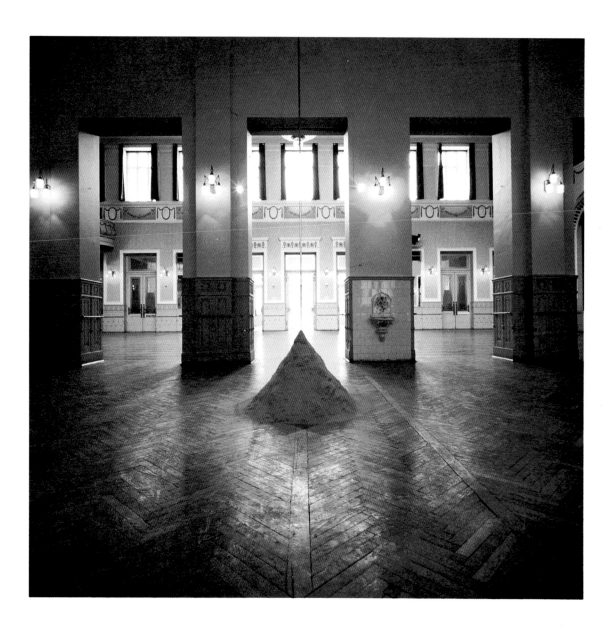

EXPOSING the FOUNDATION of

CHRIS BURDEN
8/8/86

STAIRS
ENABLING
VIEWERS TO
DESCEND
INTO OPEN
TRENCH

CONCRETE FOUDATIONS

THE MUSEUM

VIEWERS CAN OBSERVE WHERE THE CONCRETE MEETS THE EARTH

STEEL I BEAMS SUPPORTING MUSEUM

OPEN TRENCH 15' WIDE X 40' LONG X 10' DEEP

INSIDE MUSEUM

# Figure, Myth, and Allegory
*Achille Bonito Oliva*

The figure is the focal point in art. It has the centrality of language. It carries the intention of the visionary, the desire for power, a desire that takes, among various disguises, the appearance of chance tied to expressive need. The figure in art is diverse and in constant change. Through different materials and techniques, it takes form to present itself to the eye. In each case, it is seductive and dazzling.

Art does not hold its communion on the level of ordinary conversation or speak through the masks of daily life. Instead, it takes on original, unexpected forms. Its seduction is born from the need to create an opening, an excitement in the inert practicality of the quotidian, in the stupor that runs through social interactions in an impermeable horizontal stratum. Man lives in a universe populated by figures that do not pretend, that express only the need to consume, in as economical a way as possible. Art fears that kind of economy, which blocks the spectator's eye from astonishment and contemplation. Art's strength is based in its effortless presence and magnificent attire; it shows no sign of difficulty but a natural abandonment before the open and astonished eye.

The figure in art delineates a threshold. It marks the division between the manifestation of art, which masquerades continually in different figures and disguises, and other manifestations. Art's beat is regulated by the eccentric assumption of a particular eroticism: the desire to be the tool that defeats man's vulgarity.

Gregory Bateson has said that art is one of many aspects in man's search for grace; at times, when he partly triumphs, it is his ecstasy; it can be his madness and agony when he fails. It is ecstasy above all that captures the artist, and necessarily so. Only in ecstasy can he carry the image's disguise toward epiphany. Before art's parade of diversity, the external, contemplating eye must also take a rapturous gaze, which gives way only later to the accomplishment of modifying man's relationship with reality. In its nature, art has a tendency to curb the impetuosity of its initial apparition and to establish a socializing rapport in the moment of contemplation.

The figure again stands at this threshold, between the need for catastrophe and a systemic wisdom, between the break—the schism—and the impulse to destine itself as a social entity. It places itself between these poles to fortify art against an initial inertia, an ostensible ease of communication, by introducing a state of "turbulence." Turbulence comes from the epiphany of the image, its breaching of expectations, and the figure acts as the "disturber," an alarming sign in image and language. At the same time, however, the figure expresses art's desire to establish a profound relationship with the outside world, to mend, supported by a systemic wisdom, the initial schism, and to remedy the radical and lonely violence of the individual seer.

The figure acts as a wedge, a passage between the calm of social communication and the turbulence contained in artistic gesture. It constructs a manifestation that elicits admiration rather than fear or misunderstanding. While the figure's disguise can appear frightening at times, its intention is to produce a certain expectation, so that it can make its grand entrance into the world under attentive, admiring eyes ready to accept diversity.

Art cannot tolerate indifference, the inert, absent-minded look. Thus the figure always introduces beauty, which is, according to Alberti, a form of defense—a defense against the inertia of the everyday, against the possibility of failure caused by glances indifferent to art's dazzling apparition. Art's proverbial eccentricity and its element of surprise are part of a strategy to consolidate the difference between the artistic image and other images.

"I demand that art make me escape from man's society to introduce me into another society," Claude Lévi-Strauss has affirmed. The desire here is not to flee from reality, but rather to enter another space, to enlarge a passage that is normally precluded. Art corrects nearsightedness. Its view is no longer merely frontal but far-reaching and differentiated, a peripheral view that skirts the insurmountable frontality of things and takes them by surprise. The figure—the

many figures—are the repertoire through which the artist exercises his relationship with the world, a relationship moved by ambivalent pulsations, by desires that take him toward a certain state of mind, toward the crossing of the sentimental and emotional oscillations that constitute identity.

Nietzsche asked, "Are you among those that observe or among those that participate?" The artist, his hands warm from the work in progress, replies that he is a participant, for he makes the figure, the representational machine that builds the presence of art. "To pretend certain things, or to add others, and to fragment some of one's own invention is worthy of praise," G. Comanini has said. The representational machine is constituted by many parts; in its confusion and cancellations, it cannot take a linear construction. The artist must accept elements independent of his concentration or control, spontaneous growths that take him by surprise.

The figure is a shining example of a nostalgia for unity, that supposed target of the creative process as it moves toward a goal. The model of creation, of the work of art as a conscious, uniform project, is a demiurgic one. But the figure is the result of manipulation, of a work that progresses in irregular leaps and bounds through its contacts with various elements and circumstances, not all of which are fostered by the artist and his creative strategy. Other factors are involved in its progress, other factors mark its function and its maker's activity: the figure represents a convergence of artistic tensions, a meeting place where all the fragments of the visionary come together. Ecstasy permits the artist to amalgamate and finish a figure. It prevents his resistance, leading him to accept elements and fragments that come from recesses both light and dark.

Thus the figure cannot be repeated, for the action that defines it is not repeatable. It is possible to recognize the disguises that come with it, but only in order to indicate its source. The artist can add a margin of pretense, a technical participation useful in the definition of the image, but his skills cannot fill the gaps between the various fragments that constitute his work. The artist is not the source of the figure, but its agent of transition; it has its foundation and source somewhere else.

The fragments' traces set unity aside. They point to an irregular course that does not allow a passage back in time or space. Knowledge is a useless instrument before them; a pretense, it stays on the surface of signs. Resting on the semiotic of grace, observing the smooth surfaces of the figure, it cannot go beyond or beneath the surface of art. At this point the eye surveys the image, enveloping its contour, unable to make contact with that inner action created by its presence. *They could not make others like themselves, because not knowledge made them what they were. . . . Then if it were not knowledge, right opinion is left, you see. . . . they have no more to do with understanding than oracle-chanters and diviners, for these in ecstasy tell the truth often enough, but they know nothing of what they say. . . . Then it is fair, Menon, to call those men divine, who are often right in what they say and do, even in grand matters, but have no sense while they do it. . . . Then we should be right in calling these we just mentioned divine, oracle-chanters and prophets and the poets or creative artists, all of them . . . we should say they are divine and ecstatic, being inspired and possessed . . . while they say grand things although they know nothing of what they say.*[1]

The figure as truth in art is an irrefutable and evident presence, almost tangibly subjected to the outer scrutiny of art and to the inner scrutiny of the artist. The figure is the result not of mere mental thought, nor of the kind of rational knowledge that can be transmitted and taught ad infinitum, but of a chain of associations. The artist cannot transmit the knowledge of how he created a figure, because the figure is the consequence of unforeseeable events. It is his lack of knowledge that prevents him from resisting it, that welcomes unaffectedly the formulation that will bring results. The affirmation of a work of art is not the affirmation of the artist; it is displaced into the figure, in a displacement in which the artist loses memory of the work done.

This loss of memory coincides with the loss of the ordinary man's proverbial lucidity. The creative act is singular; again, it cannot be repeated. It is subordinated to a tension that itself does not remember how it came to be. In the act of the figure's creation the presence of the figure fills the scene of contemplation, unheeding of the demands of any external motive; time does not exist outside the fascination of the work and the dazzle caused by the apparition of turbulence.

The existence of art is based on the image of the figure; it is this that produces the artist's fleeting indemnity. Accepting an inner action that would otherwise remain hidden from the world, the artist becomes a mediator. This does not mean that he is reduced to the role of executor, but rather that he becomes, through the process of condensation and abbreviation that leads to the making of the figure, an activator.

With the belief that art could become manifest, that it could transform society's passivity, the historical avant-garde pushed the figure toward the realm of turbulence and the destruction of communication. Today, in a historical moment with no direction, no sense of renewal or perspective, that transformation, even that belief, is impossible. In this transitional period, seemingly outside the continuity of any historical project, another behavior has appeared. In the face of the semantic catastrophe that had overtaken art's languages and ideologies, the trans-avantgarde has placed the figure between turbulence and serenity, letting it move freely and unquestioned as to its provenance or direction. The trans-avantgarde has recognized a sense of pleasure in art, reinstating the work's supremacy, its power over technique. Here the opulence of painting introduces the possibility of connecting art's systemic wisdom to the instinctual search for grace. Sustained by the art's need to ensure a space for its appearance and its contemplation, the figure is the irrefutable presence that carries beauty. The trans-avantgarde courts the figure according to the dictates of a peripheral view, one that takes a circular walk around the work of art. And this is art's dream.

From Raphael on, the artist has taken up the sacred and the mythic as a way of working against art's linguistic boundaries, of displacing the mechanisms of signs and symbols—of iconography. From the historical avant-garde through the new avant-garde to the trans-avantgarde, modern art has approached the iconography of the sacred and the mythic not in iconoclastic and therefore contained terms, but rather as lay spiritual inspiration, as a way of changing form. Breaking visual conventions with new images (the results of linguistic research—research into the language of painting), modern art subordinated the iconographic to the devotional; it transformed the language of formal autonomy by formalizing inspiration in a visual system free of iconographic restrictions. Contemporary art, especially that of our time, has manifested its emancipation didactically: the artist is the sole creator.

The contemporary artist believes that he is the author of a new linguistic reality, the maker of a creation that touches upon the Creation, that possesses a visual free will that did not exist before his intervention. Working with materials stored in his conscience, in the magma of a sensibility that endures the test of creating its own art, the contemporary artist is ultimately the only one who can guarantee the work a demiurgic status, who can accord himself the role of creator. Contemporary art, riding the crest of art since mannerism, has acquired a legitimate, full autonomy.

The urge to create comes from the artist's desire to attain immortality. This desire determines the need to include in a work of art a symbol that can challenge time (and death), that can bear witness to a conflict unconcerned with worldly matters, that can stand as a true recognition of every prior creation. Only through perfection of form can the artist attain such a symbol, such a possibility. At a time when the theologies of history's various revolutions have failed, the striving for the perfection of form casts art as one of modern man's last forms of spirituality.

With the trans-avantgarde, one is faced with a situation in which creative strategy is based on the impossibility of totally assimilating

myth and allegory. The opportunity for a vision of an ideologically united world no longer exists; rather, ideology provides the contemporary artist with no more than a range of linguistic findings, a limited repertory of historical fragments, to use and quote in his work. Unable to redesign them, he can only quote them superficially, in irony, which is, as Goethe said, passion set free through detachment.

In the neomanneristic art of the trans-avantgarde, styles mix eclectically, melding figure and abstraction, narrative and decoration, combining fragments of various and diverse provenances. Removed from their original context and placed in a new figurative reality, old linguistic elements become a kind of ready-made. And myth and allegory become the vehicles for the stylistic resurgence of an image that no longer has the ideological arrogance to claim totality as its field, but reverts instead to a smaller sphere, a dimension open to the expression of individual mythologies.

The passage from a collective myth to diverse individual ones transports the linguistic developments of modern art into expressive and expressionistic dimensions in which, in a play of vital contradictions, the artist represents a subjectivity no longer unitary and coherent but fragmented, confusing—both sentimental and cynical, emotional and cerebral. Against the arrogantly unitary "I" of the neo–avant-garde, a domestic "me" represents itself, both dramatically and comically. In European art, the linguistic matrix is clearly expressionistic; in American art, it stems from a certain realist tradition, which it links with a popularly accessible sense of the fantastic.

Symbolism, expressionism, realism, and pop, then, are the linguistic references of both the European and the American trans-avantgarde. The artists combine these various traditions in culturally eclectic images, pictorial ready-mades which utilize myth and allegory as rhetorical figures to underline the subjectivity of art. And both the European and American trans-avantgarde share a paradox: they reveal the depth of the psyche by blocking the depth of the picture, through a heavy rendering of its surface.

Using painting to express his narcissism, Francesco Clemente deploys linguistic references ranging from the turn-of-the-century Vienna Secession and German expressionism to the sense of space in oriental art. Clemente portrays human bodies as Egon Schiele did, fragmented or mutilated. Schiele, obsessed with his own image, tore and dissected it in his imagination, while refusing any rapport with the outside world. Clemente's obsession with self-portraits is also marked not by calm but by conflict: he tends to exaggerate his features, to resort to an expressionistic asymmetry. This dramatic approach, however, is accompanied by a humorous touch which he seems to enjoy. And he locates his figure, or that of others, in a space that recaptures the sense of void and tranquillity typical of Indian art. Enveloped in serene contemplation, the figures seem renewed. In the end, intellectual and popular references in a continuous motif create a dual and healthily ambiguous image.

David Salle works with images inspired by the work of Francis Picabia and Andy Warhol. A young artist from the American trans-avantgarde, he salvages from the European dadaists the idea of the image as a decal, a transparent, weightless structure on the painting's surface. From the pop artists, Salle borrows the iconography of mass media, and the melding of these two influences in his work produces visual sequences of stratified imagery that bring to mind overlapping television images. In Salle's tight compositions, design prevails over matter; the figures seem attempts to penetrate the painting. Crossing the image's plane, the pictorial elements are both narrative and decorative, compilations of undramatic fragments accumulated according to an order at once fluid and formal, open and systematic. Salle creates a short circuit between conventional mass-media language and original images that seem to come from a world of dreams. The end result is an image that transforms banality into surprise, convention into visual dynamism.

Anselm Kiefer represents European culture, particularly the

romantic, epic, mythical, and allegorical traditions of Germany. His large-scale painting and sculpture is made out of a need to bring past memories to life, and it serves as a means to carry on a dialogue with the great men of German history—a history populated by heroes and thinkers whose message of unification is belied by Kiefer's worn and fragmented imagery. Kiefer's art aspires to revisualize the past while creating a positive tension with a present ridden by divisions and wounds that have not yet become history.

For Kiefer, art is a challenge to be met with an iconography based on the German genius loci; nature is the stage for great theater and Wagnerian thoughts, and architecture is the void, the place of dematerialization and ascension to a spiritual dimension. Through painting, the interior and the exterior—architecture and nature— evidence conceptual ideas that yet communicate feelings: emotional, utopian, cosmic, meditative. Myth and allegory are the means by which Kiefer creates an image that brings together the past and present.

Eric Fischl's style is a kind of subjective realism in which description and narrative are unclear. As a general rule, realism presupposes a contemplative distance between the observer and the object represented. Fischl's case is paradoxical—he eliminates that distance, and in the process obscures the picture's psychological connotations, creating a dense image devoid of spirituality. Casting a cold, objective look on the mythology of the mundane, Fischl uncovers the existential schism in American pop culture. These are images of the gray routine of daily life, taking place in gray landscapes; the same emotional color connects subjects with objects, flattening any diversity or distance. Here, observation takes the place of living. The rules of bourgeois life become an anthropological stereotype, the standard for an existential condition. The observer is able to see, to think, only while looking. The brutal circumspection of these paintings derives from a tradition that does not need to resort to expressionistic or chromatic distortion. Fischl is a truly American artist; his influences come directly from American culture, and his

taste for the cinematic is the sign of an American allegory.

Julian Schnabel is probably the only American artist of the trans-avantgarde who makes a connection between European cultural memory and the American spirit. His large-scale surfaces are reminiscent of America's great expanses. The canvas becomes the place where events occur, objects accumulate, and signs, reminiscent of both Antoni Gaudí and Robert Rauschenberg, reappear. From Gaudí, Schnabel takes a mosaiclike placement of objects in a rhythmic sequence that establishes a new formal order; from Rauschenberg, he takes a vitality of gesture that upsets the order previously defined.

Combining pictorial gesture with ordinary objects, Schnabel has created an assemblage of painting, architecture, and sculpture in a stylistic interplay that reveals a deep knowledge of composition. In this important dimension, archetypal signs undergo a revitalization. The influence of European painting can be seen in Schnabel's oeuvre in, for example, his use of El Greco's filiform shapes and dematerialized figures, which he places on velvet, a fabric that has always been considered precious. Here reference, subject matter, and contemplation finally merge to become part of the past; organic and historic memory become one on the picture plane.

Charles Garabedian's paintings combine the short span of personal experience and the language of the present with the vast time of mythological experience and the iconography of a mythological and biblical past. These two types of imagery converge on large surfaces looking much like fresco painting, and populated with stolid figures taken from the depository of art history. In the background, ruins speak of the passage of time, of change, upsetting the picture's stability in the present yet allowing for new hope.

Garabedian brings together pictorial devices drawn from his own generation—the abstract, two-dimensional depiction of the field, for example—and narrative topics taken from mythology. His cultural

nomadism takes him from the plasticity of primitive sculpture to Pablo Picasso (in his use of color), Yves Tanguy (in his ossified taste for landscape), Francis Bacon (in the contortion of his figures), and Paul Klee (in his filiform depiction of ruins and architecture). Garabedian's stylistic eclecticism results in an image and an iconography at once mobile, rarefied, pagan, and earthly.

Tony Berlant also follows a nomadic pictorial trajectory, one populated by references to high culture ranging from Roman mosaics to the American cubism of Stuart Davis, but constructed with quite ordinary material—found tin and tacks. These currents, high and low, come together in collages that offer the historical importance of art to mass-produced metal and to the anonymous found paintings it often frames. The result is complex and evident: on one hand, the Roman mosaic ennobles the mundane material; on the other, the banality of the salvaged images actualizes the references to high culture. Berlant mythicizes the contemporary while demythicizing the past. The technique of the mosaic, the combination of a number of small and disparate units into a visual whole, is an appropriate vehicle for Berlant's art, which synthesizes a variety of linguistic sources and alternates figurative and abstract elements. The result is a two-dimensional and flowing image that resembles an electronic memory, archaic yet open to the future, in the temporary dimension fixed within the work of art.

Susan Rothenberg builds her paintings around the retrieval of signs and archetypes—primary abstract and figurative symbols—outlined simply on the painting's surface. The image oscillates between the emotional and the contemplative, allowing first the artist and later the spectator to perceive the essence of object or figure. The shape of an animal, details of animated forms, or a series of evocative primary signs with the sketchy appearance of primitive painting arise from abstract backgrounds. Figure and space have an emotional, intuitive rapport that eliminates the geometric or perspective construction of depth, allowing the image to move on the flat plane in stylistic abbreviations, in simple curved lines that focus on the subject matter.

The smoothed, lightly brushed surfaces lend weight to the signs depicted in the composition. The emotional space the signs construct in the ground is also a mental one. It is part of an objective memory, but one that transcends the vision's identity, rendering it simultaneously subjective. Rothenberg's work traces a trajectory that starts from the artist's soul to end in the senses of the spectator.

This essay attempts to indicate the trans-avantgarde's abandonment of the neo–avant-garde's linguistic internationalism—its elimination of anthropological and cultural differences—in favor of genius loci, the inspiration that comes from that aspect of an artist's personality that privileges diversity. If it is true that the trans-avantgarde's philosophical mentality is based on the retrieval of the picture for art, it is also true that the trans-avantgarde has supported the artist's need to express subjective motivations. The term "genius loci" reestablishes territorial differences on an anthropological level and creates the possibility of a composition fragmented by diverse artistic forms. European art leans toward the rediscovery of narcissistic or mythical subjectivity, while American work tends toward the retrieval from the past of an emotional, less stylized kind of art that follows the demands of a vital cultural nomadism marked by stylistic eclecticism. The proverbial Anglo-Saxon pragmatism allows the American trans-avantgarde to adopt the linguistic innovations of an earlier avant-garde, flexibly melding them like patchwork. The proverbial need of European art to adhere to formal qualities determines a compositional level less inclined to contain references to popular culture; the popular has a style of its own.

Translated from Italian by Alma Ruiz.

1. Plato, "Meno," in *Great Dialogues of Plato*, ed. Eric H. Warmington and Phillip G. Rouse, and trans. W. H. D. Rouse (New York: New American Library, 1956), p. 67.

**Anselm Kiefer**

Sea Lion, *1976*
*Oil on linen*
*82 × 120"*
*Collection of Norman and Irma Braman*

**Anselm Kiefer**

*Departure from Egypt, 1984*
*Straw, lacquer, and oil on canvas*
*with lead rod attached*
*149½ × 221"*
*The Museum of Contemporary Art, Los Angeles*
*Purchased with funds provided by Douglas S. Cramer,*
*Beatrice and Philip Gersh, Lenore S. and Bernard A. Greenberg,*
*Joan and Fred Nicholas, Robert A. Rowan, Pippa Scott,*
*and an anonymous donor*

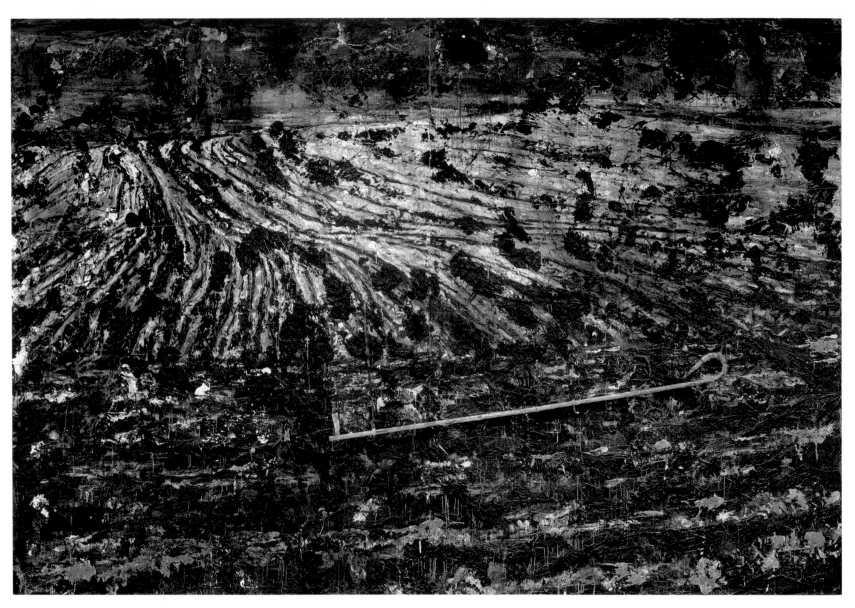

**Susan Rothenberg**

*The Hulk, 1979*
*Acrylic and flashe on canvas*
*89 × 132¼"*
*The Museum of Contemporary Art,*
*Los Angeles:*
*The Barry Lowen Collection*

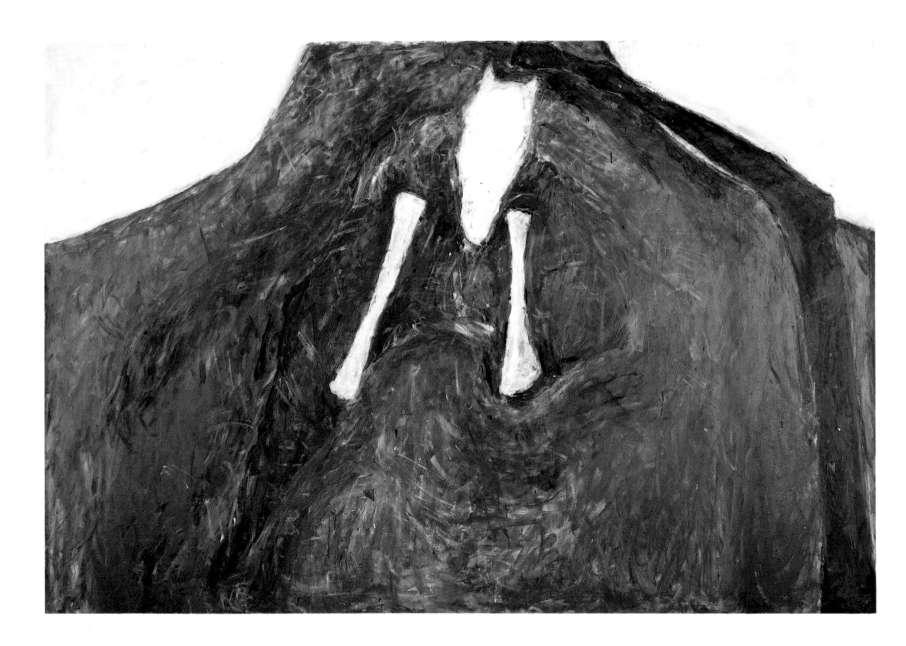

**Susan Rothenberg**

Blue Body, *1980–81*
*Acrylic and flashe on canvas*
*108 × 75"*
*Collection of Eli and Edythe L. Broad*

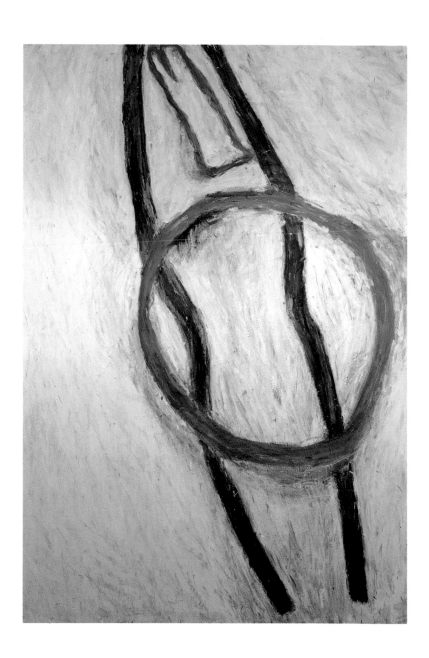

**Charles Garabedian**

Ruin V, *1981*
*Acrylic on canvas*
*72 × 72"*
*The Museum of Contemporary Art,*
*Los Angeles*
*Gift of Robert A. Rowan*

252

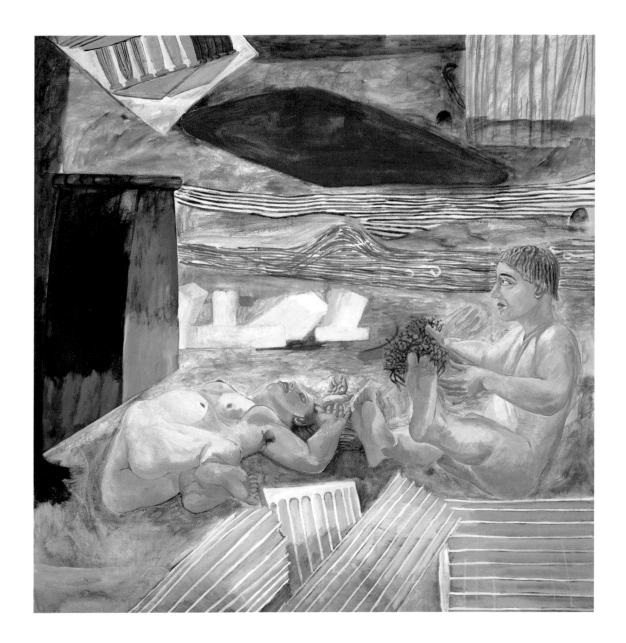

**Charles Garabedian**

Mutants Playing, *1983–84*
*Acrylic on panel*
*48 × 60"*
*The Capital Group, Inc.*

**Eric Fischl**

The Old Man's Boat and the Old Man's Dog,
*1982*
*Oil on canvas*
*84 × 84"*
*Saatchi Collection, London*

**Eric Fischl**

*Master Bedroom, 1983*
*Oil on canvas*
*84 × 108"*
*The Museum of Contemporary Art,*
*Los Angeles:*
*The Barry Lowen Collection*

**Tony Berlant**

I, *1982*
*Tin, nails, plywood, and found oil painting*
*70½ × 66¾ × 3¼"*
*The Museum of Contemporary Art,*
*Los Angeles*
*Gift of the Janss Foundation*

**Tony Berlant**

Untitled Ending, *1982*
*Tin, nails, plywood, and found oil painting*
*92¾ × 61 × 3"*
*Collection of Robert A. Rowan*

**Francesco Clemente**

Ricordo, *1983*
*Oil on canvas*
*140 × 175"*
*Collection of Robert A. Rowan*

**Francesco Clemente**

Suzanne, *1983*
*Oil on canvas*
*88 × 103"*
*Collection of Robert A. Rowan*

**Julian Schnabel**

The Student of Prague, *1983*
*Oil, plates, wood, and auto body filler on wood*
*116 × 234"*
*Collection of Emily and Jerry Spiegel*

**Julian Schnabel**

Throne, *1983*
*Oil and modeling paste on rug batting*
*120 × 84"*
*Collection of Ed Cauduro*

# Image and Language:
## Syllables and Charisma
*John C. Welchman*

The various modes of relation between words and images, between linguistic signs and nonlinguistic, visual signs, have been of progressive and determining importance during the modernist period, despite the vaunted definition of visual modernism as somehow independent of other discursive orders, as "autonomous" in its materials and articulations. For the last twenty years or so the interdependence of word and image in the visual arts, as well as in broader visual signifying systems, has become even more complex, if more explicit in proportion, suggesting a certain discursive break in the last half of the 1960s away from the reiterated concerns of late modernism toward art practices that do not (usually) employ conventional fine-art materials, do not produce merely formal configurations, and are often frankly theoretical, textual, and provisional. These practices cannot adequately be designated under rubrics such as "conceptual art," "postmodernism," or "postminimalism," which each have their own agendas, polemics, and advocates. They can, however, be reconvened, at least in part, through a discussion of their discursive confrontation of textual and image-object material. A few specific examples, discussed below, will be displayed in the exhibition to which this essay contributes.

One of many symptoms of the hyperexpansion of textual activity within and around the visual domain in the last two decades has been the broad and varied attention paid to it. In art criticism this has ranged from Harold Rosenberg's attempt in "Art and Words"[1] to pronounce in quasi-phenomenological terms the essential dependence of much 1960s art on various interested critical discourses, to the pseudosociologizing of Tom Wolfe, whose *The Painted Word*[2] is a low-grade journalistic jibe at the ceaseless implication of all aspects of the art world (galleries, exhibitions, critics, objects, etc.) in an elaborate textual scheme plotted by the powerfully determining criticism of master critics Clement Greenberg, Leo Steinberg, and Rosenberg himself. For Wolfe, their textual "responses" to postwar American art "shockingly" confounded its visual integrity, and in the end played too forceful a role in the actual construction of movements from abstract expressionism to minimalism.

Criticism and theory that has discussed the word-image relation more rigorously has tended to be, implicitly or explicitly, structuralist or derived from structuralism. That is, it has been based on the governing axiom of structuralist activity: that nonlinguistic systems can profitably be analyzed as if they were structured like a language.[3] European criticism, especially that of the French structuralists,[4] began to examine the various relationships between language and image in visual systems early on, but there have been few fully developed structural analyses of visual art in the modern period in English, excepting, perhaps, Jack Burnham's *The Structure of Art* (1971).[5] However, increasingly numerous diluted versions have appeared, as structuralist theory has become (belatedly) absorbed by the "radical" wing of Anglo-American art criticism-theory-history. Concurrently, a small stream of publications from the academic presses has translated Eastern European formalist and semiotic writing by such authors as Jan Mukarovsky;[6] produced compilations of interdisciplinary and cross-cultural comparative analyses such as W. J. T. Mitchell's *The Language of Images*;[7] or, more rarely, offered as philosophically cogent an account of the definition and function of art practices as Nelson Goodman's *The Languages of Art*.[8] Moreover, there are now at least two English-language journals—*Art and Text* and *Word and Image*—whose titles expressly signal their focus on aspects of the word-image confrontation,[9] and even such mainstream periodicals as *Art Journal*, in its issue of Summer 1982, have begun to produce thematic issues centered on this problematic.

The institutional recognition of the relationship of word and image as a prominent feature of contemporary practice is further demonstrated by the many exhibitions in recent years that have structured themselves around subsets of that relationship. In the 1970s these were often small scale and "alternative," usually adjuncts of conceptual art; but in the 1980s, as the thematic exhibition has been progressively sanctioned over the group show or individual retrospective, especially in Europe, the issue has been addressed more specifically. The largest exhibition to date predicated on certain kinds of relation between words and images was "Ecritures dans la

peinture," held at the Villa Arson, Centre National des Arts Plastiques, in Nice, France, in the spring of 1984, and coordinated by Michel Butor, whose own (slight) text *Les Mots dans la peinture* (1969)[10] is an ad hoc, ahistorical juxtaposition of countless interactions between words and images from all historical periods. The exhibition featured mainly French artists, accompanied by some Italians, Germans, Americans, and one English artist, as well as a few others: 117 in total. The group was divided into twelve sections by eleven critics, who each contributed to the second volume of the extensive catalogue a text purporting to outline the particular fraction of the word-image relation that informed his or her selection of works. The result is a spectacular jamboree of visual practices and meditations on the numerous physical presences of words in art objects, from the early twentieth century—baldly treated—to the 1970s and 1980s, where examples proliferate. The range of issues covered includes *peintre-poésie, calligrammes*, typography, collage, signatures, calligraphy, ideograms, lettrism, concrete poetry, phototext, conceptual art, documentation, etc. In "Ecritures dans la peinture" and in other similarly expansive thematic exhibitions and anthologies,[11] the word-image preoccupation appears as a sprawling theoretical catchall, one abetted by the attempted sophistication of European and especially French and Italian curator-critics armed with approximate structuralist ideas and intent on imposing individual, momentary unities on the pluralistic visual production of the last fifteen years. Particularly noticeable in the Nice exhibition and elsewhere is the tendency to legitimize contemporary practices by annexing a few works and individuals from the historical avant-garde—André Masson, René Magritte, Max Ernst, Raoul Hausmann—in an effort to create transhistorical categories (which are, finally, rather unstable) across modernism.

To reinvest the orders of relation between words and images in (and out of) modernism with more historical specificity is difficult after the rampant decontextualizing of recent years—epitomized in the "renegade thematics" of much art-magazine writing. Still, in the end, a number of interpenetrating yet semidiscrete orders can be identified, which together constitute the textual unconscious of visual modernism—and initiate an essential relay between the visual and the political, the subjective and the sexual. There is space here only to sketch these orders in outline and to concentrate briefly on a number of artists whose use of language in image-making has been significant in the last thirty or so years. One notable penalty of this abbreviation will be the suppression of many of the historical coordinates invoked above.[12]

The simplest mode of relation between words and modern images is through titling.[13] The title of a painting or sculpture is the name of that object; as name, it sets up a complex rapport with the surface or volume to which it relates. It is demonstrably implicated in the signifying capacity of the work, providing probably the first term in its description and its context. In premodern painting the image was dependent for its signification on officially sanctioned and well-developed generic orders: history painting, portraiture, landscape, and genre. And as the works were prepositioned generically through a recognizable system of references to, mainly, historical, mythical, and religious texts, titles were obviously of less strategic importance to both artworks and audiences. In portraiture and landscape a title merely named an individual, group, or place. Only in the titling of genre painting was there some deviation from these norms, as Charles Baudelaire noted in his pamphlet on the salon of 1846.[14]

As visual modernism emerged in the later nineteenth century—marked by a new subject matter that was annexed more insistently from the real, the everyday, and the modern, as well as by new markets, institutions, and publications (including both the salon and Baudelaire's pamphlet)—titles took on a new function, or rather a combination of three functions, in relation to the images they designated and in respect to their premodern signification. The traditional denotative reference, in which words are presumed to stand in direct and untroubled reference to what is represented, continued, but two alternative modes of titling also developed: the first intends a more "poetic" title to provoke allusive or connotative

*Paul Signac*
Against the Enamel of a
Background Rhythmic with Beats
and Angles, Tones and Colors,
Portrait of M. Félix Fénéon in 1890, *1890*
*Oil on canvas*
*29⅛ × 37⅜"*
*Private Collection*

reference through an image; the second, a conclusively modernist practice, advertises the absence or inapplicability of a title through the designation "untitled," or through referring to the works by number or by other systematic nonreferential designations.

In general, the impressionists produced titles that were still anchored descriptively to the site where the painter experienced the "impression" and registered it through the materials of painting. Additions to the mere specification of place qualify the location by indicating time or season or the natural, temporal events in process— for example, in Claude Monet's *Lavacourt, Sun and Snow* (1873). These are emphatic environmental and atmospheric indicators, never before used so consistently in Western painting. Further emphasis is introduced by such qualifiers as "effect" or "impression"; their importance is attested by the adoption of the earliest and now most famous of such appellations, Monet's *Impression, Sunrise* (1873), for the whole group of painters associated with Monet's interests.

The paintings of Paul Signac provide some of the earliest evidence of these two paradigmatic modernist situations in titling—the apparently overscripted, offbeat, or uncomfortable title on the one hand, and the untitled or merely numbered work on the other. His *Against the Enamel of a Background Rhythmic with Beats and Angles, Tones and Colors, Portrait of M. Félix Fénéon in 1890* demonstrates some of these processes of exchange between title and work, which signal displacements of humor, irony, and esoterica to the viewer.[15] At the other end of the titling spectrum, an account of the origins and early history of the untitled work has yet to be written. It seems likely, however, that Signac and James McNeill Whistler were among the first to use the names of their paintings to signify that the viewer should look past the motif to apprehend first the formal, and especially the rhythmic, elements of the composition. As in many late nineteenth-century passages between word and image, this was most effectively managed through the directed intervention of music as an analogue. Whistler, as is well known, entitled a series of his works "Nocturnes" and explicitly noted the

*Wassily Kandinsky*
Accord réciproque, *1942*
*(Reciprocal Accord)*
*Oil and enamel on canvas*
*44⅞ × 57½"*
*Musée National d'Art Moderne*
*Centre Georges Pompidou, Paris*
*Gift of Mme Nina Kandinsky*

titles' indication of "an artistic interest alone."[16] And while Signac
had a strong set of nonformal interests—particularly in anarchism,
which at times may have confounded the implications of his musical
abstractness—he painted in 1891 a series of five works under the
general title *La Mer, les barques, Concarneau,* that were
individually designated by opus number and by the expressive
musical signatures *Scherzo, Larghetto, Allegro Maestroso, Adagio,*
and *Presto (finale).*

The avant-garde movements of the early twentieth century can
usefully be aligned with these symbolist-derived modes of titling.
Fauvism and cubism witnessed a partial continuation of the
denotative title, while the development of (geometric) abstraction on
the one hand and of dada and surrealism on the other revealed the
pursuit first of untitling or restrained titles, and second of
"excessive" titles, often in complex denominating relation(s) to the
image. Interestingly, the simple alignment of autonomous, self-
referential, modernist abstraction with absent or numerical titles and
of externally referenced figurative representation with provocative or
allusive titles is inaccurate. Important intersections occur between
these two poles, of which the abstracting tendencies within
surrealism and the nomination of minimalist works in the 1960s
provide the most obvious examples. Indeed, consideration of the
titles by artists such as Morris Louis, Frank Stella, and Anthony
Caro, which are almost always suppressed into parentheses or
ignored altogether in the dominant literature,[17] would seem to pose a
fundamental threat to the formal and technical closures placed on the
signification of late-modernist works by American formalist criticism.

One of the many questions provoked by the consideration of titles, as
well as by the suppression of such consideration, is that of their
function as a kind of prosthesis for abstract works, as a manufacturer
of meaning, or meaningfulness. If doubts about the status of title-
assisted abstraction as a form of communication are sustained, then
titles like Wassily Kandinsky's *Reciprocal Accord* (1942) or *At Rest*
(1928), an example offered by Stephen Bann citing Ernst Gombrich

*Georges Braque*
Clarinet, *1913*
*Pasted papers, charcoal, chalk,*
*and oil on canvas, 37½ × 47⅜"*
*Museum of Modern Art, New York*
*Nelson A. Rockefeller Bequest*

*René Magritte*
La trahison des images, *1952*
*(The Betrayal of Images)*
*Gouache on paper, 5¾ × 7"*
*Private Collection, Houston, Texas*

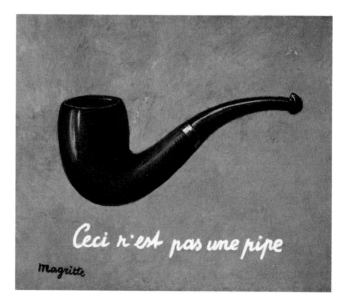

and Claude Lévi-Strauss, become roguish operations designed to furnish, under the cover of misplaced notions of artistic intention and psychological correspondence, a semantic legitimacy—a content—for a "parasitic" image.[18] Ironically, it is the very provision of titles in an attempt to guarantee and control the exchange of emotion between artist and viewer that permits a meaningful deconstruction and the possible exposure of a certain powerful fraud in the celebrated signifying pretensions of much abstract art.

A second mode of relation between words and images, the physical presence of words or letters in art objects, is the one most often associated with the word-image confrontation (as the title of the Nice exhibition suggests). The deliberate incorporation of words into the surface of a painting, against the impulse of perspectival space and unsupported by a "naturally occurring" represented motif, was an invention of the analytic cubism of Pablo Picasso and Georges Braque, and developed around 1912. From the Renaissance up to this time words in paintings, with the exception of signatures, had been present only as legible portions of the visible scene, as in Gustave Caillebotte's hazy, partly erased café legends and Raoul Dufy's representation of posters at Trouville. To an extent this was also the case for analytic cubism, in which the stenciled words, whole or incomplete, were almost always "explained" as part of a still life composition of everyday objects inhabiting the studio: newspapers, sheet music, books, bottle labels, and so forth, on which large-type text could always be glimpsed. Of greater significance, however, was the development of collage, in which alien found materials, often printed, were combined on the picture's surface to articulate a completely new formal configuration.

Cubism, then, originated the two dominant modes of the physical presence of words in modernist art: words actually painted onto the surface freehand or with stencils or other devices and words from preexistent printed sources juxtaposed by collage. The two modes have persisted in various manifestations throughout modernist art and beyond. The futurists, dadaists (notably in Kurt Schwitters's

266

collages), and surrealists (especially in the painted words of Joan Miró and Magritte) all made conspicuous use of words, often in order to achieve subversive or oneiric effects, or, in the case of Magritte specifically, to raise problems of representation. By and large, however, these works are eccentric to the trajectory and interests of mainstream modernism as defined by critics such as Greenberg. (Greenberg's difficulties with Miró's work in the mid-1920s are exemplary.[19]) The presence of words produced too many connotations foreign to the surface and material concerns of the "modernist" painting. Indeed, the recent iconographic recovery of the wit and irony of many of the juxtapositions in cubist collage has constituted an important revision in cubist studies, a move away from the almost exclusive attention to the movement's formal innovations,[20] given detailed adumbration by Greenberg in his 1959 essay "Collage": "Literal flatness now tends to assert itself as the main event of the picture."[21]

Within tachism and abstract expressionism there developed theories and practices of an autographic gesture, where the marks or touches on the canvas surface were held to be charged with the psychic energy of their artist creators. So potent and personal were the expressive pretensions that underwrote them, these notions generated a whole analogical vocabulary which designated the facture of a painted surface as a "handwriting" or "calligraphy": "the . . . handwriting of the artist is an essential clue to his identity and quality."[22] In America the calligraphic metaphor has most often been applied to the work of Robert Motherwell, Franz Kline, Mark Tobey, and Jackson Pollock; in Europe to Georges Mathieu, Alfred Wols, Henri Michaux, and Hans Hartung.[23] Visibly a development of some of the concerns of these painters, the calligraphic articulations of Cy Twombly stand apart in the complexity of their exploration of the autographic and the textual. Twombly's modulation between legible, semilegible, and unreadable signs, painted against grounds that themselves range from vigorous inflection to clear, almost unpigmented spaces, has attracted commentary from several critics (notably Roland Barthes[24]) who have won their reputations from

structuralist (or poststructuralist) discussions of (elusive) sign systems.

Twombly attempts a "poetic" visual practice out of the partial distortion, dissolution, and reinvention of the material signifiers of writing itself, conjoined, persuasively, under the subjective continuity of his personal "style" of handwriting. When the marks hover between the recognizable and the unknowable—precisely at this threshold—the viewer is carried over (through a kind of projective autographic transfer, a physiognomic metaphor) momentarily into a domain beyond writing. The forcefulness of the physical and the visible negotiates an adventure beyond the code (the knowable, the verifiable, the controllable, the social). Twombly's signs are therefore differently predicated and differently destined from those of the abstract expressionists—Pollock, Kline, etc.—whose marks, always already beyond (or before) linguistic codification, achieve "expressiveness" only through highly allusive means (always only formal and/or metaphorical), and are grounded in relation to language theory on tenuous notions of a direct psychological circuit connecting the mind of the artist, the marks on the canvas, and the mind of the viewer.

Twombly's signs may be distinguished, too, from the more "idiolectic" sign system recently generated by Matt Mullican, which seems to partake of aspects of each of the sign categories of linguist Charles Pierce—icon, symbol, index—and often departs morphologically from the injunctive "symbolism" of the street sign and other such nonlinguistic, socially encoded public signs. Though Mullican's method of interpolation beyond simple (in some cases subliminal) recognition may, like Twombly's, be said to carry the viewer over into a semilegible domain, and thus to raise provocative questions about consciousness beyond the linguistic or visual code, he does not provide a "legible phase" directly comparable to Twombly's (at least in some of the latter's paintings and drawings).

Twombly funds the passage into uncoded space with fragments,

hints, and suggestions drawn from classical and romantic culture (the culture saturating his Mediterranean environment) and from personal history/memory. Straddling the two are semiarticulate locutions, euphemisms, expletives, fillers—a palette of vocatives normally only oral—which signify the existence of mental activities beyond the reference potential of the "utterance." Apart from the marks that impinge most closely on written signs, a "syntax" of configurations, of seemingly ordered and repeated resemblances originating in Twombly's work of the mid- to late 1950s, continues, in clusters or singly, through the 1960s, where explicit quoted text and names are also often present (*Sahara*, 1960). (Curiously, one of the most recurrent of the configurations is an abbreviated rendering of buttocks, a motif that Mike Kelley subjects to extraordinary mutations in his *Monkey Island*, discussed below.) The syntactic functioning of the configurations imposes a second "grammar" across the picture surface, and many works from this period are thus triply articulated, with a pictographic grammar, a linguistic grammar, and a "shadow" or ghost textuality, apparently resistant to any ordering outside the autographic.

Some of the implications of Twombly's graphic textuality were taken up simultaneously by Robert Rauschenberg and Jasper Johns. Rauschenberg's incorporation of printed and occasionally hand-written signs in his combine paintings is, however, more in the service of an expanded understanding of collage: text is already present on Rauschenberg's found objects—a license plate, an automobile tire, or whatever—and functions, as in most collage, as an indeterminate, pseudopoetic presence referring randomly or obliquely to the outside world. Johns did not use much text in his famous encaustic works of the later 1950s, but in many of these pieces the strips of newsprint that he built into his mixture of pigment and beeswax remain only partially effaced on or near the surface. Accordingly, most of his flags and targets are explicitly sculpted out of a combination of wax, pigment, and text, carrying the printed word into the fabric of the composition—ironically disrupting, before the event, the Greenbergian/Friedian logic of the surface and its telos

in Morris Louis's pigment soaked into the weave of the canvas.

When the range of Johns's occasional usages is considered in full,[25] it reveals his interest in painted or objectified words to be urgent, if in the end subordinate (as may also be argued for Magritte) to investigations of the image-object system. Thus the alphabet series represents letters as stenciled, serial, sequential, inoperative, unsyntactic, and anonymous. The idea of the alphabet is objectified as a monotonous grid, striking by virtue less of its heterogeneity or difference than of its placid, slightly offhand physicality. Johns's heaviest assertion of the objectness of language is in the 1961 work *NO*, in which the two metal letters of the title hang by wires in front of the picture plane; this robust negativizing at one level seems to propose the existence of language as a tangible device analogous to the two balls that interrupt the surface in *Painting with Two Balls* (1960). The treatment of language as object is clinched in the field paintings of the early 1960s, where it overlaps with another Magrittean interest—labeling, misnomination, and (material) difference (for Johns, most associated with color identification). Concomitant with this rather austere and depersonalized physical presence of language is another, more evocative mode, found in *Tennyson* (1958) and in two works with titular dedications to Frank O'Hara and Hart Crane.

In pop art the physical presence of text is rarely as elusive as in the work of Twombly, Rauschenberg, or Johns. Words and letters are incorporated in much the same manner as other popular motifs annexed from social circulation. As with the cubists, text is carried over into the representation as (if) inscribed on Coca-Cola bottles (Andy Warhol) or on domestic appliances and in comic strips (Roy Lichtenstein).

Ed Ruscha's paintings belong to pop or conceptual art only as approximately and unsatisfactorily as Twombly's belong to abstract expressionism. The sum of his production represents the most scrupulous and consistent development and analysis of the iconicity of

*Jasper Johns*
Grey Alphabet, *1956*
*Encaustic and newsprint on canvas*
*66 × 49"*
*Private Collection, Houston, Texas*

*Jasper Johns*
Tennyson, *1958*
*Encaustic and canvas collage on canvas*
*73½ × 48¼"*
*Des Moines Art Center*
*Coffin Fine Arts Trust Fund*

written language over the last quarter-century. Moving from his early collage technique to the dark-hued, heavily impastoed works of 1961, such as *Ace* and *Boss*, Ruscha inaugurated a single-minded attention to the representation of words, on a variety of supports and in a number of different media. While he has also represented objects (comic books, gas stations, medicines, bowling balls, marbles, apples, olives, sheets), places (the Los Angeles County Museum of Art), and events (a "miracle," or a marble shattering a drinking glass), both with and more often without an accompanying text, the majority of his works are preoccupied with the "objectification of the word."[26] Except for an experimentation in the first half of the 1970s with organic media (yolk and white of egg, blood, fruit juices, and spinach) and moiré supports, Ruscha's text-images are fairly restrained in their formal and technical means.

The words and phrases in these paintings interact with their physical environments in a variety of ways that partially determine their signification. In a number of works on paper from the late 1960s (*Air, Motor, Lips, 1984,* and *Raw*), Ruscha used graphite, gunpowder, and pastel to build up a trompe l'oeil image of a single word, fashioned to look as if it were made of paper cut-outs resting on edge. Around the same time, he used a similar illusionistic device, in oil on canvas, to render single words as if they were formed out of viscous liquids contaminated for extra effect by clusters of beans, berries, and olives (*Desire, Rancho, City, Adios*). Other devices were occasionally used to reinforce, somewhat crudely, the connotations of the represented word. In *Damage* (1964), the word *damage*, in capital letters, is partially consumed by flames; in *Noise, Pencil, Broken Pencil, Cheap Western* (1963), the word *noise*, seeming to recede through perspective in the top-right sector of the image, is offset formally and semantically by images of the objects listed in the title. *Jinx* (1973–74) is one of the few instances in which the word does not appear handwritten, in which it seems not only nontypographic but unwritten: *jinx* is formed out of (painted) intersecting stalks of grass.

In his works since the mid-1970s Ruscha has normally proceeded by first spelling out in tape the words on the canvas, then painting his usually simple "backgrounds" over them; the letters are represented by the absence of pigment, in an unfanciful straight-lined typography. While a number of variables—the color and design of the painted environment, the typographic arrangements, the word breaks, and so on—again reinforce the signification(s) of the textual matter (often comically, as in *Hot and Cold Vegetables*, in which the ground is half green and half red), the attention-grabbing formal and illusionistic devices have been jettisoned. These recent works more brazenly and cumulatively assert the physical presence (through literal absence) of the textual formula. There seems to be little point in attempting a systematic analysis of the linguistic or semantic structures of Ruscha's language, especially as he himself locates the source of what are increasingly "turns of phrase" rather than single words in intuition or preconscious activity, and in conversation, magazines, and the mass media. In this respect at least, his linguistic sources come closest to Robert Barry, though Barry is perhaps more rigorous in his compilation of an ongoing index, alphabetically arranged, containing what the artist senses are the more poignant words and formulations of his everyday world.

In most of the representations of words in modern visual art, including most of the (few) examples adduced here, the dominant effect of the fracturing of the word from its "normal" circulation can be summarized as a kind of "defamiliarization": the veiled ideological neutrality of colloquial diction is exposed at every moment that it is isolated and displayed. Ruscha in particular is revealed as what Barthes terms a "performer of the text":[27] in dealing with the "letters" of language he constantly evokes its metaphorical escape from the closure of denotation, though he does so with much greater "cool" than do artists in the "baroque" tradition of "figurative metamorphosis" that Barthes reviews.

If Twombly, Johns, and Ruscha have effected a diverse set of late-modernist responses to the painting of words into images inaugurated by Picasso, Braque, Miró, and Magritte, Alexis Smith is one of the

*Kurt Schwitters*
Okokade, *1926*
*Collage*
$3^{13}/_{16} \times 2^{13}/_{16}"$
*Private Collection, Houston, Texas*

few contemporary artists, apart from Rauschenberg, to have re-explored the expressive potential of collage following the cubists and the dadaists Schwitters and Ernst. Though Smith claims that her collage technique came from childhood habits rather than from consciousness of art history, her practice is necessarily inflected by many of the historical constraints of the development of one of the paradigmatic modernist techniques.

These constraints are presented most interestingly in John Elderfield's discussion of perhaps the most elaborately worked out of collaged oeuvres, that of Schwitters. Departing from premises that appear to be little more than refinements of Greenbergian formalism (and to which Gombrich also has lent support[28]), Elderfield, in the course of a long essay, progressively reveals that the various textual materials in Schwitters's work constantly escape from the strictures of the self-referential system. Despite his censure of "quarrying for latent structure which subsumes the manifest structure of the work,"[29] and his production of a rich vocabulary to describe formal procedures and effects—"alignment," "axes," "edge-positioning"—he concludes by arguing for a kind of mixed economy of collage signification in which reference and "autonomy" can only exist in mutual relation. The collage thus becomes a "mixture of signs" whose reception is a "bodily" experience for the viewer. While Elderfield goes too far in pronouncing an equivalence in Schwitters's collage between content and "morality," his identification of the inevitable defection implicit in any technique of juxtaposition from the tyranny of formalist monotheism is useful.

Smith's collages differ noticeably from those of the early modernists. Their presentation is much more fastidious and clean-edged than Schwitters's magpie accumulation of tarnished and fading urban ephemera. In particular, texts are not so much found as scrupulously selected, from either modernist prose (Jorge Luis Borges, John Dos Passos, Thomas Mann) or popular fiction (especially Raymond Chandler); and they are not so much represented in their original state as reprinted, sometimes cut and decontextualized to serve a

specific function. And rather than the singular incidents of Schwitters's or Braque's work, Smith produces sequences of panels, from the two in *Asphalt Jungle* (1985) to the eight cardboard planes of *Cannery Row* (1980), so that collage is imbricated with narrative. The thematic interconnectedness of the panels is reinforced by formal overlaps, rhymes, and structural symmetries. In *American Way* (1980–81), each of five metal printing plates has, first, a text printed at the bottom, which takes on the function of a caption; second, a number of printed images of commercial products—a Coca-Cola bottle, a kettle, a refrigerator, a frying pan, a bra—mostly rendered in period design style; and third, a nonprinted collage object affixed to its center—half a baseball card, a house number *5*, a red plastic airplane, play money, a button. The work, as often in Smith's pieces, is packed with cross-references, some of them bordering on the overliteral, others more whimsical and evasive.

The text captions in Smith's work, culled from unpunctuated modernist prose, often allude directly to the techniques and interests of collage, as well as to the vague narrative or situational suggestions of the panels' component parts. The first text in *American Way*, for example, rehearses the experience of the collagist's impulse and is as appropriate (with suitable name changes) to Schwitters's Hannover as to Smith's Los Angeles:
*walk the streets and walk the streets inquiring of Coca-Cola signs Lucky Strike ads pricetags in store windows scraps of overheard conversations stray tatters of newsprint yesterday's headlines sticking out of ashcans.*[30]

In the end, Smith's low-key, deadpan, formally exacting, swiftly enunciated 1980s collage style risks so many insecurities and ambivalences in respect to other, apparently more politically and formally vigorous practices (such as Barbara Kruger's) that she achieves considerable success through the strategic deflation of pretension and overstatement. She has risked designations such as "cutism"[31] and has been characterized, less polemically, as a "lighthearted poet/parodist of romantic clichés."[32] But while works

like *Asphalt Jungle*, which represents man and woman as rifle-range targets, could not immediately be described as "feminist," its significations are quietly and effectively antivirile. Woman is bound by the convolutions of a green snake; her two lines of text indicate consciousness of impending death: "She tried to close her eyes but could not." Man, on the other hand, sports a fashionable leopard-skin, a lion-tamer's button, and a large reclining sheep. His text ironically asserts the legendary phallic, impulsive fearlessness of the Tarzan figure: "A mighty naked white man dropped as from heaven into the path of the charging lion."

The making of titles for works and the incorporation of text into them are the two most obvious and visible modes of relation between words and images in modern art. But to separate these modes from the partially determining relations between images, and image systems, and other discursive fields is arbitrary and insufficient. At least two second-order discourses originate and/or support the signification of visual objects at a primary level: artists' writings about their own practice, the practice of other artists, or about visual art in general; and the writing of critics.

In the most abbreviated terms, visual modernism has experienced a number of both textually rich moments (symbolism, futurism, surrealism, minimalism) and textually impoverished ones (impressionism, cubism). Artists' writings have modulated from the casual and the epistolary (Vincent van Gogh, Paul Cézanne) to the development of sustained theoretical treatises designed to underpin the concerns of increasingly group-oriented avant-garde practices (Paul Gauguin, Maurice Denis, Kandinsky). Two paradigmatic modernist textual forms were developed in the late nineteenth century: the "manifesto" and the "statement." (The later "interview," in its various forms, is a cross-fertilization between the speech of artists and criticism.) Manifestos, which have their historical origins elsewhere, tend to make generalizing group-cohesive propositions; statements tend to be related to an individual set of concerns.

*Alexis Smith*
Asphalt Jungle, *1985*
*Mixed media collage*
*Two panels: 45⅛ × 25″ each*
*The Museum of Contemporary Art,*
*Los Angeles*
*The El Paso Natural Gas Company*
*Fund for California Art*

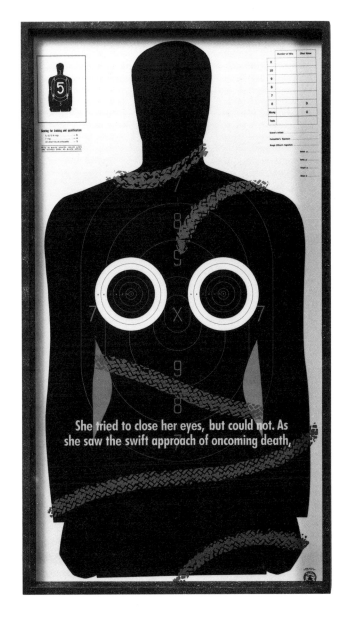

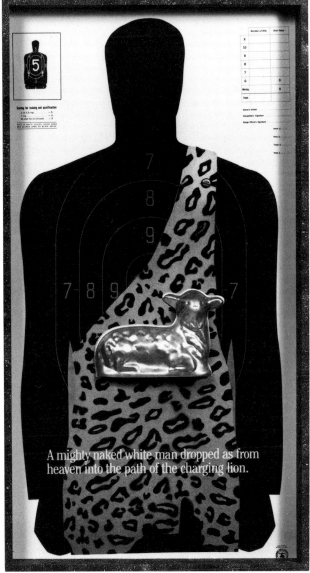

The twentieth century has witnessed a great expansion of the work of the visual artist as writer, a recognition, active or implicit, of textuality as a coproducer of meaning in visual objects, but there is another history across modernism, one of enigma, reticence, and silence.[33] Indeed, the increase of writing on images has moved a significant number of would-be unloquacious modern artists into lengthy articulations of the resistance of images to written exegesis or to any of the ramifications of the word. One form of this resistance has already been noticed—the untitling of works to protect contamination by nonvisual inputs.

Interestingly, the most prolific site of artists' writings has been around noniconic abstract production. Of the so-called pioneer abstractionists, Kandinsky, Kasimir Malevich, and Piet Mondrian all wrote both profusely and obliquely to simultaneously "explain" and protect their images. Charles Harrison's description of the content of these texts as "merely formal or historicist"[34] is only partly useful, since whatever may be the residue of their deconstruction, it is precisely their role in the "ratification of abstract art," as the title of his essay suggests, that is at stake. (The relation between historical importance and philosophic cogency is a complex one.)

Within American abstraction there exists an equal profusion of material written by artists. Barnett Newman, Mark Rothko, and Motherwell all wrote at length on the communicational and expressive potential of abstract expressionism. Indeed, the series "Documents of Modern Art," under Motherwell's editorship, is one of the first consistent attempts to organize the discourse of artists' words and thus to begin the assertion of its status as a source of documentary knowledge about modern art. Still, artists' writings have often remained a special case, held to be beyond the documentary: a 1976 subscription brochure for *Tracks: A Journal of Artists' Writings*[35] informed the potential reader that the journal's "format insures that these works are presented as *artists'* writings, immune from editorial alteration or comment."

The 1960s saw a spate of publications anthologizing the most significant (or the most literary) of modern manifestos and statements. Probably the densest concentration of artists' writings (conceived, written, and published as such) during the decade was associated with minimalism. At this juncture, however, the distinction between a critical discourse and artists' texts begins to dissolve, as their coexistence and interdependence, visible in, for example, *Minimal Art*,[36] edited by Gregory Battcock, demonstrates.

A detailed analysis of the function of modern criticism as a textual support system for the signification of visual products and of its relation to cultural institutions and the media (exhibition catalogues, newspapers, journals—specialized or unspecialized—and galleries), cannot even be begun here, except to note that inroads have been made in several areas, with art-historical research already undertaken on some discrete "periods" of critical activity within modernism as well as on individual critics.[37] More immediate to the present discussion are the many constructions of the relations between visual and theoretical or critical discourses that have appeared in English over the last dozen or so years—many of them under the rubric "visual poetics."[38] Now a "post-criticism," constructed on a model of collage and montage based on the writing of Jacques Derrida, has been proposed by Gregory L. Ulmer, in an attempt to disrupt the textual continuity of critical practice through (formal) techniques in part originated in the visual avant-garde.[39]

The photographer, artist, and theoretician Victor Burgin has collapsed the specificity of visual practice and critical theory even more radically. Plotting the movement (after Barthes) "from work to text," he notices two implications: first, that "a (post-modernist) *mutation* in the 'science' of criticism (theory) calls for . . . a radical interrogation of the whole discursive structure of the *institution of criticism itself*"; and second, that "the *end* of art theory *now* is identical with the objectives of *theories of representations* in general."[40] In short, the passage between Battcock and Burgin has been one of the progressive implication of textuality in visuality, to

the extent, claimed by Burgin, that a visual object is always only meaningful in relation to other signifying systems and positions of power; thus the passage is one from parallel text to (social) intertext.

The rupture in the 1960s in both criticism and visual practice, then, partially invalidates any "historical" analysis of the word-image relationship. A final discursive category of "words proposed as (visual) art," even if it attempts to accommodate only the activity of the most "radical" of conceptual projects (those purportedly dealing only with "pure" concepts or "pure" writing), ends up looking very much like the tautologies that a group such as Art & Language has kept uncovering in all aspects of the functioning of the modernist art world.

The practices of three of the artists in the present exhibition exemplify this impasse and reveal the plural, hybrid play of language through visual forms in the last two decades. While Marcel Broodthaers might be designated as a pre-(non)-conceptualist and Kelley as a postconceptualist, Barry is most commonly identified as one of the "originators" of conceptual art (with Joseph Kosuth and Lawrence Weiner in New York, and Art & Language in England).

Barry's work after about 1968 can be roughly divided into two types of activity. His earlier production—to risk a positivist reduction—centers on the attenuation of the formal means of art-making; extrapolating a purportedly minimalist logic to the point of no return, it deals, as he has put it himself, "with space almost rather than the object itself." [41] In 1968 Barry stretched black monofilament from wall to wall in Seth Siegelaub's New York apartment, and the following year he produced the "Inert Gas" series, in which argon (in Santa Monica), for example, and helium (in the Mojave Desert), were returned to the atmosphere. The mode of existence of these works is threefold: historical event, documentary photograph, and text(s)—certificate, title, autograph, and written description, which function finally as gallery items and salable commodities. [42] Despite this triple articulation of presence, the "Inert Gas" series and *Radiation*

*Piece* (in which barium 133 was buried in New York's Central Park), also of 1969, have been seen as some of the most extreme "dematerializations"—and thus radical antiformalisms—within conceptual art.

The second phase of Barry's work has been more exclusively concerned with aspects of language use and perception. In many ways this accumulation of linguistic attentions constitutes one of the most developed explorations of the "physical presence" of words in visual art beyond painting and drawing. Barry reinforces this understanding, disassociating himself from any preoccupation with "the analysis of language or any of the language philosophers" per se, and asserting a stronger interest in "readings centered around Heidegger and Merleau-Ponty . . . because they dealt not so much with language but with what it was to be a speaker, to be a talking person." [43] This bracketing out of interest in the productivity and the system of language can be criticized as evasive and certainly runs counter or prior to analytic language philosophy (invaded by Art & Language) and structural linguistics (occasionally of direct and indirect concern to conceptualists such as John Baldessari and, in a different way, Daniel Buren). The antithesis becomes most pronounced in Barry's progressively explicit late romanticism.

Barry's conceptual word pieces of 1969–70 seem to manifest a more ideational austerity than the recent painted wall "environments," projecting or imagining mental activities circumscribed by general propositions. Even so, many of the cognitive or sensory states invoked by these texts are willfully fantastic: "Something which can never be any specific thing," for example. The texts and their metaphysics are often transcendental and utopian, fundamentally an effort of the imagination. As if to register this affinity, the layout of the text takes on the lineation of poetry, even while the syntactic arrangement is, often, a long parataxis of qualities or effects (in, e.g., *Artwork with 20 Qualities*, 1970).

The projection or "perception word" pieces of the early 1970s offer a

*Robert Barry*
Refrain, *1975*
*81 35mm slides*
*Panza Collection*

material transformation of Barry's essentialism, taking it off the surface of the page and into an environment controlled by light and darkness and by the presence/absence of the unitary word. At this stage, writing ceases to delimit, define, or propose in relation to an ulterior concept; instead, the word (as lighted space) becomes a kind of signifying beacon, issuing an endless flow of connotations to the viewer. This arena of preemptive free association is augmented by the interpolation of simple photographic images between the words and modified by the invasion of speech into the environment. Again, even in the aural redaction, Barry asserts the physicality of the experience: "the words really punctuate the space. . . . After a while they become almost physical." [44] In contrast to the informational objectivity of the "Inert Gas" pieces, the reception of the projections is held as subjective and contextual.

Barry's more recent painted walls have in some senses a paradoxical effect in relation to his earlier practice, although there are also many recognizable continuities. The walls reinstitute a two-dimensional painted surface, even if they are specifically coordinated with the architectural environment. Words are made to float on a pigmented ground, organized according to a rectangular or circular (clock-face) grid and, after 1980, usually clustered around a central, partly effaced, schematic image of a tree, including both its branches and its roots. The tree is an explicit organic/romantic symbol and fuels the temptation to interpret these works in part as word bolts shot out of the Shelleyan blue.

So, in one sense, Barry's materializations of words through the 1970s and up to the present may be held as a kind of summation of the "presence" of the logos—an articulation that appears to constitute the very antithesis of the Derridian critique of "logocentricity." Derrida sees language as a cascade of signifiers always related by "difference"—*différance*—"all signs including traces of other signs"; [45] and Barry's elaboration of presence also puts the signifier in constant movement, positing an *absence* of "theological" reference. The projected and wall words are strongly antidenotative; their

signification is rerouted through the environmental (theatrical) structure of the object-space toward the indeterminate receiving consciousness of the participatory viewer.

Many of the other practices associated with conceptual art employ language either as a simple documentary appurtenance or in order to explore aspects of linguistic structure itself (not Barry's concern, as we have seen). John Baldessari, however, has incorporated words in and around his works in virtually the whole repertoire of functions summarized here. Some of his titles literalize a photographic arrangement with (comic) denotative insistence—*Alignment Series: Arrows Fly Like This, Flowers Grow Like This* (1975); others, such as *Kiss/Panic*, among his 1984 gelatin silver prints, both describe and initiate an interpretation; in *Ingres and Other Parables* (1971) a lengthy anecdotal narrative accompanies each of ten photographic images.

Text is incorporated within the bounds of the work with even greater heterogeneity; the work *is* the repeated, handwritten injunction in *I will not make any more boring art* (1971). More often, Baldessari's autographic text is printed, in uppercase letters, on or in proximity to photographic images. This strategy is worked out most complexly in the "Blasted Allegories" series, which combines photographic stills (mostly from television), superimposed text, caption text, and a set of connective logical notations. The "Blasted Allegories" may or may not constitute "a parody of the activity or simulacrum of the structuralists" [46]—though irony and humorous deflation are rarely absent from Baldessari's work—but they do represent a particularly developed extension of Magritte's interest in the relation between visual and textual sign systems (especially as argued by Michel Foucault) [47] and of Johns's investigation of textual and object reference. But Baldessari is usually less (pseudo-) systematic and more teasingly playful, as in the "Embed Series" (1974), in which words are hidden deeply in retouched black-and-white photographs (of, for example, a rose, or a partly peeled orange) so as to be invisible to all but informed or intensive gazes. He is without doubt

an ironist before he's an analyst, even though his work over the last twenty years can be seen as a kind of summa or conceptual thesaurus of the possibilities of the word-image juxtaposition.

While Baldessari's phototexts can be located somewhere within the provisional ensemble of conceptual art, and his use of language related to the well-advertised and polemic interests of that tendency, the posing, as a point of critical departure, of the question of the relation between words and images in the oeuvre of Marcel Broodthaers does not necessarily muster full conviction. Broodthaers made objects, films, environments, and even "museums"; he wrote texts, and variously intervened in the art world in Europe from 1964 until his death in 1976. His work appears particularly resistant to even the most persuasive discursive analysis.

Granted, this resistance is itself a behavioral trope and can be analysed as such. Broodthaers was indeed "eccentric," or, better, inconsistent and abundantly paradoxical.[48] And he is increasingly something of a cult figure, in the manner of Marcel Duchamp or of certain of the surrealists (though not of Magritte, who lived a fastidious, low-key, middle-class existence in Brussels, where he met Broodthaers when the latter was a young man). If there is a profoundly antisystematic impulse behind Broodthaers's activity, the different practices themselves always stand in proximal relation to existing systems (of language, of exhibitions, of symbols, etc.), often negating their premises and their postulates by constructing a new and unstable "context," or by exploding their usually unchallenged characteristics. Broodthaers always opposed "literalness" and always came up with sophisticated or irreverent indirection. The works are often jubilant, utopian, or absurdist. At other times the physical gesture is deliberately slight, as in the deletion of the letters *li* and their replacement with the letter *é* in the caption to a political map of the world, transforming it into a *Carte du monde Poétique* (1968), or in his representations and additions to small objects (in the present exhibition). These modest interferences in the signifying potential of objects and images are more effective as a challenge to their

ideological embeddedness in the social world of the everyday than are wholesale erasure or distortion.

As Benjamin Buchloh has written, an account of paradox, negativity, and indeterminacy in Broodthaers must recognize the artist's own realization that "objectization within the discourse of art has become impossible without being simultaneously appropriated by the ideology of the culture industry."[49] To work against this tendency (or inevitability) it was necessary to demonstrate an awareness of the impasse in practice—to examine critically the sites of the exhibition, reception, and commodification of visual art (which Broodthaers achieved in his "Musée d'Art Moderne" project in Brussels, Antwerp, Dusseldorf, Basel, Cologne, and in Kassel at Documenta V), and to work against the grain of simple denotative signification.

Although Broodthaers was as suffused in the culture of the book as any twentieth-century artist—having been a poet, a lecturer, a journalist, and a bookseller—his textual strategies were (almost) always bound in complex and elusive compounds with other material signifying systems and in an explicit denial of system. In this sense Nicolas Calas is misleading when he talks of Broodthaers's "interpretation" of "spatial concepts required for recognition into an analytic function of a linguistic process,"[50] or of his "language of objects,"[51] in short, his mode of existence as a "structuralist artist."[52] Similarly, the constant critical citation by Calas and others[53] of metonymy as a (relative) structural constant through Broodthaers's projects is only of limited usefulness. The term, which the Oxford English Dictionary defines as the "substitution of the name of an attribute for that of the thing meant," is often used in generalized applications of structuralist analysis as coextensive with the syntagm (the chain or the series) and as opposed to the paradigm (the system, the metaphor). But rather than using metonymic substitution, Broodthaers more typically poses an object or set of objects in relationships that do not profit from such a structural linguistic analogy: rarely does an object function as a part substituting for a whole. In his language usage; in his object construction, selection,

and augmentation; and in a variety of mixed usages, Broodthaers indulges in puns, symbolic games, and plays on the system, which proceed more like metaphors and the paradigmatic mode, through effects of substitution and superimposition, than like metonymy. In reality, none of these analogies are an adequate measure of the discursive disruptions that are the sum of Broodthaers's oeuvre.

Mike Kelley seems to stand in relation to the tendencies of the 1970s—conceptual art, performance, environments, etc.—with an obliqueness similar to Broodthaers's stance toward surrealism, pop, and European protoconceptualism in the late 1950s and 1960s. Kelley's polymorphous performance/monologue/installation works (*Meditation on a Can of Vernors*, in 1981, at LACE, Los Angeles; *Monkey Island*, in 1983, at Beyond Baroque, Venice, California; and *The Sublime*, in 1984, at The Museum of Contemporary Art, Los Angeles) are rampant analogical "*combinatoires*" that inscribe unstable, almost hallucinatory fields of reference across textual enunciations, physical gestures, installed objects, and a large range of images.

Kelley's projects have no terminus and variable modes of material presentation (text, edited or reduced text, text and image, performance event); they are characteristically "in process" throughout their production and reception. Their point of origination is usually in writing—jottings, ideas, associations—eventually assembled as semicontinuous prose poetry for oral recitation. Images and objects are interwoven through the performance as visual structures, spin-offs, experiments, and doodles.

The process of a work such as *Monkey Island* saturates the unconscious through a counterpoint of structure and dissolution. Sexuality dominates both levels, though never to the extent of posing what Jacques Lacan noted as Freud's equivalence of the unconscious with "sexual reality."[54] Still, an important motivating event for *Monkey Island* was the trauma/taboo experience of a childhood encounter of Kelley's with baboons, in which he became aware of their exposed sexuality, especially the prominence and coloration of their buttocks. The dreamlike sequence of *Monkey Island*, its promiscuous (free) associating, and its panoply of rhetorical and visual devices make it resistant to formal exegesis. The work is a formation of the imaginary, a structure without a geography, an arena for the play of intellectual morphology against coarse alehouse wit: "The crystal facets in the compound eye fuse to form any shape whatever."[55]

*His bladder smacks you on the head*
*Whole body a bladder*
*An obnoxious asshole*
*Infected and spreading*
*Hitting you over the head*

Before anything else, *Monkey Island* enacts a series of deliberately overextended somatic metaphors and similes. Body, animal, and insect parts ("eyes," "head," "abdomen," "ass," "bladder," etc.) are "shifted" into mobile sociopolitical signifiers through a whole subtext of relays and morphological permutations ("compound," "bilateral division," "infinite multiplication," "tangled," "complementary inversion," "constant shift," etc. These are the frictions of structural change). The text runs from the infantile subjective (Kelley's version of Freud's "Fort/Da"—"The Rumpus Room/Us Rump/You-Me/Us Rump") to clichés like "the body politic," from the diagnostic "look at the face to ascertain the state of the guts" to the geomorphological "the island as an entirety has a resemblance to the compound eye of an insect," and so on. Two potent transformatory symbols— ambergris, a waxlike odoriferous tropical flotsam found in the intestines of sperm whales and used in perfumery, and the mandrake, in the OED's words, "a poisonous plant with emetic and narcotic properties, with root thought to resemble human form and to shriek when plucked"—are woven into the text to pluralize the already numerous processes of transference and analogy. Any pretentiousness the piece may be felt to possess is punctured by insistent wit and slapstick comedy.

This is the work, one realizes, of an educated, alienated, sexualized

*Mike Kelley*
Promotion Agency
The Obscure with its Indeterminate Size
The Perfect Circle
*from* The Sublime, *1984*
*Acrylic on paper*
*Three parts: 42 × 34¾" each*
*Courtesy of the artist and*
*Rosamund Felsen Gallery, Los Angeles*

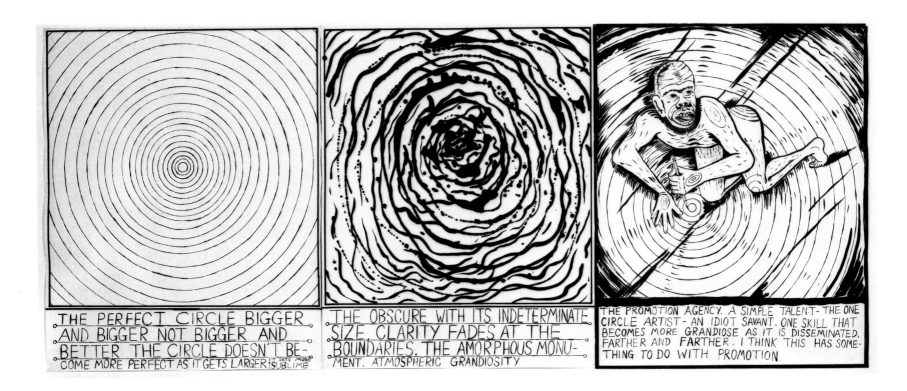

THE PERFECT CIRCLE BIGGER AND BIGGER NOT BIGGER AND BETTER THE CIRCLE DOESN'T BE- COME MORE PERFECT AS IT GETS LARGER IT GETS MORE SUBLIME

THE OBSCURE WITH ITS INDETERMINATE SIZE. CLARITY FADES AT THE BOUNDARIES. THE AMORPHOUS MONU- MENT. ATMOSPHERIC GRANDIOSITY

THE PROMOTION AGENCY. A SIMPLE TALENT- THE ONE CIRCLE ARTIST- AN IDIOT SAVANT. ONE SKILL THAT BECOMES MORE GRANDIOSE AS IT IS DISSEMINATED. FARTHER AND FARTHER. I THINK THIS HAS SOME- THING TO DO WITH PROMOTION

American-encultured subject in search of the structure of his relationship to social and intellectual formations. There is a kind of tactical formalism in the redacting and picturing of these relationships in (subverted) rational, ordered, or patterned schemata. But the converse is also present in Kelley's radical anarchic play between signifying difference and similarity: between presence and absence—"being" in and out of language.

At this juncture in contemporary visual practice, then, when words have been used in modernism, as modernism, and to make modernism, as well as in postmodern antitheses to these, we can claim that the linguistic sign—at least when it is an "aspect" of the visual sign—always carries into the work its remorseless potential to oppose "perceptual autonomy," but also, equally, to reveal the insufficiency of linguistic determinism or notions of the ultimate loss of visuality.

Within discussions of postmodernism an understanding of the sublime has been excavated and refurbished, especially by Jean-François Lyotard[56] (though "popular" versions are now appearing in the art press[57]), precisely to discover a space of "indeterminacy" (used by Lyotard as virtually synonymous with "sublime") in the play of systems and between the clash of polarities. But even in the thoroughgoing critique offered by Meaghan Morris of Lyotard's understanding of postmodernism and the sublime (he is accused of "collaging" "mathematical game-theory, paradoxology, analytical philosophy, and speech-act theory" in "a kind of transcendent renewal"[58]), which is at one level exemplary, the question remains, posed also by other disquisitions on the sublime (such as Kelley's own), or by any ontological theorizing,[59] as to how practice (or theory) can "go on" without the managed incorporation of the "other"—word/image, presence/absence, material/transcendence—into its discursive fabric.

Morris' description of Lyotard's comprehension of postmodernity is meant to be polemic:

*The pastime of an old man grubbing in the garbage-bin of finality to find scraps, brandishing bits of unconscious, slips, edges, limits, gulags, parataxes, nonsense, paradoxes, making from them his glory of novelty, his promise of change.*[60]

In fact, Morris is describing Kelley and collage, and offering a hyperbolic notation for the condition of those artistic practices that cannot be subsumed under dogma, propaganda, or illustration.

1. Harold Rosenberg, "Art and Words," in *The De-Definition of Art* (New York: Horizon Press, 1972).

2. Tom Wolfe, *The Painted Word* (New York: Farrar, Straus, Giroux, 1975).

3. See, for example, Claude Lévi-Strauss on tribal rituals and mythology in *Tristes Tropiques* (New York: Russell, 1955); Roland Barthes on fashion in *Système de la mode* (Paris: Editions de Seuil, 1967); or Jacques Lacan on the unconscious in *Ecrits* (Paris: Editions de Seuil, 1966).

4. In her "Structure and Pleasure," in *Block* 9 (1983): 13, Claire Pajaczkowska provides a brief but useful review of five texts (by Jean-Louis Schefer, Jean Paris, Marcelin Pleynet, Guy Rosolato, and Julia Kristeva) demonstrating the transition from (loosely) structuralist to poststructuralist analyses of visual systems. She concludes that the "opposition of image to language is an untenable formulation, as is the proposition of the equivalence of image and language," and proposes "the interrelation of psychoanalytic and semiotic theories."

5. Jack Burnham, *The Structure of Art* (New York: George Braziller, 1971).

6. For example, Jan Mukarovsky, "Between Literature and the Visual Arts," in *The Word and Verbal Art: Selected Essays by Jan Mukarovsky*, ed. and trans. John Burbank and Peter Steiner (New Haven: Yale University Press, 1977).

7. W. J. T. Mitchell, ed., *The Language of Images* (Chicago: University of Chicago Press, 1980).

8. Nelson Goodman, *The Languages of Art* (Indianapolis: Indiana University Press, 1976).

9. *Art and Text* (Melbourne, Australia: Prahran) is edited by Paul Foss and Paul Taylor; its first number appeared in the autumn of 1981. *Word and Image* (Basingstoke, England) is edited by John Dixon Hunt and was first published in 1984.

10. Michel Butor, *Les Mots dans la peinture* (Geneva: Albert Skira, 1969).

11. For example, Flavio Caroli, *Parola-Imagine* (Milan: Fabbri Editori, 1979). This is basically a visual anthology of artworks using text, subtitled *Per un'anthologia dell'immaginario: l'arte della cecita*.

12. This summary derives from a larger work in progress, which originated from research for a doctoral dissertation at the Courtauld Institute of Art, London, and the Department of Art History and Architecture, Columbia University, New York.

13. Ernst Gombrich ("Image and Word in Twentieth-Century Art") and Stephen Bann ("The Name as Mythical Conception: Titling the Work of Art in the Modern Period") have both given stimulating lectures on this subject, to which the following is occasionally indebted. Gombrich's lecture was the first Hilla Rebay lecture at the Solomon R. Guggenheim Museum, New York, delivered in October 1980.

14. See Charles Baudelaire, "Ary Scheffer and the Apes of Sentiment," in *The Mirror of Art: Critical Studies by Charles Baudelaire*, ed. and trans. Jonathan Mayne (Garden City, N.Y.: Doubleday, 1956), pp. 104–8.

15. John House discusses some of the particular significations of this work in John House and Mary Anne Stevens, eds., *Post-Impressionism: Cross-Currents in European Painting* (New York: Harper & Row, 1979), the catalogue for an exhibition of the same title at the Royal Academy of Arts, London. He calls Signac's work a "key example of a type of private attributive portraiture" (p. 139).

16. Quoted in Stanley Weintraub, *Whistler: A Biography* (New York: Weybright and Talley, 1974), p. 201.

17. See, for example, Robert Rosenblum, "Frank Stella: Five Years of Variations on an 'Irreducible' Theme," *Artforum* 3, no. 6, March 1965. Rosenblum at least makes an allusion to a title, *Jasper's Dilemma*, which he notes as a "topical reference to Johns's own problems of color versus grisaille" (p. 25). In her catalogue *Frank Stella: The Black Paintings* (Baltimore: Baltimore Museum of Art, 1976), Brenda Richardson goes some way to rectify this situation, noticing in her first sentence that "there has not been adequate consideration given to the titles Stella selected for the Black paintings" (p. 3).

18. Bann's essay "Abstract Art—A Language?" in *Towards a New Art: Essays on the Background to Abstract Art 1910–1920* (London: Tate Gallery, 1980), rehearses the positions of Gombrich and Lévi-Strauss on abstract art and communication, and draws its own conclusion that "the abstract work . . . simulates the structure of meaningful discourse and borrows its functions in a parasitic fashion" (p. 144). There are some grounds for doubt, then, that abstract painting can ever be more than a willfully subjective conundrum, even the decorative satisfaction of which Gombrich denies.

19. Clement Greenberg, *Joan Miró* (New York: Quadrangle, 1948), p. 32. "He made serious mistakes in almost every painting I have seen that he executed between . . . 1925 and . . . 1928."

20. See especially Rosenblum's "Picasso and the Typography of Cubism," in Roland Penrose and John Golding, eds., *Picasso in Retrospect* (New York: Praeger, 1973).

21. Clement Greenberg, "Collage," in *Art and Culture* (Boston: Beacon, 1961), p. 75.

22. Herbert Read, *A Concise History of Modern Painting* (New York: Praeger, 1968), p. 248.

23. Rosenberg noted the fallacy here: "Pollock's handling of paint has, however, been misinterpreted as a version of automatic writing." "Art and Words," p. 61.

24. Roland Barthes, "Non multa sed multum," introduction to *Cy Twombly: Catalogue Raisonné des oeuvres sur papier de Cy Twombly* (Milan: Yvonne Lambert, Multhipla, 1979).

25. In his *Jasper Johns* (New York: Harry N. Abrams, 1967), Max Kozloff discusses Johns's encounter with the writing of Ludwig Wittgenstein, after 1961, and some of its implications for his work.

26. Peter Plagens, "Ed Ruscha, Seriously," in *I Don't Want No Retrospective: The Works of Edward Ruscha* (New York: Hudson Hills Press, and San Francisco: San Francisco Museum of Modern Art, 1982), p. 37.

27. Roland Barthes, "The Spirit of the Letter," in *The Responsibility of Forms: Critical Essays on Music, Art and Representation*, trans. Richard Howard (New York: Hill and Wang, 1985), p. 102.

28. Gombrich, "Image and Word in Twentieth-Century Art." "The main point of collage is after all that we do not attend to the words but to the form."

29. John Elderfield, "The Early Work of Kurt Schwitters," *Artforum* 10, no. 3 (November 1971): 60.

30. An excerpt from John Dos Passos, the *U.S.A.* trilogy, part three, *The Big Money*.

31. Peter Schjeldahl, review, *Artforum* 17, no. 5 (January 1979): 68.

32. Fidel Danieli, "Not So Plain Janes," *Artweek* 16, no. 32 (October 5, 1985): 3.

33. Bann, in "Language in and about the Work of Art," *Studio International* 183, no. 942, March 1972, notices Theo van Doesburg's expulsion of words from the visual domain, creating a "language vacuum."

34. Charles Harrison, "The Ratification of Abstract Art," in *Towards a New Art*, p. 154.

35. *Tracks: A Journal of Artists' Writings*, edited and published in New York by Herbert George, was first published in Fall 1974.

36. Gregory Battcock, ed., *Minimal Art: A Critical Anthology* (New York: E. P. Dutton, 1968).

37. See, for example, Steward Buettner, *American Art Theory 1945–1970* (Ann Arbor, Mich.: UMI Research Press, 1981).

38. See *Twentieth Century Studies* 15/16 (December 1976), edited by Bann,

which was devoted to "visual poetics."

39. See Gregory L. Ulmer, "The Object of Post-Criticism," in Hal Foster, ed., *The Anti-Aesthetic: Essays on Postmodern Culture* (Port Townsend, Wash.: Bay Press, 1983).

40. Victor Burgin, *The End of Art Theory: Criticism and Postmodernity* (London: Macmillan Education, 1986), pp. 200, 204.

41. Robert Barry, interviewed by Robin White, *View* 1, no. 2 (May 1978): 5.

42. See Robert C. Morgan, "The Role of Documentation in Conceptual Art: An Aesthetic Inquiry" (Ph.D. diss., New York University, 1978).

43. "Discussion: Robert Barry and Robert Morgan," in Eric Franz, ed., *Robert Barry* (Bielefeld, West Germany: Karl Kerber, 1986, forthcoming), p. 64.

44. Ibid., p. 68. Morgan also notes the romantic bases of Barry's work, its closeness to the concerns of Maurice Merleau-Ponty's perceptualism and to "gestalt psychology," as well as its propagation of "lyrical reflectiveness" and, borrowing a term from Edmund Husserl, its "transcendental intersubjectivity."

45. Rosalind Coward and John Ellis, *Language and Materialism: Developments in Semiology and the Theory of the Subject* (London: Routledge & Kegan Paul, 1977), p. 126.

46. Hal Foster, "John Baldessari's 'Blasted Allegories,'" *Artforum* 18, no. 2 (October 1979): 54.

47. Michel Foucault, *This Is Not a Pipe*, trans. James Harkness (Los Angeles: University of California Press, 1983).

48. Benjamin Buchloh observes Broodthaers's "persistent sense of contradictions," in one of the most useful considerations of the artist, "Marcel Broodthaers: Allegories of the Avant-Garde," *Artforum* 18, no. 9 (May 1980): 52.

49. Ibid., p. 55.

50. Nicolas and Elena Calas, "Marcel Broodthaers's Human Comedy," in *Transformations: Art Critical Essays on the Modern Period* (Ann Arbor, Mich: UMI Research Press, 1985), p. 184.

51. Ibid., p. 181.

52. Ibid., p. 187.

53. In addition to Calas, see for example Michael Compton's contribution to his *Marcel Broodthaers* (London: Tate Gallery, 1980), which also includes Barbara Reise's "The Imagery of Marcel Broodthaers." In the same vein is Pat Gilmore, "The Prints of Marcel Broodthaers," *Print Collector's Newsletter* 7, no. 2 (May–June 1976): 45.

54. Jacques Lacan, *The Four Fundamental Concepts of Psychoanalysis*, ed. Jacques Alain Miller and trans. Alan Sheridan (London: Penguin, 1979), p. 150.

55. All citations from unpaginated ms, *Monkey Island*.

56. See, for example, Lyotard's "The Sublime and the Avant-Garde," *Artforum* 22, no. 8, April 1984.

57. See, for examples, the line-up of Robert Nickas, "The Sublime was Then (Search for Tomorrow)," Phillip Taaffe, "Sublimity, Now and Forever, Amen," and Peter Halley's untitled contribution, in *Arts Magazine* 60, no. 7 (March 1986): 14–21.

58. Meaghan Morris, "Postmodernity and Lyotard's Sublime," *Art and Text* 16 (Summer 1984): 57–59.

59. David McNeil's "Pictures and Parables," in *Block* 10 (1985), offers what I take to be an extended discussion of this issue. McNeil is dissatisfied with what he terms "perceptual conventionalism" (the inevitable arbitrariness of the Saussurian sign, Goodman's "unrealistic view of iconicity") and reinvigorates Pierce's signifying triad in order to evince a more adequate understanding of the production of knowledge.

60. Morris, "Postmodernity and Lyotard's Sublime," p. 59.

**Marcel Broodthaers**

*Glass case with various works (from top left):*
Paquet de lettres, *1974;* Jambes 1 2, *1964;*
Bocal et reproduction (Magritte), *1967;* Oscar-Turpitude, *1973;*
Bocal avec oeil, *1966 (not in exhibition);* B, *1966;* Les frites, *1968;*
Cigarettes et Cendrier ABC ZZ, *1974 (not in exhibition);*
Poêle de moules, *1965;* T plus grand que, *1967–69;*
Deux boules en plâtre peintes en doré, *1964;*
L'architecte était un chien Blanc, de caractères, *1967;* Deux tonneaux, *1966*
*Marian Goodman Gallery, New York*

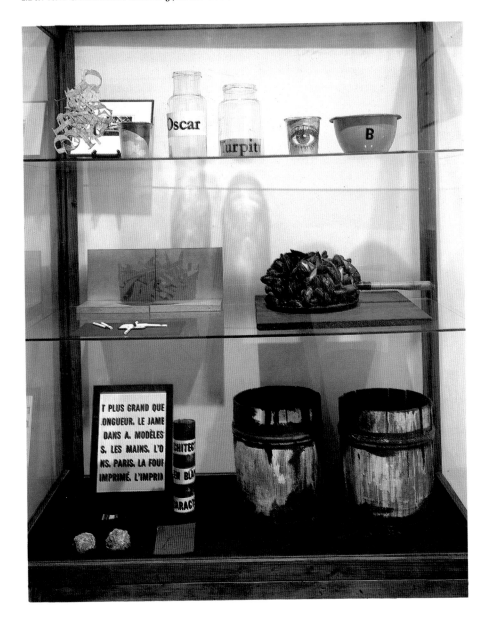

**Marcel Broodthaers**

Oscar-Turpitude, *1973*
*Glass jars and printing on canvas*
*Two units: 10²/₅ × 4¹/₃"; 8⁷/₈ × 5¹/₃"*
*Marian Goodman Gallery, New York*

**Marcel Broodthaers**

Paquet de lettres, *1974*
*Letters printed on canvas*
*Marian Goodman Gallery, New York*

**Marcel Broodthaers**

B, *1966*
*Enameled metal bowl, eggshells, and*
*adhesive letter*
*4¹/₃ × 7⁷/₈"*
*Marian Goodman Gallery, New York*

**Marcel Broodthaers**

L'architecte était un chien Blanc,
de caractères, *1967*
*Cardboard tube and printing on paper*
*10⁴/₅ × 2³/₄"*
*Marian Goodman Gallery, New York*

**Robert Barry**

All the Things I Know, *1969*
*Plan for wall piece*
*Pencil on paper*
*14¼ × 12¾"*
*Collection of the artist*

ALL THE THINGS I KNOW
BUT OF WHICH I AM NOT
AT THE MOMENT THINKING -
1:36 PM; JUNE 15, 1969.

**Robert Barry**

All About, *1986*
*Plan for wall piece*
*Pencil and paint on paper*
*17⅝ × 17⅝"*
*Collection of the artist*

287

money    you understand what he meant the old party with the white beard beside the crystal inkpot at the clear varnished desk in the walnut office in whose voice boomed all the clergymen of childhood and shrilled the hosannahs of the offkey female choirs.

ives than walking
,    do    make

All you say is very true but there's such a thing as sales    And I have daughters    I'm sure you too will end by thinking differently    make

**Mike Kelley**

Symmetrical Sets:
Ass Insect; Red Reefs;
Splitting Cell; Two Tents
*from* Monkey Island, *1982–83*
*Acrylic on paper*
*18 × 24"*
*Courtesy of the artist and*
*Rosamund Felsen Gallery, Los Angles*

**Mike Kelley**

Travelogue:
The Baggy Pants Comedian
The Celibate Genius
The Green Black Green Flag
The Two Islands Merge To Form a Boat
*from* Monkey Island, *1982–83*
*Acrylic on paper*
*24¼ × 19¼"*
*Collection of Robert A. Rowan*

# The Future Is Certain
*Thomas Lawson*

*Well we know where we're going*
*But we don't know where we've been*
*And we know what we're knowing*
*But we can't say what we've seen*
*And we're not little children*
*And we know what we want*
*And the future is certain*
*Give us time to work it out*

*We're on a road to nowhere*
*C'mon inside,*
*Taking that ride to nowhere*
*We'll take that ride.*
*Feeling OK this morning,*
*And you know,*
*We're on a road to paradise,*
*Here we go, here we go.*
Talking Heads, *Road to Nowhere*

As we drift inexorably toward a future we fear as already over familiar, a future informed by science but envisioned by art, artists and critics on both sides of the Atlantic continue to celebrate, often with a melancholic nostalgia, this future, which, however aged, has never really arrived. Promoted as a place of hope, a deliverance from our present lot, the future that we dread is to be a place of clean efficiency, a spotless, mechanized society ruled by well-meaning reason. An enlightened despotism, it would allow little deviant thought or behavior, but on the whole that is understood as being for the better. A new and improved society should provide less cause for dissent. Throughout modern times, versions of this utopia have fueled both revolutions and wars, have helped oppose brutality and oppression, and have inspired even greater brutality and more wide-reaching oppression. Refractions from the same vision have given us bright, sanitary buildings and cities, and dangerous housing projects and ghettos. We call this vision modernism, and its progeny, the modern world.

Modernism has always denied history, always sought to negate the past in an ever present longing for a better future. Tomorrow and tomorrow and tomorrow, goes the relentless optimism of its irresponsible advance toward a superior homogeneity. In its wake, modern society has reduced its history to a collection of emblematic moments, one-dimensional tags that elicit—and are supposed to elicit—nothing more than one-dimensional responses: The Revolution, The Crash, The Six Million, The Communist Threat, Vietnam, Watergate. An unthinking history ensures an unending repetition, each more deadly, more farcical, than the last. This telescoping, a denial of difference, is apparent wherever one looks, as much a part of the work of the early modernist avant-garde as it is of the recent techniques of the mass media.

The modern understanding of the world is framed by the easy reference, the quick take, the instant replay. It is an understanding as shuttered and isolated as the image provided by a snapshot. Indeed, one of the great enigmas of modernism is the photograph, the modern invention par excellence. Its deathly shadow has given form to much of the modern experience, and yet in that shadow can be discerned the seeds of modernism's collapse into postmodernism. The photograph captures the moment, and in doing so it denies time. It reduces history to a disjointed array of images given significance by their immobility. Until recently a photograph was an intimate thing, a trace of proximity. In fixing the light emanating from a subject, it became the memoir of an instant, a reliquary of the fleeting. Commercially the photograph began life as a means of perpetuating death, of capturing the final moments of a life on earth. Through the course of its development it has become the death of much life, reducing experience to so many photo opportunities. Under the tyranny of the ubiquitous camera, individuals live a series of posed and candid shots—birth, marriage, friends, vacations, family, death; none of this exists without a photograph to prove it.

The camera caught the aura of life, but this was hardly new—Vermeer's camera obscura had already done so. What was new was

the ability to print and reprint that captured image, to reproduce infinitely the selected moment in a simulacrum of fecundity, one without issue. In this fruitless repetition the aura of life was lost, for it was not simply the work of art that was threatened by mechanical reproduction, but the individual's sense of his or her own life as a separate, different thing.

The photograph now dominates the modern landscape, giving form and substance to all aspects of life. Like a language, it gives meaning to the existence it frames. But it is not a language, and it has no meaning. Mirroring the development of capitalist society as a whole, its burgeoning production (of images) has spawned a relentless need to consume. Production and reproduction have grown out of control, and even so find themselves surpassed by an all-encompassing consumption. Steel and automobiles give way to Big Macs and TV shows—easier to make, much easier to swallow. At the same time, real life gives way to soap opera—more predictable, more manageable.

The strength of this narcotic is a godsend, for increasingly powerful drugs are needed to maintain an analgesic effect. As the Western economy falters, operating on ever larger, less secure credit, the harsh reality of fewer secure and productive jobs and more minimum-wage maintenance work must be kept as far out of sight and mind as possible. Such reality cannot be denied, but it can be made to disappear, if only for a while. This disappearing trick is the work of the spectacle of the mass media.

The modern world, like the empires of the ancient world, has been ruled by spectacle. But a tremendous change has overtaken people's relation to that spectacle, and it is a change of great significance. The spectacle is no longer simply a staged event, a coronation or rally invented to provide the legitimacy of tradition and pomp. It is now a pervasive nonevent, its consumption made easy enough that to reject it is almost impossible. The nonparticipatory spectacle is only a switch away. It is so easy to relax right into it. This most efficient of

social controls moves from the public realm to the private, bringing pictures of terrorism, warfare, crime, the good life, sex, and happiness right into the living room. The operations of the spectacle move from the overt to the covert, from the blatantly coercive to a blend of suggestion and hypnotism. We are numbed by an ecstasy of input and gradually find it more and more difficult to think or act coherently. The narcotic turns us into somnambulant consumers subsiding toward an easeful, oversated death. Gradually we become little more than eyes, tourists watching the spectacle of our own ruin. As we allow this spectacle to hypnotize us, it infiltrates more than our critical faculties; it insinuates itself into the dreamworld, the unconscious realm that shapes our relations to others and the world. Growing from an imitation of life, it becomes so pervasive that life imitates it.

A truly engaged art gives form to the artist's self-consciousness about the historical pressures that shape his or her work. It is political in its recognition that at any particular time and place certain modes of expression are useless, even dangerous, to the continued practice of making art that is more than decor or public relations. This same politics surfaces in the recognition that at any particular time and place certain modes of expression until then unthought of or disparaged may take on the urgency of necessity in the artist's ongoing struggle to locate the idea of the individual in modern society. What this kind of political art does not do is solve problems; at its best, it shows that the proposition of solutions perpetuates the crisis of art and society.

As Harold Rosenberg noted: "The achievement of Action Painting lay in stating this issue with creative force. Art had acquired the habit of *doing.* . . . Only the blank canvas, however, offered the opportunity for a doing that would not be seized upon in mid-motion by the depersonalizing machine of capitalist society, or by the depersonalizing machine of the world-wide opposition to that society."[1] Rosenberg took this act to be unmediated, a clean break. Each painting by Jackson Pollock, Willem de Kooning, or Franz Kline

was seen as a feat of negation for the liberation of all. Pouring scorn on the various art professionals who wished to tidy up abstract expressionism, to pigeonhole it in a neat scheme of pseudohistory, Rosenberg asserted as strenuously as he could what he called the crisis content of the art: the paintings had been brought into being as a particular response to the unresolvable tensions of mass society. He was not blind to the inherent ambiguity of an action that took place on canvas rather than in society—indeed, he wished to privilege that ambiguity as the source of abstract expressionism's strength. To Rosenberg, only the literal-minded found the presence of a contradiction invalidating; he considered it to be what made action painting appropriate and necessary. As he wrote, "It retains its vigor only as long as it continues to sustain its dilemmas: if it slips over into action ('life') there is no painting; if it is satisfied with itself as painting it turns into 'apocalyptic wallpaper.'"[2]

Straddling this fine line, Pollock and the rest were able to sustain their sense of self through their difference. Acutely aware of their position in history at the end of a war that had devastated Europe and had confirmed the status of the United States as a world power, they wanted to uphold the traditions of European modernism in a way that would make sense under vastly altered conditions. The concept of internationalism, the ideal of the modernists, had been Americanized by force. In this context, the artists' deployment of scale, of gesture, and of the moment seemed to address both sides of the Atlantic. Pollock's nonspaces, the cancellations and obliterations in the atomic squalls of his best paintings, were almost mimetic in their Americanness, except that their negativity, their identity as refusal, denied the assumed benevolence of the American way of life.

A great deal of what Rosenberg has to say about abstract expressionism (and about the art-world professionals who effectively killed it with their many small kindnesses) seems much to the point. It is certainly more direct, more lively than the often attenuated abstractions of Clement Greenberg's theories. But there is a fatal flaw in his argument—his assumption that it was possible for his "champions" to act in a purely unmediated way, and to keep acting that way. Ignoring everything he has said about traditions and paintings growing out of paintings, he needs, at the crucial moment, to pretend that all Pollock and de Kooning were doing was leaving tracks, innocent of the conventions of representation. Suddenly it becomes clear that, for Rosenberg, art is available as a method of self-location only to those with the right stuff. With the certainty of faith, he knows that true believers are the only ones with the key to the authentic. The skeptic is closed out.

Yet Rosenberg was skeptical enough to know that what he was saying about a particular group of artists in New York in the late 1940s could apply only to them, and that both their work and his explanations would be copied and reused by other people, in other places, for other purposes. As that happened, abstract expressionism would degenerate into mere style, appropriated in an ever widening circle of influence until swallowed whole by mass culture. Reporting from São Paulo's sixth biennial in the early 1960s, Rosenberg wrote,
*Here was a painter who rothko'd well; one who newmanned by tricking the eye with a line that wasn't there; another who whited on his whites and blacked on his blacks—he also blacked on his white and blacked under his white. Some gorky'd heavily, more gottliebed a bit; there were stillifiers, gustonators, vincenteasers, albersians, mechanicists and mistophiles. A half-painter-half-embroiderer laid beads to his drips.*[3]

But while Rosenberg noted this, he may not have fully attended to it; like so many intellectuals of his generation, he was fired with such scorn for the mass media that he probably refused adequately to observe their goings-on. Whatever the case, his realization of a fatal dilution came late. It had already informed the dogmatic exorcisms of Ad Reinhardt, whose black-on-black canvases served to emphasize the tendency of abstract expressionism to degenerate into little more than a conventionalized display of recognizable signs of selfhood. More generously, the same observation informed Robert Rauschenberg's playful strategies during the early 1950s. In his

*White Painting* of 1951, he presented the art world with Rosenberg's preferred sign of immanent being, the blank canvas, offering the gallery public directly what had been for the action painters "the opportunity for a doing." Two years later, in *Erased de Kooning Drawing*, he rubbed out a de Kooning; with a conspiratorial wink to Marcel Duchamp's mustachioed femme fatale, he raised the level of implicit violence, if only in a small way. Rauschenberg simply called the bluff, made a joke of high seriousness in a period heavily infected with that virus. His *Factum I* and *Factum II*, twin paintings from 1957, continued the confrontation, presenting in duplicate a catalogue of abstract expressionist mannerisms—a mirroring of a typically "spontaneous," ad hoc composition of drips, strokes, and paste-ons.

These art jokes, important as indications of dissent from the prevailing notion of the acceptable, still remain a part of modern art's separate, isolated aesthetic discourse. The real value of Rauschenberg's contribution is to be found in his willingness to expand that field. In *Bed* (1955) he accelerates his razzing of de Kooning: the virtuoso wrist work, leaving ejaculatory trails of paint across sheets and pillow, makes witty mockery of the onanism implicit within expressionist practice. Yet by attaching quilt and pillow to his painting support, Rauschenberg makes literal the idea of the canvas as an arena in which to act—no ideal space of aesthetic action, but a real place in which real quotidian events might take place. The trajectory of vision implied in a work like *Bed*, downward as much as straight ahead, suggests the openness and inclusiveness of the artist's great combine paintings of the middle 1950s. In doubting the value of the expressionists' solipsism, Rauschenberg found a way to consider a range of possibilities that would attach his art-making to life in society at large. What we see collected in these works is the random meaninglessness of endless reproduction. Handmade and machine-made, painted and printed, private and public, found, altered, and constructed, a blurred catalogue of the signs of modern life is held before our eyes for the pleasure of unanchored recognition. We are not asked to interpret the signs offered, or to find a larger significance in the marks they make on our consciousness; we are

asked only to register that they exist, and that their existence spins a web of fascination from which we cannot escape.

Rauschenberg's open-ended approach, his willingness to accept the risks of randomness in his art, no doubt stemmed from the teachings of John Cage. Undoubtedly important, but obliquely so, Cage was never more than theoretically interesting, a latter-day advocate of an aerated *japonisme*. It was Rauschenberg who gave convincing form to Cage's ideas, and it was Rauschenberg's work that loosened the guidelines directing younger artists in the second half of the 1950s and into the 1960s.

It is the paradox of abstract expressionism that the elements of its success conspired in the end to undermine its pretensions. Its routine use of large scale to evoke the monumental, and the idea of the brushstroke as an existential marker, contained an inherent theatricality that could be used in the hands of those with a more skeptical view of art's mission to unravel the claims of moral legitimacy made in the name of pure painting.

Rauschenberg's tying of the new American painting to an aesthetic of impermanence reintroduced a notion of time as a visible entity. Wanting to bring art out of the privileged isolation of the studio into the daily traffic of real life, Rauschenberg revived the dadaist range of practices—collage, bricolage, decoupage, assemblage—and reframed them with the rhetoric of action used to describe abstract expressionism. The results were manifold and long-ranging. In the immediate term, literal-minded artists decided to make the act the main event. Georges Mathieu made painting a picture into a public performance, Yves Klein made the performance an art work; Allan Kaprow and others staged "happenings" in which the spectators participated in making the experience that was labeled "art." Artists everywhere realized that they could use any material and that it had only to be presented within the space normally set aside for art (museum courtyard, private gallery, collector's living room) to be seen as art. Duchamp was rescued from obscurity on 14th Street, and

*Robert Rauschenberg*
Factum I, *1957*
*Combine painting*
*61½ × 35¾"*
*The Museum of Contemporary*
*Art, Los Angeles:*
*The Panza Collection*

*Robert Rauschenberg*
Bed, *1955*
*Combine painting*
*75¼ × 31½ × 6½"*
*Collection of Mr. and Mrs. Leo Castelli*

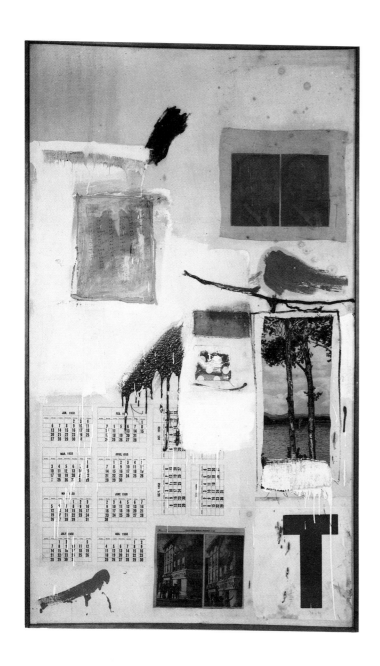

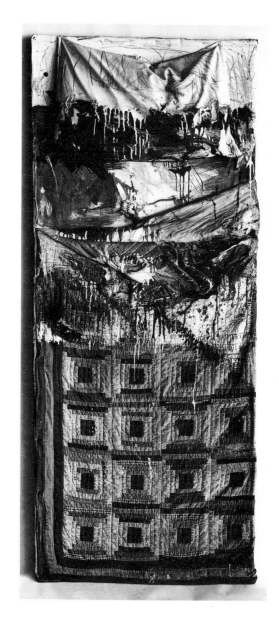

given the honors Pablo Picasso had forfeited on retiring behind the locked gates of La Californie.

There was a great euphoria about all this, partly because it provided a clue as to how artists might continue to work within a society increasingly dominated by an alienating mass culture, and partly because it was fun and easy to do and to understand. Longtime outsiders, the abstract expressionists had rejected mass culture and consumerism as a matter of course. But such innocent purity was never available to succeeding generations. For artists working from the mid-1950s on, art is inextricably timely. When it's hot, it's hot. When it's not, it's simply commodity, a souvenir of the moment no different from a pop song. Returning again to Rosenberg: *Circulating as an event in art history, the painting sheds its materiality: it assumes a spectral other self that is omnipresent in art books, illustrated articles, exhibition catalogues, TV and films and the discourses of art critics and historians. Composed in the first instance of the painter's motions in time, the picture also exists temporally in the frequency-rate of its public appearance. To introduce it into and identify it as part of the cultural system, it must carry an art historical tag that relates it to paintings of other times. Thus the painting becomes inseparable from language; in actual substance it is a centaurlike being—part words, part art supplies.*[4]

During this free-form period most artists wanted to be like jazz musicians or beat poets, to improvise in a way that would refuse the very idea of development. Jasper Johns, however, recognizing the ineffable melancholy of an art reduced to this arbitrary play of signs, took the role of the blues singer, working an extremely limited repertoire of possibilities for maximum effect. Like the blues singer, Johns (who grew up in the rural South) was interested in "signifying," in returning an urgent dignity to a series of commonplaces made banal by their nonstop reiteration. By juxtaposing signs so familiar as to be bereft of meaning (flags and targets) with a variety of equally invisible and overused abstract

expressionist devices—heavy impasto, impulsive brushing, emphasized contours, streaks, smears, and drips—he sought to concentrate the mind. More economically, more concisely than before, Johns indicated the necessarily shifting relationship between the public and the private perception of an image; he made it possible to consider what makes one collection of marks work as art, and another, of similar appearance, degenerate into a species of advertising.

In their attempts to describe and tame Johns's meditations on representation, a great many commentators have tied themselves in knots over the identity of the signs he manipulates. "Is it a flag, a painting of a flag, or a painting of a painting of a flag?" So runs the usual, absurdly limited litany. It has never been clear if anyone really accepted the premise of this ridiculous argument that a person might mistake a Johns painting for the Stars and Stripes. Perhaps in humorous response to the level of too much discussion in the art magazines, Claes Oldenburg played the shifting signifier game— when is a flag not a flag?—with a goofier, raunchier sense of humor. In 1961, in an old storefront on New York's Lower East Side, he opened "The Store," offering for sale an assortment of plaster replicas of foodstuffs and clothing. These were not exact replicas, but rather obviously "arty" recreations: lumpy, drippy, expressively inept copies of the real thing. Thus Oldenburg offered up a conundrum of value, locating the arbiter of such measurements squarely within the terms of the marketplace. Inedible foodstuffs that looked not too different from the inedible foodstuffs normally offered for sale in small coffee shops and delicatessens were offered for sale as art objects. But these weird little paint-daubed plasters tended to look like art to the same extent that they looked like food. This puzzle of conflicting appearances and unexpected contexts has been Oldenburg's operational tactic ever since, as he has worked with the conflicting responses elicited by mismatching image, texture, scale, and context, following his desire to make "an art that is political-erotical-mystical, that does something other than sit on its ass in a museum."[5]

*Jasper Johns*
Three Flags, *1958*
*Encaustic on canvas, 30⅞ × 45½ × 5"*
*Whitney Museum of American Art,*
*New York*
*50th Anniversary Gift of the*
*Gilman Foundation, Inc., the*
*Lauder Foundation, A. Alfred*
*Taubman, an anonymous donor,*
*and purchase*
*Acq.# 80.32*

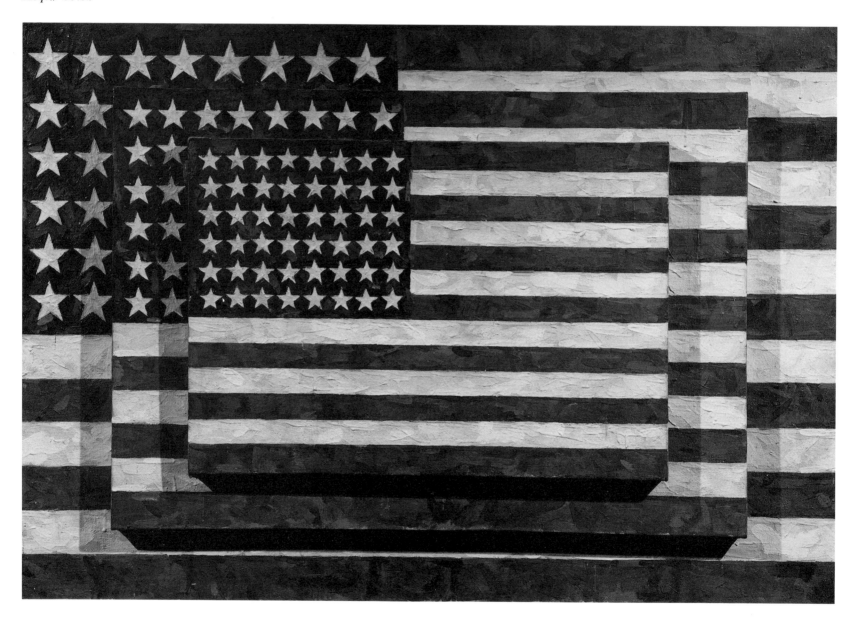

The modernism of abstract expressionism was based on the artists' alienation from mass culture, from the values of a consumer society anesthetized by a cocoon of bad taste. It was an outsider stance all too easily formalized and made sentimental, an exquisite railing against entrenched power. The generation that came of age at the start of the 1960s saw a need to reverse this, to disguise their alienation behind a mask of eager acceptance. This camp attitude, which found inspiration where the guardians of civilization saw only ruin, was a radical one because it permitted, for a while, an unsentimental acknowledgment of the pleasure available from corrupt sources. Taking alienation as a given, as a part of the scheme of things, it opened up a different, less hoity-toity view of culture, one that allowed for the existence of another perspective. From this other perspective, the relativity of value, the interchangeability of signs and portents, and the essential identity of all commodities as floating markers in a game of exchange became apparent. And that perception became useful to artists. The credo of those who worked from it, the pop artists, can best be summed up by a sentence from a manifesto Oldenburg wrote in 1961:

*I am for Kool-art, 7-Up art, Pepsi-art, Sunshine art, 39 cents art, 15 cents art, Vatronol art, Dro-bomb art, Vam art, Menthol art, L & M art, Ex-lax art, Venida art, Heaven Hill art, Pamryl art, San-o-med art, Rx art, 9.99 art, Now art, New art, How art, Fire sale art, Last Chance art, Only art, Diamond art, Tomorrow art, Franks art, Ducks art, Meat-o-rama art.*[6]

In the bright, brave 1960s life was good, life was fun; and pop was the bratty child who said so. Perky pop music and cheery pop paintings reassured both the mass audience and the discriminating patrons of the art gallery that we were finally in the best of all possible worlds, one in which a ballooning market was coming of age. Some old fuddy-duddies cried foul, saying it was all hype and novelty for novelty's sake, but nobody paid any attention to them. Youth wanted out, and pop was the vehicle of choice—metaphorically speaking, that is. The automobile was the real thing in the USA. The rest of us simply dreamed it, a fantasy of modernity, of sex and technology, that guaranteed freedom or at least fluidity of movement. The complexities of the past could now be simplified, ironed over by that visible and very concrete sign of progress, the highway. Everything old could be bypassed, redeveloped, or simply ignored as irrelevant. We could now get out on the highway, looking for adventure in a rhythmic continuum of never climaxing euphoria. To survive in this new environment cultural life had to become pared down, streamlined. The meandering complexities of European models were no longer adequate in the face of such simple and American universals as the United Nations and the Justice League of America.

Looking back from the vantage point of a generation that takes pop for a father figure (and, indeed, pop art in general must be understood as a male response to the fantasy offered by the spectacle of commodity fetishism, whose central fascinations—fast cars, girls and boys, violent death—pop sought to make visible, and controllable, through the rituals of the gaze) and dada a distant granddad, it is sometimes difficult to recapture the youthfulness of it all back then. The contemporary literature tends to be ecstatic, both in praise and condemnation. Reading it, one gets a real sense of adventure, of new beginnings, new opportunities in an art world grown staid. But these bright days have faded, along with the Technicolor that recorded them. Reds have pinked, blues faded, whites gone grubby. The edges are smudged with too many sticky fingers. What remains is bitter laughter as the repeating disasters of a decade of failed dreams parade by in the bright, snappy designs of modern packaging, in a display of a too too quick absorption into the marketplace of mainstream culture.

What enflamed passions in the art world of the early 1960s was the publicness, the commonness of pop. Here was an art that questioned the sanctity of the artist's image-making powers, favoring instead the readymade icons of mass culture; an art that distanced itself from the look of personalized engagement that characterized so much New York school painting, preferring mechanical or quasi-mechanical means; an art that was far less concerned with the private

mythologies of expressionist artists than with trading in the shifting meanings and implications of the public image. Image-making was stripped of its high-toned aura and seen as a species of publicity—and that clarification was taken as a healthy and important step for art.

The first refinements on the achievements of Johns and Rauschenberg were formal ones, but they were to have a wide-ranging effect on the way the art of the 1960s looked. As early as 1958, Frank Stella reduced Johns's multilayered flag paintings to a two-tone stripe, a semiotically deft strategy that reflected the image-making of an earlier generation while focusing attention on the problematic status of modern painting as culturally located object/image. What kind of artifact is a modern painting—is it a sign of dissent, or, in the wake of the much-heralded triumph of American painting, a badge of patriotic cheerleading? Johns's flag paintings can be understood as the result of a complicated and melancholy brooding on these matters. A painting like Stella's *Die Fahne hoch!* (1959) more clearly and acerbically brings the issue into the open, indicating a crisis of confidence in the possibility of locating any notion of individual authenticity in the work. Such a painting must be seen as a distress flag signaling the collapse of the idea of the unique in an age of mechanical reproduction.

The pop artists proper, those who wished to confront the pervasive repetition of representation in the public realm more directly than through the oblique stratagems of modernist abstraction, took some time to realize the potential of the technical advances made by the abstractionists. In 1960 Andy Warhol began reproducing images culled from newspapers—from cartoons and advertising drawings—using a freehand style that left plenty of room for the virtuoso display of an accumulation of artistic mannerisms become illustrational devices. A year later Roy Lichtenstein abandoned abstract expressionist method and began producing paintings that were flatter, simpler, and more highly finished; scaled-up facsimiles of comic book panels, they included such characteristic details as benday

dots and snippets of loaded dialogue. During the same period James Rosenquist was beginning to investigate ways in which to present in an art context the unanchored, fragmented, dominating images that he had experienced as a billboard painter, working in close-up on a large scale. The idea of a definable pop style began to coalesce in 1962. In New York, Lichtenstein had a show at the Leo Castelli Gallery; later in the year Warhol showed at the Stable Gallery. More importantly, Warhol made a technical breakthrough, discovering the possibilities of mechanical reproduction itself.

*In August '62 I started doing silkscreens. The rubber stamp method I'd been using to repeat images suddenly seemed too homemade; I wanted something stronger that gave more of an assembly-line effect. With silkscreening, you pick up a photograph, transfer it in glue onto silk, and then roll ink across it. . . . That way you get the same image, slightly different each time. It was all so simple—quick and chancy, I was thrilled with it.*[7]

Of the three most important pop artists Lichtenstein has consistently remained the most restrained, one might almost say the most conservative. As his work has developed in the twenty-some years since his debut at Castelli, he has wrought ever more elegant demonstrations of the sheer pleasure to be taken in the imperfect banality of the mechanically reproduced image. With a fine eye for the interweaving patterns of recognition that enliven our day-to-day appreciation of pictures—comic books, ads, signs, art reproductions—he has established a body of work that teases our perceptions of style as content. In the early painting *Golf Ball* (1962) a schematic rendering of the ball fills a square, easel-size painting. The ball looms out of scale, as an Oldenburg object might but without the fun house comedy. Lichtenstein's humor is more scholarly here, a compacted series of art-historical jokes that encompass the early-modernist debate between abstraction and reality. The arrangement of the markings that compose the image subtly parodies Piet Mondrian's first attempts toward nonobjectivity, while the circle-in-square format more boldly recalls later constructivist nostrums. And both high-minded ventures are mercilessly brought to earth by the

stunning banality of the image itself, that icon of suburban comfort and leisure, a golf ball. All the basic elements of Lichtenstein's work are contained in this example from his earliest pop period. As he grew more confident, his intertwining of popular and fine-art sources, of art issues and life issues, of text and image, of styles of representation, became ever more complex, building an extended essay on the contradictory claims of the public and private spheres in the creation of individual consciousness.

Three important suites from 1963–64 demonstrate Lichtenstein's commitment to the theme of the public treatment of private fears and desires. Using the clichés of pulp romance and war comics, he gives us images of America's double obsession—sex and death. Each work is clearly discrete, yet each presents itself as an idealized fragment, a perfect moment of high drama elegantly caught in the full-bodied curves and not quite regular dots of Lichtenstein's rendering of a printer's screen. We are shown moments of crisis: tears spilling from the corner of a beautiful girl's eyes; a burst of fire from a snarling machine gun; a dramatic brushstroke, the heroic "doing" of an action painter frozen under glass for our inspection. Lichtenstein leaves the connotations inescapably clear: the dream he depicts is the hopelessly and dangerously innocent American dream of an untroubled powerfulness fired by the optimism of the righteous.

For all its pop brutality, Lichtenstein's work is sly. Its wit creeps up on you. Rosenquist's work is more loquacious; it is big, loose-limbed, loudmouthed. More overtly political, formally and technically more ambitious, it falls short of the expressive punchiness of Lichtenstein's taut little canvases. Taking his cue from Rauschenberg, Rosenquist sprawls across the wall and over the floor. Ripping the images of public America from their "natural" contexts on hoardings and advertising pages, he flings them together to make fairly clear reflections on contemporary life. An early painting, *President Elect* (1960–61) presents us with a smiling, handsome John F. Kennedy; a pair of sleek hands, the nails polished, breaking a piece of cake; and the wheel of a large automobile. *I Love You with My Ford* (1961)

delivers, as promised, a stylish (but outdated) car grille, the profile of a girl (eyes closed, prone), and a seething mass of Franco-American spaghetti. Too-familiar images are cut, reprocessed, reframed, mindlessly magnified, and presented in the ambiguously slick tones and non-textures of billboard painting. They are instantly knowable, but a sickness lingers, a premonition of decay. Or, as Ivan Karp wrote in a 1967 exhibition catalogue,

*James Rosenquist employs images derived primarily from inelegance and surreal unseemliness, gross, cruel and fantastic. An abiding nostalgia for the recent past permeates the spirit of the work, purposely fake and forced, and at the same time an aura of astonishment and disbelief at the terror of this rude reality is an abiding and unifying voice.*[8]

Metal and flesh, machines and flesh, machines and flesh and canned spaghetti; using his own vocabulary of borrowed signs and portents, Rosenquist reiterates the same themes as Lichtenstein, indulging only in a more heavy-handed surrealism, one that, not content to suggest meaning, seems to strive for it. Nowhere is this more clear than in his magnum opus of 1965, *F-111*, an eighty-six-foot-long painting installed around the walls of the Castelli gallery. The fighter jet named in the title is laid out across the entire work, its nose dipped in Rosenquist's signature ruby-red—juicy-red—canned pasta. At intervals across the surface of this phallic representation of American might are placed alien images: a section of tire, some light bulbs, a young girl under the dryer, a mushroom cloud, a diver (that Johnsian motif of the sinking subject). The painting, built of a number of interlocking compartments, is a linear diagram of Rosenquist's usual compositional methods. Immense images jostle for recognition; having won it, they scream to connect to the others. And they do, with a goofy certainty. Laid out before us is a megadisplay of innocence and death, of the terrors of the war machine and the lonesome, sensitive figure of the artist.

Despite the sometimes awkward gigantism of his work, Rosenquist remains something of a gadfly, a quixotic figure lost in the modern

*Roy Lichtenstein*
Drowning Girl, *1963*
*Oil and synthetic polymer paint on canvas*
*67⅝ × 66¾"*
*Museum of Modern Art, New York*
*Philip Johnson Fund*

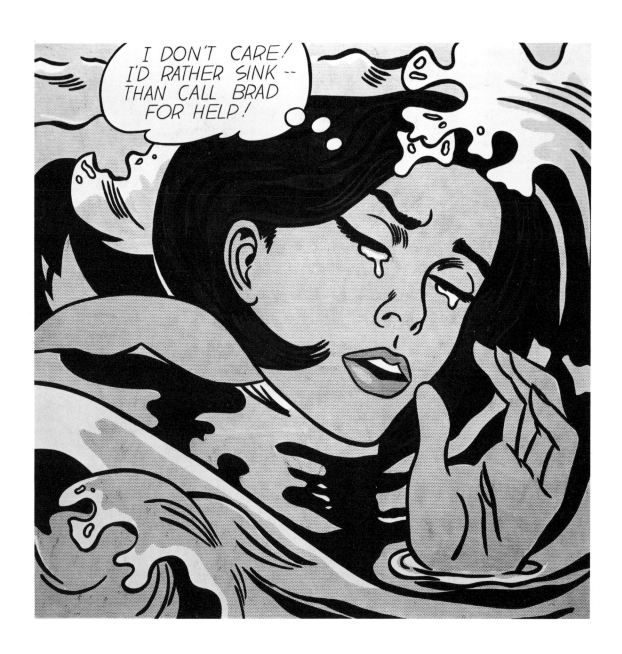

*James Rosenquist*
**F-111**, *1965 (detail)*
*Oil on canvas with aluminum*
*10 × 86' overall*
*Private Collection*

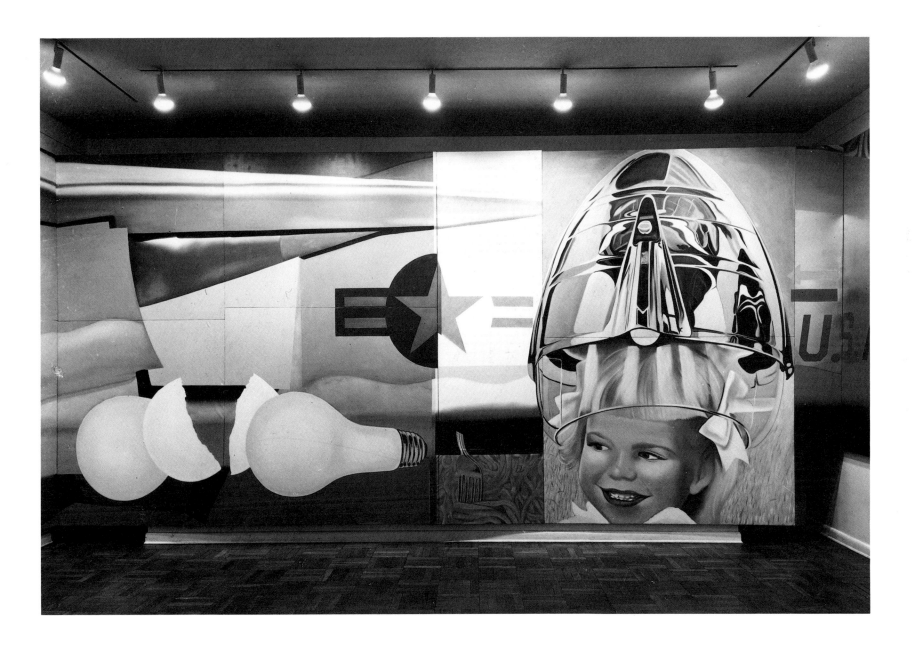

landscape. He dabbles in images, messes with materials, and sometimes scores big. But the dedication to variety that served Rauschenberg so well was less certainly a guarantee of success by the mid-1960s. It was all very well to want to use contemporary materials like Plexiglas and Mylar, but they lost some of their specific punch when just tossed into a big salad surprise. What was needed was the demonic concentration of a Donald Judd focusing on the materiality of plastic or aluminum, or of a Warhol focusing on the dematerialized image of the public subconsciousness.

Of all these artists, Warhol took the most radical steps to redefine the place of art within the continuum of culture. In the first waves of what could be termed a postmodern sensibility, during the 1950s, there had been a steady erosion of the vanguard artist's traditional elitist position, but it was Warhol who most decisively accepted mass culture as an arena of concern every bit as compelling as the privileged angst of the fine-art specialist. Warhol claimed to "like" everything, and in doing so he tore down the barriers between art and life with a shocking finality. In laying claim to this populist aesthetic, he demonstrated an intuitive grasp of the semiotics of power in a capitalist democracy, for by liking everything, he made it clear that he finds everything to be alike. For Warhol (and he shows us this in every aspect of his work), all cultural objects, high and low, share an identifying similarity: they are merely tokens of exchange, endlessly reproducible signs of wealth and power.

In the great series of works Warhol produced in the early 1960s, images are repeated over and over until any spark of idiosyncracy they may have possessed is lost in an overwhelming blandness. Increasing, they grow pale; more is very much less merrier. Coke bottles, soup cans, dollar bills, Elvises, Marilyn Monroes, Troy Donahues, Statues of Liberty, Mona Lisas, car crashes, electric chairs, Jackies—all rolled off the rather rickety production line of Warhol's Factory like so many imperfects headed for the bargain basement of a souvenir store. However, while all are so much the same, so hopeless, somehow they are also alluring. For Warhol had discovered that all images are not the same; some are much more likable. In the democracy of "all is pretty," some images separate out, become more distinct, more valuable. These are the ones to which is attached the frisson of glamour, the ambience of power, the smell of death. In this way we understand why row upon row of identical Marilyn Monroe faces, like death masks, seem more moving than similar rows of the Mona Lisa. Leonardo's beauty enjoys only a schoolbook fame; we all know she's beautiful, unbelievably valuable, incredibly guarded and protected, yet she is after all only an old picture, in France or someplace. But Marilyn is hyperreal, a spectral goddess shimmering in ether, visible to all, available only to men of power; her premature death ensures that her sexuality transcends its physical limitations and becomes pure vision, a feast for the eyes. In *Gold Marilyn Monroe* (1962), her masklike face, lips parted, eyes hooded, nestles on a field of gold, an image of power as image.

In the oscillations of Warhol's work as a whole the repeating Marilyns and Elvises served to routinize glamour while the soup cans and Brillo boxes glamorized routine. In both cases the routine was seen as a ritual of despair, the expected outcome of an unyielding alienation. The relentlessness of the work has a macabre quality, an obsession with the power of the inanimate. And indeed death itself, in the "Disaster" and "Electric Chair" series, provided Warhol the opportunity to investigate the ghoulish down side of the hypnotic stare of fascination that is the depleted pleasure of the victimized consumer in a society sated with the spectacle of successful consumption. Ultimately Warhol's liking is not likable, but scary; it illuminates too much for comfort.

At the Factory Warhol dispensed his gaze, bestowed the grace of his attention, however momentarily, on those who would be superstars. By identifying glamour as the life force of the commodity he became empowered to confer glamour on those he favored, an effervescent moment of stardom in which desire is stilled and one becomes desired—an image freed of the constraints of daily life. Rauschenberg had introduced the element of time, of the everyday,

*Andy Warhol*
Gold Marilyn Monroe, *1962*
*Synthetic polymer paint,*
*silkscreened, and oil on canvas*
*83¼ × 57"*
*Museum of Modern Art, New York*
*Gift of Philip Johnson*

*Andy Warhol*
Orange Disaster, *1963*
*Acrylic and silkscreened enamel on canvas*
*106 × 81½"*
*Solomon R. Guggenheim Museum,*
*New York*

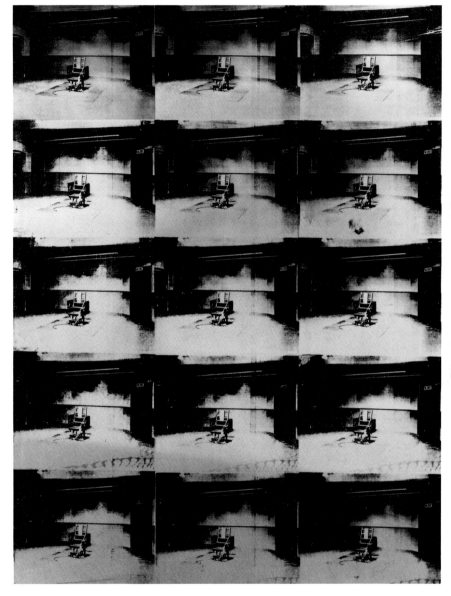

into art. Warhol transformed that gift by making a fetish of it, turning art into a reliquary, a suitable devotional for a vampiric culture.

While most European art in the 1950s remained under the domination of what was left of the school of Paris, producing domesticated canvases for metaphysical delectation, American artists and intellectuals were not alone in their interest in the issues surrounding representation in modern culture. In Paris, Roland Barthes was developing Claude Lévi-Strauss's analysis of myth into a lucid explanation of the ideological messages implanted in advertising and other public displays of power and prestige. And in London, a group calling itself the Independent Group, associated with the Institute of Contemporary Art (including Lawrence Alloway, Reyner Banham, Richard Hamilton, John McHale, and Eduardo Paolozzi), was responsible for a program of lectures, discussions, and exhibitions that explored the implications of mass culture through an examination of its sign systems. The most public of the Independent Group's efforts were their environmental exhibitions, with titles like "Parallel of Life and Art," "Man, Machine, and Motion," and, most famously, "This Is Tomorrow," which was staged at the Whitechapel Gallery in 1956. These shows were team efforts, the collaborative work of architects, sculptors, painters, and photographers. They conferred no special privilege on art objects, but treated them instead as pieces of evidence on a par with documentary and scientific photography, technical drawing and computer plotting, advertising, typography, comic books, and movie stills. Information and images were appropriated from the spectrum of modern knowledge; signs of human progress isolated from the discourses that gave them meaning, they were presented within the context of aesthetic experience, and subjected to the erratic, useless criteria of beauty that that framework imposes. These exhibitions, rather than the individual artworks of the people involved with the Independent Group, might mark the first time a fascination with pop culture led to something that could be called pop art.

Pop art proper broke out in London in the early 1960s. The Royal College of Art produced numbers of bright young artists attracted to the speed and romance of American pop culture, the glamour of high-gloss packaging, and the excitement of the Mersey sound. David Hockney and Derek Boshier did stylish pastiches of style, wittily cross-referencing art and kitsch. Richard Smith developed large-scale paintings inspired by American cigarette packs. Gerald Laing, Peter Phillips, and Alan Jones pushed Hamilton's rather tentative and academic observations about machines and sex toward a sleeker, sexier product, at the same time that J. G. Ballard was writing his sci-fi fantasies about the eroticism of the automobile. Zhandra Rhodes and others were inventing Carnaby Street and "swinging London," where pop art pizzazz enlivened fashion, repaying its debt to popular culture.

A world away, in the Hollywood that British artists dreamed of (and to which Hockney eventually traveled, becoming the living recorder of its swimming pools and sunny terraces), another group of artists, alerted by events in New York, began to dream the American dream in the pop style. Some, like Billy Al Bengston and John McCracken, made the autoerotic objects the British artists theorized. Slick and beautiful, these love objects were the pure, nonfunctional products of the perfect body shop, licked to a clean hard shine, given the gloss of untouched and untouchable commodity. Others, like Ed Ruscha, played the part of the wise guy, cracking neat little one-liners on the state of art. In a city whose whole ambience is pop, a city of stars and one-night stands, of freeways, billboards, and amusing hamburger joints, the New Yorkers' aggressive, art-smart tactics might have seemed strained. Ruscha's easygoing pop accepted the humor of the given in a much more likable way than Warhol's. His books of more or less uninteresting photographs of gas stations, palm trees, and small fires have an "aw shucks" quality to them, a friendly, bemused affection. Similarly, his word paintings and drawings, with their offbeat wit, play a relatively gentle, contemplative game with the limits of representation when compared to the fierce gambits of the New York artists. Under their civilized veneer, the New Yorkers remained alienated from their culture, angered by their

understanding of it. Ruscha, on the other hand, played dumb, pretending to love California's earthly paradise, warding off ennui with charm and quick facility.

Nineteen sixty-eight was the year the music flared and died. It was the year of the Prague spring and the Watts riots in Los Angeles, of the student revolt in Paris and the Chicago convention, of the Tet offensive and the Cultural Revolution. It was the year the peppy optimism of pop music turned acid: mop-tops became hippies, dedicated followers of fashion gave way to the demonstrative anticonsumerism of the counterculture. It was the year Warhol got shot. The prevailing winds of culture had shifted. The happy face pop turned to the world no longer seemed viable, much less honest. The snappy, happy double take had suffered a fatal mutation: we had seen the Beatles replaced by the Monkees, pop by popism. The icons of pop art regained their original use as advertising, reappearing in the mass market as chic decor in clubs and pubs and up-to-date homes. And a new generation of artists began to recognize the knowing humor and camp tease of pop art as accomplices in its apparent compliance with officialdom.

The pop artists' recognition of art as a system of culturally defined signs had opened the way to an understanding of art's place within a larger system of meaning, to the understanding that art itself functions as an ideological sign within bourgeois culture. In the face of pop art's surrender, the critique of representation that fired a goodly part of the ambitions of working artists dematerialized, became more overtly intellectual, more aware of its context, and, informed by the idealism of the student uprisings and anti–Vietnam war demonstrations, more clearly antagonistic to the status quo. So-called conceptual art grew from a sense of disappointment that the aggressively mechanistic and antiexpressive aspects of pop and minimalism had not extended to a radical disruption of the entire cultural apparatus. Conceptual artists wanted to transform the emblematic display of dissent, with its cushioning ironies and double entendres, into a directly critical form of expression. Artists like

Daniel Buren, Dan Graham, Hans Haacke, Joseph Kosuth, and Lawrence Weiner constructed a critical language from the discourses of publicity, journalism, and the academy. Using sly appropriations of typography and utterance, they helped make explicit the insight that both the university system and the media conglomerates, thoroughly purged of socially critical ideas during the period of the cold war, articulated an idea of freedom that was essentially one-dimensional, bureaucratized, and clearly circumscribed within the limits of public relations. At its best, this work presents a condensed image of a supposedly "value-free" discourse in the guise of corporate design, underscoring the implications of going public. Still, conceptualism was a utopian effort, largely innocent of the constraints of making a living; the economic disruptions following the oil crises of the early 1970s served to accelerate an inevitable disillusionment, and the return to an ironical, self-conscious marketing. Conceptualism is a melancholy footnote to the cynical social realism of pop, dragging out its dusty card files and yellowed printouts, what Jeff Wall has called "its caskets of information [in which] social subjects are presented as enigmatic hieroglyphs and given the authority of the crypt."[9]

*We're on a road to nowhere*
*C'mon inside,*
*Taking that ride to nowhere,*
*We'll take that ride.*
*Feeling OK this morning,*
*And you know,*
*We're on a road to paradise,*
*Here we go.*

Now we are in the 1980s, and once again it is the best of times, and the worst. Implacably, it is an age of return and repetition, suffering a politics of déjà vu. Once again a great future is promised, while the present, pictured in rosy hues in the mass media, offers its charms only to a few. Under the intense pressure of the prevailing sense of cultural depletion, consistent attempts have been made to generate renewal through "resource recovery" (the "new" painting being the most obvious example), that most civilized way of dealing with the

vast accumulation of trash and detritus that threatens to engulf us. In such a situation the issues raised by the pop artists' questioning of the standard ideas about originality and representation have taken on a new urgency.

But it is difficult to get a clear understanding of today's art, to weigh its intentions. There is more art being produced than ever before. More of it is exhibited, written about, sold; one might say that a renaissance of sorts is under way. And yet so much of this abundance seems trivial in effect, and, more depressing, trivial in intention. The art is concerned only with display; it shows off its emotionalism or its intellectualism (rarely together—emotion and intelligence are thought to be mutually exclusive in this art world); it declares allegiance rather than earning it. There are many explanations for this shallowness, but the most convincing is simply the pressure of numbers. A huge increase has occurred in the number of people wanting to be artists, attracted no doubt by an image of a "free" style of life. The resulting competition, which one might expect to be wide ranging, is instead reduced to the simplest level of all, the floor of the marketplace. The outcome, already familiar from other arenas, is that success is often acclaimed for the boldest promotion. Appearances are rewarded over substance.

Today, the burden of history is something to be dropped without delay, dropped and hidden. Most of the new art produced in recent years has shown as much awareness of its place within the continuum of culture as a box of Twinkies, which is to say that its place is wholly conditioned, while its understanding of the conditioning is nonexistent. One might call this a denial of history, but such a description seems too active: this is not a refusal of history but an inability to recognize it. This is the dangerous ignorance of the innocent. Such oblivion is already familiar: it is the consequence of the temptation offered by the mass media to set aside all responsibility. What is disconcerting is to find the strategy repeated in the production of art, suggesting that many artists today prefer complicity with power to the provision of the means to express dissent.

We have seen artists struggle with power, and the rise and fall of their successes. The great triumphs of a pure, transcendent modernism were finally not strong enough to sustain their own integrity in the face of the behemoth. The terrible lesson for artists of our time is that they may ignore the modern world only at their own risk. Johns and Rauschenberg were among the first to understand this, to move toward a more complicated position, one that could be understood as being adversarial toward the different sources of power. The work these artists produced in the 1950s initiated a critique of the ways in which the mass media, by an incessant manipulation and remanipulation of representational codes, seek to flatten experience. Since that time, a similar aspiration has moved several generations of artists to oppose the increasing rigidity of high modernism with a play of investigations, in words as well as pictures, of the means and meanings of representation. This development has recently suffered the fate of all successful challenges to a reigning orthodoxy; it has been given a label that attempts to make it seem reactionary and unoriginal—it has been called postmodernism. Such labels of convenience are never accurate, of course, and this one is no exception. But it must be said that the art I am talking about is not simply an art that questions the certainty of any type. It is an art of ambiguity that addresses the question of reality in an age of appearance and illusion. It is an art that acknowledges the irony of reality, and in this sense it might be called an art of real life.

The artists here have been chosen to be representative, the presence of their works a signpost to a narrative that is largely missing here, and sometimes misleadingly marked. Of the five artists intended to represent a critical art in the present (or the future of critical art), all but one are American, and all but one are male. The following paragraphs may provide a clue as to the most appropriate interpretation of these signs and others, so that in the end a tale of some value may have been told.

Over the years, Sigmar Polke has developed a painting style that

brings together a sophisticated taste for popular culture and kitsch with a spicy transcendentalism. Since the mid-1960s he has luxuriated in a delirious appropriation of materials, images, and styles, all orchestrated within the confining and convention-bound proscenium offered by painting itself. Working in a cryptonaive mode similar to that of many performance artists in the 1970s, he has mimicked banal forms of photography and high-modern abstraction, lifted images from wallpaper design and comic books, used all sorts of untraditional and unstable materials, worked with thick paint and thin, in large scale and small. The images he has chosen are inverted, converted, turned inside out and outside in. He paints them in a variety of styles, which often overlap on the same canvas, each style identified by its well-established conventions. In appropriating this multiplicity of visual languages he does not seek to capture the look of reality but rather to bypass the problem of originality. Having freed himself from the task of creating art's future, Polke uses previously established stylistic conventions to entertain aesthetic questions of present interest. Foremost among them is whether the objectivity of the photographic is more or less weighty than the subjectivity of the painterly gesture.

Since the late 1960s John Baldessari's project has been a quizzical interrogation of the structures of representation, particularly as framed by the idea of the artwork. Abiding by the rule he laid down, over and over, in a 1971 lithograph, *I will not make any more boring art*, he takes pleasure in the quirky observation, in pointing to the seams in an otherwise apparently seamless gestalt. Baldessari began by making fun of painting and its pretensions to grandeur, and still does the favor for art in general. An early series, "The Commissioned Paintings" (1969), consisted of standard canvases whose painted parts were commissioned, the central images from amateur artists, the descriptive texts from professional sign painters. Not long after this he realized that it would be more economical, and more to the point, to use photographs to tell the shaggy-dog stories he wanted to tell. Since hours of gazing at movies and television have made people more adept at looking at photographic images than at painted ones, he

found that less explanation was necessary; he could point at things without having to point out how he was doing the pointing. Since that time he has worked exclusively with photographs, slicing and cutting, arranging and rearranging, in what has by now developed into an encyclopedic catalogue of the common and not so common, the strange, funny, and pedestrian tropes of the image as processed by film labs, movie studios, and assorted publishers, respectable and otherwise. The earlier works, from the first half of the 1970s, tend to a greater degree of pedagogy, each series bearing the marks of the seminar. In the later work, beginning perhaps with the "Blasted Allegories" of 1978, Baldessari's method is looser and more challenging in its associations. Do we get it? Is there anything to get? Like a stand-up comedian completely at ease with his material, Baldessari constructs loopy entertainments dependent upon a network of free associations spun from a variety of visual puns, half-recognized resemblances, acknowledged thefts, half-told tales, and almost forgotten anecdotes. The obvious and the subtle nestle cheek by jowl, beckoning our understanding and then refusing it.

Much like his mentor Baldessari, Matt Mullican might be said to deal with the mental and emotional processes of image generation. He is less concerned with objects for their own sake than with the connections we make between objects to give ourselves meaning. Mullican's art demands to be understood as a continuing project, with the individual pieces functioning as markers on a longer journey. At any given moment, current work must therefore be regarded as incomplete in some essential way, composed of fragments of something larger and as yet unfinished. While all the artists under consideration here work with a fractured vocabulary of culture's flotsam and jetsam, seeking some deeper, structural unity, no other has Mullican's almost religious conviction that his procedures might work, that he might be able to achieve a sense of self-realization through the production of art. Working initially with intensely private images derived in part from hypnosis, he has inevitably arrived at correspondences with material that lies beyond his own direct experience, correspondences that are part of the culture to

which he belongs. The images he has taken to be his own he distills to the point at which they can be understood to belong to everyone.

In recognizing his relation to the cultural restraints of the sign, Mullican provides himself with a framework from which he can develop his elegiac vision of life in terms that are accessible to all. The contradictory aspect of much of his work, the range of its appearance, is the source of its strength, for it emphasizes the tentative and fragmentary character of the whole enterprise, a characteristic easily forgotten in the face of the seeming confidence of Mullican's large banners (which echo oddly with those earlier flags by Johns and Stella, which heralded so much of the work under review here). It is the close juxtaposition of very different kinds of simplicity—the proximity, say, of a male figure made from weathered lumber and pierced with bent nails to a bright reproduction of the universal stick figure familiar from toilets in airports and railway stations—that gives the work as a whole its air of melancholy certitude. In every case, the private man is forced to confront his public destiny, to recognize that every secret, every wish, is already understood, that the individual must discover for himself things that are already known, each placed within the framework of language.

Mullican still seems to believe in the possibility of some kind of redemption, an end to the futile desire for meaning. David Salle has long given up on that hope; he has learnt the lesson of the times and is intent on showing us how well. A smart-ass student proficient in the three Rs—Rauschenberg, Rosenquist, Ruscha—he makes tremendously stylish paintings, paintings sophisticated enough to look good in the most elegant of rooms. After all, if you are going to get fucked by the system, why not make the best of it? Living well is supposed to be the best revenge. Despite his obligatory forays into alternative media in his student days, Salle learned from Polke about the greater efficiency of painting, particularly in a period that, intellectually speaking, despised the form. And he learned from Warhol that despite what the intellectuals said, people love paintings and buy them. If you are interested above all in the ramifications of the idea of the image as a fetishized commodity, why not make a real humdinger commodity fetish? To this end Salle's choices and juxtapositions of color, texture, and image are brilliant. The colors he uses are predominantly pale; the stained fields are highlighted with bright contrasting lines that have the look of high fashion. His canvases are mostly textureless, but show sudden disruptions of thick, goopy paint, or actual extrusions and adhesions of objects from fabric to furnishings. And his imagery is perfect in its deadpan: benignly recognizable, threateningly obscure, emotionally and intellectually dead, emotionally and intellectually disturbing. Most often his subjects are objectified women; these representations are at best cursory and offhand, and at worst brutal and disfiguring, making their subjects ridiculous or ugly through juxtaposition with containerlike objects. In fact, Salle's central metaphor revolves around naked women in close proximity to tubular furniture. It is a metaphor that keeps on turning, going nowhere.

Salle's work is indisputably seductive, but obscure. It brims with heterogeneity; it is promiscuous in its come-on. We are primed to understand the work metaphorically, but the metaphors refuse to gel in the way we expect. Meaning is intimated but finally withheld. It appears to be on the surface, but as soon as it is approached it disappears, provoking the viewer into a deeper examination of prejudices bound inextricably within the conventional representations that express them.

The secret shame of the art world is its continuing, near-exclusive fascination with the expression of male desires and fears. Condoned by the modernist myth of originality, that fascination has survived all too intact in an era that is claimed to have outgrown the tradition of the new. The male artist's wish to create himself anew, through his own efforts, free of the prior constraints of the womb of culture, has been conceded as a masturbatory fantasy since the early 1950s, when Rauschenberg allowed his paints to come all over the bed linen. And yet this same fantasy has served to fuel the recent marketing success of the much vaunted "new spirit in painting." Salle's work has been

*Sherrie Levine*
After Walker Evans, *1981*
*Black-and-white photograph,*
*unlimited edition*
*10 × 8"*
*Baskerville + Watson, New York*

implicated in this regressive movement, and has only been able to escape such inclusion to the extent that he makes no claims to interpretation. His work's ice-cold distance enables the artist to present his misogyny as a case to be studied, more or less as interesting as the other representational codes he projects with such careful indifference upon the originating field of the blank canvas.

Since the mid-1970s a growing number of women artists have been trying to confront the pervasive maleness of cultural expression, to break the stranglehold of this art-world fascination. Exemplary in this regard have been Yvonne Rainer's restructuring of film narrative, exposing its standard conventions as mechanisms to lock in unthinking and unexamined sexism; Sherrie Levine's blunt appropriations of the work of emblematic male artists, denying the singularity of the discourse of originality; and Barbara Kruger's agitprop phototexts, in which the rude laughter of the dispossessed rends the seamless fabric of a domineering ideology. Less disruptively but perhaps more effectively, Cindy Sherman has been engaged since 1978 in a discursive examination of the public image of women as found in B-movies, soap operas, and the melodramas of fashion advertising, which is to say in the image constellation many women feel compelled to accept as exemplary. Sherman, who uses herself as a model, subjects herself to the rigors of the picturing of others in an attempt to work through to a position from which she might be able to begin to picture herself for herself. Before the ever vigilant eye of the camera which unblinkingly records every hopeless mannerism, every mediated, compromised attempt at self-realization, she dresses up and acts out the roles assigned to photogenic young women. Secretaries and tramps, vamps and ingenues, the abused and abandoned, the seductive and sexy, the athletically asexual, the little girl lost, the haughty fashion queen—such are the images Sherman tries on for size. Lights and filters are manipulated to provide the requisite contextual clues: the chiaroscuro of *film noir* and its many progeny, the back lighting of the fashion shoot, the Vaselined filter of soft porn.

*Barbara Kruger*
Untitled, *1981*
*Black-and-white photograph*
*60 × 40"*
*Max Protetch Gallery, New York*

The success of these post-pop appropriations lies in the complexity of the response they elicit. Staring at these works, we find that we recognize ourselves in the mirror of reproduction they hold before us; and we do not know if we should be flattered or offended. Does Salle celebrate the triumph of a depoliticized aestheticism, or insult us for succumbing to the blandishments of the merely good-looking? Does Sherman seduce us with her pathetically pretty girls, or force us to reconsider the ways in which we view women? How do we resolve the puzzle of Warholian mimesis, the perfected realization of an amateur simulacrum of the hyperreal? Give us time to work it out.

*Well we know where we're going*
*But we don't know where we've been*
*And we know what we're knowing*
*But we can't say what we've seen*
*And we're not little children*
*And we know what we want*
*And the future is certain*
*Give us time to work it out.*

*Road to Nowhere* lyrics by David Byrne. © 1985 Index Music, Inc. and Bleu Disque Music Co., Inc. All rights administered by WB Music Corp. All rights reserved. Used by permission.

1. Harold Rosenberg, "Action Painting: Crisis and Distortion," in *The Anxious Object* (New York: Horizon Press, 1964), p. 39.

2. Ibid., p. 46.

3. Rosenberg, "Art in Orbit," in *The Anxious Object*, p. 19.

4. Rosenberg, "The Art Object and the Aesthetics of Impermanence," in *The Anxious Object*, pp. 93–94.

5. Claes Oldenburg, quoted in Barbara Rose, *Claes Oldenburg* (New York: Museum of Modern Art, 1970), p. 190. The statement was written for the catalogue of the exhibition *Environments, Situations, Space*, at the Martha Jackson Gallery, New York, May 23–June 23 1961; it was edited for and reprinted in *Store Days* (New York: Something Else Press, 1967).

6. Ibid.

7. Andy Warhol and Pat Hackett, *Popism: The Warhol Sixties* (London and New York: Harcourt, Brace, Jovanovich, 1980), p. 22.

8. Ivan Karp, "James Rosenquist," in *American Masters: Art Students League* (New York: Art Students League, 1967). Reprinted in *James Rosenquist* (Ottawa: National Gallery of Canada, 1968), unpaginated.

9. Jeff Wall, "Dan Graham's Kammerspiel" part one, *Real Life Magazine* 14 (Winter 1985–86): 17.

**Robert Rauschenberg**

Coca-Cola Plan, *1958*
*Combine painting*
*26¾ × 25¼ × 4¾"*
*The Museum of Contemporary Art,*
*Los Angeles:*
*The Panza Collection*

**Robert Rauschenberg**

*Interview, 1955*
*Combine painting*
*72¾ × 49¼"*
*The Museum of Contemporary Art,*
*Los Angeles:*
*The Panza Collection*

**Andy Warhol**

Dick Tracy, *1960*
*Casein and crayon on canvas*
*48 × 33½"*
*Collection of Mr. and Mrs. Peter M. Brant*

**Andy Warhol**

Storm Door, *1960*
*Acrylic on canvas*
*46 × 42⅛"*
*Collection of Thomas Ammann, Zürich*

**Claes Oldenburg**

The Store, *1961*
*Interior view with the artist*
*107 East 2nd Street*
*New York*
*December 1961*

**Claes Oldenburg**

White Shirt on Chair, *1962*
*Plaster-soaked muslin over wire*
*frame, painted with enamel*
*39¾ × 30 × 25¼"*
*The Museum of Contemporary Art,*
*Los Angeles:*
*The Panza Collection*

**Edward Ruscha**

ACE, *1962*
*Oil on canvas*
*72 × 67"*
*Collection of the artist*

**Edward Ruscha**

HONK, *1961–62*
*Oil on canvas*
*72 × 67"*
*Ulrike Kantor Gallery*

**Roy Lichtenstein**

Desk Calendar, *1962*
*Acrylic on canvas*
*48½ × 68"*
*The Museum of Contemporary Art,*
*Los Angeles:*
*The Panza Collection*

**Roy Lichtenstein**

Strong Hand (The Grip), *1962*
*Acrylic on canvas*
*30 × 30¼"*
*The Museum of Contemporary Art,*
*Los Angeles:*
*The Panza Collection*

**James Rosenquist**

*A Lot to Like, 1962*
*Oil on canvas*
*92½ × 203"*
*The Museum of Contemporary Art,*
*Los Angeles:*
*The Panza Collection*

**James Rosenquist**

Vestigial Appendage, *1962*
*Oil on canvas*
*72 × 93¼"*
*The Museum of Contemporary Art,*
*Los Angeles:*
*The Panza Collection*

**Billy Al Bengston**

The High and the Mighty, *1967*
*Polyurethane and lacquer on aluminum*
*60 × 58"*
*Collection of the artist, Venice, California*

**Billy Al Bengston**

The Star Packer, *1970*
*Lacquer and polyester resin on aluminum*
*23 × 22"*
*Collection of the artist, Venice, California*

**David Salle**

View the Author through Long
Telescopes, *1980*
*Acrylic on canvas*
*72 × 96"*
*The Museum of Contemporary Art,*
*Los Angeles:*
*The Barry Lowen Collection*

**David Salle**

Brother Animal, *1983*
*Oil and acrylic on canvas*
*94 × 168"*
*The Museum of Contemporary Art,*
*Los Angeles:*
*The Barry Lowen Collection*

**Cindy Sherman**

Untitled #88, *1981*
*Type-C print*
*24 × 48"*
*The Museum of Contemporary Art,*
*Los Angeles:*
*The Barry Lowen Collection*

**Cindy Sherman**

Untitled #92, *1981*
*Type-C print*
*24 × 48"*
*Collection of Eli and Edythe L. Broad*

**Sigmar Polke**

Paganini, *1982*
*Dispersion on canvas*
*78¾ × 177"*
*Saatchi Collection, London*

**Sigmar Polke**

Die Lebenden stinken und die
Toten sind nicht anwesent, *1983*
*Mixed media on fabric*
*115 × 140"*
*Collection of Emily and Jerry Spiegel*

**John Baldessari**

*Horizontal Men, 1984*
*Gelatin silver prints*
*97¼ × 48⅝″*
*Frederick R. Weisman Collection*

**John Baldessari**

*Some Rooms, 1986*
*Black-and-white photographs and gouache*
*96½ × 109½"*
*The Museum of Contemporary Art,*
*Los Angeles*
*Gift of the Eli Broad Family Foundation*

**Matt Mullican**

Untitled, *1986*
*(Heaven, God, Choosing Parents, Life,*
*Fate, Demon and Angel, Death, Hell)*
*Eight banners of cotton appliquéd nylon*
*20 × 20' each*

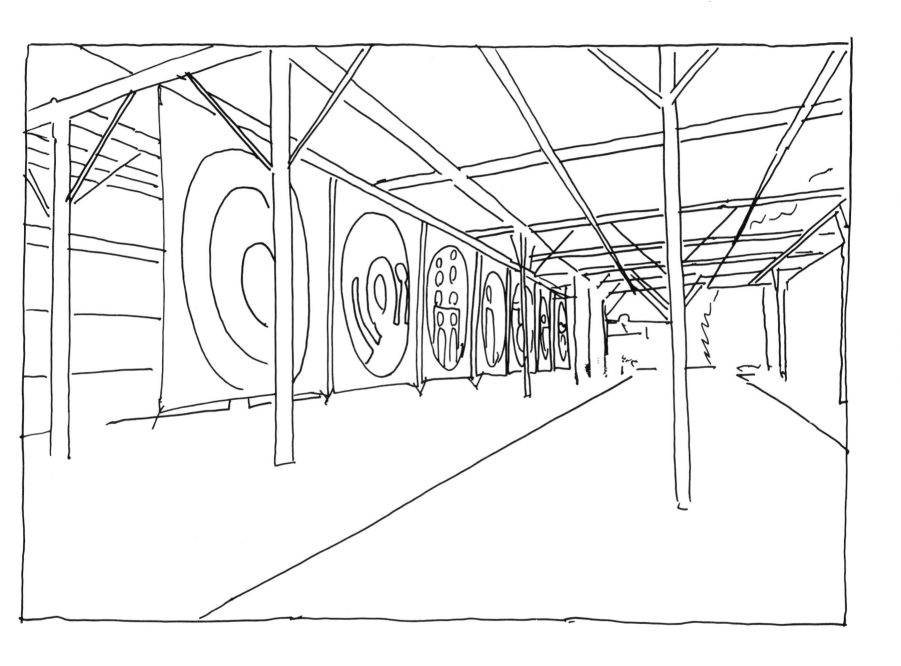

**Checklist of the Exhibition**

**John Baldessari**

Born 1931 in National City,
California
Lives in Santa Monica, California

Horizontal Men, *1984*
*Gelatin silver prints*
*97¼ × 48⅝"*
*Frederick R. Weisman Collection*

Kiss/Panic, *1984*
*Gelatin silver prints*
*81 × 72¾"*
*Collection of Toni*
*and Martin Sosnoff*

Various Shadows, *1984*
*Gelatin silver prints*
*61¼ × 49¼"*
*The Capital Group, Inc.*

Spaces Between: Equal Time,
*1985*
*Black-and-white photographs*
*on aluminum panels*
*96 × 144"*
*Margo Leavin Gallery,*
*Los Angeles*

Some Rooms, *1986*
*Black-and-white photographs*
*and gouache*
*96½ × 109½"*
*The Museum of Contemporary*
*Art, Los Angeles*
*Gift of the Eli Broad Family*
*Foundation*

**Robert Barry**

Born 1936 in New York City
Lives in Teaneck, New Jersey

All The Things I Know, *1969*
*Pencil on wall*
*Dimensions variable*
*Collection of the artist*

Refrain, *1975*
*81 35mm slides*
*Dimensions variable*
*Panza Collection*

Somehow, *1982*
*Pencil and paint on wall*
*Dimensions variable*
*Collection of the artist*

All About, *1986*
*Pencil and paint on wall*
*Dimensions variable*
*Collection of the artist*

**Larry Bell**

Born 1939 in Chicago
Lives in Taos, New Mexico

Untitled, *1985*
*Quartz and silicone monoxide*
*on glass*
*cube: 36 × 36 × 36";*
*base: 36 × 36 × 36"*
*The Museum of Contemporary*
*Art, Los Angeles*
*Gift of the artist*

Leaning Room II, *1986*
*Sheet rock, paint, and*
*fluorescent light*
*Installation based on*
Leaning Room, *1970*
*Artist's studio,*
*Venice, California*
*Collection of the artist*
*Commissioned for the exhibition*

## Billy Al Bengston

Born 1934 in Dodge City, Kansas
Lives in Venice, California

The High and the Mighty, *1967*
*Polyurethane and lacquer*
*on aluminum*
*60 × 58"*
*Collection of the artist,*
*Venice, California*

Hangman's House, *1968*
*Lacquer and polyester resin*
*on aluminum*
*26 × 25"*
*Collection of the artist,*
*Venice, California*

Liberty Valance, *1968*
*Lacquer and polyester resin*
*on aluminum*
*27 × 25"*
*Collection of the artist,*
*Venice, California*

Three Faces West, *1968*
*Lacquer and polyester resin*
*on aluminum*
*87 × 77"*
*Collection of the artist,*
*Venice, California*

Dark Command, *1969*
*Lacquer and polyester resin*
*on aluminum*
*36 × 34"*
*Collection of Tony Berlant,*
*Santa Monica, California*

The Star Packer, *1970*
*Lacquer and polyester resin*
*on aluminum*
*23 × 22"*
*Collection of the artist,*
*Venice, California*

## Tony Berlant

Born 1941 in New York City
Lives in Santa Monica, California

The Journey, *1981–85*
*Found metal collage on plywood*
*with brads*
*84 × 141"*
*Xavier Fourcade, Inc., New York*

I, *1982*
*Tin, nails, plywood,*
*and found oil painting*
*70½ × 66¾ × 3¼"*
*The Museum of Contemporary*
*Art, Los Angeles*
*Gift of the Janss Foundation*

Untitled Ending, *1982*
*Tin, nails, plywood,*
*and found oil painting*
*92¾ × 61 × 3"*
*Collection of Robert A. Rowan*

The High Desert, *1984–85*
*Tin, nails, plywood,*
*and found oil painting*
*70 × 70½"*
*Collection of Mr. and Mrs.*
*Robert J. Woods, Jr.*

For Dad, *1985*
*Found metal on plywood*
*with brads*
*78 × 90"*
*Private Collection*
*Courtesy L.A. Louver Gallery,*
*Los Angeles*

## Joseph Beuys

Born 1921 in Krefeld, Germany
Died 1986 in Dusseldorf,
West Germany

Blitzschlag mit Lichtschein auf
Hirsch, *1958–85*
*(Lightning with Stag in its*
*Glare)*
*Bronze and aluminum*
*Environment with 39 parts*
*Anthony d'Offay Gallery,*
*London*

## Louise Bourgeois

Born 1911 in Paris
Lives in New York City

Persistent Antagonism, *1946–48*
*Painted wood*
*67⅞" high*
*Robert Miller Gallery, New York*

The Blind Leading the Blind,
*c. 1947*
*Painted wood*
*67⅛ × 64⅜ × 16¼"*
*Robert Miller Gallery, New York*

Quarantania, *1947, cast 1984*
*Bronze with white patina*
*80½ × 27 × 27"*
*Robert Miller Gallery, New York*

Observer, *1947–49*
*Painted wood*
*76½" high*
*Robert Miller Gallery, New York*

Portrait of C. Y., *1947–49*
*Painted wood*
*66¾" high*
*Robert Miller Gallery, New York*

Portrait of Jean-Louis, *1947–49*
*Painted wood*
*35" high*
*Robert Miller Gallery, New York*

Red Fragmented Figure, *1949*
*Painted wood*
*62½" high*
*Robert Miller Gallery, New York*

Pillar, *1949–50*
*Painted wood*
*64⅜" high*
*Robert Miller Gallery, New York*

Pillar, *1949–50*
*Painted wood*
*69" high*
*Robert Miller Gallery, New York*

## Marcel Broodthaers

Born 1926 in Brussels, Belgium
Died 1976 in Cologne,
West Germany

## Chris Burden

Born 1946 in Boston
Lives in Los Angeles

Sleeping Figure, *1950*
*Balsa wood*
*74½" high*
*Museum of Modern Art,*
*New York*
*Katharine Cornell Fund, 1951*

Memling Dawn, *1951*
*Painted wood*
*67¼" high*
*Robert Miller Gallery, New York*

Deux boules en plâtre peintes
en doré, *1964*
*Two gold-painted plaster bulls*
*2¾" and 2½"*
*Marian Goodman Gallery,*
*New York*

Jambes 1 2, *1964*
*Black-and-white photograph*
*and inscriptions*
*Marian Goodman Gallery,*
*New York*

Poêle de moules, *1965*
*Circle of mussels with wooden*
*and metal handle fixed on wood*
*7¾ × 17¾ × 17¾"*
*Marian Goodman Gallery,*
*New York*

B, *1966*
*Enameled metal bowl, eggshells,*
*and adhesive letter*
*4⅓ × 7⅞"*
*Marian Goodman Gallery,*
*New York*

Brick, *1966*
*Brick*
*7 × 2¾ × 3¼"*
*Marian Goodman Gallery,*
*New York*

Deux tonneaux, *1966*
*Two wooden barrels, metal,*
*painted eggshells, and mussels*
*13 × 9¾" each*
*Marian Goodman Gallery,*
*New York*

Bocal et reproduction (Magritte),
*1967*
*Glass jar, paper, and cotton wool*
*4 × 4"*
*Marian Goodman Gallery,*
*New York*

L'architecte était un chien Blanc,
de caractères, *1967*
*Cardboard tube and*
*printing on paper*
*10⅘ × 2¾"*
*Marian Goodman Gallery,*
*New York*

T plus grand que, *1967–69*
*Printing on paper*
*10¾ × 7¾"*
*Marian Goodman Gallery,*
*New York*

Les frites, *1968*
*Photosensitized canvas*
*Four parts: 8½ × 6¼" each*
*Marian Goodman Gallery,*
*New York*

Vingt ans apres, *1969*
*Book in an edition of 75*
*numbered copies*
*6½ × 4¼"*
*Marian Goodman Gallery,*
*New York*

Oscar-Turpitude, *1973*
*Glass jars and printing*
*on canvas*
*Two units: 10⅖ × 4⅓"; 8⅞ × 5⅓"*
*Marian Goodman Gallery,*
*New York*

Bottle, *1974*
*Glass jar and cotton wool*
*11¾ × 2¾ × 2¾"*
*Marian Goodman Gallery,*
*New York*

Paquet de lettres, *1974*
*Letters printed on canvas*
*7 × 8"*
*Marian Goodman Gallery,*
*New York*

Exposing the Foundation of the
Museum, *1986*
*Excavation of the northeast*
*corner of the Temporary*
*Contemporary*
*Collection of the artist*
*Commissioned for the exhibition*

| **Vija Celmins** | **Francesco Clemente** | **Joseph Cornell** | **Willem de Kooning** |
|---|---|---|---|

Born 1939 in Riga, Latvia
Lives in New York City

Born 1903 in Nyack, New York
Died 1972 in Flushing, New York

Born 1904 in Rotterdam, Holland
Lives in Easthampton, New York

Starfield, *1981–82*
*Graphite on acrylic ground*
*on paper*
*19 × 27"*
*Collection of Mr. and Mrs.*
*Harry W. Anderson*

From China, *1982*
*Graphite on acrylic ground*
*on paper*
*21 × 21"*
*Collection of the artist*

Moving Out (Starfield II), *1982*
*Graphite on acrylic ground*
*on paper*
*21 × 27"*
*Collection of Mr. and Mrs.*
*Robert K. Hoffman,*
*Dallas, Texas*

Holding on to the Surface, *1983*
*Graphite on acrylic ground*
*on paper*
*17 × 15"*
*Collection of David*
*and Renee McKee*

Blue Painting, *1986*
*Oil on linen*
*70 × 72"*
*David McKee Gallery, New York*

Wall, *1986*
*Oil on linen*
*70 × 72"*
*David McKee Gallery, New York*

*February 10–March 29, 1987*
*A survey exhibition organized*
*by the John and Mable Ringling*
*Museum of Art, Sarasota,*
*Florida*

Habitat Group for a Shooting
Gallery, *1943*
*Construction*
*15½ × 11⅛ × 4¼"*
*Des Moines Art Center*
*Coffin Fine Arts Trust Fund*

Hotel de l'Etoile, *c. 1950–54*
*Construction with wood, paper*
*collage, bangle, rod, wire mesh,*
*tempera, and glass*
*16½ × 10½ × 4¾"*
*Frederick R. Weisman Collection*

Untitled *(Grand Hotel de*
*l'Univers), c. 1953–55*
*Construction*
*19 × 12⅝ × 4¾"*
*Collection of June Schuster,*
*Pasadena, California*

Untitled *(Medici Boy), c. 1953*
*Construction*
*18¼ × 11½ × 5½"*
*Fort Worth Art Museum*
*The Benjamin J. Tillar*
*Memorial Trust*

Untitled *(Parrot Habitat), 1953*
*Construction*
*17⅛ × 11⅛ × 5"*
*Collection of Tony Berlant,*
*Santa Monica, California*

Trade Winds #2, *c. 1956–58*
*Construction*
*11 × 16¹³⁄₁₆ × 4¹⁄₁₆"*
*Collection of Edwin Janss*

The Birth of the Nuclear Atom,
*1961*
*Construction*
*9¾ × 15 × 3¾"*
*Private Collection, Los Angeles*

Seated Woman, *1940*
*Oil and charcoal on*
*composition board*
*54 × 36"*
*Philadelphia Museum of Art*
*The Albert M. Greenfield and*
*Elizabeth M. Greenfield*
*Collection*

Pink Lady, *1944*
*Oil and charcoal on*
*composition board*
*48⅜ × 35⅜"*
*Collection of Betty and*
*Stanley K. Sheinbaum*

Pink Angels, *c. 1945*
*Oil on canvas*
*52 × 40"*
*Collection of Frederick Weisman*
*Company*

Zurich, *1947*
*Oil on paper mounted*
*on fiberboard*
*36 × 24⅛"*
*Estate of Joseph H. Hirshhorn*

Black Friday, *1948*
*Oil and enamel on composition*
*board*
*48 × 38"*
*The Art Museum,*
*Princeton University*
*Partial and promised gift of*
*Mr. and Mrs. H. Gates Lloyd*

Gansevoort Street, *1949*
*Oil on cardboard*
*30 × 40"*
*Collection of Mr. and Mrs.*
*Harry W. Anderson*

Sail Cloth, *1949*
*Oil on canvas*
*24 × 30"*
*Collection of Donald and*
*Barbara Jonas*

**Richard Diebenkorn**

Born 1922 in Portland, Oregon
Lives in Santa Monica, California

Ocean Park #14, *1968*
*Oil on canvas*
*93 × 80"*
*Collection of Beatrice and*
*Philip Gersh*

Ocean Park #90, *1976*
*Oil on canvas*
*100 × 81"*
*Collection of Eli and*
*Edythe L. Broad*

Ocean Park #107, *1978*
*Oil on canvas*
*93 × 76"*
*The Oakland Museum*
*Gift of the Women's Board*

Ocean Park #136, *1985*
*Oil on canvas*
*58 × 58"*
*Collection of the artist*

Ocean Park #140, *1985*
*Oil on canvas*
*100 × 81"*
*Collection of Douglas S. Cramer*

**Mark di Suvero**

Born 1933 in Shanghai, China
Lives in Petaluma, California

Pre-Natal Memories, *1976–80*
*Cor-ten steel*
*264 × 482 × 110½"*
*The Museum of Contemporary*
*Art, Los Angeles*
*Gift of Robert A. Rowan*

**John Duff**

Born 1943 in Lafayette, Indiana
Lives in New York City

Kachina, *1983*
*Fiberglass resin, paint,*
*and plywood*
*59½ × 18 × 22¾"*
*Oliver-Hoffmann Family*
*Collection*

Wall Piece Red Lead, *1983*
*Fiberglass*
*72 × 9 × 30"*
*Collection of Alan and*
*Wendy Hart*

White Oracle, *1983*
*Painted fiberglass*
*71½ × 12¼ × 14½"*
*Collection of Councilman*
*Joel Wachs, Los Angeles*

Double Tongue, *1985*
*Fiberglass and enamel paint*
*61 × 28 × 12"*
*Collection of Roger I. Davidson*

Point Break, *1985*
*Fiberglass and enamel paint*
*67 × 16 × 13½"*
*Blum Helman Gallery, New York*

Red Devil Pink, *1985*
*Fiberglass and enamel paint*
*44 × 10½ × 10¼"*
*Blum Helman Gallery, New York*

**Eric Fischl**

Born 1948 in New York City
Lives in New York City

Bad Boy, *1981*
*Oil on canvas*
*66 × 96"*
*Saatchi Collection, London*

The Old Man's Boat and the Old
Man's Dog, *1982*
*Oil on canvas*
*84 × 84"*
*Saatchi Collection, London*

Master Bedroom, *1983*
*Oil on canvas*
*84 × 108"*
*The Museum of Contemporary*
*Art, Los Angeles:*
*The Barry Lowen Collection*

Savior Mother, Save Your
Love(r), *1984*
*Oil on canvas*
*78 × 108"*
*Menil Foundation Collection,*
*Houston, Texas*

**Dan Flavin**

Born 1933 in New York City
Lives in Wainscott, New York

the diagonal of May 25, 1963
(to Constantin Brancusi), *1963*
*Yellow fluorescent light*
*96 × 3¾"*
*Collection of the artist*
*Courtesy Leo Castelli Gallery,*
*New York*

the nominal three
(to William of Ockham), *1963*
*Daylight fluorescent light*
*Six units: 96" high*
*Panza Collection*

pink out of a corner
(to Jasper Johns), *1963*
*Pink fluorescent light*
*96 × 3¾"*
*Collection of the artist*
*Courtesy Leo Castelli Gallery,*
*New York*

a leaning diagonal (in memory
of David Smith), *1965*
*Cool white fluorescent light*
*96" long*
*Collection of the artist*
*Courtesy Leo Castelli Gallery,*
*New York*

untitled (to the "innovator"
of Wheeling Peachblow), *1968*
*Daylight, pink, and yellow*
*fluorescent light*
*96" high*
*Collection of the artist*
*Courtesy Leo Castelli Gallery,*
*New York*

"monument" for V. Tatlin, *1969*
*Cool white fluorescent light*
*96 × 32"*
*Collection of Lenore S. and*
*Bernard A. Greenberg*

**Richard Fleischner**

Born 1944 in New York City
Lives in Rumford, Rhode Island

Project for The Museum of
Contemporary Art, Los Angeles,
1986
*Modular block constructions*
*with inlay*
*11 × 20 × 20'*
*Collection of the artist*
*Commissioned for the exhibition*

**Sam Francis**

Born 1923 in San Mateo,
California
Lives in Santa Monica, California

White #4, *1950–51*
*Oil on canvas*
*69 × 59"*
*Collection of Eli and*
*Edythe L. Broad*

Grey, *1951*
*Oil on canvas*
*90⅛ × 68⅞"*
*Collection of the artist*

White, *1951*
*Oil on canvas*
*56 × 40½"*
*Frederick R. Weisman Collection*

Grey, *1954*
*Oil on canvas*
*119¼ × 76½"*
*Private Collection, Los Angeles*

**Helen Frankenthaler**

Born 1928 in New York City
Lives in New York City

Europa, *1957*
*Oil on canvas*
*70½ × 54¼"*
*Private Collection*

Jacob's Ladder, *1957*
*Oil on canvas*
*113⅜ × 69⅞"*
*Museum of Modern Art,*
*New York*
*Gift of Hyman N. Glickstein,*
*1960*

Before the Caves, *1958*
*Oil on canvas*
*102⅜ × 104½"*
*University Art Museum*
*University of California,*
*Berkeley*
*Anonymous Gift*

Mother Goose Melody, *1959*
*Oil on canvas*
*82 × 104"*
*Virginia Museum of Fine Arts*
*Gift of Sydney and*
*Frances Lewis*

## Charles Garabedian

Born 1923 in Detroit, Michigan
Lives in Santa Monica, California

Ruin V, *1981*
*Acrylic on canvas*
*72 × 72"*
*The Museum of Contemporary*
*Art, Los Angeles*
*Gift of Robert A. Rowan*

Island #1, *1982*
*Acrylic on canvas*
*72 × 96"*
*Collection of Michael Krichman*
*and Leslie Simon*

Island #2, *1982*
*Acrylic on canvas*
*72 × 96"*
*Private Collection*
*Courtesy Hirschl & Adler*
*Modern, New York*

Mutants in Landscape, *1983–84*
*Acrylic on canvas*
*60 × 48"*
*Collection of H. D. Vrem*

Mutants Playing, *1983–84*
*Acrylic on panel*
*48 × 60"*
*The Capital Group, Inc.*

## Robert Graham

Born 1938 in Mexico City
Lives in Venice, California

Stephanie, *1980*
*Cast bronze with gold leaf*
*69½ × 11½ × 7½"*
*The Museum of Contemporary*
*Art, Los Angeles*
*Gift of the Stark Fund of the*
*California Community*
*Foundation*

Spy, *1981*
*Cast bronze*
*47¼ × 55 × 14"*
*Collection of Roy and*
*Carol Doumani*

Fragments

Untitled, *1978*
*Cast bronze with oil paint*
*24 × 6 × 6"*
*Collection of the artist*

Untitled, *1978*
*Cast bronze with oil paint*
*13¾ × 7 × 7"*
*Collection of the artist*

Untitled, *1978*
*Cast bronze with oil paint*
*27½ × 6½ × 6"*
*Collection of Steven Graham*

Untitled, *1983–84*
*Porcelain*
*11½ × 7¾ × 7¾"*
*Collection of the artist*

Untitled, *1985*
*Cast bronze with gold plating*
*34 × 12 × 12"*
*Collection of the artist*

Untitled, *1985*
*Cast bronze with silver plating*
*40½ × 9½ × 9½"*
*Collection of Joan and*
*Jack Quinn*

Untitled, *1985*
*Cast bronze with gold leaf*
*6½ × 4½ × 25½"*
*Collection of Steven and*
*Kitty Moses*

Untitled, *1985*
*Cast bronze*
*38½ × 11½ × 12"*
*Collection of the artist*

Untitled, *1985*
*Cast bronze*
*34½ × 12 × 12"*
*Collection of Nick*
*and Felisa Vanoff*

Untitled, *1985*
*Cast bronze with silver plating*
*36½ × 12 × 12"*
*Collection of Earl McGrath,*
*New York*

Untitled, *1985*
*Cast bronze with silver plating*
*24¾ × 7½ × 7½"*
*Collection of the artist*

Untitled, *1985*
*Cast bronze with rodium plating*
*36½ × 12 × 12"*
*Collection of the artist*

Untitled, *1985*
*Cast bronze*
*46 × 9½ × 10½"*
*Collection of the artist*

## Michael Heizer

Born 1944 in Berkeley, California
Lives in New York City

Double Negative, *1969–70*
*240,000 ton displacement in*
*rhyolite and sandstone*
*1,500 × 50 × 30'*
*Morman Mesa, Overton, Nevada*
*The Museum of Contemporary*
*Art, Los Angeles*
*Gift of Virginia Dwan*

## George Herms

Born 1935 in Woodland,
California
Lives in Venice, California

All I Wanna Do Is Swing n' Nail,
*1960*
*Assemblage*
*31½ × 18½ × 10"*
*University Art Museum*
*University of California,*
*Berkeley*
*Gift of Alfred Childs, Berkeley*

The Poet, *1960*
*Wood, stack of pages tied with*
*string, rusted klaxon, and wire*
*27 × 27 × 27"*
*Collection of Arthur J.*
*Neumann, M. D., San Francisco*

Qabalah of the Elements, *1960*
*Assemblage*
*8 × 11 × 2"*
*Collection of Paul*
*Cornwall-Jones*

Scorpio, *1965*
*Assemblage*
*23 × 29 × 6"*
*Collection of the Grinstein*
*Family, Los Angeles*

Secret Archives, *1974*
*Assemblage*
*66 × 69 × 18"*
*Collection of the artist*
*Courtesy L.A. Louver Gallery,*
*Venice, California*

## Eva Hesse

Born 1936 in Hamburg, Germany
Died 1970 in New York City

Hang-Up, *1966*
*Acrylic on cloth over wood*
*and steel*
*72 × 84 × 78"*
*Collection of Mr. and Mrs.*
*Victor W. Ganz*

Unfinished, Untitled, or Not Yet,
*1966*
*Nine dyed net bags with weights*
*and clear polyethylene*
*72 × 24 × 14"*
*Collection of Mr. and Mrs.*
*Victor W. Ganz*

Addendum, *1967*
*Painted papier-maché, wood,*
*and rubber tubing*
*5 × 119 × 6"; cords: 84½"*
*The Trustees of the Tate Gallery,*
*London*

Repetition 19, III, *1968*
*Nineteen tubular fiberglass units*
*19 to 20¼" high × 11 to 12¾"*
*in diameter*
*Museum of Modern Art,*
*New York*
*Gift of Charles and Anita Blatt,*
*1969*

Vinculum I, *1969*
*Fiberglass, rubber tubing,*
*and metal screen*
*Two parts: 104 × 8½" each;*
*104 × 24" overall*
*Collection of Mr. and Mrs.*
*Victor W. Ganz*

## Rebecca Horn

Born 1944 in Michelstadt,
Germany
Lives in Bad Konig-Zeil,
West Germany

*Commission for the exhibition*

## Robert Irwin

Born 1928 in Long Beach,
California
Lives in Las Vegas, Nevada

Central Avenue Meridian, *1986*
*Phyllostachys viridis cultivar*
*"Robert Young" (McClure)*
*bamboo; aqua Kolorgaard*
*⅝" aperture, plastic-coated*
*fencing; stainless steel poles,*
*fittings, and turnbuckles; and*
*Mee II cloud-fog system*
*184 × 6'*
*Collection of the artist*
*Commissioned for the exhibition*

## Jasper Johns

Born 1930 in Augusta, Georgia
Lives in New York City

Corpse and Mirror, *1974*
*Oil, encaustic, and collage*
*on canvas*
*50 × 68⅛"*
*Collection of Mr. and Mrs.*
*Victor W. Ganz*

Dancers on a Plane, *1979*
*Oil on canvas with objects*
*77⅞ × 64"*
*Collection of the artist*

Tantric Detail I, *1980*
*Oil on canvas*
*50⅛ × 34⅛"*
*Collection of the artist*

Tantric Detail II, *1981*
*Oil on canvas*
*50 × 34"*
*Collection of the artist*

Tantric Detail III, *1981*
*Oil on canvas*
*50 × 34"*
*Collection of the artist*

## Donald Judd

Born 1928 in Excelsior Springs,
Missouri
Lives in New York City

Untitled, *1982*
*Brushed aluminum with*
*bronze Plexiglas*
*Four units:*
*39⅜ × 39⅜ × 9⅞" each*
*Oliver-Hoffmann Family*
*Collection*

Untitled, *1983*
*¾" Douglas fir plywood*
*Four units:*
*39⅜ × 39⅜ × 19¾" each*
*Collection of Lauretta Vinciarelli*

Untitled, *1984*
*½" milled aluminum*
*39⅜ × 39⅜ × 13⅛"*
*Leo Castelli Gallery, New York*

Untitled, *1986*
*¾" Douglas fir plywood and*
*orange Plexiglas*
*Six units:*
*39⅜ × 39⅜ × 29⅝" each*
*Paula Cooper Gallery, New York*

## Mike Kelley

Born 1954 in Detroit, Michigan
Lives in Los Angeles

*Works from* Monkey Island,
*1981–83*

Insect Face, *1981–82*
*Acrylic on sheetmetal and wood*
*17 × 27½"*
*Collection of the artist*
*Courtesy Metro Pictures,*
*New York*

Monkey's Ass, *1981–82*
*Acrylic on sheetmetal and wood*
*17 × 27½"*
*Collection of the artist*
*Courtesy Metro Pictures,*
*New York*

Two Islands, *1981–82*
*Acrylic on sheetmetal and wood*
*17 × 27½"*
*The Lannan Foundation*

Cell Dividing, *1982*
*Acrylic on sheetmetal and wood*
*17 × 27½"*
*Collection of the artist*
*Courtesy Metro Pictures,*
*New York*

Landscape, *1982*
*Acrylic on sheetmetal and wood*
*Two parts: 17 × 27"; 27 × 17"*
*Collection of the artist*
*Courtesy Metro Pictures,*
*New York*

The Bells, *1982–83*
*Acrylic on paper*
*23½ × 77½"*
*Courtesy of the artist and*
*Rosamund Felsen Gallery,*
*Los Angeles*

Bladder, *1982–83*
*Latex and cloth with acrylic,*
*cord, and painted wood bracket*
*70 × 19 × 36"*
*Courtesy of the artist and*
*Rosamund Felsen Gallery,*
*Los Angeles*

The Bug-Eye, *1982–83*
*Acrylic on paper*
*13⅛ × 53⅛"*
*Courtesy of the artist and*
*Rosamund Felsen Gallery,*
*Los Angeles*

Canto 31 of The Divine Comedy/
Paradise, *1982–83*
*Acrylic on paper*
*Two parts: 60 × 36½"; 60 × 41"*
*Collection of Edward and*
*Melinda Wortz*

Choreographic Figure, *1982–83*
*Acrylic on foam core*
*Eight parts: 30⅛ × 20" each*
*Courtesy of the artist and*
*Rosamund Felsen Gallery,*
*Los Angeles*

Creationism, *1982–83*
*Acrylic on poster board*
*Four parts: 38 × 25" each*
*Courtesy of the artist and*
*Rosamund Felsen Gallery,*
*Los Angeles*

Expansions, *1982–83*
*Acrylic on brown paper*
*Two parts: 86 × 87";*
*15¼ × 14¾ × 5" folded*
*Courtesy of the artist and*
*Rosamund Felsen Gallery,*
*Los Angeles*

Fabric, *1982–83*
*Acrylic on paper*
*54½ × 48"*
*Collection of Jeffrey Kerns,*
*Los Angeles*

Fallopian Tube, *1982–83*
*Wood, acrylic, and wire*
*47 × 42 × 30"*
*Courtesy of the artist and*
*Rosamund Felsen Gallery,*
*Los Angeles*

The Farmer's Daughter, *1982–83*
*Acrylic on foam core*
*Two parts: 35⅞ × 17"; 40 × 17⅛"*
*Courtesy of the artist and*
*Rosamund Felsen Gallery,*
*Los Angeles*

Giant Insect, *1982–83*
*Acrylic on paper*
*94 × 103¾"*
*Courtesy of the artist and*
*Rosamund Felsen Gallery,*
*Los Angeles*

Infinite Multiplication, *1982–83*
*Acrylic on foam core*
*Four parts: 43⅛ × 40" each*
*Courtesy of the artist and*
*Rosamund Felsen Gallery,*
*Los Angeles*

The Intestinal Garland, *1982–83*
*Cloth with acrylic*
*72 × 153"*
*Courtesy of the artist and*
*Rosamund Felsen Gallery,*
*Los Angeles*

King of the Mountain, *1982–83*
*Acrylic on paper*
*47⅜ × 37⅜"*
*Courtesy of the artist and*
*Rosamund Felsen Gallery,*
*Los Angeles*

The Poor Farm Wet and Dry,
*1982–83*
*Acrylic on paper*
*36 × 52½"*
*Collection of Janet Ray,*
*Pasadena, California*

Shock, *1982–83*
*Three panels: acrylic and*
*Mercurochrome on paper*
*47¾ × 37½" each*
*One panel: acrylic on paper*
*24 × 19"*
*Courtesy of the artist and*
*Rosamund Felsen Gallery,*
*Los Angeles*

Symmetrical Sets:
Two Hemispheres, Red Reefs,
Splitting Cell, Compound Eye,
Two Mounds, Two Tents, Ass
Insect, Two Buttocks, *1982–83*
*Acrylic on paper*
*18 × 24" each*
*Courtesy of the artist and*
*Rosamund Felsen Gallery,*
*Los Angeles*

The Tiny Insect Magnified
Becomes Its Own Farm, *1982–83*
*Acrylic on paper*
*56 × 42⅛"*
*Courtesy of the artist and*
*Rosamund Felsen Gallery,*
*Los Angeles*

Travelogue:
Spurting Whale, Singing Root,
They Mount The Island, The
Green Black Green Flag, The
Celibate Genius, The Baggy
Pants Comedian, Stand-Up or
Sick Monkey, The Two Islands
Merge To Form a Boat, *1982–83*
*Acrylic on paper*
*24¼ × 19¼" each*
*Collection of Robert A. Rowan*

Two Alchemical Drawings,
*1982–83*
Sea Monkeys
*Sea monkeys on rice paper*
*25 × 19½"*
Mandrake Root
*Sperm on rice paper*
*25 × 19½"*
*Collection of Barry Sloane,*
*Los Angeles*

Two Sirens, *1982–83*
*Acrylic on paper*
*23½ × 52"*
*Collection of Nora Halpern,*
*Los Angeles*

Yellow Piece, *1966*
*Acrylic on canvas*
*75 × 75"*
*Private Collection*

Diagonal with Curve I, *1978*
*Oil on canvas*
*109 × 105"*
*Private Collection*

Dark Blue Panel, *1980*
*Oil on canvas*
*103½ × 146"*
*Collection of Stephen*
*and Nan Swid*

Dark Green Panel, *1980*
*Oil on canvas*
*101 × 101½"*
*Private Collection*

Orange Panel, *1980*
*Oil on canvas*
*114 × 92½"*
*Private Collection*

Red/Orange, *1980*
*Oil on canvas*
*91 × 113"*
*The Museum of Contemporary*
*Art, Los Angeles*
*Gift of Douglas S. Cramer*

Dark Purple Curve, *1982*
*Oil on canvas*
*72 × 131¼"*
*Private Collection*

Green Curve, *1986*
*Oil on canvas*
*51¾ × 180½"*
*Collection of the artist*
*Courtesy Blum Helman Gallery,*
*New York*

**Anselm Kiefer**

Born 1945 in Donaueschingen,
Germany
Lives in Walldurn-Hornbach,
West Germany

**Edward Kienholz**

Born 1927 in Fairfield,
Washington
Lives in Hope, Idaho

**Nancy Reddin Kienholz**

Born 1944 in Los Angeles
Lives in Hope, Idaho

**Yves Klein**

Born 1928 in Nice, France
Died 1962 in Paris

**Franz Kline**

Born 1910 in Wilkes Barre,
Pennsylvania
Died 1962 in New York City

Sea Lion, *1976*
*Oil on linen*
*82 × 120"*
*Collection of Norman*
*and Irma Braman*

To the Unknown Painter, *1983*
*Straw, emulsion, shellac, latex,*
*oil, and acrylic on linen*
*81¾ × 149¾"*
*Private Collection, Germany*

Departure from Egypt, *1984*
*Straw, lacquer, and oil on*
*canvas with lead rod attached*
*149½ × 221"*
*The Museum of Contemporary*
*Art, Los Angeles*
*Purchased with funds provided*
*by Douglas S. Cramer, Beatrice*
*and Philip Gersh, Lenore S. and*
*Bernard A. Greenberg, Joan*
*and Fred Nicholas, Robert A.*
*Rowan, Pippa Scott, and an*
*anonymous donor*

Seraphim, *1984*
*Emulsion, shellac, oil, and*
*acrylic on canvas*
*110¼ × 110¼"*
*Collection of the artist*

Sollie 17, *1979–80*
*Mixed media environment*
*120 × 336 × 168"*
*Private Collection*
*Courtesy L.A. Louver, Venice,*
*California*

Drawing for Sollie 17, *1980*
*Assemblage*
*94 × 48 × 82½"*
*Private Collection*
*Courtesy L.A. Louver Gallery,*
*Venice, California*

M38 (*Untitled Red*
*Monochrome*), 1955
*Dry pigment in synthetic resin*
*on fabric on board*
*19¹¹⁄₁₆ × 19¹¹⁄₁₆ × 2"*
*Private Collection*

M35 (*Untitled Green*
*Monochrome*), 1957
*Dry pigment in synthetic resin*
*on fabric on board*
*15¾ × 23⅝ × 1⅜"*
*Private Collection*

M84 (*Untitled Yellow*
*Monochrome*), 1958
*Dry pigment in synthetic resin*
*on fabric on board*
*50 × 50"*
*Private Collection*

ANT85, *1960*
*Blue acrylic pigment on paper*
*on canvas*
*61¼ × 138¾"*
*Private Collection*

MG10 "Le Silence est d'Or"
(*Gold Monochrome*), 1960
*Gold leaf on primed board*
*58½ × 44⅞ × ⅝"*
*Private Collection*

SE33, *1960*
*Dry pigment in synthetic resin*
*on sponge*
*17" high*
*Private Collection*

IKB66 (*Blue Monochrome*), 1966
*Dry pigment in synthetic resin*
*on fabric on board*
*79 × 148"*
*Private Collection*

Tower, *1953*
*Oil on canvas*
*81 × 52"*
*The Museum of Contemporary*
*Art, Los Angeles:*
*The Panza Collection*

Buttress, *1956*
*Oil on canvas*
*46½ × 55½"*
*The Museum of Contemporary*
*Art, Los Angeles:*
*The Panza Collection*

Monitor, *1956*
*Oil on canvas*
*78¾ × 115¾"*
*The Museum of Contemporary*
*Art, Los Angeles:*
*The Panza Collection*

Hazelton, *1957*
*Oil on canvas*
*41¼ × 78"*
*The Museum of Contemporary*
*Art, Los Angeles:*
*The Panza Collection*

Line Through White Oblong, *1959*
*Oil on canvas*
*60¼ × 81"*
*The Museum of Contemporary*
*Art, Los Angeles:*
*The Panza Collection*

Orleans, *1959*
*Oil on canvas*
*101 × 76"*
*The Museum of Contemporary*
*Art, Los Angeles:*
*The Panza Collection*

Sabro II, *1959–60*
*Oil on canvas*
*62 × 79"*
*The Museum of Contemporary*
*Art, Los Angeles:*
*The Panza Collection*

**Jannis Kounellis**

Born 1936 in Piraeus, Greece
Lives in Rome

**Lee Krasner**

Born 1908 in Brooklyn, New York
Died 1984 in New York City

**Mark Lere**

Born 1950 in La Moure,
North Dakota
Lives in Los Angeles

Black Iris, *1961*
*Oil on canvas*
*108¼ × 79½"*
*The Museum of Contemporary*
*Art, Los Angeles:*
*The Panza Collection*

Untitled, *1986*
*Four steel panels with lead sheets*
*slashed and filled with lead and*
*one steel panel with baked red*
*enamel*
*81½ × 74⅘" each*
*Collection of the artist, Rome*
*Courtesy Galleria Christian*
*Stein, Turin/Milan*

The Gate, *1959–60*
*Oil on canvas*
*92¾ × 144½"*
*Robert Miller Gallery, New York*

Polar Stampede, *1960*
*Oil on cotton duck*
*93⅝ × 159¾"*
*Robert Miller Gallery, New York*

Primeval Resurgence, *1961*
*Oil on cotton duck*
*77 × 57¼"*
*Collection of Gordon F. Hampton*

Another Storm, *1963*
*Oil on cotton duck*
*93⅝ × 175⅝"*
*Robert Miller Gallery, New York*

Block Head, *1986*
*Bronze*
*64 × 42 × 24"*
*Margo Leavin Gallery,*
*Los Angeles*

Standard, *1986*
*Aluminum*
*204 × 30 × 15"*
*Margo Leavin Gallery,*
*Los Angeles*

Strut, *1986*
*Bronze*
*84 × 96 × 48"*
*The Museum of Contemporary*
*Art, Los Angeles*
*Gift of the Pasadena Art*
*Alliance*

**Sol LeWitt**

Born 1928 in Hartford,
Connecticut
Lives in Spoleto, Italy

Wall Drawing, *1986*
*Red, yellow, blue, and grey*
*ink washes*
*12 × 12 × 12'*
*Collection of Eva LeWitt*
*Commissioned for the exhibition*

**Roy Lichtenstein**

Born 1923 in New York City
Lives in Southampton, New York

Washing Machine, *1961*
*Oil on canvas*
*56½ × 68½"*
*Richard Brown Baker Collection*

Cézanne, *1962*
*Acrylic on canvas*
*70 × 48½"*
*The Museum of Contemporary*
*Art, Los Angeles:*
*The Panza Collection*

Desk Calendar, *1962*
*Acrylic on canvas*
*48½ × 68"*
*The Museum of Contemporary*
*Art, Los Angeles:*
*The Panza Collection*

Eddie Diptych, *1962*
*Oil on canvas*
*Two panels: 44 × 52" overall*
*Collection of Ileana and*
*Michael Sonnabend, New York*

Golf Ball, *1962*
*Oil on canvas*
*32 × 34"*
*Collection of Pauli Hirsh*

Meat, *1962*
*Acrylic on canvas*
*21¼ × 25¼"*
*The Museum of Contemporary*
*Art, Los Angeles:*
*The Panza Collection*

Strong Hand (The Grip), *1962*
*Acrylic on canvas*
*30 × 30¼"*
*The Museum of Contemporary*
*Art, Los Angeles:*
*The Panza Collection*

**Morris Louis**

Born 1912 in Baltimore,
Maryland
Died 1962 in Washington, D. C.

Spark, *1958*
*Acrylic on canvas*
*91 × 144"*
*Collection of Mr. and Mrs.*
*Robert J. Woods, Jr.*

Untitled A, *1960*
*Acrylic on canvas*
*104 × 121"*
*Collection of Mr. and Mrs.*
*Robert J. Woods, Jr.*

Alpha Iota, *1961*
*Acrylic on canvas*
*104½ × 144"*
*Collection of Robert A. Rowan*

Nu, *1961*
*Acrylic on canvas*
*103½ × 170"*
*Collection of Robert A. Rowan*

**Brice Marden**

Born 1938 in Bronxville,
New York
Lives in New York City

Fass, *1969–73*
*Oil and beeswax on canvas*
*53½ × 70½"*
*The Museum of Contemporary*
*Art, Los Angeles:*
*The Barry Lowen Collection*

First Figure (Homage to
Courbet), *1973–74*
*Oil and wax on canvas*
*75 × 30"*
*Collection of the artist*
*Courtesy Mary Boone Gallery,*
*New York*

Red, Yellow, Blue II, *1974*
*Oil and wax on canvas*
*74 × 72"*
*The Museum of Contemporary*
*Art, Los Angeles:*
*The Barry Lowen Collection*

Frieze, *1979*
*Oil and beeswax on canvas*
*30 × 120"*
*The Museum of Contemporary*
*Art, Los Angeles:*
*The Barry Lowen Collection*

**Agnes Martin**

Born 1912 in Maklin,
Saskatchewan, Canada
Lives in New York City

**Ed Moses**

Born 1926 in Long Beach,
California
Lives in Venice, California

**Matt Mullican**

Born 1951 in Santa Monica,
California
Lives in New York City

**Elizabeth Murray**

*Adventure, 1967*
*Gesso, acrylic, and graphite*
*on canvas*
*72 × 72"*
*The Pace Gallery, New York*

*Untitled #0, 1975*
*Acrylic, pencil, and gesso*
*on canvas*
*72 × 72"*
*The Pace Gallery, New York*

*Untitled #2, 1977*
*India ink, graphite, and gesso*
*on canvas*
*72 × 72"*
*The Museum of Contemporary*
*Art, Los Angeles:*
*The Barry Lowen Collection*

*Untitled #4, 1980*
*Gesso, acrylic, and graphite*
*on linen*
*72 × 72"*
*The Museum of Contemporary*
*Art, Los Angeles*
*Gift of the American Art*
*Foundation*

*Untitled #12, 1984*
*Acrylic and pencil on paper*
*72 × 72"*
*The Pace Gallery, New York*

*Untitled, 1985*
*Oil and acrylic on canvas*
*78 × 68"*
*Collection of David H. Vena*

*Untitled, 1985*
*Oil and acrylic on canvas*
*78 × 68"*
*Collection of Laura-Lee W. Woods*

*Untitled, 1986*
*Oil and acrylic on canvas*
*78 × 68"*
*The Museum of Contemporary*
*Art, Los Angeles*
*Gift of the Friends of*
*Nancy Yewell*

*Untitled, 1986*
*Oil and acrylic on canvas*
*78 × 68"*
*L.A. Louver Gallery,*
*Venice, California*

*Untitled, 1986*
*Oil and acrylic on canvas*
*78 × 68"*
*L.A. Louver Gallery,*
*Venice, California*

*Untitled, 1986*
*(Heaven, God, Choosing*
*Parents, Life, Fate, Demon and*
*Angel, Death, Hell)*
*Eight banners of cotton*
*appliquéd nylon*
*20 × 20' each*
*Collection of the artist*
*Commissioned for the exhibition*

*July 28–September 20, 1987*
*A survey exhibition organized*
*by the Dallas Museum of*
*Art, Dallas, Texas,*
*and the Massachusetts Institute*
*of Technology, Boston,*
*Massachusetts*

## Bruce Nauman

Born 1941 in Fort Wayne, Indiana
Lives in Pecos, New Mexico

Collection of Various Flexible
Materials Separated by Layers of
Grease with Holes the Size of My
Waist and Wrists, *1966*
*Aluminum foil, plastic sheet,*
*foam rubber, felt, and grease*
*1½ × 90 × 18"*
*Saatchi Collection, London*

Neon Templates of the Left Half
of My Body Taken at Ten Inch
Intervals, *1966*
*Neon tubing*
*70 × 9 × 6"*
*Exhibition piece courtesy of*
*the artist and Philip Johnson*

Untitled Eye-Level Piece, *1966*
*Varnished cardboard with paint*
*7 × 4¼ × 19¾"*
*Private Collection*

Device for a Left Armpit, *1967*
*Copper painted plaster*
*14 × 7 × 10"*
*Panza Collection*

Six Inches of My Knee Extended
to Six Feet, *1967*
*Fiberglass*
*70 × 6 × 4"*
*Collection of Robert A. M. Stern*

Kassel Corridor Elliptical Space,
*1977*
*Two curved wood and*
*wallboard walls*
*Outer wall: 12 × 47';*
*inner wall: 12 × 46½'*
*27" apart at center tapering to*
*approximately 4" at either end*
*Panza Collection*

## Louise Nevelson

Born 1899 in Kiev, Russia
Lives in New York City

Sky Cathedral Presence,
*1951–64*
*Black painted wood*
*117 × 174 × 29"*
*Walker Art Center, Minneapolis*
*Gift of Mr. and Mrs. Kenneth N.*
*Dayton, 1969*

Night Landscape, *1955*
*Painted wood*
*35½ × 38½ × 15"*
*The Museum of Contemporary*
*Art, Los Angeles*
*Gift of Mr. and Mrs.*
*Arnold Glimcher*

Moon Fountain, *1957*
*Black painted wood*
*43 × 36½ × 34"*
*The Museum of Contemporary*
*Art, Los Angeles*
*Gift of Mr. and Mrs.*
*Arnold Glimcher*

Sky Cathedral: Southern
Mountain, *1959*
*Black painted wood*
*114 × 124 × 16"*
*The Museum of Contemporary*
*Art, Los Angeles*
*Gift of the artist*

## Barnett Newman

Born 1905 in New York City
Died 1970 in New York City

Onement I, *1948*
*Oil on canvas*
*27 × 16"*
*Collection of Annalee Newman*

Onement IV, *1949*
*Oil and casein on canvas*
*33 × 38"*
*Allen Memorial Art Museum*
*Oberlin College*
*Anonymous Gift 69.35*

Onement V, *1952*
*Oil on canvas*
*60 × 38"*
*Collection of Annalee Newman*

Onement VI, *1953*
*Oil on canvas*
*102 × 120"*
*Weisman Family Collection—*
*Richard L. Weisman*

The Three, *1962*
*Oil on canvas*
*76 × 72"*
*Collection of Mr. and Mrs.*
*Bagley Wright*

## Isamu Noguchi

Born 1904 in Los Angeles
Lives in Long Island City,
New York

The Cry, *1959*
*Balsa wood on steel base*
*84 × 30 × 18"*
*Solomon R. Guggenheim*
*Museum, New York*

Mortality, *1959*
*Bronze*
*74 × 20 × 18"*
*Walker Art Center, Minneapolis*
*Gift of the T. B. Walker*
*Foundation, 1964*

Lunar, *1959–60*
*Anodyzed aluminum with wood*
*base*
*74 × 22½ × 11¾"*
*Solomon R. Guggenheim*
*Museum, New York*

Soliloquy, *1962*
*Bronze*
*89½ × 8 × 5½"*
*Arnold Herstand & Company,*
*Inc., New York*

Solitude, *1962*
*Bronze*
*73¾ × 11¾ × 11¾"*
*Arnold Herstand & Company,*
*Inc., New York*

## Claes Oldenburg

Born 1929 in Stockholm, Sweden
Lives in New York City

*Works shown as "The Store" in "Environments, Situations, Spaces," a group exhibition at the Martha Jackson Gallery, 1961*

Blue and Pink Panties, *1961*
*Plaster-soaked muslin over wire frame, painted with enamel*
*62¼ × 34¾ × 6"*
*The Museum of Contemporary Art, Los Angeles:*
*The Panza Collection*

Bride Mannikin, *1961*
*Plaster-soaked muslin over wire frame, painted with enamel*
*61 × 37½ × 35½"*
*The Museum of Contemporary Art, Los Angeles:*
*The Panza Collection*

Bunting, *1961*
*Plaster-soaked muslin over wire frame, painted with enamel*
*22 × 33⅞ × 4⅜"*
*Collection of the artist*

Cigarette in Pack Fragment, *1961*
*Plaster-soaked muslin over wire frame, painted with enamel*
*32¾ × 30¾ × 6¾"*
*The Museum of Contemporary Art, Los Angeles:*
*The Panza Collection*

Chocolates in Box *(Fragment), 1961*
*Plaster-soaked muslin over wire frame, painted with enamel*
*44 × 32 × 6"*
*The Museum of Contemporary Art, Los Angeles:*
*The Panza Collection*

Green Stockings, *1961*
*Plaster-soaked muslin over wire frame, painted with enamel*
*43¼ × 18"*
*The Museum of Contemporary Art, Los Angeles:*
*The Panza Collection*

Man's Shoe, *1961*
*Plaster-soaked muslin over wire frame, painted with enamel*
*23½ × 43¼"*
*The Museum of Contemporary Art, Los Angeles:*
*The Panza Collection*

Mu-Mu, *1961*
*Plaster-soaked muslin over wire frame, painted with enamel*
*63½ × 41¼ × 4"*
*The Museum of Contemporary Art, Los Angeles:*
*The Panza Collection*

Pepsi-Cola Sign, *1961*
*Plaster-soaked muslin over wire frame, painted with enamel*
*58¼ × 46½ × 7½"*
*The Museum of Contemporary Art, Los Angeles:*
*The Panza Collection*

Store Cross, *1961*
*Plaster-soaked muslin over wire frame, painted with enamel*
*52¾ × 40½ × 6"*
*The Museum of Contemporary Art, Los Angeles:*
*The Panza Collection*

*Works shown in "The Store," 107 East 2nd Street, New York December 1961–January 1962*

Black Ladies' Shoe, *1961*
*Plaster-soaked muslin over wire frame, painted with enamel*
*5⅛ × 10⅝ × 3"*
*Collection of William J. Hokin*

Calendar, *1961*
*Painted plaster*
*21 × 14"*
*Collection of William J. Hokin*

Candy Counter with Candy, *1961*
*Enamel paint on plaster in a painted sheet steel and wood case*
*11½ × 34¾ × 21¾"*
*Collection of William J. Hokin*

Cherry Pastry, *1961*
*Plaster-soaked muslin over wire frame, painted with enamel*
*2½ × 2 × 5½"*
*Collection of Mr. Robert H. Halff*

Cigarette Pack, *1961*
*Plaster and enamel on wood base*
*5 × 3 × 1"*
*Collection of William J. Hokin*

Decimal Point of 9.99, *1961*
*Plaster-soaked muslin over wire frame, painted with enamel*
*6¼"*
*Collection of the artist*

Half Cheese Cake, *1961*
*Plaster-soaked muslin over wire frame, painted with enamel*
*10 × 32 × 16"*
*Collection of the artist*

Ice Cream Cone and Heel, *1961*
*Plaster-soaked muslin over wire frame, painted with enamel*
*22½ × 22½"*
*Collection of Margo H. Leavin*

Match Cover, *1961*
*Plaster-soaked muslin over wire frame, painted with enamel*
*4 × 2¾ × 1⅛"*
*Collection of the artist*

Pile of Toast, *1961*
*Plaster-soaked muslin over wire frame, painted with enamel*
*9 × 4"*
*Collection of the artist*

Roast, *1961*
*Plaster-soaked muslin over wire frame, painted with enamel*
*14 × 17 × 16"*
*Collection of Ileana and Michael Sonnabend, New York*

Sandwich, *1961*
*Plaster-soaked muslin over wire frame, painted with enamel*
*2¼ × 6 × 5½"*
*Collection of Margo H. Leavin*

Small Yellow Pie, *1961*
*Plaster-soaked muslin over wire frame, painted with enamel*
*16½ × 17⅜ × 7"*
*Collection of the artist*

Three Ladies' Stockings, *1961*
*Painted plaster and wood*
*20⅜ × 21½"*
*Collection of William J. Hokin*

"Vulgar" Pie, *1961*
*Painted plaster on painted metal tray*
*12 × 7½"*
*Collection of Beatrice and Philip Gersh*

Street poster for "The Store," *1961*
*Print*
*27¾ × 22"*
*Collection of the artist*

Street poster rough, *1961*
*Cut paper and watercolor on*
*printed poster*
*27¾ × 22"*
*Collection of the artist*

*Works shown at the Green*
*Gallery, New York*
*September, 1962*

Blue Pants on Chair, *1962*
*Plaster-soaked muslin over wire*
*frame, painted with enamel*
*37 × 17 × 26¾"*
*The Museum of Contemporary*
*Art, Los Angeles:*
*The Panza Collection*

Breakfast Table, *1962*
*Plaster-soaked muslin over wire*
*frame, painted with enamel*
*34½ × 35½ × 34½"*
*The Museum of Contemporary*
*Art, Los Angeles:*
*The Panza Collection*

Cocoanut Pie, *1962*
*Enamel and yarn on canvas*
*3 × 17 × 17"*
*Collection of Betty Asher*

Cup of Coffee *1962*
*Enamel on plaster*
*6 × 11 × 11"*
*Collection of Betty Asher*

Hamburger, *1962*
*Plaster-soaked muslin over wire*
*frame, painted with enamel*
*7 × 9 × 9"*
*The Museum of Contemporary*
*Art, Los Angeles:*
*The Panza Collection*

Jockey Shorts, *1962*
*Canvas filled with kapok,*
*painted with enamel*
*Three pieces: 1½ × 16 × 18" each;*
*with wood box: 7½ × 19 × 20"*
*Collection of the artist*

Umbrella and Newspaper, *1962*
*Plaster-soaked muslin over wire*
*frame, painted with enamel*
*38½ × 19½ × 6"*
*The Museum of Contemporary*
*Art, Los Angeles:*
*The Panza Collection*

White Gym Shoes, *1962*
*Plaster-soaked muslin over wire*
*frame, painted with enamel*
*24 × 24 × 10"*
*The Museum of Contemporary*
*Art, Los Angeles:*
*The Panza Collection*

White Shirt on Chair, *1962*
*Plaster-soaked muslin over wire*
*frame, painted with enamel*
*39¾ × 30 × 25¼"*
*The Museum of Contemporary*
*Art, Los Angeles:*
*The Panza Collection*

*Works made after the Green*
*Gallery exhibition*

Pie à la Mode, *1962*
*Plaster-soaked muslin over wire*
*frame, painted with enamel*
*22 × 18½ × 11¾"*
*The Museum of Contemporary*
*Art, Los Angeles:*
*The Panza Collection*

## Sigmar Polke

Born 1941 in Oels, Poland
Lives in Cologne, West Germany

Skelett, *1974*
*Dispersion on fabric*
*77 × 72"*
*Saatchi Collection, London*

Paganini, *1982*
*Dispersion on canvas*
*78¾ × 177"*
*Saatchi Collection, London*

Die Lebenden stinken und die
Toten sind nicht anwesent, *1983*
*Mixed media on fabric*
*115 × 140"*
*Collection of Emily and*
*Jerry Spiegel*

Untitled, *1984*
*Oil and lacquer on canvas*
*102½ × 78½"*
*Collection of Susan and*
*Lewis Manilow*

Hochsitz II, *1984–85*
*Silver, silver oxide, and*
*synthetic resin on canvas*
*119¹³⁄₁₆ × 88¹¹⁄₁₆"*
*Carnegie Museum of Art,*
*Pittsburgh, Pennsylvania*
*William R. Scott Jr. Fund, 1985*

## Jackson Pollock

Born 1912 in Cody, Wyoming
Died 1956 in Long Island,
New York

Mural, *1943*
*Oil on canvas*
*97¼ × 238"*
*The University of Iowa*
*Museum of Art*

Night Mist, *c. 1944*
*Oil on canvas*
*36 × 74"*
*Norton Gallery of Art,*
*West Palm Beach, Florida*

Enchanted Forest, *1947*
*Oil on canvas*
*83 × 45⅛"*
*The Peggy Guggenheim*
*Collection, Venice*
*Solomon R. Guggenheim*
*Foundation, New York*

Number 1, *1949*
*Enamel and aluminum paint*
*on canvas*
*63 × 102½"*
*Rita and Taft Schreiber*
*Collection*

Number 8, *1949*
*Oil, enamel, and aluminum*
*paint on canvas*
*34⅛ × 71¼"*
*Neuberger Museum,*
*State University of New York*
*at Purchase*
*Gift of Roy R. Neuberger*

Number 11, *1951*
*Enamel on canvas*
*57½ × 138⅝"*
*Sarah Campbell Blaffer*
*Foundation, Houston, Texas*

Number 28, *1951*
*Oil on canvas*
*30⅛ × 54⅛"*
*Collection of Mr. and Mrs.*
*David N. Pincus*

**Ken Price**

Born 1935 in Los Angeles
Lives in South Dartmouth,
Massachusetts

Blumpo, *1985*
*Fired clay with acrylic and
metallic paint*
*Two parts: 7½ × 6½ × 7″;
6½ × 3½ × 4″*
*The Edward R. Broida Trust,
Los Angeles*

Gomo, *1985*
*Fired clay*
*Two parts: 10½ × 6 × 6″;
9 × 2½ × 2½″*
*Willard Gallery, New York*

The Pinkest and the Heaviest,
*1985*
*Fired clay with acrylic and
metallic paint*
*Two parts: 8 × 8½ × 7½″;
7 × 4 × 4″*
*Willard Gallery, New York*

Celtic, *1986*
*Fired clay*
*Two parts: 8 × 7½ × 7″;
9 × 2½ × 2½″*
*Willard Gallery, New York*

Iconoclast, *1986*
*Fired clay*
*Two parts: 7½ × 10½ × 9″;
7½ × 6 × 5″*
*Willard Gallery, New York*

**Martin Puryear**

Born 1941 in Washington, D. C.
Lives in Chicago, Illinois

Greed's Trophy, *1984*
*Wood, steel, wire, and plastic
relief*
*153 × 20 × 55″*
*Museum of Modern Art,
New York*
*David Rockefeller Fund
and purchase, 1984*

Keeper, *1984*
*Wood and steel wire*
*100 × 34 × 37″*
*Collection of Alan and
Wendy Hart*

Spell, *1985*
*Pine, cedar, and steel*
*56 × 84 × 32″*
*Collection of the artist
Courtesy Donald Young Gallery,
Chicago*

**Robert Rauschenberg**

Born 1925 in Port Arthur, Texas
Lives in New York City

Interview, *1955*
*Combine painting*
*72¾ × 49¼″*
*The Museum of Contemporary
Art, Los Angeles:
The Panza Collection*

Untitled Combine, *1955*
*Combine painting*
*86½ × 37 × 26¼″*
*The Museum of Contemporary
Art, Los Angeles:
The Panza Collection*

Small Rebus, *1956*
*Combine painting*
*35 × 46″*
*The Museum of Contemporary
Art, Los Angeles:
The Panza Collection*

Factum I, *1957*
*Combine painting*
*61½ × 35¾″*
*The Museum of Contemporary
Art, Los Angeles:
The Panza Collection*

Coca Cola Plan, *1958*
*Combine painting*
*26¾ × 25¼ × 4¾″*
*The Museum of Contemporary
Art, Los Angeles:
The Panza Collection*

Gift for Apollo, *1959*
*Combine painting*
*43¾ × 29½″*
*The Museum of Contemporary
Art, Los Angeles:
The Panza Collection*

Inlet, *1959*
*Combine painting*
*84½ × 48½″*
*The Museum of Contemporary
Art, Los Angeles:
The Panza Collection*

Kickback, *1959*
*Combine painting*
*75 × 32″*
*The Museum of Contemporary
Art, Los Angeles:
The Panza Collection*

Painting with Grey Wing, *1959*
*Combine painting*
*31 × 21″*
*The Museum of Contemporary
Art, Los Angeles:
The Panza Collection*

Slow Fall, *1961*
*Combine painting*
*55 × 20″*
*The Museum of Contemporary
Art, Los Angeles:
The Panza Collection*

Trophy III (for Jean Tinguely),
*1961*
*Combine painting*
*96 × 65¾″*
*The Museum of Contemporary
Art, Los Angeles:
The Panza Collection*

**James Rosenquist**

Born 1933 in Grand Forks,
North Dakota
Lives in Aripeka, Florida

**Susan Rothenberg**

Born 1945 in Buffalo, New York
Lives in New York City

**Mark Rothko**

Born 1903 in Dvinsk, Russia
Died 1970 in New York City

Push Button, *1960–61*
*Oil on canvas*
*82¾ × 105½"*
*The Museum of Contemporary*
*Art, Los Angeles:*
*The Panza Collection*

White Cigarette, *1961*
*Oil on canvas*
*60½ × 35¾"*
*The Museum of Contemporary*
*Art, Los Angeles:*
*The Panza Collection*

A Lot to Like, *1962*
*Oil on canvas*
*92½ × 203"*
*The Museum of Contemporary*
*Art, Los Angeles:*
*The Panza Collection*

Capillary Action, *1962*
*Oil on canvas*
*92½ × 136¼"*
*The Museum of Contemporary*
*Art, Los Angeles:*
*The Panza Collection*

Vestigial Appendage, *1962*
*Oil on canvas*
*72 × 93¼"*
*The Museum of Contemporary*
*Art, Los Angeles:*
*The Panza Collection*

Waves, *1962*
*Oil on canvas*
*56 × 77"*
*The Museum of Contemporary*
*Art, Los Angeles:*
*The Panza Collection*

For the Light, *1978–79*
*Acrylic and flashe on canvas*
*105 × 87"*
*Whitney Museum of*
*American Art, New York*
*Purchased with funds from*
*Peggy and Richard Danziger*

Squeeze, *1978–79*
*Acrylic and flashe on canvas*
*92 × 87"*
*Saatchi Collection, London*

The Hulk, *1979*
*Acrylic and flashe on canvas*
*89 × 132¼"*
*The Museum of Contemporary*
*Art, Los Angeles:*
*The Barry Lowen Collection*

Red Head, *1980*
*Acrylic and flashe on canvas*
*114 × 110"*
*Private Collection*

Blue Body, *1980–81*
*Acrylic and flashe on canvas*
*108 × 75"*
*Collection of Eli and*
*Edythe L. Broad*

Black Dress, *1982–83*
*Oil on canvas*
*67 × 73"*
*Collection of Beatrice*
*and Philip Gersh*

Brown, Blue, Brown on Blue,
*1953*
*Oil on canvas*
*115¾ × 91¼"*
*The Museum of Contemporary*
*Art, Los Angeles:*
*The Panza Collection*

Violet and Yellow on Rose, *1954*
*Oil on canvas*
*83½ × 67¾"*
*The Museum of Contemporary*
*Art, Los Angeles:*
*The Panza Collection*

Black, Ochre, Red over Red,
*1957*
*Oil on canvas*
*99¼ × 81½"*
*The Museum of Contemporary*
*Art, Los Angeles:*
*The Panza Collection*

Purple Brown, *1957*
*Oil on canvas*
*84 × 72"*
*The Museum of Contemporary*
*Art, Los Angeles:*
*The Panza Collection*

Red and Brown, *1957*
*Oil on canvas*
*68 × 43"*
*The Museum of Contemporary*
*Art, Los Angeles:*
*The Panza Collection*

Red and Blue Over Red, *1959*
*Oil on canvas*
*93 × 80¾"*
*The Museum of Contemporary*
*Art, Los Angeles:*
*The Panza Collection*

Black on Dark Sienna on Purple,
*1960*
*Oil on canvas*
*119¼ × 105"*
*The Museum of Contemporary*
*Art, Los Angeles:*
*The Panza Collection*

## Edward Ruscha

Born 1937 in Omaha, Nebraska
Lives in Los Angeles

Boss, *1961*
*Oil on canvas*
*72 × 67"*
*Collection of Dr. Leopold S.*
*Tuchman/Cynthia S. Monaco*

HONK, *1961–62*
*Oil on canvas*
*72 × 67"*
*Ulrike Kantor Gallery*

ACE, *1962*
*Oil on canvas*
*72 × 67"*
*Collection of the artist*

Annie, *1962*
*Oil on canvas*
*72 × 67"*
*Collection of Betty Asher*

War Surplus, *1962*
*Oil on canvas*
*71 × 66⅜"*
*Collection of the artist*

OOF, *1963*
*Oil on canvas*
*72 × 67"*
*Collection of the artist*

## Robert Ryman

Born 1952 in Nashville,
Tennessee
Lives in New York City

Resource, *1984*
*Acrylic on fiberglass with steel*
*and aluminum*
*131⅞ × 125⅝"*
*Collection Raussmüller,*
*Hallen für Neue Kunst,*
*Schaffhausen, Switzerland*

Credential, *1985*
*Oil on aluminum*
*62¼ × 22 × 22"*
*Collection of Ralph I. and*
*Helyn D. Goldenberg*

Distributor, *1985*
*Oil on fiberglass with wood and*
*aluminum*
*48 × 43"*
*Refco Group, Ltd.*

Expander, *1985*
*Oil on aluminum*
*28 × 28"*
*Collection of the artist*
*Courtesy Galerie Maeght Lelong,*
*New York*

Instructor, *1985*
*Oil on fiberglass with aluminum*
*51½ × 47¾"*
*Collection of Barbara Balkin*
*Cottle and Robert Cottle,*
*Chicago*

## David Salle

*April 21–June 14, 1987*
*A survey exhibition organized by*
*the Institute of Contemporary*
*Art, University of Pennsylvania,*
*Philadelphia*

## Lucas Samaras

Born 1936 in Kastoria, Greece
Lives in New York City

Untitled Box No. 3, *1963*
*Pins, rope, stuffed bird,*
*and wood*
*24½ × 11½ × 10¼"*
*Whitney Museum of American*
*Art, New York*
*Gift of the Howard and Jean*
*Lipman Foundation, Inc.*
*Acq.# 66.36*

Box No. 4, *1963*
*Wood construction, steel, straight*
*pins, nails, hinges, razor blades,*
*fork, plastic, sand, glass plate*
*and goblet, mosaic tiles, and*
*colored wool yarn*
*18¼ × 24½ × 11½"*
*Saatchi Collection, London*

Box # 38 (Hermaphrodite), *1965*
*Mixed media*
*8 × 12 × 9"*
*Collection of Milly and*
*Arnold Glimcher*

Box #43, *1966*
*Mixed media*
*9 × 12 × 9"*
*Collection of Mr. Robert H. Halff*

Chicken Wire Box #4, *1972*
*Acrylic paint on chicken wire*
*15½ × 9 × 9"*
*Richard Brown Baker Collection*

Box 109, *1983*
*Mixed media*
*Open: 17¼ × 21 × 13½";*
*Closed: 11 × 14 × 8"*
*Denver Art Museum*
*Purchased with funds from the*
*Acquisition Challenge Grant,*
*the American Art Foundation,*
*and Mr. and Mrs. Kenneth*
*Robins*

**Julian Schnabel**

Born 1951 in New York City
Lives in New York City

**Richard Serra**

Born 1948 in San Francisco
Lives in New York City

**Joel Shapiro**

Born 1941 in New York City
Lives in New York City

**Cindy Sherman**

Born 1954 in Glen Ridge,
New Jersey
Lives in New York City

Sir Herbert Read, *1983*
*Oil, fiberglass, and burlap on*
*tarpaulin*
*120 × 84"*
*Collection of Douglas S. Cramer*

The Student of Prague, *1983*
*Oil, plates, wood, and auto body*
*filler on wood*
*116 × 234"*
*Collection of Emily and Jerry*
*Spiegel*

Throne, *1983*
*Oil and modeling paste on*
*rug batting*
*120 × 84"*
*Collection of Ed Cauduro*

Bob and Joe, *1984*
*Oil and modeling paste on velvet*
*120 × 108"*
*The Eli Broad Family*
*Foundation*

The Incantation, *1984*
*Oil and modeling paste on velvet*
*108 × 120"*
*Collection of Douglas S. Cramer*

Call Me Ishmael, *1986*
*Cor-ten Steel*
*Two sections: 12 × 52' × 2½" each*
*Collection of the artist*
*Courtesy Leo Castelli Gallery,*
*New York and The Pace Gallery,*
*New York*
*Commissioned for the exhibition*

Untitled, *1980–81*
*Oil and acrylic on poplar*
*54 × 42 × 37"*
*The Museum of Contemporary*
*Art, Los Angeles:*
*The Barry Lowen Collection*

Untitled, *1985*
*Bronze*
*117 × 123 × 72"*
*Paula Cooper Gallery, New York*

Untitled, *1985*
*Bronze*
*38½ × 28½ × 14"*
*Paula Cooper Gallery, New York*

Untitled, *1985*
*Bronze*
*36¼ × 53 × 40"*
*Paula Cooper Gallery, New York*

Untitled #88, *1981*
*Type-C print*
*24 × 48"*
*The Museum of Contemporary*
*Art, Los Angeles:*
*The Barry Lowen Collection*

Untitled #92, *1981*
*Type-C print*
*24 × 48"*
*Collection of Eli and*
*Edythe L. Broad*

Untitled #94, *1981*
*Type-C print*
*24 × 48"*
*Collection of Eli and*
*Edythe L. Broad*

Untitled #95, *1981*
*Type-C print*
*24 × 48"*
*Metro Pictures, New York*

## Alexis Smith

Born 1949 in Los Angeles
Lives in Venice, California

Cannery Row, *1980*
*Collage with cardboard*
*13½ × 70"*
*Collection of William J. Hokin*

Mean Streets, *1980*
*Mixed media*
*16 × 72½"*
*Collection of Harold I. Huttas*

American Way, *1980–81*
*Mixed media collage in*
*Plexiglas case*
*16 × 52"*
*Margo Leavin Gallery,*
*Los Angeles*

All the Simple Old-fashioned
Charm, *1984*
*Lacquered wood chair with*
*stick-on letters*
*34 × 17¼ × 19½"*
*Margo Leavin Gallery,*
*Los Angeles*

Asphalt Jungle, *1985*
*Mixed media collage*
*Two panels: 45⅛ × 25" each*
*The Museum of Contemporary*
*Art, Los Angeles*
*The El Paso Natural Gas*
*Company Fund for*
*California Art*

The End, *1986*
*Mixed media collage*
*25 × 96"*
*Collection of the artist*

*These works are exhibited*
*in a painted installation*
*commissioned for the exhibition*

## David Smith

Born 1906 in Decatur, Indiana
Died 1965 in Bennington,
Vermont

Tanktotem I, *1952*
*Steel*
*90 × 39"*
*The Art Institute of Chicago*
*Gift of Mr. and Mrs.*
*Jay Z. Steinberg*
*In memory of her father*
*Maurice Kallis*

Tanktotem III, *1953*
*Steel*
*84½ × 27 × 20"*
*Collection of Mr. and Mrs.*
*David Mirvish*

Tanktotem IV, *1953*
*Steel*
*92⅝ × 34 × 29"*
*Albright-Knox Art Gallery,*
*Buffalo, New York*
*Gift of Seymour H. Knox, 1957*

Portrait of a Painter, *1954*
*Bronze*
*96³⁄₁₆ × 24½ × 11⅞"*
*Collection of Candida and*
*Rebecca Smith, New York*
*Courtesy M. Knoedler & Co., Inc.,*
*New York*

Construction with Forged Neck,
*1955*
*Rusted steel*
*76¼ × 13 × 8⅝"*
*Collection of Candida and*
*Rebecca Smith, New York*
*Courtesy M. Knoedler & Co., Inc.,*
*New York*

Personage of August, *1956*
*Steel*
*74⅞ × 15⅞ × 16⅜"*
*Collection of Candida and*
*Rebecca Smith, New York*
*Courtesy M. Knoedler & Co., Inc.,*
*New York, and the*
*Art Gallery of Ontario, Toronto*

Sentinel II, *1956–57*
*Stainless steel*
*71⅜ × 14½ × 14½"*
*Hirshhorn Museum and*
*Sculpture Garden,*
*Smithsonian Instiutution,*
*Washington, D. C.*
*Gift of Joseph H. Hirshhorn*

The Woman Bandit, *1956–58*
*Cast iron, bronze, and steel*
*68¼ × 12⅛ × 12½"*
*Collection of Candida and*
*Rebecca Smith, New York*
*Courtesy M. Knoedler & Co., Inc.,*
*New York, and the*
*National Gallery of Art*
*Washington, D.C.*

Pilgrim, *1957*
*Bronze*
*81 × 26"*
*The Contemporary Collection of*
*the Cleveland Museum of Art*

Tanktotem VI, *1957*
*Painted steel*
*103⅞" high*
*Collection of Candida and*
*Rebecca Smith, New York*
*Courtesy M. Knoedler & Co., Inc.,*
*New York*

Sentinel, *1961*
*Stainless steel*
*106 × 23 × 16½"*
*Collection of Candida and*
*Rebecca Smith, New York*
*Courtesy M. Knoedler & Co., Inc.,*
*New York, and the*
*National Gallery of Art,*
*Washington, D. C.*

## Keith Sonnier

Born 1941 in Mamou, Louisiana
Lives in New York City

BA-O-BA IV, *1969*
*Neon and glass*
*96 × 96 × 120"*
*Collection of Syd Goldfarb*

Neon and Scoop Lights, *1969*
*Mixed media*
*Dimensions variable*
*The Museum of Contemporary*
*Art, Los Angeles*
*Gift of Rose, Feldman, Radin,*
*Feinsod, and Skehan*

## Frank Stella

Born 1936 in Malden,
Massachusetts
Lives in New York City

Delta, *1958*
*Enamel on canvas*
*85 × 96"*
*Collection of the artist*

Point of Pines, *1959*
*Enamel on canvas*
*84¾ × 109¼"*
*Collection of the artist*

Tomlinson Court Park, *1959–60*
*Enamel on canvas*
*84 × 108"*
*Collection of Robert A. Rowan*

Kingsbury Run, *1960*
*Aluminum paint on canvas*
*77 × 74½"*
*Collection of Joan Carpenter*
*Troccoli*

Union Pacific, *1960*
*Aluminum paint on canvas*
*77¼ × 148½"*
*Des Moines Art Center*
*Coffin Fine Arts Trust Fund*

Ouray, *1961*
*Copper paint on canvas*
*93¾ × 93¾"*
*Collection of Rita*
*and Toby Schreiber*

## Clyfford Still

Born 1904 in Grandin,
North Dakota
Died 1980 in New Winsor,
Maryland

Untitled, *1949*
*Oil on canvas*
*68 × 58¼"*
*The Museum of Fine Arts,*
*Houston*
*Museum purchase with funds*
*from the Brown Foundation*

Untitled, *1951*
*Oil on canvas*
*108 × 92½"*
*Collection of Marcia S.*
*Weisman,*
*Beverly Hills, California*

Untitled, *1960*
*Oil on canvas*
*113⅛ × 155⅞"*
*San Francisco Museum*
*of Modern Art*
*Gift of Mr. and Mrs.*
*Harry W. Anderson*
*74.19*

## Donald Sultan

November 24, 1987–
January 10, 1988
*A survey exhibition organized by*
*the Museum of Contemporary*
*Art, Chicago*

## Robert Therrien

Born 1947 in Chicago
Lives in Los Angeles

No Title, *1983–84*
*Oil on cardboard*
*52 × 40"*
*The Museum of Contemporary*
*Art, Los Angeles*
*Gift of Carl and*
*Roberta Hartnack*

No Title, *1983–84*
*Oil on cardboard*
*52 × 40"*
*The Museum of Contemporary*
*Art, Los Angeles*
*Gift of Carl and*
*Roberta Hartnack*

No Title, *1983–84*
*Oil on cardboard*
*52 × 40"*
*The Museum of Contemporary*
*Art, Los Angeles*
*Gift of Carl and*
*Roberta Hartnack*

No Title, *1985*
*Oil and tempera on canvas on*
*wood*
*64 × 96"*
*Collection of Teresa Bjornson*

No Title, *1985*
*Tin on bronze*
*74⅝" high; 35¼" diameter*
*The Eli Broad Family*
*Foundation*

No Title, *1985*
*Wood, enamel, and bronze*
*50 × 12½ × 3¾"*
*Collection of Diane and*
*Steven M. Jacobson*

No Title, *1986*
*Mixed media on bronze*
*35½" high; 16" diameter*
*Collection of the artist*

**James Turrell**

Born 1943 in Los Angeles
Lives in Flagstaff, Arizona

**Cy Twombly**

Born 1928 in Lexington, Virginia
Lives in Rome, Italy

**Andy Warhol**

Born 1930 in Forest City,
Pennsylvania
Lives in New York City

No Title, *1986*
*Enamel and mixed media on*
*brass*
*84 × 35 × 4¾"*
*Collection of the artist*

2nd Meeting, *1986*
*Skyspace with entry room*
*Skylit exterior, tungsten interior*
*20 × 20 × 20'*
*Collection of the artist*
*Commissioned for the exhibition*

Untitled, *1956*
*Oil, crayon, and pencil*
*on canvas*
*48⅛ × 69"*
*Saatchi Collection, London*

Sahara, *1960*
*Oil, crayon, and pencil*
*on canvas*
*80 × 110"*
*Saatchi Collection, London*

Bay of Naples, *1961*
*Oil, pencil, and wax crayon*
*on canvas*
*95¼ × 117⅝"*
*Dia Art Foundation, New York*

Untitled, *1967*
*Oil and crayon on canvas*
*58 × 70"*
*The Museum of Contemporary*
*Art, Los Angeles:*
*The Barry Lowen Collection*

Synopsis of a Battle, *1968*
*House paint and crayon on*
*canvas*
*79 × 103⅛"*
*Virginia Museum of Fine Arts*
*Gift of Sydney and Frances*
*Lewis*

Untitled *(Bolsena), 1969*
*House paint, oil, crayon, and*
*pencil on canvas*
*78¾ × 98½"*
*Saatchi Collection, London*

Dick Tracy, *1960*
*Casein and crayon on canvas*
*48 × 33½"*
*Collection of Mr. and Mrs. Peter*
*M. Brant*

Storm Door, *1960*
*Acrylic on canvas*
*46 × 42⅛"*
*Collection of Thomas Ammann,*
*Zürich*

Dance Diagram—Tango, *1962*
*Acrylic on canvas*
*72 × 54"*
*Museum für Moderne Kunst,*
*Frankfurt am Main*

**Doug Wheeler**

Born 1939 in Globe, Arizona
Lives in Marina del Rey,
California

**William Wiley**

Born 1937 in Bedford, Indiana
Lives in Marin County, California

RM 669, *1969*
*Vacuum formed transluscent*
*Plexiglas and white ultraviolet*
*neon light*
*96 × 96"*
*(room dimensions variable)*
*The Museum of Contemporary*
*Art, Los Angeles*
*Purchased with funds provided*
*by Bullock's/Bullock's Wilshire*

Ship's Log, *1969*
*Cotton webbing, latex rubber,*
*salt licks, leather, plastic, wood,*
*canvas, lead wire, nautical and*
*assorted hardware, and ink and*
*watercolor on paper*
*82 × 78 × 54"*
*San Francisco Museum of*
*Modern Art*
*William L. Gerstle Collection*
*William L. Gerstle Fund*
*Purchase*
*70.37 A-L*

Thank You Hide, *1970–71*
*Construction with wood, leather,*
*pick, found objects, and ink and*
*charcoal on cowhide*
*70 × 64"*
*Des Moines Art Center*
*Coffin Fine Arts Trust Fund*

How to Chart a Coarse, *1971*
*Construction of acrylic and ink*
*on canvas, felt, leather, painted*
*wood, wire, brass, branches,*
*glass, silk, rubber, metal, hard-*
*bound book, and rabbits' feet*
*87 × 144 × 78"*
*The Oakland Museum*
*Gift of the Collectors Gallery,*
*the Timken Fund, and*
*Anne and Stephen Walrod*

**Board of Trustees**

William F. Kieschnick,
*Chairman*
Frederick M. Nicholas,
*Vice Chairman*
Lenore S. Greenberg,
*President*
Dr. Leon O. Banks

Daisy Belin
Tom Bradley,
*ex-officio*
Eli Broad
Betye Monell Burton
Douglas S. Cramer
John C. Cushman III
Dominique de Menil
Sam Francis
Beatrice Gersh
James C. Greene
Gordon F. Hampton
Carl E. Hartnack
Elizabeth Keck
Richard Koshalek,
*ex-officio*
Ignacio E. Lozano, Jr.
George E. Moss
Jane Fallek Nathanson
William A. Norris
Giuseppe Panza di Biumo
Robert A. Rowan
Pat Russell,
*ex-officio*
Bruce Schwaegler
Henry T. Segerstrom
Rocco Siciliano
David S. Tappan, Jr.
Seiji Tsutsumi
DeWain Valentine
Joel Wachs
Marcia Weisman
Morton M. Winston
Leopold S. Wyler

**Museum Staff**

Sue Barrett,
*Development Assistant*
Pej Behdarvand,
*Museum Store Clerk*
Stephen Bennett,
*Production Manager*
Lynn Berman,
*Ticket Clerk*
John Bowsher,
*Chief Preparator*
Kevin Boyle,
*Art Handler*
Randall Brockett,
*Art Handler*
Kerry Brougher,
*Assistant Curator*
Lessie Brown,
*Receptionist*
Kerry J. Buckley,
*Director of Development*
Cynthia Campoy,
*Communications Secretary*
Yvonne Carlson,
*Membership Secretary*
Brick Chapman,
*Facilities and Operations Manager*
Carol Chrisong,
*Bookkeeper*
Elaine Cohen,
*Secretary to the Director*
Jacqueline Crist,
*Assistant Curator*
Patrick DeBlasi,
*Art Handler*
Dory Dutton,
*Museum Store Manager*
Robert Espinoza,
*Art Handler*
Jeff Falsgraf,
*Art Handler*
Leslie Fellows,
*Curatorial Secretary*
Nancy Fleeter,
*Controller*
Sherri Geldin,
*Associate Director*
Bob Gibson,
*Art Handler*

Betsy Gilbert,
*Art Handler*
Ann Goldstein,
*Research Associate*
Catherine Gudis,
*Publications Secretary*
Robin Hanson,
*Grants Officer*
Sylvia Hohri,
*Public Outreach Coordinator*
Ken Hurbert,
*Art Handler*
Susan Jenkins,
*Curatorial Secretary*
Kimberley Kanatani,
*Education Specialist*
Richard Koshalek,
*Director*
Barbara Kraft,
*Director of Communications*
Julie Lazar,
*Curator*
Valerie Lee,
*Senior Accountant*
Brian Levitz,
*Membership Coordinator*
Leslie H. Lizotte,
*Inaugural Events Assistant*
Suzanne Loizeaux-Witte,
*Personnel Manager*
Darryl Lowe,
*Museum Courier*
Mike Lynch,
*Ticket Clerk*
Eric Magnuson,
*Art Handler*
Brenda Mallory,
*Ticket Clerk*
Celeste Mannis,
*Development Assistant*
Leslie Marcus,
*Support Program Coordinator*
Portland McCormick,
*Registrarial Secretary*
Rudy Mercado,
*Art Handler*
Cardie K. Molina,
*Development Assistant*

Ray Navarro,
*Art Handler*
Marc O'Carroll,
*Art Handler*
Carter Potter,
*Museum Store Clerk*
Robin Price,
*Slide Librarian*
Jill Quinn,
*Assistant Registrar*
Loren Quintana,
*Museum Store Clerk*
Sarah-Jane Rairden,
*Development Secretary*
Pam Richey,
*Museum Store Assistant Manager*
Nancy Rogers,
*Administrative Assistant*
Alma Ruiz,
*Executive Assistant*
Diana Schwab,
*Curatorial Secretary*
Mo Shannon,
*Registrar*
Howard Singerman,
*Publications Coordinator*
Elizabeth A. T. Smith,
*Assistant Curator*
Gabriela Ulloa,
*Press Intern*
Deborah Voigt,
*Curatorial Secretary*
Holly Wilder,
*Ticket Clerk*
Marilyn Welch,
*Museum Store Clerk*
Rhyan Zweifler,
*Membership Assistant*

# Index

abstract expressionism, 30, 36, 38, 40, 41, 49, 274, 294–95, 299

Acconci, Vito, 205

*Accord réciproque* (Kandinsky), *265*

*ACE* (Ruscha), 270, *320*

*Acoustic Corridor* (Nauman), 207

*Adagio* (Signac), 265

Adams, John, 6

*Adios* (Ruscha), 270

Adorno, Theodor W., 31, 32, 106, 121

*Afrum Blue* (Turrell), 199

*After Walker Evans* (Levine), *311*

*Against the Enamel of a Background Rhythmic with Beats and Angles, Tones and Colors, Portrait of M. Félix Fénéon in 1890* (Signac), *264*

*Air* (Ruscha), 270

*Akar's Visit* (Turrell), 200

*Alignment Series: Arrows Fly Like This, Flowers Grow Like This* (Baldessari), 277

*All About* (Barry), *287*

*Allegro Maestroso* (Signac), 265

*All I Wanna Do Is Swing 'n' Nail* (Herms), *134*

Alloway, Lawrence, 51, 52, 306

*All the Things I Know* (Barry), *286*

Altoon, John, 197

*American Way* (A. Smith), 272, *288–89*

Anderson, Laurie, 177

Andre, Carl, 55, 162, 194; works of, *166*

*ANT 85* (Klein), *73*

*architecte était un chien Blanc, de caractères, L'* (Broodthaers), *284, 285*

Armajani, Siah, 208, 210

Arnason, H. H., 51

Artaud, Antonin, 225

Asher, Michael, 177

Ashton, Dore, 31, 38, 40, 43

*Ashville* (de Kooning), 43

*Asphalt Jungle* (A. Smith), 272, *273*

*At Rest* (Kandinsky), 265

automatism, 38

avant-garde, 175–77, 225, 244, 265

Aycock, Alice, 194, 205, 208; works of, *204*

*B* (Broodthaers), *284, 285*

Bachelard, Gaston, 197

Bacon, Francis, 247

Baer, Jo, 52

Baldessari, John, 275, 277–78, 309; works of, *334, 335*

Ballard, J. G., 306

*Baltimore Project* (Fleischner), 208, *218*

Banham, Reyner, 306

Bann, Stephen, 265

*BA-O-BA IV* (Sonnier), *142*

Barry, Robert, 270, 275–77; works of, *276, 286, 287*

Barthes, Roland, 173, 267, 270, 274, 306

Bateson, Gregory, 242

Battcock, Gregory, 274

*Batten* (Turrell), 199, 200

Baudelaire, Charles, 32, 33, 113, 263

Baudrillard, Jean, 179

*Bay of Naples* (Twombly), 49, *85*

Baziotes, William, 34

*Beanery, The* (Kienholz), 228

Beckett, Samuel, 225

*Bed* (Rauschenberg), 295, *296*

*Before the Caves* (Frankenthaler), *48*

Bell, Larry, 162, 202; works of, *186, 187*

*Belts* (Serra), *120*, 122

*Bender* (Ryman), 54

Bengston, Billy Al, 52, 197, 306; works of, *326, 327*

Benjamin, Walter, 32

Berlant, Tony, 247; works of, *256, 257*

*Betrayal of Images, The* (Magritte), *266*

Beuys, Joseph, 106, 109, 110, 116–19, 121, 122, 225–26; works of, *118, 119, 150, 151*

*Big Wheel, The* (Burden), 228

Bishop, Jim, 52

*Black, Ochre, over Red* (Rothko), 42

*Black Bath with Two Simultaneous Waves* (Horn), *238*

*Black Egg and Three Lemons* (Sultan), *101*

*Black on Dark Sienna on Purple* (Rothko), *71*

"Black Paintings" (Stella), 51

"Blasted Allegories" series (Baldessari), 277, 309

*Blind Leading the Blind, The* (Bourgeois), *126*

*Blitzschlag mit Lichtschein auf Hirsch* (Beuys): details, *118, 119, 151*

*Blue Body* (Rothenberg), *251*

*Blumpo* (Price), *159*

*Bocal avec oeil* (Broodthaers), *284*

*Bocal et reproduction (Magritte)* (Broodthaers), *284*

*Book 4* (Samaras), *114*, 115

Borges, Jorge Luis, 271

Borofsky, Jonathan, 6, 22

Boshier, Derek, 306

*Boss* (Ruscha), 270

Bourgeois, Louise, 122; works of, *126, 127*

*Box #43* (Samaras), *137*

*Box 1* (Samaras), 115

Braque, Georges, 266, 270, 272; works of, *266*

Brauntuch, Troy, 177

Breton, André, 38

Brewster, Michael, 194

Brice, William, 6

Broodthaers, Marcel, 275, 278–79; works of, *284, 285*

*Brother Animal* (Salle), *329*

*Brown, Blue, Brown on Blue* (Rothko), *70*

Buchloh, Benjamin, 178, 278

Burden, Chris, 205, 228; works of, *203, 240–41*

Buren, Daniel, 178, 275, 307

Bürger, Peter, 176–77

Burgin, Victor, 274, 275

Burnham, Jack, 262

Butor, Michel, 263

*Buttress* (Kline), *74*

Cage, John, 6, 163, 295

Caillebotte, Gustave, 266

Calas, Nicolas, 278

Callis, Jo Ann, 6

*Cannery Row* (A. Smith), 272

*Can You Hear Me?* (Murray), *96*

Caro, Anthony, 265

Carroll, Lewis, 57, 162

*Carte du monde Poétique* (Broodthaers), 278

Celmins, Vija, 7, 57–58; works of, *98, 99*

*Central Avenue Meridian*, plans for (Irwin), *220, 221*

Cézanne, Paul, 56, 272

Chamberlain, John, 6, 171

Chandler, Raymond, 271

Chasseguet-Smirgel, Janine, 116

Childs, Lucinda, 6

*Cigarettes et Cendrier ABC ZZ* (Broodthaers), *284*

*City* (Ruscha), 270

*Clara-Clara* (Serra), *189*

*Clarinet* (Braque), *266*

Clark, T. J., 32

Clemente, Francesco, 6, 245; works of, *258, 259*

*Coca-Cola Plan* (Rauschenberg), *314*

*Collection of Various Flexible Materials Separated by Layers of Grease with Holes the Size of My Waist and Wrists* (Nauman), 123, *140*

Comanini, G., 243

"Commissioned Paintings, The" (Baldessari), 309

Cornell, Joseph, 222–23, 229; works of, *230, 231*

*Corpse and Mirror* (Johns), 56, *88*
*Corridor* (Nauman), 170
*Corridor with Mirror and White Lights* (Nauman), 205
Corse, Mary, 6
Crane, Hart, 268
Cratylism, 35
Crimp, Douglas, 177
*Cry, The* (Noguchi), *133*
cubism, 14, 38, 42, 46, 47, 265, 266
Culler, Jonathan, 122
Cunningham, Merce, 6, 163

*Damage* (Ruscha), 270
*Dark Blue Panel* (Kelly), *94*
*Dark Pond* (de Kooning), 43, *44*
Davenport, Guy, 210
Davis, Stuart, 247
*Dead Man* (Burden), 228
*Decker* (Turrell), 199
de Kooning, Willem, 31, 36, 42, 43, 46, 293, 294, 295; works of, *44*, *45*, *60*, *61*
Deleuze, Gilles, 57
Denis, Maurice, 272
*Departure from Egypt* (Kiefer), *249*
Derrida, Jacques, 274, 277
*Desire* (Ruscha), 270
*Desk Calendar* (Lichtenstein), *322*
*Deux boules en plâtre peintes en doré* (Broodthaers), *284*
*Deux tonneaux* (Broodthaers), *284*
*Diagonal Sound Wall* (Nauman), 207
*Dick Tracy* (Warhol), *316*
Diebenkorn, Richard, 55–56; works of, *90*, *91*
Dine, Jim, 223
*Dissipate* (Heizer), 194
*Distributor* (Ryman), *103*
di Suvero, Mark, 122, 162, 171, 208; works of, *144*, *145*
*Door to the River* (de Kooning), *45*, 46

Dos Passos, John, 271
*Double Negative* (Heizer), 6, 194, *195*, 210, *212*, *213*
*Double Tongue* (Duff), *153*
*Drowning Girl* (Lichtenstein), *302*
Duchamp, Marcel, 110, 163, 171, 175, 176, 223, 224, 278, 295
Duff, John, 123; works of, *152*, *153*
Dufy, Raoul, 266

*Eden* (Frankenthaler), 47
Elderfield, John, 271
El Greco, 246
"Embed Series" (Baldessari), 277
*"Empire" ("Papa") Ray Gun* (Oldenburg), *112*
*Enchanted Forest* (Pollock), *62*
*Erased de Kooning Drawing* (Rauschenberg), 295
Ernst, Max, 109, 263, 271
*Europa* (Frankenthaler), *76*
*Excavation* (de Kooning), 46
existentialism, 43
*Exposing the Foundation of the Museum* (Burden), *240–41*
expressionism, 49

*Factum I* (Rauschenberg), 295, *296*
*Factum II* (Rauschenberg), 295
*Fahne Hoch!, Die* (Stella), *50*, 51, 300
*Falling Shoestring Potatoes* (Oldenburg), *111*
*Fass* (Marden), 54, *86*
fauvism, 265
Ferenczi, Sandor, 116
Fischl, Eric, 246; works of, *254*, *255*
Flavin, Dan, 6, 162, 175, 194, 205; works of, *168*, *184*, *185*
Fleischner, Richard, 194, 205, 207, 208–10; works of, *209*, *218*, *219*
*F-111* (Rosenquist), 301, *303*
formalism, 41, 43, 49, 50–51, 57

Foucault, Michel, 180, 277
Francis, Sam, 7, 47; works of, *66*, *67*
Frankenthaler, Helen, 47; works of, *48*, *76*, *77*
Freud, Sigmund, 106, 113, 116, 279
Fried, Michael, 49, 170–77, 268
*Frieze* (Marden), 54
*frites, Les* (Broodthaers), *284*
"Future Forward," 8, 9

Garabedian, Charles, 246–47; works of, *252*, *253*
*Gate, The* (Krasner), 46, *80*
Gaudí, Antoni, 246
Gauguin, Paul, 272
Gehry, Frank O., 6, 7, 10, 14, 15, 20, 21, 23
Genette, Gerard, 35
*Giant Tube Being Stepped On* (Oldenburg), 111
Giegerich, Jill, 6
Gilman, Sander L., 121
*Glass Ship, The* (Burden), 229
Gogh, Vincent van, 272
*Gold Marilyn Monroe* (Warhol), 304, *305*
Goldstein, Jack, 177
*Golf Ball* (Lichtenstein), 300
Gombrich, Ernst, 265, 267, 268, 271
Goodman, Nelson, 262
Gorky, Arshile, 38
Gottlieb, Adolph, 38
Graham, Dan, 307
Graham, Robert, 123; works of, *148*, *149*
*Grand Rapids Project* (Morris), 196
*Greed's Trophy* (Puryear), *156*
Greenberg, Clement, 32, 33, 36, 46, 50, 51, 106–8, 121, 163, 170–75, 177, 262, 294
Greenberg, Jay, 111
*Grey Alphabet* (Johns), *269*
*Guardians of the Secret* (Pollock), *37*
Guilbaut, Serge, 38

Haacke, Hans, 178, 307
Hamilton, Richard, 306
*Hang-Up* (Hesse), *138*
*Harbor, July 6, 1984* (Sultan), *100*
Harrison, Charles, 274
Harrison, Newton, 210
Hartung, Hans, 267
Hausmann, Raoul, 263
*Hazelton* (Kline), 43
*Heart and Mind* (Murray), *97*
Heizer, Michael, 6, 194, 199, 208, 210; works of, *195*, *212*, *213*
Held, Al, 51
Herms, George, 122; works of, *134*, *135*
Hess, Thomas, 40, 43
Hesse, Eva, 55, 122, 123; works of, *138*, *139*
*High and the Mighty, The* (Bengston), *326*
Hockney, David, 306
Hofmann, Hans, 46; works of, *45*
*HONK* (Ruscha), *321*
*Horizontal Men* (Baldessari), *334*
Horn, Rebecca, 225, 227; works of, *238*, *239*
*Hot and Cold Vegetables* (Ruscha), 270
*Hotel de l'Etoile* (Cornell), *230*
*House of Cards* (Serra), 163, *169*
*Hulk, The* (Rothenberg), *250*
Husserl, Edmund, 170

*I* (Berlant), *256*
*I Love You with My Ford* (Rosenquist), 301
*Impression, Sunrise* (Monet), 264
impressionism, 47
Independent Group (London), 306
"Inert Gas" series (Barry), 275, 277
*Ingres and Other Parables* (Baldessari), 277

International Klein Blue, 55
*Interview* (Rauschenberg), *315*
Irwin, Robert, 6, 7, 50, 194, 197–99, 200, 202, 205, 208, 210; works of, *198, 220, 221*
*Isolated Mass/Circumflex* (Heizer), 194
Isozaki, Arata, 10, 14–15, 20–21, 23

*Jacob's Ladder* (Frankenthaler), *77*
*Jadito's Night* (Turrell), 200
*Jambes 1 2* (Broodthaers), *284*
Jameson, Fredric, 178, 180
*Jinx* (Ruscha), 270
Johns, Jasper, 6, 51, 56–57, 163, 171, 176, 184, 223, 268, 270, 277, 297, 300, 308, 310; works of, *88, 89, 269, 298*
Jones, Alan, 306
Judd, Donald, 162, 163, 170, 171, 172, 174, 175, 304; works of, *164, 190, 191*
*Just in Time* (Murray), 58

Kandinsky, Wassily, 34, 40, 265, 272, 274; works of, *265*
Kaprow, Allan, 223, 295
Karp, Ivan, 301
*Kassel Corridor Elliptical Space* (Nauman), 207; plan for, *206*
*Keeper* (Puryear), 123, *157*
Kelley, Mike, 268, 275, 279–81; works of, *280, 290, 291*
Kelly, Ellsworth, 51–52; works of, *94, 95*
Kelly, Mary, 178
Kernberg, Otto, 121
Khlebnikov, Velimir, 7
Kiefer, Anselm, 245–46; works of, *248, 249*
Kienholz, Edward, 228; works of, *236–37*
Kienholz, Nancy Reddin: works of, *236–37*
*Kiss/Panic* (Baldessari), 277
Klee, Paul, 247
Klein, Melanie, 111, 113

Klein, Yves, 54–55, 176, 225, 295; works of, *72, 73*
Kline, Franz, 42–43, 267, 293; works of, *74, 75*
Kolbowski, Silvia, 178
Kosuth, Joseph, 275, 307
Kounellis, Jannis, 122, 225, 226–27; works of, *234, 235*
Krasner, Lee, 46–47; works of, *80, 81*
Krauss, Rosalind E., 50, 163, 170, 172, 173
Kruger, Barbara, 178, 272, 311; works of, *312*

*Laar* (Turrell), 199–200
Lacan, Jacques, 279
Laing, Gerald, 306
*La Jolla Grove Proposal Drawing* (Fleischner), *219*
*Larghetto* (Signac), 265
Larsen, Susan C., 56
*Lavacourt, Sun and Snow* (Monet), 264
Lawler, Louise, 178
*Leaning Room* (Bell), *186*
*Lebenden stinken und die Toten sind nicht anwesent, Die* (Polke), *333*
Ledoux, Claude-Nicolas, 20
Leonardo da Vinci, 304
Lere, Mark, 6, 123, 124; works of, *160, 161*
Levine, Sherrie, 177, 311; works of, *311*
Lévi-Strauss, Claude, 242, 266, 306
LeWitt, Sol, 55, 162, 205; works of, *167, 193*
Lichtenstein, Roy, 176, 223, 268, 300–301; works of, *302, 322, 323*
*Lighted Center Piece* (Nauman), 205
*Lightning* (Beuys), 117, 121, *150*, 226
Lightning with Stag in its Glare, see *Blitzschlag mit Licht-schein auf Hirsch*

*Lips* (Ruscha), 270
Longinus, 41
Longo, Robert, 177
*Lot to Like, A* (Rosenquist), *324*
Louis, Morris, 47, 49, 265, 268; works of, *78, 79*
Lyotard, Jean-François, 281

*Ma*, Japanese concept of, 14
Magritte, René, 263, 267, 268, 270, 277, 278; works of, *266*
Malevich, Kasimir, 274
Mallarmé, Stéphane, 33, 34, 35, 36, 42, 55
Man, Paul de, 34
Mandel, Ernest, 179
Manzoni, Piero, 225
Marden, Brice, 54; works of, *86, 87*
Martin, Agnes, 55; works of, *92, 93*
Masson, André, 263
*Master Bedroom* (Fischl), *255*
Mathieu, Georges, 267, 295
Matisse, Henri, 34, 42, 47, 55
Matta, 38
McCracken, John, 306
McEvilley, Thomas, 55
McHale, John, 306
*Meditation on a Can of Vernors* (Kelley), 279
*Mer, les barques, Concarneau, La* (Signac), 265
Merz, Mario, 225
Meyer, Franz, 117
Michaux, Henri, 267
minimalism, 41, 55, 57, 162–80, 274
Miró, Joan, 34, 267, 270
Miss, Mary, 194, 205, 208, 210
Mitchell, Stephen, 111
Mitchell, W. J. T., 262
*M. I. T. Project* (Fleischner), 208, *209*
modernism, 30–33, 46, 50, 51, 54, 57, 107, 281, 292, 299
Mondrian, Piet, 274, 300
Monet, Claude, 179, 264
*Monitor* (Kline), *75*

*Monkey Island* (Kelley), 268, 279, 290, 291
*"monument" for V. Tatlin* (Flavin), *185*
*Monuments to the Stag* (Beuys), 117
*Moon Fountain* (Nevelson), 130
Morris, Meaghan, 281
Morris, Robert, 162, 170, 172, 173, 174, 194, 196, 197, 199, 200, 205, 208, 210; works of, *165, 196*
*Mortality* (Noguchi), *132*
Moses, Ed, 52, 197; works of, *104, 105*
Motherwell, Robert, 32, 267, 274
*Motor* (Ruscha), 270
*Mountain King* (Beuys), 117
*Mountains and Sea* (Frankenthaler), 47
*Moving Out (Starfield II)* (Celmins), *99*
*M38 (Untitled Red Monochrome)* (Klein), *72*
Mukarovsky, Jan, 262
Mullican, Matt, 267, 309–10; works of, *336, 337*
*Mural* (Pollock), *39*
Murray, Elizabeth, 6, 58; works of, *96, 97*
Museum of Contemporary Art, 6–9, *17, 24*; architecture, 10–23; Gallery A (entrance gallery), 10, *11*, 14–15; library and office wing, *25*; north façade, *13*; North Gallery, 15; skylights, 10, *12*, 14, 15, 23; South Gallery, 15
*Mutants Playing* (Garabedian), *253*

Nauman, Bruce, 123, 170, 205–8; works of, *140, 141, 206, 207*
*Neon and Scoop Lights* (Sonnier), *143*
*Neon Templates of the Left Half of My Body Taken at Ten Inch Intervals* (Nauman), *141*

Nevelson, Louise, 6, 122; works of, *130, 131*
Newman, Barnett, 36, 38, 40–41, 42, 274; works of, *64, 65*
Nietzsche, Friedrich, 41, 243
*9 Spaces, 9 Trees* (Irwin), 199
*1984* (Ruscha), 270
*NO* (Johns), 268
Noguchi, Isamu, 122, 123; works of, *132, 133*
*Noise, Pencil, Broken Pencil, Cheap Western* (Ruscha), 270
Noland, Kenneth, 47, 51, 173
*nominal three (to William of Ockham), the* (Flavin), *168*
Nordman, Maria, 6, 202, 205, 207, 208, 210
*No Title* (Therrien), *154*
*No Title* (Therrien), *155*
*Nu* (Louis), 49, *79*
*Number 1* (Pollock), 40, *63*

"Ocean Park" (Diebenkorn), 56
*Ocean Park #90* (Diebenkorn), *90*
*Ocean Park #140* (Diebenkorn), *91*
O'Doherty, Brian, 31, 36, 42, 210
O'Hara, Frank, 42, 268
*Okokade* (Schwitters), *271*
Oldenburg, Claes, 110–13, 115, 116–17, 119, 223, 224–25, 297, 299, 300, *318*; works of, *111, 112, 318, 319*
*Old Man's Boat and the Old Man's Dog, The* (Fischl), *254*
Olitski, Jules, 173
*Onement I* (Newman), 40, *64*
*Onement VI* (Newman), *65*
*One Ton Prop (House of Cards)* (Serra), 163, *169*
Oppenheim, Dennis, 194, 208
*Orange Disaster* (Warhol), *305*
Orr, Eric, 202
*Oscar-Turpitude* (Broodthaers), *284, 285*
*Ouray* (Stella), *83*
Owens, Craig, 177

*Pace and Progress* (Morris), 196
*Paganini* (Polke), *332*
*Painted Bronze* (Johns), 56
*Painting with Two Balls* (Johns), 268
Paolini, Giulio, 225
Paolozzi, Eduardo, 306
*Paquet de lettres* (Broodthaers), *284, 285*
*Parting and Together* (Murray), 58
*Pasiphaë* (Pollock), 38
Pei, I. M., 208
*Pendulum with India Yellow Pigment* (Horn), *239*
*Perimeters, Pavilions, Decoys* (Miss), 205
Phillips, Peter, 306
Picabia, Francis, 245
Picasso, Pablo, 6, 34, 38, 43, 247, 266, 270, 297
Pierce, Charles, 267
*Pillar* (Bourgeois), *127*
*Pink Angels* (de Kooning), *61*
*Pinkest and the Heaviest, The* (Price), *158*
*Pink Lady* (de Kooning), 43, *60*
*pink out of a corner (to Jasper Johns)* (Flavin), *184*
*Pleiades* (Turrell), 200
*Poêle de moules* (Broodthaers), *284*
*Polar Stampede* (Krasner), 46
Polke, Sigmar, 308–9, 310; works of, *332, 333*
Pollock, Jackson, 36, 38, 40, 42, 47, 222, 223, 229, 267, 293, 294; works of, *37, 39, 62, 63*
Poons, Larry, 55
pop art, 52, 178–80, 223–29, 299–301, 306–7
postmodernism, 281, 308
*Pre-Natal Memories* (di Suvero), *144, 145*
*President Elect* (Rosenquist), 301
*Presto (finale)* (Signac), 265
Price, Ken, 123; works of, *158, 159*

*Primeval Resurgence* (Krasner), 46, 47, *81*
*Promotion Agency; The Obscure with its Indeterminate Size; The Perfect Circle* (Kelley), *280*
*Purple Brown* (Rothko), 42
Puryear, Martin, 123; works of, *156, 157*
*Pyramids* (LeWitt), *192–93*

*Radiation Piece* (Barry), 275
Rainer, Yvonne, 311
*Rancho* (Ruscha), 270
Raphael, 244
Rauschenberg, Robert, 49, 163, 170, 176, 179, 180, 223, 246, 268, 271, 294–95, 300, 301, 304, 308, 310; works of, *296, 314, 315*
*Raw* (Ruscha), 270
*Reason for the Neutron Bomb, The* (Burden), 228
Reciprocal Accord, see *Accord réciproque*
*Red, Yellow, Blue II* (Marden), *87*
*Red/Orange* (Kelly), *95*
Reinhardt, Ad, 294
*Repetition 19, III* (Hesse), *139*
*Resource* (Ryman), 54, *102*
Rhodes, Zhandra, 306
*Ricordo* (Clemente), *258*
*RM 669* (Wheeler), *201*
Robbe-Grillet, Alain, 225
Rodin, Auguste, 170, 179
*Room with My Soul Left Out/ Room that Does Not Care* (Nauman), *207*
Rose, Barbara, 47
Rosenberg, Harold, 170, 262, 293–95, 297
Rosenquist, James, 223, 300, 301, 304, 310; works of, *303, 324, 325*
Rosler, Martha, 178
Rosso, Medardo, 223
Rothenberg, Susan, 247; works of, *250, 251*

Rothko, Mark, 38, 41–42, 47, 55, 274; works of, *70, 71*
*Roxy's* (E. Kienholz), 228
*Ruin V* (Garabedian), *252*
Ruppersberg, Allen, 6
Ruscha, Ed, 268, 270, 306–7, 310; works of, *320, 321*
Ryder, Albert Pinkham, 38
Ryman, Robert, 52, 54, 55; works of, *53, 102, 103*

*Sahara* (Twombly), 49, *84*, 268
Salle, David, 6, 245, 310–11, 312; works of, *328, 329*
Samaras, Lucas, 115–17, 119; works of, *114, 136, 137*
*SA MI DW SM 75* (Wheeler), 202, *216–17*
Sartre, Jean Paul, 35–36, 43, 106, 115, 121
Satie, Erik, 34
Saussure, Ferdinand de, 170
Schapiro, Meyer, 33
*Scherzo* (Signac), 265
Schiele, Egon, 245
Schnabel, Julian, 246; works of, *260, 261*
Schönberg, Arnold, 34
Schwitters, Kurt, 266, 271, 272; works of, *271*
sculpture, 106–61; minimalism and, 163, 170–73, 179
*Sea Lion* (Kiefer), *248*
*2nd Meeting*, plan for (Turrell), 200, *214*
*Secret Archives* (Herms), 122, *135*
*Seedbed* (Acconci), 205
*Seer* (Puryear), 123
*Sentinel* (D. Smith), *129*
Serra, Richard, 23, 119, 122, 123, 162, 163, 170; works of, *120, 169, 188, 189*
*SE33* (Klein), *72*
*Seven Types of Ambiguity* (Frankenthaler), 47
Shapiro, Joel, 123; works of, *146, 147*
Sherman, Cindy, 177, 311, 312; works of, *330, 331*

*Shift* (Serra), 170
*Ship's Log* (Wiley), 122, *232*
*Shoot* (Burden), 228
Siegelaub, Seth, 275
Signac, Paul, 264–65; works of, *264*
*Simple Network of Underground Wells and Tunnels, A* (Aycock), *204*, 205
*Sky Cathedral: Southern Mountain* (Nevelson), *131*
*Skyspace I* (Turrell), *214*
*Slow Swirl by the Edge of the Sea* (Rothko), 42
Smith, Alexis, 270–72; works of, *273, 288–89*
Smith, David, 119, 123, 171, 208, 306; works of, *128, 129*
Smith, Tony, 171, 172, 173
Smithson, Robert, 170, 175, 177, 194, 208, 210
*Sollie 17* (E. and N. R. Kienholz), 228, *236–37*
*Some Rooms* (Baldessari), *335*
Sonnier, Keith, 122; works of, *142, 143*
*Spark* (Louis), 49, *78*
*Spiral Jetty* (Smithson), 170
*Spy/Stephanie* (Graham), *148*
stain technique, 47, 49
*Standard* (Lere), *161*
*Starfield* (Celmins), *98*
*Star Packer, The* (Bengston), *327*
*State Hospital, The* (E. Kienholz), 228
*Steam* (Morris), 196
Steinberg, Leo, 180, 262
Stella, Frank, 51, 52, 162, 171, 173, 265, 300, 310; works of, *50, 82, 83*
Still, Clyfford, 38, 41, 55; works of, *68, 69*
*Store, The* (Oldenburg), 225, 297, *318*
*Storm Door* (Warhol), *317*
*Street, The* (Oldenburg), 224–25
*Strong Hand (The Grip)* (Lichtenstein), *323*
*Strut*, drawing for (Lere), *160*

*Student of Prague, The* (Schnabel), *260*
*Sublime, The* (Kelley), 279, 280
Sultan, Donald, 6, 58; works of, *100, 101*
surrealism, 38, 42
*Suzanne* (Clemente), *259*
Sweeney, James Johnson, 40
symbolism, 34–36
*Symmetrical Sets: Ass Insect; Red Reefs; Splitting Cell; Two Tents* (Kelley), *290*

*Table–Version II* (Hoffman), *45*
Tanguy, Yves, 247
*Tanktotem III* (D. Smith), *128*
*Tantric Detail* (Johns), 56
*Tantric Detail II* (Johns), *89*
Tatlin, Vladimir, 7, 175, 185
Temporary Contemporary, 6, 7, 8, *26*; after renovation, *19*; architecture, 10, 15, 20; chain-link canopy, *18*; "First Show, The," *11, 27*; prior to renovation, *18*
*Tennyson* (Johns), 268, *269*
"Territory of Art, The" (radio program), 7, 9
*Thank You Hide* (Wiley), *233*
Therrien, Robert, 6, 54, 58, 123; works of, *154, 155*
*13/11* (LeWitt), *167*
*Three Flags* (Johns), *298*
*Three Rulers* (Morris), *196*
*Throne* (Schnabel), *261*
*Through the Night Softly* (Burden), 228
*Tilted Arc* (Serra), *188*
Tobey, Mark, 267
*Tomlinson Court Park* (Stella), *82*
*T plus grand que* (Broodthaers), *284*
*Trabajos en la Ciudad* (Nordman), 202
*Trade Winds #2* (Cornell), *231*
*trahison des images, La* (Magritte), *266*
Trakas, George, 208

*Travelogue: The Baggy Pants Comedian; The Celibate Genius; The Green Black Green Flag; The Two Islands Merge To Form a Boat* (Kelley), *291*
*Triangular Yellow Room* (Nauman), 207
Turrell, James, 6, 194, 197, 199–200, 202, 207, 208, 210; works of, *214, 215*
Twombly, Cy, 49, 267–70; works of, *84, 85*
*Two Running Violet V Forms* (Irwin), 199

Ulmer, Gregory L., 274
*Untitled* (Bell), *187*
*Untitled* (Fleischner), *218*
*Untitled* (Graham), *149*
*Untitled* (Graham), *149*
*Untitled* (Irwin), *198*
*Untitled* (Judd), *164*
*Untitled* (Judd), *190*
*Untitled* (Judd), *191*
*Untitled* (Kounellis), *234*
*Untitled* (Kounellis), *235*
*Untitled* (Kruger), *312*
*Untitled* (Moses), *104*
*Untitled* (Moses), *105*
*Untitled* (Mullican), *336, 337*
*Untitled* (Ryman), *53*, 54
*Untitled* (Shapiro), *146*
*Untitled* (Shapiro), *147*
*Untitled* (Still), *68*
*Untitled* (Still), *69*
*Untitled* (Twombly), 49
*Untitled Box No. 3* (Samaras), *136*
*Untitled Ending* (Berlant), *257*
*Untitled #2* (Martin), *92*
*Untitled #4* (Martin), *93*
*Untitled #88* (Sherman), *330*
*Untitled #92* (Sherman), *331*

Valéry, Paul, 34, 36
Vermeer, Jan, 292
*Vestigial Appendage* (Rosenquist), *325*
*Video Corridor* (Nauman), 207

*View the Author through Long Telescopes* (Salle), *328*
*Violet and Yellow on a Rose* (Rothko), 42

*Wait, The* (E. Kienholz), 228
Wall, Jeff, 307
Warhol, Andy, 176, 178, 179, 180, 223, 224, 245, 268, 300, 304–6, 307, 310, 312; works of, *305, 316, 317*
*Weeping Women* (Johns), 56
Weiner, Lawrence, 275, 307
Wheeler, Douglas, 6, 200–202, 205, 208; works of, *201, 216–17*
Whistler, James McNeill, 264
*White* (Francis), *67*
Whitehead, Alfred North, 110
*White Light/White Heat* (Burden), *203*, 205
*White #4* (Francis), *66*
*White Oracle* (Duff), *152*
*White Painting* (Rauschenberg), 295
*White Shirt on Chair* (Oldenburg), *319*
Wiley, William, 122, 227; works of, *232, 233*
Wolfe, Tom, 262
Wollheim, Richard, 163
Wols, Alfred, 267
*Woman and Bicycle* (de Kooning), 46
*Wood Interior* (Fleischner), 205, 207, *219*
Wortz, Ed, 197, 200
Wortz, Melinda, 202

*Yipes* (Murray), 58
Youngerman, Jack, 51

*Zangęzi* (Khlebnikov), 6–7
*Zinc-Lead Plain* (Andre), *166*

## Photography Credits

Most of the photographs reproduced in this volume have been provided by the artists or collections indicated in the accompanying captions. We wish to thank them for their generosity and to acknowledge the following photographers as well:
Claudio Abate, Rome: page 234; Jon Abbott: page 91; David Aschkenas: page 188; Ben Blackwell: pages 134, 232; Courtesy Blum Helman Gallery, New York: page 153; Courtesy Mary Boone Gallery, New York: page 255; Rudolph Burckhardt: pages 302, 318; Rudolph Burckhardt, courtesy Leo Castelli Gallery, New York: pages 165, 296 (right), 303; Courtesy Leo Castelli Gallery, New York: pages 89, 141; Geoffrey Clements: pages 45 (left), 50, 298; Geoffrey Clements, courtesy Leo Castelli Gallery, New York: page 164; Geoffrey Clements, copyright © 1979 Dia Art Foundation: page 85; Giorgio Colombo: page 206; Grey Crawford: pages 67, 230, 334; Prudence Cuming Associates, Ltd.: page 140; Bevan Davies: page 196; James Dee: pages 147, 166; John Eden, Art Documentation: pages 12, 16, 22; Roy Elkins, New York: page 316; eeva-inkeri, courtesy Ronald Feldman Fine Arts, New York: page 203; Lee Fatherree: pages 83, 98; Courtesy Flow Ace Gallery, Los Angeles: pages 142, 144; Brian Forrest: pages 326, 327; Ira Garber: page 219 (bottom); Carmelo Guadagno: page 62; Carmelo Guadagno and David Heald: page 133; Bob Hale: page 18 (right); Charles Harrison: page 159; Hickey-Robertson: page 269 (left); Courtesy Hirschl & Adler Modern, New York: page 253; Bill Jacobson Studio: page 249; Walter Klein: page 128; Charles Larrieu: page 72 (left); J. Littkemann, Berlin: pages 118, 119, 151; Courtesy L. A. Louver Gallery, Venice, California: pages 104, 105, 257; Courtesy Gallerie Maeght Lelong, New York: page 103; Daniel Martinez: pages 68, 82, 135, 220, 221, 231; Robert E. Mates: pages 102, 305 (right); Robert E. Mates and Paul Katz: page 53; Courtesy David McKee Gallery, New York: page 99; Courtesy Robert Miller Gallery, New York: page 81; Andrew Moore: page 101; Michael Moran: pages 11 (left), 24, 25; William Nettles: pages 286, 287, 336, 337; Courtesy Annina Nosei Gallery, New York: page 312; Copyright © Douglas M. Parker Studio: pages 44, 61, 152, 154, 155, 157, 160, 161, 251, 273, 280, 288, 290, 291; James A. Penny: pages 233, 269 (right); Eric Pollitzer, courtesy Leo Castelli Gallery, New York: pages 88, 184; Pollitzer, Strong, and Meyer: page 138; Dirk Reinhartz, Buxtehude: page 189 (top); Copyright © 1985 Steve Rosenthal: page 209; Paul Ruscha: pages 320, 321; Paulo Mussat Sartor: page 235; Tracy Schiffman/Roland Young Design Group: page 17; F. W. Seiders: page 266; Gian Sinigaglia: pages 120, 168, 276; Copyright © 1981 by Steven Sloman, courtesy Harry N. Abrams, Inc.: page 76; Squidds & Nunns: pages 13, 26, 70, 71, 74, 75, 86, 87, 92, 93, 96, 130, 131, 145, 146, 185, 201, 216–17, 250, 252, 296 (left), 314, 315, 319, 322, 323, 324, 325, 328, 329, 330; Tim Street-Porter: pages 11 (right), 18 (left), 19, 27; Joan Tewkesbury: page 198; Frank Thomas: pages 60, 90; Jerry L. Thompson: page 136; Charles Uht: pages 264, 266 (top); Malcolm Varon: pages 64, 78; Tom Vinetz: pages 63, 65, 187, 195 (right), 212, 213, 236, 237; Copyright © 1985 Ellen Page Wilson: page 191; Dick Wiser: page 215; Janet Woodward, Houston: page 271; Dorothy Zeidman: page 207; Zindman/Fremont: pages 260, 261; Zindman/Fremont, courtesy Leo Castelli Gallery, New York: page 190.